SCANDINAVIA

CERAMICS & GLASS IN THE TWENTIETH CENTURY

The collections of the Victoria & Albert Museum

Jennifer Hawkins Opie

V&A Publications

Catalogue sponsored by Oy Arabia Ab and Christie's London

First published by V&A Publications, 1989
Reprinted 2001

© 1989 The Board of Trustees of the Victoria and Albert Museum

Jennifer Hawkins Opie asserts her moral right to be identified as author of this book.

ISBN 1 85177 071 2

A catalogue record for this book is available from the British Library.

Designed by Morrison Dalley Design Partnership

Printed in Italy

 V&A Publications
160 Brompton Road
London
SW3 1HW
www.vam.ac.uk

Cover illustrations:
Front: Vase, 'Kantarelli' (Chanterelle), clear colourless glass, made by Iittala,
designed by Tapio Wirkkalla, 1946, cat. No. 196
Back: Sculpture 'Lansetti II' (Lancet II), clear colourless glass, made by Iittala,
designed by Timo Sarpaneva 1952, cat. No. 202

CONTENTS

ACKNOWLEDGEMENTS

This catalogue could not have been compiled and written without the most generous co-operation of many friends and colleagues abroad and support and help over and above their expected daily duties from colleagues in this Museum.

While any errors are entirely my responsibility I owe grateful thanks to many people for their time spent in reducing these to a minimum.

Jennifer Hawkins Opie.

Denmark

Freddy Jensen (Royal Copenhagen)
Martin Kaldahl
Malene Müllertz
Steen Nottelmann (Bing & Grøndahl, Royal Copenhagen)
Mogens Schlüter (Holmegaard)
Jørgen Schou-Christiansen (Kunstindustrimuseum, Copenhagen)
Bjørn Wiinblad
Vibeke Woldbye (Kunstindustrimuseum, Copenhagen)

Finland

Marianne Aav (Taideteollisuusmuseo, Helsinki)
Marketta Kahma (Iittala)
Marjo Kalo (Finnish Embassy)
Kaisa Koivisto (Suomen Lasimuseo, Riihimäki)
Marjut Kumela (Arabia)
Timo Sarpaneva
Barbro Schauman
Oppi Untracht

Norway

Jens Berg (Hadeland)
Åsmund Beyer (Porsgrunn Bymuseum)
Ulla Tarras-Wahlberg Bøe (Norsk Form)
Liv Mørch Finborud (Royal Ministry of Foreign Affairs, Oslo)
Jan Flatla (formerly Norwegian Embassy)
Randi Gaustad (Kunstindustrimuseet, Oslo)
Ina Iverson (Norske Kunsthåndverkere)
Poul Jensen (Porsgrund)
Jan-Lauritz Opstad (Nordenfjeldske Kunstindustrimuseum, Trondheim)
Ada Polak
Anne Ulset (Norwegian Embassy)

Sweden

Kerstin Asp-Johnsson (formerly Swedish Embassy)
Steffi Burgaz (Nationalmuseum, Stockholm)
Helena Dahlbäck Lutteman (Nationalmuseum, Stockholm)
Inger Nordgren (Gustavsberg)
Ingegerd Råman
Anders Reihnér (Orrefors)
Ingrid Schaar
Barbro Hovstadius (Nationalmuseum, Stockholm)
Kajsa Wahlström (Kosta Boda)

This project was only possible through the especially valuable support of John Mallet, formerly Keeper of the Department of Ceramics and Glass. The entire department has helped but especially Tanya Rebuck, Ann Eatwell, Fiona Gunn and Oliver Watson, with marathon work by Christine Smith of the Photo Studio.

In addition I must thank the sponsors, Dan Klein (Christies), Harry Blömster (Arabia); my editor Esther Caplin for bringing order from chaos in time to meet increasingly tight deadlines, and, for help with the biographies, Hilary Bracegirdle, Catherine Croft, Eva Seeman and most especially Gisela Almquist Liardet.

Finally, my thanks for years of unfailing patience are due to Constance and George Hawkins, Geoff and Jonathan Opie.

ELIZABETH ESTEVE-COLL
Director, Victoria & Albert Museum

The Victoria and Albert Museum has collected Scandinavian ceramics and glass through-out this century. The major groupings were acquired in the 1930s, particularly from Denmark. In the 1950s and 1960s acquisitions were largely made from Finland and Sweden. Over the last five years the Museum has identified gaps in its collection of Scandinavian work and has been able to fill many of them, as well as adding a considerable selection of contemporary work from these three countries. It has also added a significant group from Norway. This catalogue documents the entire collection.

The project was begun and largely completed under J V G Mallet, Keeper of the Department of Ceramics and Glass (1976-89) and it is fitting that he should have written a prelude which expresses his personal knowledge of this aspect of Scandinavian art.

The Museum owes a great debt to the staff of all four Scandinavian embassies, and to artists, designers and factories in each of these countries. Their generous support and enthusiasm for this project has enriched the Museum's collection immeasurably, whilst close co-operation with Jennifer Opie has resulted in a catalogue which will take its place among the Museum's scholarly works which disseminate information about our collections to an international public and researchers worldwide.

The single minded pursuit of excellence over several years that has characterised Jennifer Opie's dedication to this project has culminated in an exhibition and catalogue which is a definitive and comprehensive statement about the Scandinavian contribution to twentieth century ceramics and glass.

15 May 1989

From January 1940 until soon after the Nazi surrender my father was British Minister Plenipotentiary in Stockholm. It was there that for two of those Wartime years, between the ages of twelve and fourteen, my own interest in the visual arts received stimulation from a teacher of genius, Wolfgang Reybekiel, who taught me drawing and painting once a week, seated at a birchwood table from Svenskt Tenn.

During the two boyhood years I spent in Stockholm, Scandinavia was more divided than at almost any other period in history: Denmark and Norway occupied by the Nazis; central Finland used for transit by Germany, and unhappily drawn into renewed conflict with Russia following the 'Winter War' of 1939; Sweden preserving a precarious neutrality, eager enough for the downfall of Hitler yet in no hurry to see the Baltic become a Russian lake. After such divisions it was remarkable how quickly the Scandinavian identity imprinted by Geography and History reasserted itself the moment hostilities ceased, and how quickly countries, some of whom had suffered bitter experiences, were able to renew their impact on the field of international design.

The Swedes, like the British, were pioneers in collecting early Chinese ceramics. My father, who had joined the Oriental Ceramic Society in London, found this enthusiasm mirrored amongst many of his Swedish friends. The qualities of refinement and restraint that I recall in Carl Kempe's remarkable Chinese collection at Ekolsund were just such as appealed to Swedish craftsmen and designers of the time. Equally, I am sure my father's response to the two Swedish bowls in this catalogue (nos 356, 357) that he purchased in those Wartime years was conditioned by the Chinese aesthetic that he perceived in them.

I can imagine some Scandinavians may resent the perpetual pigeonholing of all their works as cool and sensible. Munch and Strindberg should remind us that the Nordic temperament has its darker side and is capable of astonishing outbreaks of exuberance when the Spring sun or the local firewaters unlock pent-up energies. I have accordingly watched with increasing admiration as Jennifer Opie has picked her way between the conflicting claims of different tendencies amongst Scandinavian designers and craftsmen, in her attempt to round out the existing collections of the Museum in time for the present catalogue and exhibition. One can try to make a collection such as this representative, never complete. 'What's past is prelude': let us hope the Museum will continue to review and from time to time add to its collections of ceramics and glass from Scandinavia.

FACTORIES AND WORKSHOPS

☐ Arabia (Helsinki)
☐ Bing & Grøndahl (Copenhagen)
3 Bo Fajans
4 Bornholm
5 Eda
☐ Frysja (Oslo)
7 Gefle
8 Gullaskruf
9 Gustavsberg
10 Hadeland
11 Höganäs
12 Holmegaard
13 Iittala
14 Iris workshops
15 Johansfors
16 Kaehler Keramik
17 Karlskrona
18 Kongsberg
19 Kosta Boda

20 Kuppittaan Savi
21 Lidköping
22 Nuutajärvi
23 Nymølle
24 Orrefors
25 Plus Glasshytte
26 Porsgrund
27 Pukeberg
28 Reimyjre
29 Riihimäki
30 Rörstrand
☐ Royal Copenhagen (Copenhagen)
32 Saxbo
33 Skruf
34 Stavangerflint
☐ Stelton (Copenhagen)
36 Strömbergshyttan
37 Transjö
38 Upsala-Ekeby

Despite recent and increasing concerns about defoliated forests and dying lakes in Scandinavia, the popular view persists of a group of countries consisting of lakes and pine trees, peopled with design-conscious healthy blonds who enjoy the advantages of the most liberal of social systems with advanced material and technical comforts, and who live in spacious birch and pine wood houses furnished in a style perfected and forever fixed at around 1953. Their year is neatly divided into short winter days with brilliant crisp snow and endless summers spent in summer houses dotted among the pine forests and in boats drifting on the myriad lakes.

There are elements of truth in this enviable picture and, indeed, many Scandinavians themselves cherish this image. Nevertheless, to the more critical observer it quickly becomes obvious that the four countries represented in this catalogue are quite distinctly different and the picture is considerably more complex. Ingmar Bergman's idyllic film of 1952, 'Summer with Monika', may be one view, but before that the history of ceramics and glass design alone reveals an altogether more serious side, concerned with social development and a worldly and political awareness which has earned the countries collectively an honourable reputation.

'Scandinavia' is the term commonly used today to cover the group of Nordic countries comprising Denmark. Finland, Iceland, Norway and Sweden. On occasions, it is also stretched to include Greenland and the Faroë Islands. Interpreted in strictly geographical terms it is the peninsula of Norway and Sweden combined with part of Finland. Linguistically however, it also includes the Germanic tongues of Norway, Sweden, Iceland, Denmark, the Faroë Islands and the Swedish-speaking Finns and Estonians. The Finnish language stands apart and is one of the Ugro-Finnic tongues which stem from northern and central Asia. Today its nearest related language is Hungarian. The term 'Scandinavia' is most commonly used, but 'Nordic' is sometimes preferred as being more evocative. It is also a more historic term and has distinct associations with the medieval Norse traditions.

1 Vase
Stoneware; made by Edith Sonne Bruun at Bing & Grøndahl. Denmark. 1986
Cat. no. 102

Denmark, Finland, Norway and Sweden share a long history of interrelationships and shifting balances of power. By the end of the 19th century they had arrived at a point where each nation was concerned with establishing an identity independent of its neighbours. Nationalist movements were growing against a background of increasing industrialisation, of rural poverty and demands for social reform and of the same groundswell of popular concerns which affected most European countries at this period. Denmark was nearing the end of a lengthy period of intermittent conflict with Germany over the border areas of Schleswig and Holstein. Finland, for centuries under Swedish and then Russian dominance, was taking the first steps towards independence. Norway was slowly extracting itself from a union with Sweden in which it had been the dominated partner. Sweden, after enjoying senior status in its relationships with Finland and Norway, was adjusting to its reduced area of influence within the Scandinavian group. These political, social and economic factors all played a fundamental part in the development of industrial production, including the glass and ceramics industries, and in the direction taken by the

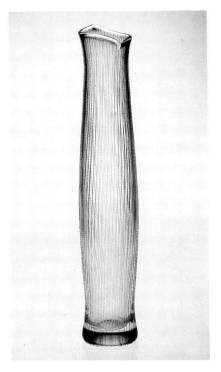

2 Vase 'Tuonen Virta'
Glass; made by Iittala, designed by Tapio Wirkkala, Finland, 1951
Cat. no. 200

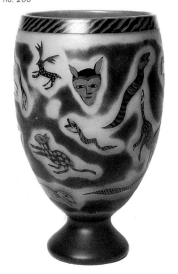

3 Vase 'Föralskade Ormar'
Glass; made by Kosta Boda, designed and decorated by Ulrica Hydman-Vallien, Sweden, c. 1985
Cat. no. 533

crafts as individual artists responded to changes in their personal circumstances and that of society around them.

Assessments of the qualities that characterise Scandinavian design, whatever variations are identified, usually agree on a fundamental group including craftsmanship, quality, humanity and restraint combined with a sympathetic respect for the natural materials and a concern for their 'proper' use by the designer and consumer. This apparently instinctive feeling for natural materials takes different forms. Danish designers and artists excel particularly in the use of exotic effects. Danish studio potters and industrial manufacturers have specialised in rich oriental glazes drawn from Chinese and Japanese originals, allowing the depths and colours full rein (Fig.1). Finnish designers and artists are especially conscious of their own landscape and the elements which form it. Time and again, Finnish artists refer to the Archipelago of coastal islands, and to the effects of water and wind on stone or ice. Artists from all four countries include in their vocabulary symbols related to hunting and fishing and the age-old struggle to survive the dark, frozen northern winters. Another formative element which is deeply rooted in the Scandinavian subconscious and which is even now very much a part of Scandinavian's creativity is an inheritance of folklore and dark, Nordic mysticism. This special language is still very apparent in references to the 'Kalevala' in Finnish design (Fig. 2), in the sophisticated work of Bertil Vallien, and in a more nakedly instinctive and unsettling manner in the painted glass and ceramics of Ulrica Hydman-Vallien (Fig.3). It is equally identifiable in the early slip-decorated earthenwares by Bjørn Wiinblad (cat. no. 63). Curiously, it is least apparent in the work of contemporary Norwegian potters and glassmakers.

An additional factor which is very noticeable in much Scandinavian design is the influence of fine arts — painting, sculpture and architecture — on individual ceramic and glass studio work and, perhaps more surprisingly, on the design of objects for multiple production. Many designers received their basic training at the factory where they were employed but supplemented this with classes at local art schools or by sandwiching in a year or more of full-time drawing and painting. Schools of art and design have a long-established tradition in Scandinavia; the Konstfackskolan (now National College of Art, Craft and Design, NCACD) was set up in Stockholm in 1844, for instance. In the later 19th and early 20th centuries a significant number of art directors and designers came to the factories with full training in the fine arts, only later increasing their skills to include the design of ceramics or glass. Of the 209 designers represented here a quarter trained first in one of these disciplines and some combined several disciplines. The architect and designer Alvar Aalto for instance (as has been identified by Göran Schildt, *Alvar Aalto: The Early Years*, NY 1984), was fundamentally influenced by the work of painters such as Paul Cézanne, for his constructional approach in assembling a three dimensional situation by the careful placing of precisely selected elements; and the Finn Tyko Sallinen for his use of fluid curving contours to represent the Finnish countryside. Other designers brought a painter's or sculptor's vocabulary directly to their designs. Edward Hald associated with Henri Matisse in Paris, Arthur Percy had been a practising painter in France (Fig.4). Wilhelm Kåge (who trained as a painter) designed the functionalistic 'Praktika' tableware (Fig. 5) at Gustavsberg which, when assembled into its fully space-saving, stacked unit, is as much a formal sculpture as it is a highly useful and practical set of domestic containers. In considerable contrast he was able to produce the virtually impractical 'Surrea' series of vases and bowls (cat. no.

354) which are predominantly an elaborate and witty backward glance at some of the major international art forms of the 20th century.

In the 19th century Pietro Krohn at Bing & Grøndahl was a painter and illustrator and a member of a group of highly knowledgeable collectors and connoisseurs with international contacts. More recently, in Finland, Timo Sarpaneva qualified as a graphics artist and designed posters for littala and the company's red 'I' symbol, while Tapio Wirkkala trained as a sculptor and throughout his life drew on this first talent in everything he designed. Grethe Meyer in Denmark is an architect and designer of ceramics. Individual designer/artists switch with ease from a major sculptural or architectural commission to the design of a drinking glass, cooking pot or cutlery set. Indeed, frequently the design takes on a sculptural quality, enriching its aesthetic appeal. Evidence that this close relationship between art and design is fully realised and accepted throughout Scandinavia is the absence of that especially British confusion over the relative roles of the two disciplines. For example, the exhibition 'Modern Art in Finland' which travelled from London to Leeds, Brighton and Dublin in 1953, was arranged by the British Arts Council with the Ateneum (Helsinki Fine Arts Academy) and Ornamo (Society of Decorative Artists), and combined a display of sculpture by Waino Aaltonen, paintings by Helena Schjerfbeck, decorative ceramics, glass and rugs without any sense of conflict. Most recently, Markku Salo, in an interview in *Form Function* (Finland 1.1989) said 'I realised how much less qualified I would have been for my work without an education in painting and graphics.'

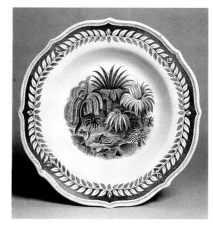

4 Plate 'Exotica'
Earthenware; made by Gefle, designed by Arthur Percy, Sweden, c. 1929-30
Cat. no. 342

This invigorating mix of backgrounds and training has also enabled individual artists and designers to work in a variety of materials. Hald and Percy both designed for glass and ceramics. Since then, designers have become ever more versatile. Sarpaneva and Wirkkala have worked in both these materials and also in metal, plastics and wood with equal success for a variety of companies. Henning Koppel, a silversmith, also designed for glass and ceramics. Saara Hopea-Untracht, a talented draughtswoman, designed glass and ceramics as well as designing and making jewellery, enamels and patchworks.

5 Stacking dishes 'Praktika'
Earthenware; made by Gustavsberg, designed by Wilhelm Kåge, Sweden, 1933
Cat. no. 349

The freedom to experiment within the factory setting is also a particularly Scandinavian achievement. Most of the major industrial manufacturers of ceramics use the studio system. Orrefors, uniquely, runs a school for training in glassmaking skills on which it can draw for its own workforce. Equally, glassmakers come from Sweden and abroad to learn their skill to advanced levels, and take this to other workshops or factory employment elsewhere. The studio system is well illustrated by Arabia where an art studio was established in 1932. From the beginning artists were invited to join the studio on a temporary or long-term basis and were allowed to work unhampered by demands for contributions to the multiple production side of the factory's output. A factory gallery provided exhibition space. This situation still applies and the factory's management see this as beneficial to the company's image and, less obviously commercially, to the creative atmosphere necessary in the design departments. In practice, many of the artists in residence respond to the rigorous challenge of designing for the production line, as have Kati Tuominen and Pekka Paikkari.

On a more prosaic level, over the last 15 to 20 years, design education in Scandinavia has taken a more formal turn and this has produced some of the most divisive and critical

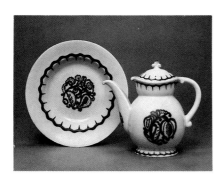

6 Tableware 'Liljeblå'
Earthenware; made by Gustavsberg, designed by Wilhelm
Kåge, Sweden, 1917
Cat. no. 334

debates. The design of industrially made goods has become a very different activity from that of the craftsman. As each stage in the production of industrially made wares becomes more mechanised and now computerised, the role of the designer is only one of a dozen or more contributing to the eventual manufacture of an object – a tea pot or saucepan – that is no longer any one person's creation. Design education has needed to encompass as much of the understanding of the machinery as of the principles of physics behind the practicality of a tea pot spout. The aesthetic considerations are simply another stage, more or less equal, in the production formula. The role of the designer, therefore, became a heated and much-debated subject in those quarters which formerly believed the central importance of such a role to be axiomatic. Such debates still produce the reflex-response that good design of any object must constitute a combination of utility and beauty with quality and cost of production appropriate to the intended role of the object. This response has been carefully nurtured and honed since its first presentation in 1917 in Stockholm with the 'Liljeblå' or 'Arbetar' (Workers') service (Fig. 6). The question of how to achieve it and whether such a combination can survive in such highly competitive industries has taken the debate further. Alf Bøe, writing in the catalogue to an exhibition of 'Scandinavian Design' held in Israel in 1974 discussed the move from craft-based training to one which should equip the new generation of designers to respond to the changing demands of industry and the practical and theoretical bases on which this move should rest. Not least, he argued, should be the humanising effect of sound industrial design principles and a sense of care and responsibility in providing artefacts for a civilised life. By 1989, Gertrud Sandqvist, writing in the thoughtful quarterly journal, *Form Function* (Finland 1.1989) reviewed an exhibition 'Paradisus Terrestis' and discussed the possibility that in Nordic or Scandinavian design, Finnish design in particular represented the only true, surviving defence of 'purity, authenticity and innocence', with its 'consideration for man and nature'.

From 1888 until the mid to later 1960s, Scandinavia, represented by one or more of its various countries, has been singled out for special mention in almost all the major international exhibitions, although not always for ceramics and glass production. In the international exhibition, Paris, Finland and Norway both attracted international acclaim for their vibrant and, to the eyes of outsiders, unexpectedly dramatic Nordic or Norse images. By 1925, the next major exhibition held in Paris, the French reports singled out Jean Gauguin (the son of the French painter, then working at Bing & Grøndahl), Effie Hegermann-Lindencrone, Fanny Garde, Axel Salto, Knud Kyhn, Nathalie Krebs and Jais Nielsen, all from Denmark, for special mention. They referred to the genius of Thorvald Bindesbøll and the work of Kaehler Keramik under Jens Thirslund. Moving to Sweden, Wilhelm Kåge, Edgar Böckman, Edward Hald and Arthur Percy were similarly lauded. In the British reports Gauguin and Nielsen were also especially praised. During the 1930s the major international exhibitions held in Paris, 1937, and in New York, 1939, were the scenes for significant displays by Finland, particularly of the work of Alvar Aalto, including his glass for Iittala.

The importance of these exhibitions was in their provision of an international stage, a forum for comment and criticism, an invigorating and sometimes productive exposure to new or alternative influences. Occasionally, foreign approbation came earlier than domestic approval. Such exhibitions boosted sales and, for museums as for all other interested parties, presented a spread of contemporary production from which to select for posterity or profit. Equally, such exhibitions were used as national demonstrations. Each

country provided a pavilion designed by the leading architect and furnished by the leading designers. The prestige and expense attached to these took on increasingly substantial proportions. The Milan Triennales began in 1933, having evolved from a biennial held first in Monza, 1923, and by the 1950s they were the most important post-war exhibitions of design and art production. The first post-war Trienniale was held in 1948, a small preliminary to the major 1951 exhibition. From then and for nearly two decades they were dominated by the Scandinavian displays (Fig. 7). The final Triennale staged in 1968 was closed prematurely by student demonstrations against 'élitist' art and production and only one more was held, in 1973. Other exhibitions, organised by selected juries, were mounted throughout Europe – in Britain, Germany and Yugoslavia – and in America, Canada and Japan. Eventually, the cost of mounting such international shows proved prohibitive and their place has since been taken by the international trade shows. The most important of these now is that held at Frankfurt. While more overtly commercial than the Triennales it nevertheless provides an arena for display and competition of production considered by the companies to be their best.

On a more limited scale, and somewhat introspectively within their own Nordic circle, there have been important exhibitions which enabled comment, criticism and competition within an exclusively Scandinavian setting. The Scandinavian exhibition of agriculture, art and industry held in Copenhagen in 1888 and the 'H55' exhibition held in Helsingborg in Sweden in 1955 are two such examples and there have been others in between these dates. The Scandinavian countries have also mounted joint exhibitions which then travelled abroad. 'Design in Scandinavia' travelled around the USA and Canada from 1954 to 1957. It was of enormous importance in establishing 'Scandinavian Design' as an unmistakably identifiable style and the term as a useful 'catch-phrase' now inextricably associated with the early 1950s. Added to the exhibition and trade show platform, there have been a number of distinguished awards made independently by trusts or foundations. Of these, the most highly regarded was the Lunning Prize, founded by Frederik Lunning, a Dane settled in New York and selling Danish and Scandinavian design there. The Lunning Prize was awarded biennially between 1951 and 1970. In 1988 a new fund was set up by the Tuborg Group, in effect a replacement for the defunct Lunning Prize and entitled the Georg Jensen Prize. It, too, is to be a biennial presentation for work in arts, crafts and industrial arts. Throughout the Scandinavian countries such awards have also been made by the respective design centres and groups and these, like the international exhibitions and competitions, have provided a useful guide to contemporary critical reception by fellow-designers and judges.

7 The design team at Arabia in 1953
L to R: Kaarina Aho, Saara Hopea, Ulla Procopé, Kaj Franck, Finland
Photo: Matti Pietinen

Since the mid-1960s Scandinavian design has fought a difficult battle. Its special qualities of craftsmanship, classicism and restraint have hardly been enough to compete with the highly stylish, imaginative and exuberant Italian design and few if any Scandinavians have

drawn directly on the example of the phenomenon of the Memphis design group, for instance. Those that did have done so with due deliberation and, more often than not they have been furniture rather than ceramics or glass designers. Perhaps more far-sightedly, many Scandinavian designers turned in the 1970s to the study of ergonomics and energy-saving techniques. This arose from an increasing awareness of the social problems of the handicapped and a wider concern about the pollution and destruction of natural resources. In this, morally, they were much in advance of other countries. In more commercial terms, the 1970s proved to be less rewarding. The far cheaper German, mid-European and Far Eastern products have been able to outstrip sales from the northern countries which pay their workforces higher wages to contribute to expensive social programmes. These problems have brought severe difficulties to the industries and, over the last five years have resulted in an unprecedented series of amalgamations, most notably of Swedish companies under Finnish conglomerates, and of the major Danish works into a combined group under Carlsberg, itself part of the Tuborg group. A further twist is the contracting out of production to other companies, even to other countries entirely. Thus Poole Pottery in England is currently manufacturing, under licence, designs by Karin Björquist for Rörstrand/Gustavsberg AB. In a leaner form the newly re-aligned forces hope to break back into the commercial market ever hungry for new production but constantly starved by the risk and expense to the manufacturers of producing it.

One area which benefitted directly from the debates of principle of the late 1960s and the 1970s was the studio pottery and glass movement. These were given a healthy boost by an atmosphere which encouraged the return to handcrafts, natural materials and the establishment of collectives or co-operative communities of artists and workshops (Fig.8). The principle of the collective in providing mutual support is a long-tried one and, although a comparatively new development for the studio artists in Scandinavia, there are parallel examples of crafts workshops in England, Germany and Austria from the end of the 19th century. In Porvoo, Finland, the Iris company was established in 1897 and sold its goods with missionary zeal in Helsinki. From this example alone (Iris lasted only until 1902) lessons may well be learnt about the snags of such an arrangement and many studio artists now are finding the problems of running and manning a sales outlet too demanding combined with the need to produce the goods. However, some have existed for 10 or 15 years, and at the present time all four countries include such shops in their capitals and provincial cities. Other retail possibilities are also supplied by the various crafts organisations and by a few museum shops of which Trondheim is a particularly enlightened example. The studio movement is now the area where some of the most vigorous developments are to be seen and in some cases it is forcing the pace of design development. Recently, exhibitions such as 'Scandinavia Today', 1987 launched in Japan, have demonstrated an up-swing of international interest in Nordic design and crafts and, at the moment, the future looks promising. International taste and Scandinavia's consistently humane perceptions, despite many years of self-doubt, seem finally to be converging again.

The background to the Victoria and Albert Museum's 20th century collections of glass, ceramics and other materials centres on the historic service of travelling exhibitions which began in 1853 and was formally set up in 1855 as the Circulating Museum, the collection travelling initially in a special rail truck. Evolving into a complex loan and exhibition service, the Museum's Department of Circulation continued until 1978. Most of the

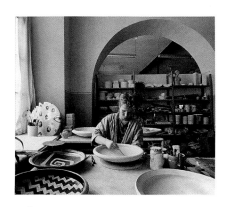

8 Åsa Hellman in her studio
Pot Viapori group of workshops, Suomenlinna, Helsinki, Finland, 1988
Photo: Johnny Korkman

ceramics and glass acquired before that date and included in this survey have a 'Circ' prefix indicating, for the purposes of Museum records, that they were acquired specifically by that department. They were chosen as examples of Scandinavian studio or industrially manufactured arts and were assembled into small-scale displays which were shown in the department's own gallery in the Museum but, most importantly, were also sent out as part of a loan system to art schools, museums and galleries throughout Britain. These educational examples were intended to show the best of contemporary international work for the instruction of British students and manufacturers.

The ceramics and glass collections of the Museum include work from Denmark, Finland, Norway and Sweden and the relative importance internationally of Scandinavian design in these materials and of the scales of production may be gauged fairly accurately by the fluctuating proportions of examples from each country over the last century. Thus the Swedish section is the largest overall, while at different periods Finnish and Danish glass and ceramics have been the more dominant. The Norwegian section is the smallest but the last five years are more strongly represented than any other period, with particular emphasis on studio work. Traditionally, painted enamels and, more recently, some plastics are included in these collections. There is also one stained glass panel (Fig.9). In a catalogue devoted solely to these materials it should be remembered constantly that the individual countries have, at one time or another, produced their strongest work in other media – furniture, textiles, silver or architecture.

There has been no attempt at all in the past to acquire examples of work from Iceland but the emergence in the last decade of a distinctly Icelandic school of potters, in particular, makes the need for a review of this situation increasingly urgent.

In the last years of the 19th and in the early decades of the 20th century the Museum's interest in Scandinavian design, never vigorous, was almost totally inactive, and only a small group of ceramics was acquired mostly by direct contact with the manufacturers. Interest in Danish production was re-kindled by the 1925 Paris exhibition and sustained by already long-established contact with Royal Copenhagen, and in Swedish design by the Stockholm exhibition of 1930. In the early 1950s these contacts were broadened as the Museum's representatives absorbed the lessons of the Triennale exhibitions at Milan and toured Scandinavia. The results were apparent in important acquisitions, especially from Finland and Sweden, by Hugh Wakefield with the helpful advice of Professor Olof Gummerus and Dr Åke Huldt. Simultaneously, the Museum has been host to a series of exhibitions from Scandinavia including, in 1951, 'Scandinavia at Table' arranged by the Council of Industrial Design, 'Finlandia' in 1961 (Fig.10) arranged by the Konstflitförenigen (Society of Craft and Design), Helsinki, and 'Svensk Form', arranged by Föreningen Svensk Form in 1980. Also, the comparatively thin representation of Scandinavian work in the Museum's late 19th century collections has recently been reversed with the acquisition of important examples of ceramic design from Denmark and Sweden. These provide a link between the vigorous art movements of the 19th century and the emerging styles of the 20th. The 'Hejrestellet' (cat. no. 1) made by Bing & Grøndahl and first exhibited in 1888 in Copenhagen, has been selected as the starting point of this survey, representing as it does a major breakthrough in technique and a stylistic approach which achieved international recognition.

9 Window panel
Designed by Einar Forseth, Sweden, 1919
Cat. no. 442

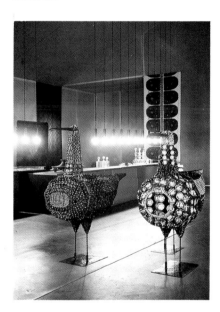

10 View of the 'Finlandia' exhibition
Victoria & Albert Museum, 1961

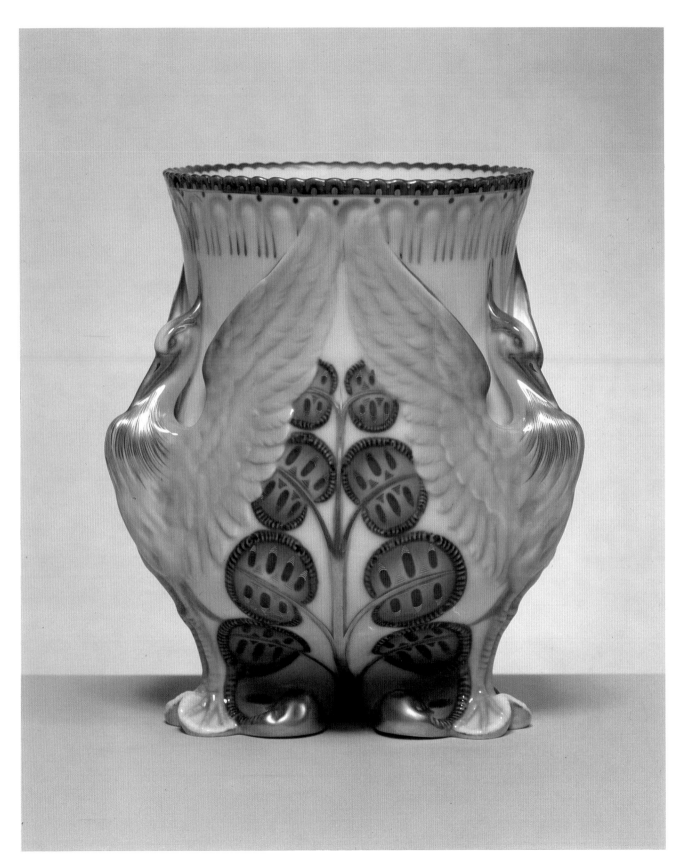

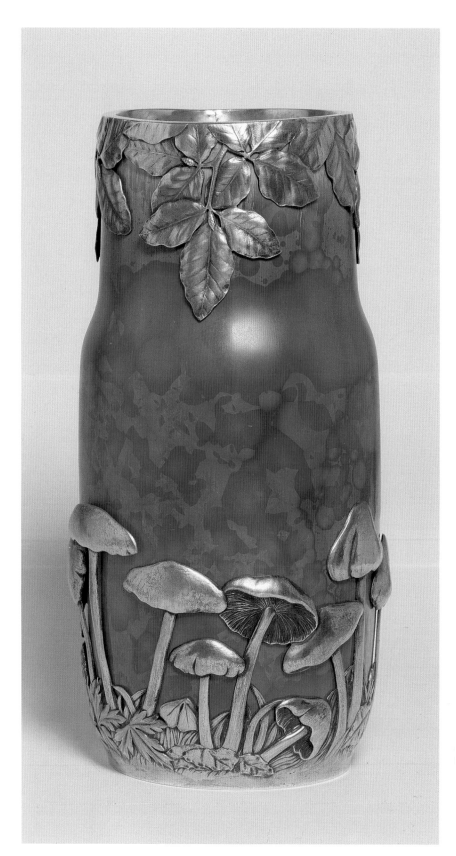

Numbers in bold refer to catalogue entries

Preceeding page
1 Ice Bucket 'Hejrestellet'
Porcelain; made by Bing & Grøndahl, designed by Pietro Krohn, Denmark, 1886-8

Left
20 Vase
Porcelain with metal mounts; made by Royal Copenhagen, glaze by Valdemar Engelhardt, Denmark c. 1909

Opposite
26 Bowl
Porcelain; made by Bing & Grøndahl, designed by Effie Hegermann-Lindencrone, Denmark, 1917

63 Dish
Earthenware; made by Bjørn Wiinblad, Denmark, 1946

65 Vase
Stoneware; made at Saxbo by Nathalie Krebs and Eva Staehr-Nielsen, Denmark, c. 1951

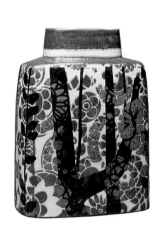

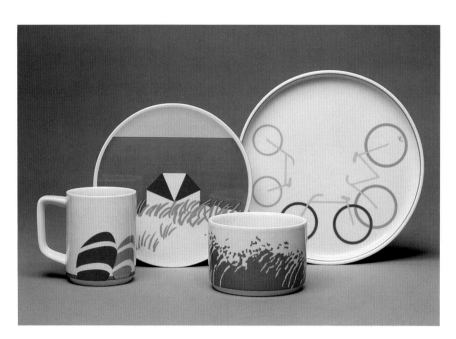

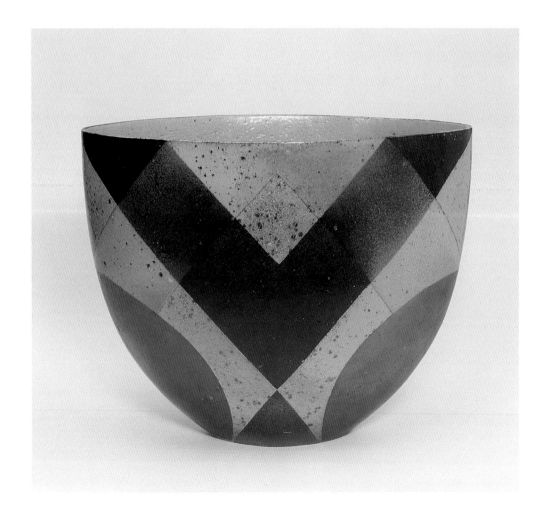

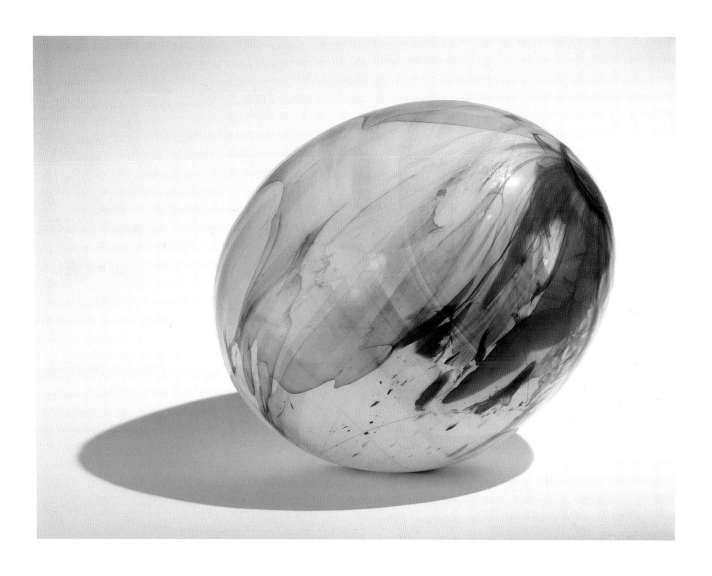

Opposite
74 Vase 'Baca' series
*Porcelain; made by Royal Copenhagen, designed by
Johanna Gerber, Denmark, 1965*

91 Tableware 'Picnic'
*Porcelain; made by Royal Copenhagen, designed by
Grethe Meyer and Ole Kortzau, Denmark, c. 1982-3*

93 Bowl
Stoneware; made by Bente Hansen, Denmark, 1985

Above
110 Form
*Glass; made by Holmegaard, designed by Per Lütken,
Denmark, 1970*

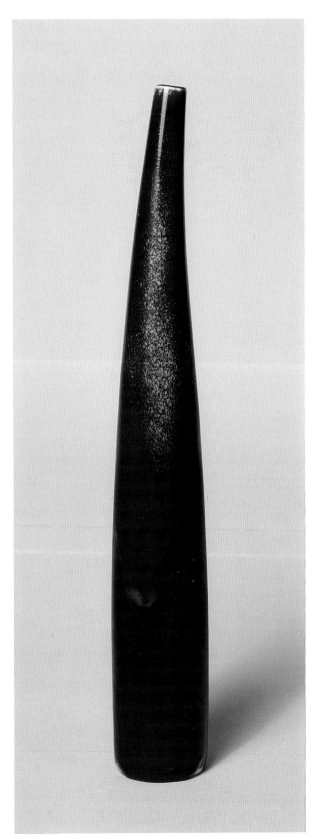

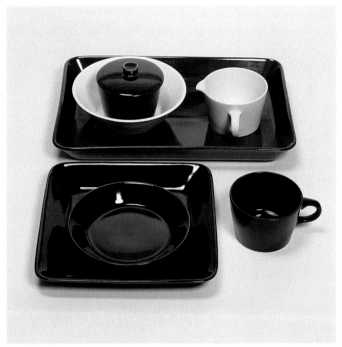

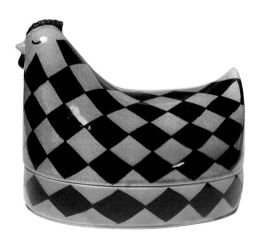

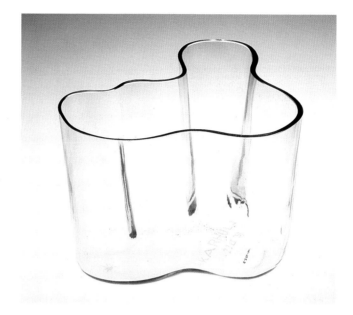

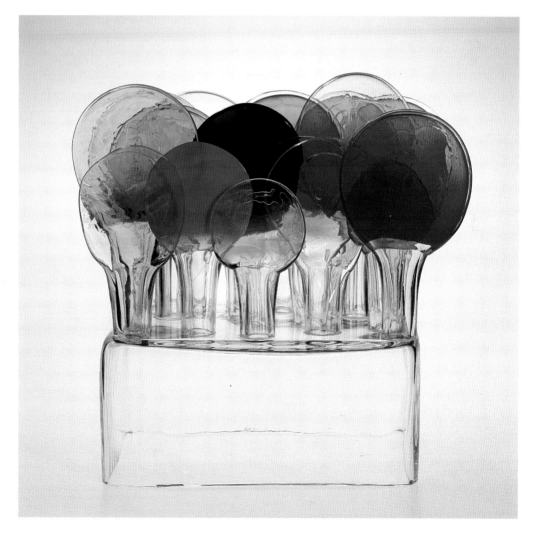

Top left
228 'Vuosikuutiot'
Glass; made by Nuutajärvi, designed by Oiva Toikka, Finland, from 1977

Above
249 'Pyramidi'
Glass; made by Nuutajärvi, designed by Heikki Orvola, Finland, 1985

Left
251, 252 'Farokin Majakka' (l), 'Rubiini' (r)
Glass; made by Nuutajärvi, designed by Markku Salo, Finland, 1987

This catalogue is arranged in four separate sections: Denmark, Finland, Norway and Sweden. A text introduces each section. Throughout the catalogue entries are numbered consecutively and within each section are in the order: ceramics; glass; enamels; plastics.

The Victoria and Albert Museum is referred to as the Museum or V&AM.

The name or title of an object is given in the native language when this is known and translated where appropriate. Shape or model codes are included in the title where these were used commercially.

The objects are listed in design date order (the production date is used if the design date is not known).

Colour of the porcelain, earthenware or stoneware body is given only when other than white and when its colour is part of the decoration.

Dimensions are in centimetres and are of the largest dimension of the object. Where there is a group or range of objects, in general the dimension given is for the largest object in the group. H. = height; D. = diameter; L. = length; W. = width; sq. = square.

Illustrations are identified by:
● = in the general introduction
○ = in the relevant introduction
C = colour plate

Following the catalogue sections are biographies of designers and artists. These are listed in alphabetical order and give each designer's country of birth and work-place if different, career details and a list of selected awards and honours only. This is followed by brief factory histories, again in alphabetical order.

International exhibitions mentioned in the texts or catalogue are generally referred to by date and location. A full list of exhibitions mentioned is provided below. Exhibition titles are given in the native language, translated where appropriate and with location and organising body where possible.

1888 Copenhagen: Landbrugs-, Kunst- og Industriudstilling (Scandinavian exhibition of agriculture, art and industry)
1897 Stockholm: Konst och industriutställningen (Stockholm exhibition of art and industry)
1900 Paris: Exposition Universelle (Universal exhibition)
1917 Stockholm (Liljevalchs Gallery); Hemutställningen (Home exhibition)
1920 Stockholm: Verkstadens (Workshop)
1920 Ulleval: Norske Foreningen Brukskunst (Norwegian Society of Arts, Crafts and Industrial Design, exhibition)
1923 Gothenburg: Jubilee exhibition
1925 Paris: Exposition Internationals des Arts Décoratifs et Industriels Modernes (the International exhibition of modern decorative and industrial arts)
1926 Gävle: Hemikulturen (Home culture)
1927 New York: exhibition of Orrefors glass
1928 Bergen: Landsutstillningen (National exhibition)
1929 Barcelona: Exposición Internacional de Barcelona (Barcelona international exhibition)
1930 London (Fine Arts Society): exhibition of Einar Forseth's glass mosaics and paintings
1930 Stockholm: Stockholmsutställningen (Stockholm exhibition)
1931 London (Dorland House): Exhibition of Swedish Industrial Art
1933 London (Fortnum & Masons): exhibition of glass and plywood by Aino and Alvar Aalto
1933- Milan Triennales
1973
1933 Oslo: Svenska Slöjdföreningen exhibition
1937 Copenhagen: Ten years of Danish glassware
1937 London (Heals): Greta-Lisa Jäderholm-Snellman
1937 Paris: Exposition International des Arts et Techniques dans la Vie Moderne (International exhibition of arts and techniques in modern life)
1938 Faenza, annual: Concorso internazionale della ceramica d'arte (International fair of ceramic art)
1939 New York: World's Fair
1940- Stockholm: exhibition of Finnish design
1941
1940- Copenhagen: exhibition of Finnish design
1941

1942 Stockholm: Fajanser Målade i Vår (Faiences painted this spring)
1942 Stockholm (Nationalmuseum): Dansk Kunsthåndvaerk (Danish Handicraft)
1945 Copenhagen: Bjørn Wiinblad earthenwares
1951 London (V&AM, Council of Industrial Design): Scandinavia at Table
1951 Zurich (Kunstgewerbemuseum): exhibition of Finnish design
1953 London (V&AM, Arts Council): Modern Art in Finland
1954 USA and Canada: Design in Scandinavia
1955 Helsingborg: H55
1957 London (V&AM, Department of Circulation): Scandinavian Tablewares
1959 London (V&AM): Three Centuries of Swedish Pottery, Rörstrand 1726-1959 and Marieberg 1758-1788
1961 London (V&AM, Konstflitföreningen): Finlandia (versions of this exhibition were also shown in Zurich and Amsterdam)
1963 London (V&AM, Department of Circulation): Glass Today
1966 London (Bethnal Green Museum): 40 Years of Modern Design
1967 Montreal: Expo '67
1968 London (V&AM, Landsforeningen Dansk Kunsthåndvaerk): Two Centuries of Danish Design
1971 London (Danasco): untitled, Danish glass
1972 London (V&AM): International Ceramics
1974 London (V&AM, Department of Circulation): Design Review
1975 London (V&AM): Liberty's 1875-1975
1978 London (Morley Gallery): Benny Motzfeldt
1979 Cambridge (Kettle's Yard): mixed exhibition including Alev Siesbye
1980 London (V&AM, Föreningen Svensk Form): Svensk Form
1982 Helsinki (Arabia Gallery): Harvest Time, Gunvor Olin Grönquist
1985 Helsinki (Arabia Gallery): Varjoostuksia, Pekka Paikkari (Shadow works)
1985 Paris: Monica Backström glass
1986 Stockholm (Djurgården): Kosta Boda sjätte sinne (Kosta Boda sixth sense)
1987 Helsinki (Galleria Bronda): Markku Salo Lasia (Markku Salo glass)
1988 Haderslev. Nutidig Dansk Lertøj (Contemporary Danish earthenware)
1988 Helsinki (Galleria Bronda): Asa Hellman
1988 Oslo (Gallerie Føyner): mixed exhibition including Poul Jensen ceramics
1988 Oslo (Kunstindustrimuseet): exhibition of drinking glasses

DENMARK

In the 1850s and 1860s in Denmark, as in the other Scandinavian countries, liberalism was becoming an important force but social improvements were delayed by the major and absorbing political problem, the Schleswig-Holstein conflict. After the secession of Norway in 1814 Denmark consisted of three parts: the Kingdom of Denmark and the two Duchies of Schleswig and Holstein. Schleswig was linguistically and culturally divided between Denmark and Germany; Holstein was a member of the German Confederation. The conflict over sovereignty degenerated into war which ended eventually in 1864 with the Treaty of Vienna which passed both Schleswig and Holstein to Prussia and Austria.

After this Denmark underwent fundamental changes in its social structure. Industrialisation escalated in the 1870s. The lack of raw materials was counteracted by Denmark's advantageous position as a commercial and trading sea port centre, located as it is between its Scandinavian neighbours, Germany and the rest of Europe, and with shipping routes around the world. Progress in industrialisation, commerce and education, coupled with increases in agricultural productivity as a result of co-operatives of small landowners, resulted in increasing prosperity. Denmark's thriving international contacts meant that of

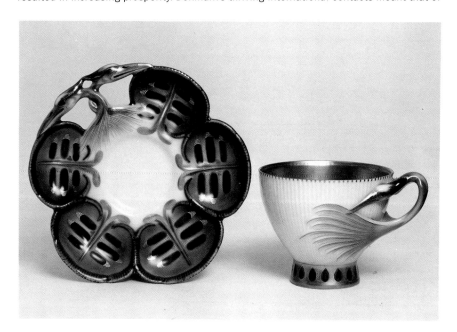

11 Cup and saucer 'Hejrestellet'
Porcelain; made by Bing & Grøndahl, designed by Pietro Krohn, 1886-8
Cat. no. 1

the four Scandinavian countries it was the least affected by the cultural identity concerns that overtook the others in the last decades of the century. At this date perhaps the most confident of the Scandinavian group, its political and social reforms were well advanced and its cultural horizons embraced the latest developments in France and Germany.

The two major porcelain manufactories, Royal Copenhagen and Bing & Grøndahl, were keenly aware of international technical advances and artistic change, and both played a significant part in these. As in Sweden, throughout the 19th century classicism had pre-

vailed as the established taste, personified in Denmark's case by the neo-classical sculptor Bertel Thorvaldsen. His passion for the classical had been aroused by the archaeological excavations he witnessed during his many years spent in Rome. The museum housing his collection of classical artefacts and contemporary paintings as well as his own works was designed in appropriate style by the architect M G Bindesbøll and built from 1839-48. It became Thorvaldsen's mausoleum. With other buildings in the style it spawned a second generation obsession with classical architecture and furnishings.

12 Bowl
*Silver, partly gilt; made by A. Michelsen, designed by
Thorvald Bindesbøll, 1899
V&A. M. 1614-1900*

Thorvaldsen's influence was all pervading and almost every factory, large or small, manufacturing porcelain or earthenware, produced at least some version of his work. Nevertheless, by the early 1880s both Royal Copenhagen and Bing & Grøndahl were looking for new directions. Copenhagen boasted a particularly strong group of collectors and critics with connections in Paris, an alert awareness of the European art scene and, especially, an interest in the collecting of Oriental arts. This meant that artists and designers were able to see exhibitions, collections and journals devoted to the study of Japanese ornament, Chinese and Japanese glazes and, in some cases the European interpretations of these. For example, the work of French ceramicists such as Ernest Chaplet was collected and exhibited in Copenhagen. Even more importantly Arnold Krog, art director of Royal Copenhagen, visited Paris where he saw the knowledgeably selected collections of the dealer and connoisseur Siegfried (Samuel) Bing. Equally Pietro Krohn, art director of Bing & Grøndahl and later first director of Det Danske Kunstindustrimuseum, Copenhagen, was a central figure in the Copenhagen Japonisme circle. In the late 1880s both factories launched new productions as a direct result of these active contacts.

In 1888 the Scandinavian exhibition of agriculture, art and industry was held at the Industrial Association in Copenhagen. At this exhibition, Royal Copenhagen first showed its distinctive underglaze painting in soft blues and greens taking advantage of the fortuitous technical limitation caused by the high temperatures needed to fire the porcelain. This painting combined a skilful interpretation of the essential naturalism and decorative asymmetry of Japanese graphic arts with a Danish romanticism and choice of Danish landscapes, flowers and animals. Bing & Grøndahl exhibited the 'Hejrestellet' (Fig.11) for the first time. Designed by Pietro Krohn, it was a superb technical and artistic achievement and in one move established Bing & Grøndahl as a major artistic force.

While the two major porcelain factories were pursuing orientalism in the form of 'art' wares, individual potters were making their contribution also. In the late 1880s Hermann A Kaehler at Kaehler Keramik began experimenting with lustre decoration. Although this owed nothing directly to the fashion for things Japanese, it was nevertheless a manifestation of the growth of the studio art movement. Their display at the international exhibition in Paris, 1900, was awarded a silver medal.

The leading artist-designer in the Danish-Japanese taste was Thorvald Bindesbøll, son of the architect M G Bindesbøll. He was a remarkably versatile designer who trained as an architect but made major contributions in the fields of furniture, silver, books and graphic arts, embroidery and ceramics. His imaginative vision and the confidence with which he approached his material resulted in distinctive and powerful designs. He began to design ceramics in 1883, as the leader of a group of Danish artists who were enthusiastically

trying their new ideas in different media. Between 1883 and 1901 when he made his last designs, Bindesbøll moved from rather unadventurous Renaissance-style patterns to the supremely confident decoration which characterises his best later work. Drawing on an appreciation of Japanese asymmetry and the freedom of interpretation of natural forms such as clouds or waves into stylised but vigorous patterns, he evolved a very personal and highly characteristic vocabulary, consistent whatever his material (Fig. 12).

Despite Denmark's keen awareness of Continental trends, Art Nouveau did not take hold as a style. Instead, the Danes developed a very individual concept, Skønvirke. This was the name with which, from about 1907, they referred to their particular form of 'aesthetic activity' and which was later disseminated through a periodical under the same title. As a style, it reflected their traditional fascination with rich, natural materials interpreted with generous forms and skilful craftsmanship, and it is in many ways a parallel to the Arts and Crafts movement in England. Bindesbøll and his circle pioneered the early stages of Skønvirke, experimenting with patterns and techniques in an enthusiastic manner. In this they were not alone. Contemporaries such as Andreas Ollestad and Andreas Schneider at Egersund Fayancefabrik in Norway were very much part of the same expressionistic exoticism, as was Helmer Osslund at Höganäs in Sweden. However, none equalled Bindesbøll for the range of his talents and the strength of his sense of pattern and design, and he has come to be seen as a key figure in this movement, which closed the 19th century and opened the 20th.

Denmark's design organisation, the Landsforeningen Dansk Kunsthåndvaerk (Danish Society of Arts and Crafts and Industrial Design) was founded in 1907. Its aim was to support the crafts and to provide an organised structure for the debate on the role of design within a changing society, which arose in Denmark as in the other Scandinavian countries. Denmark's particular strength continued to be in crafts techniques and in a special feeling for warm rich textures and colours, and a pleasure in ripe and luxurious forms. Danish modernism, although a crusade, did not spring from an intellectual or analytical approach to sociological needs or a conscious mission to reform society, unlike that of Sweden and Finland. For the Danes, good design grew out of a respect for and enjoyment of natural materials, and practical considerations of comfort, pleasure in use and visual satisfaction.

Early in the 20th century, the two major porcelain factories were at something of a crossroads. Under the art director J F Willumsen, Bing & Grøndahl had a team of artists including Fanny Garde and Effie Hegermann-Lindencrone, who were highly skilled in modelling and with a formidable technical expertise. This enabled them to produce spectacular and expensive ornamental works aimed at an exhibition or élite market. But their expertise was a direct descendant of the skills developed during the work on the 'Hejrestellet' in the 1880s and although the work continued with luxuriant vigour until the international exhibition, Paris, 1925, its mode was retrospective. The forward impetus came with the development of stoneware – a direct result of the display of French stonewares, including that of Sèvres, at Paris in 1900. At Bing & Grøndahl this was under the direction of Carl Petersen, appointed in 1912.

The same development occurred at the Royal Copenhagen factory where stoneware production was pioneered by Patrick Nordström, who joined in 1911 as technical manager. The two factories shared the services of many designers. The sculptor Knud Kyhn made some designs for Bing & Grøndahl in 1913 as well as working for Royal Copenhagen from 1905-23.

13 Vase
Stoneware; made by Royal Copenhagen, designed by Carl Halier, 1926
Cat. no. 35

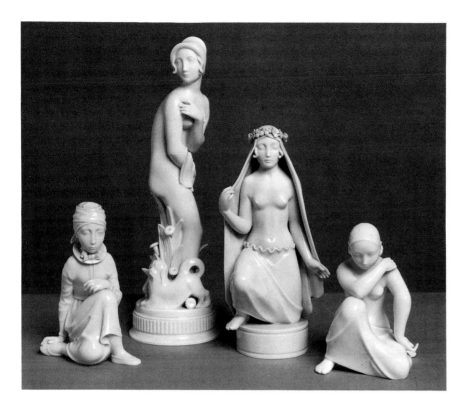

14 Group of figures
Porcelain; made by Royal Copenhagen, designed by Arno Malinowski, 1924-31
Cat. nos 31, 38, 40, 45

At Bing & Grøndahl stoneware production included painted surface decoration whereas the Royal Copenhagen strength in the early years proved to be almost entirely in the development of special glazes. The pervading Danish interest in exoticism led in ceramics to a study of Chinese and Japanese glazes. In a major industrial factory committed to supporting an experimental art studio the opportunities were impressive and Nordström at Royal Copenhagen was able to take full advantage. As the historian Merete Bodelsen has shown using an account of the French potter Jean Carriès' methods and the published experiments of the Sèvres stoneware chemists, Nordström was in a leading position and was shortly able to produce the highly complex copper, uranium and iron based glazes. This earned him a lasting reputation and gave Royal Copenhagen the solid foundation on which the successes of the 1920s and 1930s rested. Carl Halier joined Nordström in 1913 and succeeded him in 1922. Halier was a skilled potter and, apart from a break of four years from 1926-30, he stayed at Royal Copenhagen until 1948 (Fig.13). He worked with Jais Nielsen and Axel Salto, two of Royal Copenhagen's greatest artists in stoneware, as well as with Hans Henrik Hansen, Knud Kyhn and Jean René Gauguin, all modellers of widely differing talents in both style and technique. Stonewares were shown at the international exhibition, Paris, 1925, where works by Nielsen and Gauguin (son of Paul Gauguin and himself a potter of some influence) made a great impression, particularly on the British visitors. Gordon Forsyth in his report for the Department of Trade especially singled out these two artists as worth noting by the British pottery industry. Forsyth's glowing testimonial had little effect in Britain. His recommendation that every British manufacturer should set up an art studio with the same independence as the Danish examples was ignored. No British factories attempted the manufacture of studio art wares on any scale comparable to the unique art works of the Copenhagen companies. The only exception to this came later, in 1934, with the establishment of a studio for art, table and oven wares at the Bullers factory

in Stoke-on-Trent, manufacturers of industrial and electrical porcelain. This enterprising project was set up under the direct influence of Gordon Forsyth and lasted until 1952, including among its personalities the Danish potter Agnete (Anita) Hoy. What had more relevance to British design and to international modernism was the serial or multiple industrial production of the Copenhagen – and indeed all Scandinavian – factories. British tableware production owed a significant debt to the Scandinavian models.

At both factories as much a result of its material qualities, porcelain production took a different course to that of stoneware. Figure design was stylish yet refined (Fig. 14). Building on the fundamental Danish perception of classicism as a combination of elegant form and decoration with restrained yet positive functionalism, serial production entered a new age. The two most important figures at this time were Nils Thorsson at Royal Copenhagen and Ebbe Sadolin at Bing & Grøndahl. Both designers worked in the uniquely Danish mode of effortless simplicity and functionalism, evolving styles which naturally took Danish ceramic design into a modern manner without, apparently, any socially conscious theory or polemic. Nils Thorsson, with extraordinary versatility, was also Royal Copenhagen's most prolific designer of painted patterns for the earthenware production made at their Aluminia factory.

During the First World War Denmark had been neutral and, due to its central geographical position and the absence of competition the Danish economy, flourished for the first year or two. However, by the end of the war and in the immediate post-war years Denmark was hampered by economic and social fluctuations which impeded recovery both materially and culturally. Nevertheless, the seeds of democratisation were sown and in an increasingly liberal atmosphere the incipient Danish studio pottery movement took root, frequently cross-fertilised with the factory studio. This movement was mirrored in similar developments among artist-craftsmen working in other materials, and at this time Denmark was especially unusual in Scandinavia in its early establishment of a collective – a group of craftspeople combining to provide mutual support. Under the silversmith Kay Bojesen, the group opened the influential shop 'Den Permanente' in Copenhagen in 1931 where, eventually, 200 artists sold their work in what was a model enterprise of its kind, subsequently followed in the other Scandinavian countries.

In 1930, a workshop was established at Herlev by Nathalie Krebs, an event which was to have a major significance for the development and future of studio pottery in Denmark. Nathalie Krebs had previously spent 10 years working at Bing & Grøndahl and for a year after shared the studio at Islev (coincidentally leased from the Royal Copenhagen technical director, Patrick Nordström) with the potter Gunnar Nylund. He subsequently moved to Sweden to work at Rörstrand. On his departure she re-named the studio 'Saxbo' and moved it to Herlev. Her special expertise was in stoneware glazes which were inspired by Chinese and Japanese wares. At Saxbo she was joined by a number of fellow potters and collaborators, notably Eva Staehr-Nielsen who, from 1932 designed most of the forms glazed by Krebs. Under Krebs, Saxbo became the classic training ground for a generation of Danish potters. The style and quality was unmistakable and is still apparent in the work today of, for instance, Edith Sonne Bruun who spent more than 15 years there. The particular characteristics of 'classic Saxbo' are the strength and simplicity of form and the latter's complete harmony with the glaze. The restraint often appears as a disarming unpretentiousness belying the very powerful discipline and solid tradition behind the pots. In Krebs'

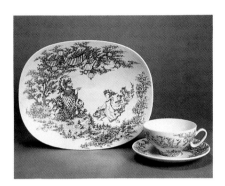

15 Tableware
Earthenware; made by Nymølle, designed by Bjørn Wiinblad, 1954
Cat. no. 66

case, the glazes were often lightly textured or feathered. Minimal relief decoration also was sometimes added in the form of ribbing, incised or applied motifs.

In glass, progress was rather more slow. During the first two decades of the century, Holmegaard, the main glassworks, produced mostly cut wares in traditional European style. In the early 1920s Oluf Jensen and Orla Juul Nielsen produced some fine shapes for table glass embellished with delicately drawn engraved lines. In 1925 Holmegaard appointed the architect Jacob Bang as a permanent staff designer. Nielsen and Bang modernised Danish glass design and gave Holmegaard an international reputation. Bang's series productions 'Primula' and 'Viol' showed an awareness of the stylistic developments in Sweden, particularly those by Gate and Hald at Sandvik, and brought the Danish glassworks into line with the new thinking. Bang's glass is characterised by soft, liquid forms mostly traditional in outline, sometimes sharpened with precisely placed wheel-cut decoration and at other times embellished with freely applied glass trails.

Denmark, like Sweden, was far less affected by the Second World War than Norway and Finland. It was occupied from 1940, and by 1943 there was a highly active resistance movement and a declared state of emergency. In that time, however, the arts were not seriously curtailed apart from material limitations and, immediately after the war, Denmark was reasonably well placed for recovery. Some designers like Henning Koppel had moved to Sweden (where he found employment with Orrefors) for the duration of the war, but of those who remained most had been able to continue working without interruption. Some were at the beginning of their careers. In 1945, Bjørn Wiinblad showed his first exhibition of slip-trailed earthenware, decorated by the traditional means of a cow-horn through which the liquid clay was applied. His first works had a darkly vigorous side reflecting, perhaps unconsciously, a Nordic preoccupation with woodland spirits. As this tendency lightened, Wiinblad's name was bracketed with that of Stig Lindberg in Sweden and Birger Kaipiainen in Finland. All three epitomised the decorative graphic side of Scandinavian design. Within five years Wiinblad had completed his move into a highly personal manner, most usually characterised as 'rococo' which he has since perfected and made entirely and very distinctively his own (Fig. 15). Following his association with the German company Rosenthal, his popularity has been overwhelming not only in ceramic design, textiles and glass, but in the myriad decorations done for the theatre, opera and ballet and for interiors and, even more, in poster design. His success in these fields has been phenomenal, particularly in America, and continues unabated.

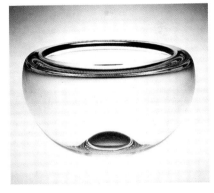

16 Bowl 'Provence'
Glass; made by Holmegaard, designed by Per Lütken, c. 1956
Cat. no. 107

Jacob Bang left Holmegaard in 1942. By 1946 he had moved to Nymølle and his place at Holmegaard was taken by Per Lütken who has remained there as chief designer until the present day. For over 40 years, therefore, Lütken has provided the mainstay of Holmegaard's unique lines and series production. In 1942, remarkably, an exhibition was held in Stockholm, 'Dansk Kunsthåndvaerk' (Danish Handicraft) and Lütken's first glass was shown there – clean, classically simple forms in clear, colourless glass. Following this he began adding colour, making, with the glass-blowers, freely flowing forms frequently with partly mixed coloured and colourless glass, that have continued to be one of his chief strengths. Throughout the 1950s and 1960s Lütken's more formal designs have reflected the characteristics of post-war Scandinavian modernism (Fig. 16).

In ceramics Denmark moved confidently into a post-war golden age. The most distinguished potter then, as now, was Gertrud Vasegaard (Fig. 17). By the 1950s she had an established reputation as an artist of discipline and supreme skill, and this was recognised when she was awarded a gold medal at the Milan Triennale 1955. For 12 years, between 1947 and 1959, she worked at Bing & Grøndahl, and between 1960 and 1975 she designed three services for Royal Copenhagen. Her principled approach to the design and production of these industrially-made wares is legendary. Both factories, creditably and painstakingly, adapted both the materials and production methods to accommodate Vasegaard's exacting demands. The results are consummately satisfying.

Denmark's designers were constantly recognised at exhibitions and by awards for their craftsmanship, their empathy with the material and for their instinctive feeling for function combined with visual appeal. Henning Koppel, who was awarded the Lunning Prize in 1953 and Milan Triennale gold medals in 1951, 1954 and 1957, exemplifies these qualities. He brought to his chosen materials, silver and other metals as well as ceramics, a trained sculptor's eye for an organic shape and springy, rhythmical outline. There is much in his work that reflects an awareness of the great 20th century sculptors such as Arp and Brancusi, an awareness that is evident in applied art design throughout Scandinavia, particularly in Finland. Koppel's skill lay in applying his familiarity with 20th century fine art to the design for a fish dish and cover (Fig. 18) for Georg Jensen, or a generously proportioned jug (cat. nos 71, 75) for Bing & Grøndahl in such a way that both become sculptural statements.

During the 1960s a new group of designers emerged, whose speciality was in applying learned principles of design to an increasingly wide range of materials and functions. Grethe Meyer, a practising architect, brought such principles to bear at Royal Copenhagen for her early design of the 'Blue Line' range (cat. no. 76) and more recent ceramic and glass tableware. In the later 1960s and 1970s designers Ole Kortzau (also an architect) and Arje Griegst (a goldsmith), both fluent in several materials, have contributed distinctively individual tablewares — in form or decoration or both — to the Royal Copenhagen range. Erik Magnussen, designer of the Stelton vacuum jug (cat. no. 120) and its accompanying set, started as a ceramicist and was employed at Bing & Grøndahl from 1962.

Glass design developed differently and at its own pace. Michael Bang joined Holmegaard in 1968 and brought a fresh set of shapes and colours to the factory's production. His imaginative designs reflect the Danish version of the Scandinavian tendency towards fantasy and a slightly whimsical humour. At the same time he has also produced cleanly simple shapes for serial production in both table glass and lighting, the latter made at the Odense glassworks subsidiary of Holmegaard. For the first time Holmegaard was producing bright red, yellow and opaque white glass in plain uncompromising shapes. This gave the factory a modern currency in the 1960s and early 1970s (cat. no. 116). In 1978 Arje Griegst designed glassware, 'Xanadu' (cat. no. 118), to accompany his tableware, 'Konkylie' for Royal Copenhagen (cat. no. 85).

In Denmark, as elsewhere in Scandinavia, a trend towards the polarisation of design on the one hand and craft on the other, emerged in the 1960s, affecting both the practice and the teaching of design. The rise of the individual workshop has been an important feature. An

17 Box and cover
Stoneware; made by Gertrud Vasegaard, 1985
Cat. no. 99

18 Fish dish and cover
Silver; made by Georg Jensen A/S, designed by Henning Koppel, 1954
Photo: Christie's

event in the mid 1970s which neatly illustrates this polarisation was the dissolution of the Landsforeningen Dansk Brugskunst og Design (Danish Society of Arts and Crafts and Industrial Design) and the emergence of two separate organisations, one for craftspeople Danske Kunsthåndvaerkeres Landforbundet (DKL, Federation of Danish Craftsmen) and one for industrial designers, Selskabet for Industriel Formgivning (Danish Society of Industrial Designers). This revolution coincided with the disintegration of the old Den Permanente organisation. In economic deep water, this was first bought up and re-shaped by a Japanese businessman and then, recently, closed down altogether. Its international role was eclipsed by the more glamorous Ilums Bolighus and many of the craftspeople became founder members of the DKL.

Studio glass made by independent glassworkers was virtually unheard of before the early 1970s and its subsequent establishment and growth was entirely due to Finn Lynggaard. He started his own workshop as a ceramicist in 1958 but began making glass only as recently as 1972. A dedicated activist for studio glass, Lynggaard not only launched the Danish movement but recently established a glass museum and study centre at Ebeltoft. His own work is richly coloured and demonstrates an obvious pleasure in combining strong colours with clear glass (Fig. 19).

19 Vases 'De fire årstider'
Glass; made by Finn Lynggaard, 1981
This suite was made as a commision from H.M. Queen Margaret the II for presentation to Emperor Hirohito of Japan
Photo: Finn Lynggaard

Ceramicists such as Ivan Weiss at Royal Copenhagen or Edith Sonne Bruun and Sten Lykke Madsen at Bing & Grøndahl have become star artists in their own right, bringing to their respective factories an artistic credibility. By their very presence they provide a creative atmosphere which enriches the company's existence and, not incidentally, raises its marketable image. Little pressure is applied on the artists to contribute to the production line. Bing & Grøndahl have maintained a policy of providing facilities — studio, materials and kiln time — to visiting artists and students, which they have seen as being of mutual

benefit to factory and potter alike, in addition to their small group of permanently attached artists. This is a system employed by many factories across Scandinavia and one which has proved to be enormously fruitful. It has continued following the merging of Bing & Grøndahl with Royal Copenhagen and Holmegaard in 1987.

While the industrial factories are being amalgamated and slimmed down, individual artists continue to thrive despite the increasingly pressurised circumstances. The strengths of the Danish tradition in pottery are continued by Gertrud Vasegaard, Edith Sonne Bruun, Lisbeth Munch-Petersen, and Gutte Eriksen, each representing themselves individually and with character. Others such as Alev Siesbye, Ivan Weiss, Bodil Manz (Fig.20), Malene Müllertz and Bente Hansen have been caught to some extent in the divisive debate and either have had to make decisions about the extent of their involvement with the factories, or else have had such decisions made for them, since all have spent at least part of their careers associated with Bing & Grøndahl or Royal Copenhagen.

The work of individual artists in Denmark, particularly independent potters, has always been highly esteemed. Today their strong, multiple, yet unanimous concerns continue to present a remarkably united front to the outside world. Simple, repeated geometric patterning, skilful and sensitive handling of glazes, strong yet unpretentious forms – nothing quirky or wayward. This is the reality which gives Denmark a much-admired reputation and a starting point for the next generation of potters.

20 'Facet' series
Porcelain; made by Bing & Grøndahl, designed by Bodil Manz, 1982
Cat. no. 89

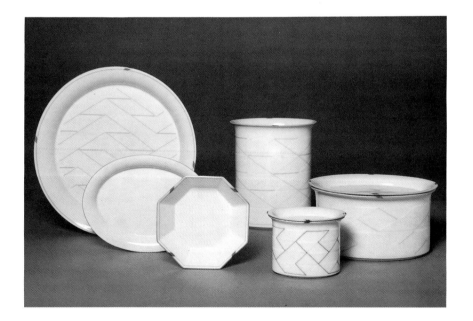

**1 Part of a table service 'Hejrestellet'
(Heron service)** C ○
*Porcelain with moulded decoration and painted in
underglaze blue and gold*
*Made by Bing & Grøndahl c. 1915; designed by Pietro
Krohn 1886-8; the original modelled by Ludvig
Brandstrup and C. O. Schjeltved*
C. 236&A&B-1986
Ice bucket, cup and saucer
*Mark on ice bucket B painted in underglaze blue, W.M.
painted in gold; on cup and saucer three towers and B &
G KJØBENHAVN DANMARK printed in green, B & G printed
in underglaze blue, W.M. painted in gold; on saucer B
painted in underglaze blue also*
H. ice bucket 12. 5

The 'Hejrestellet' was first shown at the Scandinavian
Exhibition of Agriculture, Art and Industry, held at the In-
dustrial Association in Copenhagen in 1888. It was much
acclaimed for its adventurous conception, the skilful
execution of the modelling and, particularly, the use of un-
derglaze blue. By the 1880s this method of decoration had
become the most basic and traditional technique and
Krohn's use of it on this elaborate and expensive service
was regarded as daring and revolutionary. The service was
awarded an honourable mention when it was shown in the
international exhibition held in Paris in 1889. Krohn was a
member of the jury on that occasion and consequently the
company was not eligible to compete for medals.

The original and complete service was made for 24
people. A few services were made between 1888 and
1900, and then a few more around 1915. At least one pink
version was made.

2 Group of four pots ▽
Earthenware with lustred, slightly crackled glazes
Made by Herman A. Kaehler at Kaehler Keramik 1894
251, 252, 253, 254-1894
*Mark on two HAK in monogram, 1894 incised; on all
HAK in monogram 1894 handwritten in ink (indistinct)*
H. tallest 19. 5

Purchased from the maker who, in 1894, gave his address
in London as Montague Place, Russell Square. These four
pots were selected from a group of seven which included
vases described as 'pear' and 'bulb'.

3 Plate
*Porcelain with moulded decoration painted in underglaze
blue*
*Made by Royal Copenhagen c. 1894-5; designed by
Arnold Krog*
Given by Lady M. M. Evans
C. 502-1921
*Mark DANMARK and a crown printed in green; three
wavy lines and 31 painted in underglaze blue*
D. 17. 5

This plate was made to celebrate the Silver Wedding of
Frederik, Crown Prince of Denmark (1843-1912) and Crown
Princess Louise, and is decorated with a monogram FL
enclosing the dates 1869-1894 under a crown. Production
ceased after 1,200 copies had been made.

4 Dish △
*Earthenware, a thrown blank, with slip decoration incised
and worked, and painted in green and brown glazes*
*Blank made at Københavns Lervarefabrik; designed and
decorated there by Thorvald Bindesbøll 1895*
C. 162-1988
Mark TB 1895 in monogram incised
D. 45

A note of this dish is among the Bindesbøll papers at the
Kunstindustrimuseum, Copenhagen, recording the fact
that the dish was owned by a Mr F. Andersen before 1918.

5 Vase △
Porcelain with yellow crystalline glaze
*Made by Royal Copenhagen 1898-1900; shape designed
by Arnold Krog 1896; glaze by Valdemar Engelhardt
1328-1904*
*Mark DANMARK under a crown printed in green,
three wavy lines printed in blue; 135 CL incised; VE in
monogram and D414 painted in underglaze blue*
H. 15. 2
Shape 135 CL

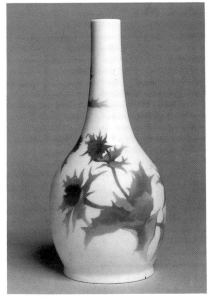

6 Vase 'Strandtidsel' (Sea holly) △
*Porcelain with painted decoration of sea holly in
underglaze colours*
*Made by Royal Copenhagen 1896; painted by Gottfred
Rode*
Henry L. Florence Bequest
C. 1264-1917
*Mark DANMARK under a crown printed in green; 601
incised; three wavy lines between M3 and 5786 over GR
in monogram painted in underglaze blue*
H. 27. 3

This vase is a 'unique piece' and, according to factory
records, was painted in March 1896 and bought by a
Mr Honce of Paris for 75 Danish kroner later that year.

7 Vase ▷
Porcelain with red/brown crystalline glaze
Made by Royal Copenhagen 1898-1900; shape designed
by Arnold Krog 1897; glaze by Valdemar Engelhardt
1329-1904
Mark DANMARK under a crown printed in green, three
wavy lines printed in blue; 153 and CL incised; D440, VE
in monogram painted in underglaze blue
H. 11. 8

With Sèvres in France, Royal Copenhagen was experimenting with crystalline glazing from the late 1880s. Both factories exhibited successful examples in the 'Exposition Internationale', Paris, 1900, and, probably as a result of this success, the Museum purchased this and the other examples in the group (see cat. nos 5, 10).

8 Vase
Porcelain, flattened globular shape with blue/green and
yellow crystalline glaze
Made by Royal Copenhagen c. 1900-1; shape designed
by Arnold Krog 1898; glaze by Valdemar Engelhardt
458-1901
Mark DANMARK under a crown printed in green, three
wavy lines printed in blue; A209 incised; VE in monogram
and E114 painted in blue
H. 9. 5

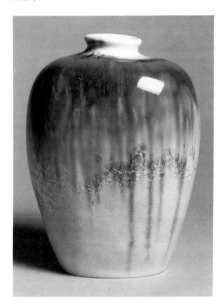

9 Vase △
Porcelain with blue crystalline glaze
Made by Royal Copenhagen c. 1900; shape designed by
Arnold Krog 1898; glaze by Valdemar Engelhardt
462-1901
Mark DANMARK under a crown printed in green, three
wavy lines printed in blue; A134D incised; VE in
monogram and E101 painted in blue
H. 16

10 Vase
Porcelain with brown crystalline glaze
Made by Royal Copenhagen 1902-4; shape designed by
Arnold Krog 1898; glaze by Valdemar Engelhardt
1327-1904
Mark ROYAL COPENHAGEN and a crown printed in
green; A134B (or 8?) incised; three wavy lines, VE in
monogram and F874 painted in blue
H. 17

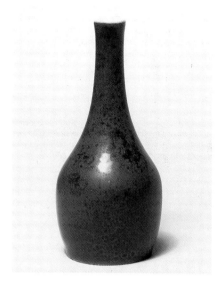

11 Vase ▽
Porcelain with moulded decoration, partly painted, of
stylised forms and herons' heads
Made by Bing & Grøndahl; designed by Hans Peter Kofoed
1899
C. 92-1987
Mark three towers and B & G KJØBENHAVN DANISH
CHINA WORKS printed in green; B&G printed in
underglaze blue; E/8 70 (or 40?) KOFOED painted in
underglaze blue
H. 50. 6

Kofoed kept a set of running numbers for his own records and included the number in the mark on each piece, in this case E/8 70 (40?).

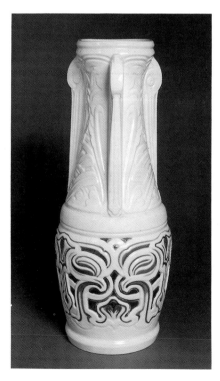

12 Vase
Porcelain with brown and greenish crystalline glaze
Made by Royal Copenhagen c. 1900; shape designed by
Arnold Krog 1899; glaze by Valdemar Engelhardt
460-1901
Mark DANMARK under a crown printed in green, three
wavy lines printed in blue; A 232 incised; VE in monogram
and E482 painted in blue
H. 22. 5

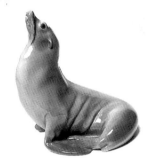

13 Figure of a seated sea-lion △
Porcelain painted with underglaze browns and other
colours
Made by Royal Copenhagen 1931-8; modelled by
Theodor Madsen, 1900
Given by the maker
C. 13-1939
Mark ROYAL COPENHAGEN DENMARK around a crown
printed in green; 265 and TM in monogram incised; 265
painted in green, three wavy lines and DHX painted in
blue 265 and TM in monogram incised
H. 27. 6
Shape 265

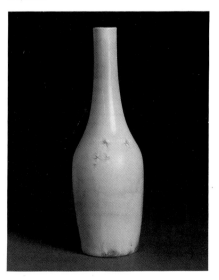

14 Vase △
Porcelain, bottle shaped, with pale green crystalline
glaze
Made by Royal Copenhagen c. 1900; glaze by Valdemar
Engelhardt
456-1901
Mark DANMARK under a crown printed in green; three
wavy lines printed in underglaze blue; 114 C. L. incised;
VE in monogram E197 painted in blue
H. 17. 3
Shape 114 C L

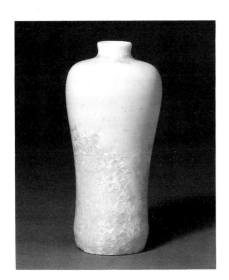

15 Vase △
Porcelain, bottle shaped, with white crystalline glaze
Made by Royal Copenhagen c. 1900; glaze by Valdemar
Engelhardt
457-1901
Mark DANMARK under a crown printed in green, three
wavy lines printed in blue; A5206 incised (indistinct); VE
in monogram and E501 painted in blue
H. 10

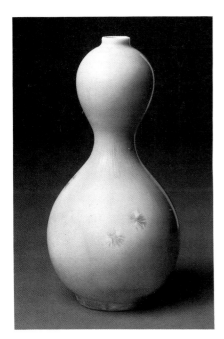

16 Vase △
Porcelain, double gourd shape, with pale green
crystalline glaze
Made by Royal Copenhagen c. 1900; glaze by Valdemar
Engelhardt
459-1901
Mark DANMARK under a crown printed in green, three
wavy lines printed in blue; D and a cross incised; VE in
monogram and C765 painted in blue
H. 17. 2

17 Plate ▷
Porcelain with impressed and painted decoration in
underglaze blue
Made by Royal Copenhagen c. 1902; designed by Arnold
Krog 1902
Given by Lady M. M. Evans
C. 501-1921
Mark ROYAL COPENHAGEN around a crown printed in
green; three wavy lines and 76 painted in underglaze blue
D. 17. 5

This plate was made to celebrate the wedding in England
of Edward and the Danish princess Alexandra in 1902 and
is decorated with the monogram EA. Production ceased
after 1,000 copies had been made.

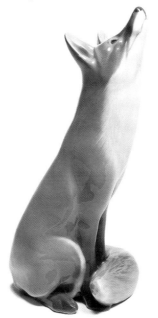

18 Figure of a seated fox △
Porcelain painted with underglaze greys and browns
Made by Royal Copenhagen c. 1930; the original
modelled by Erik Nielsen 1903
Given by the maker
C. 117-1931
Mark ROYAL COPENHAGEN DENMARK around a crown
printed in green; 437/NJ (indistinct) and EN in monogram
incised; three wavy lines and COX painted in blue,
946/437 painted in green
H. 25. 7

19 Vase ▷
Porcelain with brown crystalline glaze
Made by Royal Copenhagen c. 1907; glaze by Valdemar
Engelhardt
Given by Mrs F. C. Ormerod
Circ. 308-1953
Mark DANMARK and a crown printed in green, three
wavy lines printed in blue; 19 (indistinct) incised; VE in
monogram F238 painted in underglaze blue
H. 23. 7

Said to have been given by Royal Copenhagen to William
Burton of Pilkington, the donor's father, in about 1907. Pil-
kington were, themselves, very involved in experimental
glazes and Burton corresponded regularly with other glaze
chemists. He would have been interested in and in contact
with Royal Copenhagen in view of their leading role in the
development of crystalline glazing. See also cat. no. 332.

20 Vase 🅒
Porcelain with blue crystalline glaze and silver gilt
mounts, the rim in the shape of a band of beech leaves,
the base with a frieze of mushrooms or toadstools
Made by Royal Copenhagen c. 1909; glaze by Valdemar
Engelhardt; the mounts by the firm of Anton Michelsen
1909
C. 86-1987
Mark ROYAL COPENHAGEN and crown printed in green;
three wavy lines, VE in monogram and V 934 painted in
underglaze blue. On metal: EP, three towers, MICHELSEN,
a crown and 9255 09 HCF ER stamped on the base
H. 25. 8

Anton Michelsen was succeeded by his son Carl in 1877.
The company's traditional style continued until about
1888-90 when it was influenced by the Japanese-inspired
work of Arnold Krog, the art director of Royal Copenhagen.
By 1900 Michelsen also used a distinctive Danish Art
Nouveau style combined with a vigorous naturalism.

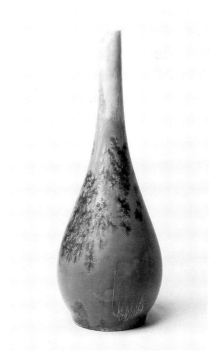

21 Bowl ▽

*Porcelain with moulded relief of berries and with under-
glaze painting
Made by Bing & Grøndahl 1910; the original modelled by
Fanny Garde
C. 91-1987
Mark three towers and B&G KJØBENHAVEN MADE IN
DENMARK printed in green; B&G printed in underglaze
blue; F GARDE 1273 /10 painted in underglaze blue
D. 12. 2*

The number 1273 refers to a numbered pattern register
which Fanny Garde shared with Effie Hegermann-Linden-
crone at Bing & Grøndahl (see cat. no. 26); 10 in the mark
refers to the date 1910.

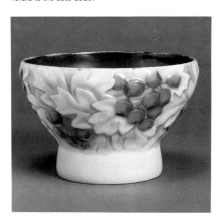

22 Vase ▽

*Stoneware with pitted, dark red reduction-fired glaze
Made by Royal Copenhagen between 1911-23; designed
and glazed by Patrick Nordström
C. 85-1987
Mark S1540 PN in monogram painted in underglaze
blue
D. 21. 8*

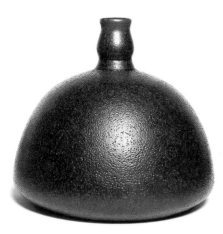

Nordström began producing stoneware glazes at Royal
Copenhagen soon after his arrival at the factory in 1911.
He specialised in metal-based glazes such as this. These
were fired at high temperatures which were then dramati-
cally reduced, the reduction causing a violent change in the
gaseous atmosphere in the kiln.

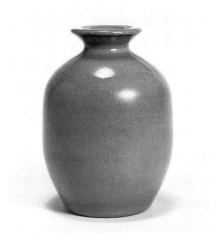

23 Vase △

*Brown stoneware with blue crackled glaze
Made by Bing & Grøndahl 1958; designed by Carl
Petersen 1912-13
C. 96-1984
Mark three towers and B&G within an oval, KØBENHAVN
DANMARK and KV7 158 impressed; U160 painted in black
H. 12*

From 1930 Bing & Grøndahl stoneware pieces were marked
with a letter/number dating system: U160 is the firing date
code for 1958.

24 Vase

*Porcelain with pale green and blue crystalline glaze
Made by Royal Copenhagen 1927; designed by Søren
Berg 1915-27
Given by the maker
C. 113-1931
Mark indistinct mark incised; three wavy lines and SB
10.3.27 painted in underglaze blue
H. 22*

25 Jar △

*Grey stoneware with mottled brown/green glazes and with
a chased copper and white metal lid
Made by Royal Copenhagen c. 1915; shape designed and
glazed by Patrick Nordström; lid by Georg Thylstrup
C. 90&A-1987
Mark PN in monogram S297 and three wavy lines
painted in underglaze blue
H. with lid 13*

The metal-worker Thylstrup was employed by Royal
Copenhagen specifically to make lids for glazed wares and
he collaborated closely with Nordström.

26 Bowl 🅲

*Porcelain with modelled and pierced decoration of foliage
and blossoms, partly aquatic and with a dragonfly,
painted in underglaze colours
Made by Bing & Grøndahl 1917; the original modelled by
Effie Hegermann-Lindencrone
C. 111-1988
Mark three towers and B&G KØBENHAVN DANMARK
printed in green; B&G EHL in monogram printed in blue;
1564/17 painted in blue
D. 14. 5*

The number 1564 refers to a numbered pattern register
which Hegermann-Lindencrone shared with Fanny Garde at
Bing & Grøndahl (see also cat. no. 21). The two artists
worked on modelling parts of the 'Hejrestellet' (cat. no. 1)
during their first years at Bing & Grøndahl.

27 Vase

*Grey stoneware with brownish green glaze and with
bronze and silver cover
Made by Royal Copenhagen 1919; shape designed and
glazed by Patrick Nordström; cover by Georg Thylstrup
Given by the maker
C. 112&A-1931
Mark three wavy lines and 19 N painted in underglaze
blue
H. 10. 8*

See also cat. no. 25.

28 Vase ▽

*Earthenware with painted decoration in red lustre on a
white ground
Made by Kaehler Keramik between 1919-42; probably
designed by and possibly decorated by Jens Thirslund
C. 94-1987
Mark HAK in monogram and an indistinct symbol
incised
H. 25*

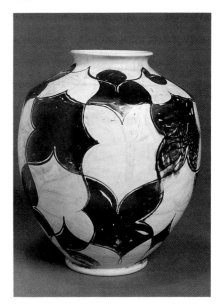

Lustre glazes were introduced at Kaehler Keramik in the
1890s. During the 1920s, under Jens Thirslund, these
glazes were used for painted patterns and figurative
decoration.

29 Set of four figures 'The Aches'
Porcelain
Made by Bing & Grøndahl; designed by Sven Lindhart
between 1920-40
Given in memory of Mr J. S. Hovell by Dr E.D.
C. 9&A-C-1986
Mark three towers and B&G KJØBENHAVN MADE IN
DENMARK and shape number printed in green, B & G
printed in underglaze blue; SV. LINDHART impressed
H. 'Earache' 11
Shapes: 2206 ('Headache'), 2208 ('Tummyache'), 2209
('Earache'), 2207 ('Toothache')

The set is still in production.

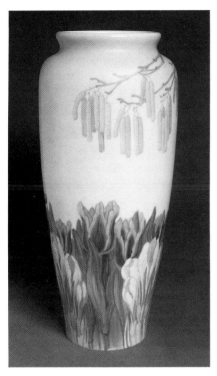

30 Vase △
Porcelain with painted decoration of crocuses, tulips and
catkins in underglaze colours
Made by Royal Copenhagen c. 1920; painted by Thyra
Manicus-Hansen
C. 93-1987
Mark ROYAL COPENHAGEN and a crown printed in
green; three wavy lines and TH. M. H. painted in
underglaze blue, 2116 142 painted in green
H. 44
Shape 142; pattern 2116

31 'Suzannah' ○
Porcelain
Made by Royal Copenhagen; the original modelled by
Arno Malinowski 1924
Circ. 277-1939
Mark ROYAL COPENHAGEN DENMARK around a crown
printed in green; three wavy lines painted in blue
H. 29
Shape 12454

Also issued decorated with overglaze painting in enamels,
this figure is described as 'Susanne' in the factory records,
although purchased as 'Suzannah' from Royal Copenhagen
in Old Bond Street in 1939. See also cat. no. 38.

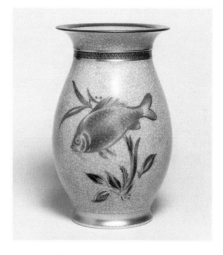

32 Vase △
Porcelain with painted decoration of two fish in overglaze
red and gold, and plants in brown/black and with a grey
crackled glaze
Made by Royal Copenhagen c. 1931-8; shape designed
by Thorkild Olsen 1924; decorated by Nicolai Tidemand
Given by the maker
C. 14-1939
Mark ROYAL COPENHAGEN DENMARK and a crown
printed in green; three wavy lines painted in blue, 196
2490 DX painted in black
H. 21. 4

At the time of its acquisition in 1939 this vase is recorded
in the Museum's papers as being by Olsen and Tidemand.
It is unusual in not being signed by Olsen.

33 Part of a tableware range ▽
Porcelain with painted and gilded decoration
Made by Royal Copenhagen; shape designed by Christian
Joachim 1925; decoration designed by Arno Malinowski
1925
Circ. 274&A, 275-1939
Sauce tureen and cover, pickle dish
Mark ROYAL COPENHAGEN DENMARK and a crown
printed in green; three wavy lines painted in blue,
734.12449 BGX painted in green
L. tureen 22. 8

The service, of which this is part, was shown in the Paris
exhibition, 1925, and Joachim and Malinowski were
awarded a grand prix for the design.

34 Bowl ▽
Stoneware with dark red glaze, the inside decorated with
a moulded relief portrait head of a god playing pan pipes
Made by Royal Copenhagen; designed by Jais Nielsen
between 1925-35
C. 87-1987
Mark ROYAL COPENHAGEN DENMARK and a crown
printed in green (indistinct); three wavy lines and JAIS
painted in underglaze blue
D. 24. 6

Jais Nielsen was one of a group of artists at the Royal
Copenhagen studio who specialised in sculptural works.
His best known figure is that of 'The Potter', a standing
figure in a strikingly stylised manner which was exhibited
at the Paris exhibition, 1925, exciting much attention
especially in the British reports. This modest bowl is deco-
rated with a stylised head, in the manner of the 1925
figure, but here simply produced as part of Royal
Copenhagen's serial studio production.

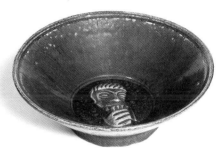

35 Vase ○
Stoneware with dark red glaze
Made by Carl Halier at Royal Copenhagen 1926
Given by the maker
C. 111-1931
Mark three wavy lines and 5-10/1926 painted in
underglaze blue
H. 21. 4

This distinctive dark red glaze was one of a number deriving
from Chinese originals and developed by Patrick Nordström
for Royal Copenhagen stoneware between 1911 and 1923.
Nordström and Halier worked together closely and, in the
original papers relating to its acquisition in 1931, this vase
is described as being by Halier although, unusually, his sig-
nature does not appear on the base.

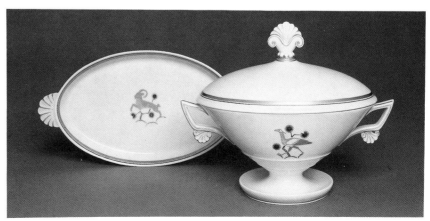

36 Vase ▽
*Stoneware with relief decoration of the four evangelists
and with turquoise glaze*
*Made by Royal Copenhagen 1926; designed by Jais
Nielsen*
Given by the maker
C. 115-1931
*Mark three wavy lines, the artist's symbol and JAIS
17-10-26 incised and painted in brown (?indistinct);
incised*
H. 22. 8

Nielsen modelled the original of this vase including the sig-
nature and other marks on the base. It was then put into
production using a mould, in the usual manner.

37 Vase
*Porcelain with painted decoration of a fish and seaweed
in blue and gold, and with crackled celadon glaze*
*Made by Royal Copenhagen c. 1926; designed by
Oluf Jensen*
Given by the maker
C. 118-1931
*Mark 2770 incised; three wavy lines 5012/2770 and 86
painted in blue, a cross painted in gold*
H. 24. 5
Shape 2770; pattern 5012

The painter is identified only by the number '86' in the mark.
Oluf Jensen, who designed the decoration, specialised par-
ticularly in fish decorations and crackled glazes.

38 'Iceland girl' ▷
Porcelain
*Made by Royal Copenhagen; the original modelled by
Arno Malinowski about 1927*
Circ. 180-1932
*Mark on side: AM in monogram; on base: 12463/2/5
incised; three wavy lines painted in blue*
H. 15. 5
Shape 12463

Malinowski was a versatile artist who trained at the Royal
Academy of Fine Arts in sculpture and who worked at Georg
Jensen, the silversmiths, as well as for Royal Copenhagen.
He made a particular speciality of such blanc-de-chine
figures. The Museum includes four in its collections (see
cat. nos 31, 40, 45). Another series in production in 1937
was 'The Five Continents', each represented by a partly
nude female figure, dressed and posed in stereotypical
style. These delicately modelled figures show one aspect
of his skill. By comparison, he also made the robustly
sculptural vase in stoneware, cat. no. 47.

39 Vase △
*Porcelain with painted decoration of a scene of white
rabbits in underglaze greys, pale brown and green*
*Made by Royal Copenhagen 1928; painted by Vilhelm
Fischer 1928*
Given by the maker
C. 114-1931
*Mark 35A H incised; three wavy lines beneath a crown
and 16.4.1928/ VILH TH. FISCHER painted in underglaze
blue*
H. 20. 5

40 Figure of a bride ○
Porcelain
*Made by Royal Copenhagen 1929; the original modelled
by Arno Malinowski c. 1928-9*
Circ. 179-1932
*Mark on side: three wavy lines and AM in monogram
incised; on base: 12468 incised; three wavy lines
painted in blue; N:37/50 painted in brown*
H. 20. 5
Shape 12468

Number 37 of an edition of 50.

41 Figure of a monkey suckling its young ▽
Grey stoneware with mottled glaze
*Made by Royal Copenhagen; the original modelled by
Knud Kyhn 1930*
Given by the maker
C. 16-1939
*Mark 20241 incised; three wavy lines and KK painted
in blue*
H. 17
Shape 20241

Knud Kyhn modelled a number of popular and successful
animal figures which were made with this particular stone-
ware glaze.

42 Bowl
*Stoneware with painted decoration on the inside of a
kicking deer in black and with clear turquoise glaze*
*Made by Royal Copenhagen; designed by Jais Nielsen
c. 1930*
C. 97-1984
*Mark ROYAL COPENHAGEN DENMARK around a crown
printed in green; three wavy lines and 110/92 painted
in brown*
W. 13. 4

43 Bowl △
*Porcelain, rounded with a small foot and covered with
finely crackled apricot/pink glaze, the foot and rim edged
with dark grey/blue*
*Made by Bing & Grøndahl; designed by Ebbe Sadolin
between c. 1930-48*
C. 98-1984
*Mark three towers and B&G KJØBENHAVN DENMARK
printed in green, B&G printed in blue; B incised; NG/403
painted in black*
D. 9. 5
Shape 403

Part of a series of which some pieces are direct copies of
Japanese and Chinese examples and others were designed
to link the series harmoniously. The colours were turquoise,
green, light yellow and pink, and, in this case, NG in the
mark indicates pink glaze.

44 Dish ▽
Porcelain with celadon glaze
Made by Royal Copenhagen 1931; designed by Elizabet Castenschiold
Given by the maker
C. 116-1931
Mark three wavy lines and 10.3.31 painted in underglaze blue
D. 23. 7

45 Figure of a sitting girl ○
Porcelain
Made by Royal Copenhagen; the original modelled by Arno Malinowski 1931
Circ. 105-1937
Mark ROYAL COPENHAGEN DENMARK around a crown printed in green; AM in monogram 12480 BL. D. CH. incised; three wavy lines painted in blue
H. 12. 2
Shape 12480

See cat. no. 38.

46 Vase △
Earthenware with matt brown glaze
Made by Royal Copenhagen; designed by Nils Thorsson c. 1933; in production from 1934
Circ. 259-1939
Mark A, three wavy lines and DENMARK printed in blue; 1479 incised; 34 over 1479 and W painted in blue
H. 17. 4
Shape 1479

The 'A' in the mark stands for Royal Copenhagen's 'Aluminia' factory where the earthenware production took place.

47 Vase ▷
Stoneware with moulded decoration and speckled green/yellow glaze
Made by Royal Copenhagen; the original modelled by Arno Malinowski 1934
Circ. 276-1939
Mark printed mark obscured; AM in monogram 20314 X incised in the mould
D. 19. 7

A comparison between this monumental work apparently based on fruit or some natural form and the delicately sculpted blanc-de-chine figures (cat. nos 31, 38, 40, 45) could hardly illustrate better the wide versatility of Malinowski's work.

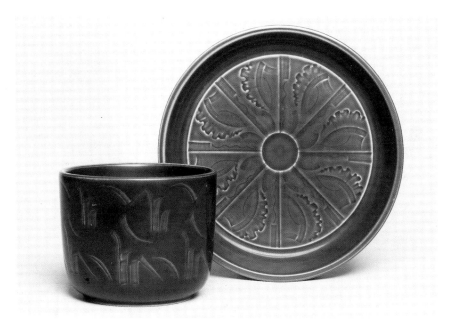

48 Part of 'Solbjerg' series △
Earthenware with moulded decoration and matt brown glaze
Made by Royal Copenhagen; designed by Nils Thorsson 1934
Circ. 107, 108-1937
Tray, bowl
Mark A with three wavy lines and DENMARK printed in blue; 1596E painted in blue
D. tray 18. 5
Shape 1596E

The 'Solbjerg' series was put into production in 1934 and was extremely successful; at least part of it was still in production as late as 1961. These two examples were the first from the 'Solberg' series to be acquired by the Museum.

49 Part of a tableware range 'Knud' (Canute)
Earthenware with painted decoration of flowers in browns, black and yellow
Made by Royal Copenhagen; designed by Nils Thorsson 1934
Circ. 265&A-C, 266-1939
Mustard pot and lid, pepper pot, salt pot, pickle dish
Mark A, three wavy lines and DENMARK 4 printed in black; 262 MP painted in black; on pickle dish S and KF. 4 impressed
L. pickle dish 24

50 Two vases, 'Solbjerg' series ▽
Earthenware, moulded decoration with matt glazes
Made by Royal Copenhagen; designed by Nils Thorsson c. 1934
Circ. 279, 281-1939
Mark A, three wavy lines and DENMARK printed, on Circ. 279-1939 in blue, on Circ. 281-1939 in black; NT in monogram incised; on Circ. 279-1939; 1613 incised, 1613 (?indistinct) painted in blue; on Circ. 281-1939 158 (partially obscured) incised; 1582E painted in black
H. taller 33
Shapes 1613, 1582

51 Vase, 'Solbjerg' series
Earthenware, moulded vertical decoration, with matt green glaze outside and brown glaze inside
Made by Royal Copenhagen; designed by Nils Thorsson c. 1934
Circ. 280-1939
Mark A, three wavy lines and DENMARK printed in blue; NT in monogram and 1584 incised; 1584 painted in blue
D. 23. 4
Shape 1584

52 Bowl △
Porcelain, ribbed sides, with black/brown 'Olivine' glaze
Made by Royal Copenhagen; designed by Hans Henrik
Hansen 1936
Circ. 106-1937
Mark 20336 and 529 incised; three wavy lines painted
in blue
D. 17. 9

This black/brown glaze is known as 'tenmoku', the Japanese
name for the original Chinese Song glaze. The Royal
Copenhagen version, called 'Olivine' was developed by Olaf
Mathieson, 1934-5, and, with this bowl, was put into serial
production the following year.

53 Bowl △
Stoneware with speckled green/yellow 'Solfatara' glaze
Made by Royal Copenhagen; designed by Nils Thorsson
1937; glaze by H. A. Madslund
Given by the maker
C. 15-1939
Mark ROYAL COPENHAGEN DENMARK around a crown
printed in brown; 20366 X NT in monogram incised; three
wavy lines painted in blue
H. 10. 5

According to factory records shape 20366 (see incised
mark) is a tobacco jar. The 'Solfatara' glaze was developed
under Hans A. Madslund in 1936. The glaze is named after
the metallic oxide on which it is based and which, during a
special firing, can change to bright yellow or black or
mottled variations between.

54 Part of a tableware range 'Birthe' ▷
Earthenware with printed decoration of flowers and
leaves in yellow
Made by Royal Copenhagen; designed by Nils Thorsson
c. 1937
Circ. 263, 264-1939
Jug, serving dish
*Mark A, three wavy lines and DENMARK BIRTHE ***
printed in brown
D. serving dish 25

55 'Pegasus' ▷
Stoneware with turquoise glaze
Made by Royal Copenhagen; the original modelled by
Hans Henrik Hansen 1938
C. 111-1986
Mark ROYAL COPENHAGEN DENMARK around a crown
printed in green; 3619 and HH 31 incised; three wavy
lines 3619 painted in blue
L. 35
Shape 3619

Hansen's entire career was spent at Royal Copenhagen. He
trained in the modellers' department, and later became its
head. He specialised in figures on classical themes.

56 Vase △
Porcelain, moulded, with fluted sides
Made by Royal Copenhagen; designed by Hans Henrik
Hansen c. 1939
Circ. 278-1939
Mark three wavy lines printed in blue, ROYAL
COPENHAGEN DENMARK and a crown printed in green;
3482 painted in blue
D. 8. 5

57 Part of a tableware range 'Margrethe'
Earthenware with painted decoration of birds and leaves
in brown and yellow
Made by Royal Copenhagen; designed by Nils Thorsson
c. 1939
Circ. 260&A, 261, 262-1939
Vegetable dish and cover, serving dish, sauce boat
Mark A, three wavy lines and DENMARK MARGRETHE
printed in brown; K impressed
D. serving dish 25

58 Part of a tableware range 'Odin'
Earthenware with slip decoration of fish in brown, black,
yellow and greens and underglaze painted enamel on a
green ground
Made by Royal Copenhagen; designed by Nils Thorsson
c. 1939
Circ. 267, 270-1939
Two fish plates
Mark A, three wavy lines and DENMARK printed in*
brown; on Circ. 267-1939 1895 over 1542, on Circ. 270-
1939 1896 over 1542 painted in brown; on Circ. 267-
1939 R and KF. 5 and NT in monogram impressed
D. 23. 5
Shape 1542; patterns 1895, 1896

This set was in production until the early 1960s.

59 Part of a fish service 'Gefion'
Earthenware with green glaze and painted decoration of
seaweed and corals in coloured slips
Made by Royal Copenhagen; designed by Nils Thorsson
c. 1939
Circ. 271, 272, 273-1939
Three plates
Mark A, three wavy lines and DENMARK printed in
black; 1887 over 1542 and NT in monogram painted in
black; on Circ. 273-1939 NT in monogram and KF5
impressed
D. 24. 5
Shape 1542; pattern 1887

In Danish mythology 'Gefion' is a goddess of lakes and
water. This service was still in production in 1965.

60 Vase, 'Solberg' series
Earthenware with moulded decoration and matt
grey/brown glaze
Made by Royal Copenhagen; designed by Nils Thorsson
c. 1939
Circ. 282-1939
Mark A and three wavy lines printed in black; monogram
(indistinct) incised
D. 11. 5

61 Vase, 'Solbjerg' series
Earthenware with moulded decoration and matt brown
glaze
Made by Royal Copenhagen; designed by Nils Thorsson
c. 1939
Circ. 283-1939
Mark A, three wavy lines and DENMARK printed in
black; 1683 painted in black
D. 10. 5
Shape 1683

62 Bowl ▷
*Stoneware with geometric moulded decoration and
brown/black and blue glazes
Made by Royal Copenhagen between 1944-60; the
original modelled by Axel Salto before 1944
C. 88-1987
Mark ROYAL COPENHAGEN DENMARK and a crown
printed in green; 145. 20. 7. 22 SALTO incised; three wavy
lines painted in underglaze blue
D. 29. 3*

Axel Salto, Jais Nielsen and Knud Kyhn were Royal Copen-
hagen's strongest sculptural stoneware modellers. Salto's
work, nevertheless, had a formal decorative quality, and
this fluted repeating pattern became a typical one, almost
a trademark.

63 Dish C
*Earthenware with trailed slip decoration of mermaids
and fish
Designed and decorated by Bjørn Wiinblad at the Lars
Syberg pottery 1946
Given by the artist
C. 176-1988
Mark BJØRN WIINBLAD 46 and HU (indistinct) 122
painted in black
D. 60. 5*

Bjørn Wiinblad held his first exhibition of earthenwares in
1944. He employed the traditional means of a cow's horn
and goose quill through which the liquid clay (slip) was
applied. His early works such as this one, have a darkly
vigorous side reflecting, perhaps unconsciously, a Nordic
preoccupation with woodland and water spirits.

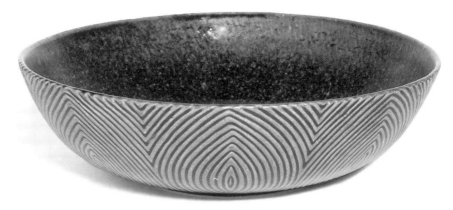

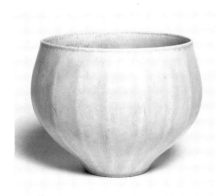

64 Bowl △
*Stoneware with yellow glaze and ribbed decoration
Made at Saxbo c. 1951; designed by Eva Staehr-Nielsen;
glazed by Nathalie Krebs
Circ. 43-1952
Mark E. ST. N. incised; Yin-yang symbol and 164 S...
(partially obscured) impressed
D. 11. 5*

This bowl was included in and acquired from the exhibition
'Scandinavia at Table' arranged by the Council of Industrial
Design at the Museum in 1951 (no. D668). Nathalie Krebs
spent formative years at Bing & Grøndahl, under H. A.
Madslund and subsequently with Gunnar Nylund. This ex-
perience gave her an impeccable glaze repertoire and the
necessary technique to fire it. Krebs adopted the Yin-yang
symbol as the the Saxbo pottery mark. From 1932 she col-
laborated with Eva Staehr-Nielsen in the production of
strong yet elegant forms combined with finely textured
and coloured glazes. These are recognised as being in
'classical' Saxbo style.

65 Vase C
*Stoneware with relief decoration and mottled blue/brown
glaze
Made at Saxbo c. 1951; designed by Eva Staehr-Nielsen;
glazed by Nathalie Krebs
Circ. 44-1952
Mark Yin-yang symbol, SAXBO DENMARK 171 11 and
two groups of dots impressed
H. 15. 2*

This vase was included in and acquired from the exhibition
'Scandinavia at Table' arranged by the Council of Industrial
Design at the Museum in 1951 (no. D753).

66 Cup, saucer and dish ○
*Earthenware with printed decoration of scenes from
Shakespeare's A Midsummer Night's Dream in red
Made by Nymølle; designed by Bjørn Wiinblad 1954
Given by Messrs A. A. Rafa Ltd
Circ. 134&A, 135-1960
Mark a two-handled vase and NYMØLLE DENMARK
DECOR: BJØRN WIINBLAD 1777-534 printed in red; on
dish A MIDSUMMER NIGHT'S DREAM ACT II SCENE I OBE-
RON, ILL MET BY MOONLIGHT, PROUD TITANIA. TITANIA:
WHAT, JEALOUS OBERON! FAIRIES, SKIP HENCE: I HAVE
FORSWORN HIS BED COMPANY. OBERON: TARRY, RASH
WANTON: AM I NOT THY LORD? TITANIA: THEN I MUST BE
THY LADY - printed in red also
L. dish 28*

67 Part of a tableware range ▽
*Porcelain with unglazed edge
Made by Bing & Grøndahl; designed by Gertrud Vasegaard
1956
Given by the maker
C. 132&A, 133&A, 134, 135&A-1987
Tea pot and lid, cup and saucer, plate, tea box and lid
Mark three towers, B&G COPENHAGEN PORCELAIN
MADE IN DENMARK and GV in monogram printed in green;
on teapot 654, on cup 473, on saucer three towers, B&G
KJØBENHAVN DENMARK and GV in monogram, on plate
615, on tea box 651 printed in green
H. tea pot 16
Shapes 654 (tea pot), 473 (cup), 615 (plate), 651 (tea
box)*

This service was selected by Finn Juhl on behalf of the
Danish Society of Arts and Crafts and Industrial Design for
inclusion in the exhibition 'Two Centuries of Danish Design'
held at this Museum in 1968. It is an achievement remark-
able as a successful collaboration between a potter of such
exacting standards as Gertrud Vasegaard and an indust-
rially based manufacturer. Bing & Grøndahl were otherwise
geared to multiple production in which commercial pres-
sures would normally exclude any possibility of catering to,
let alone supporting, the highly individual requirements of
one of Denmark's most principled studio potters.

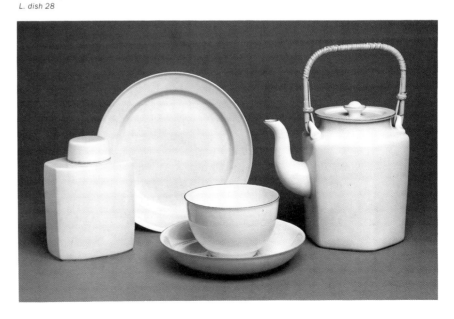

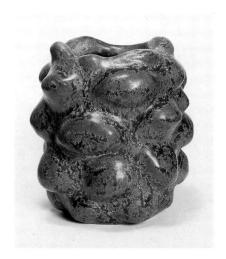

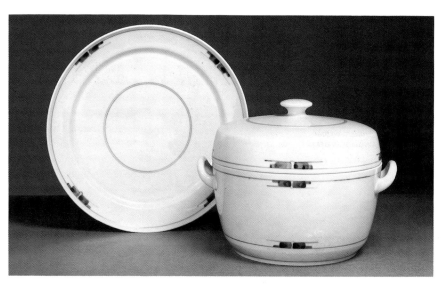

68 Vase △
Stoneware with deeply modelled decoration and green/yellow 'Solfatara' glazes
Made by Royal Copenhagen; the original modelled by Axel Salto 1957
C. 89-1987
Mark ROYAL COPENHAGEN DENMARK and a crown printed in green; SALTO incised; 21441 and three wavy lines painted in blue
H. 13

During the 1930s Salto modelled some of Royal Copenhagen's most handsome and sculptural forms using the stoneware glazes with great effect. This is a late example of his small-scale work.

70 Part of a tableware range 'Gemina' △
Stoneware with painted decoration in underglaze blue
Made by Royal Copenhagen c. 1985; designed by Gertrud Vasegaard 1960
Given by the maker
C. 132&A, 133-1986
Tureen, cover and stand
Mark on tureen ROYAL COPENHAGEN DENMARK around a crown and GV in monogram printed in green, three wavy lines printed in blue; 41/14600 XR painted in green; on stand 41 14608 X R painted in green
W. including handles 23.5
Model no. 41; shapes 14600, 14608

This range was selected by Finn Juhl on behalf of Landsforeningen Dansk Kunsthåndvaerk (Danish Society of Arts, Crafts and Industrial Design) for the exhibition 'Two Centuries of Danish Design' held at this Museum in 1968. This range and its contemporary tableware design 'Gemma' have been in production since 1960. The prototype for each shape was thrown on the wheel by Gertrud Vasegaard who chose to use stoneware, preferring the slight irregularities in the texture to the comparative flawlessness of the porcelain body. The Royal Copenhagen chemists were persuaded to retain such irregularities, demonstrating, as in the earlier collaboration with Bing & Grøndahl, the flexibility with which the Danish factories are able to work with studio artists.

71 Jug ▽
Porcelain, undecorated
Made by Bing & Grøndahl; designed by Henning Koppel 1962
Given by the maker
C. 137-1987
Mark three towers and B&G COPENHAGEN PORCELAIN MADE IN DENMARK 446 printed in green
H. 28. 3

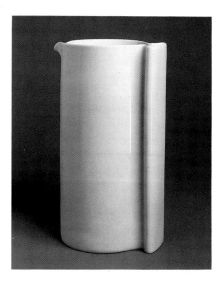

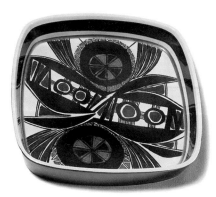

69 Dish, 'Tenera' series △
Porcelain with printed decoration in blues and greens, browns and purple
Made by Royal Copenhagen c. 1986; designed by Inge-Lise Koefoed; in production from 1959
Given by the maker
C. 125-1986
Mark ROYAL COPENHAGEN DENMARK around a crown, three wavy lines and FAJANCE printed in blue; 156/2885, ILK in monogram and an unidentified decorator's mark painted in blue
26 sq.
Model no. 2885/156

Part of a large range of varied shapes including boxes, bowls, dishes and birds all decorated in this same colour range.

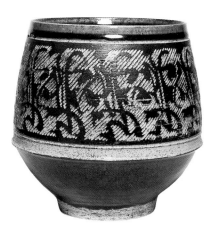

72 Bowl ◁
Stoneware with brown glaze and sgrafitto decoration
Made by Erik Reiff, Regstrup, 1962
Circ. 313-1963
Mark ER 62 and a flower impressed
D. 23

Erik Reiff was one of a small group of young potters who joined the Bing & Grøndahl studio in 1953. He produced a series of bowls and vases in Chinese style decorated with freely brushed patterns and incised work. He benefitted from the influence of Gertrud Vasegaard's connection with the company, and over the next 10 years he experimented and developed his own highly personal style in stoneware. The flower in the mark is Reiff's personal symbol.

73 Part of a tableware range ▽
Porcelain, undecorated
Made by Bing & Grøndahl; designed by Henning Koppel
1963
Given by the maker
C. 139&A, 140&A, 141&A-S-1987
Dish and cover, two sauceboats, tea pot and lid, two cups
and saucers, two plates, cream jug, sugar bowl, pepper
and salt, soup plate, two dinner plates, serving dish, two
ashtrays, two place plates
Mark on serving dish three towers and B&G COPEN-
HAGEN PORCELAIN MADE IN DENMARK 512 printed in
green; on coffee pot B&G KJOBENHAVN DENMARK printed
in green
L. teapot 26. 5

The plain glazed white porcelain used in this service and
for other designs by Henning Koppel was known within the
factory as 'Koppel white'.

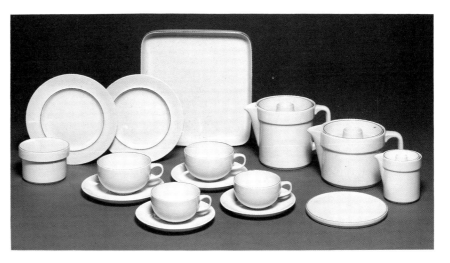

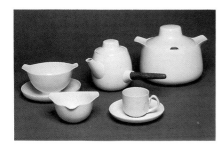

74 Vase, 'Baca' (Ring) series C
Porcelain with printed decoration in greens, blues and
browns
Made by Royal Copenhagen; designed by Johanna Gerber
1965
Given by the maker
C. 126-1986
Mark ROYAL COPENHAGEN DENMARK around a crown,
three wavy lines, FAJANCE and a ring enclosing the
designer's monogram printed in blue; 780/3121 and the
decorator's symbol painted in blue
W. 14. 7
Model no. 3121/780

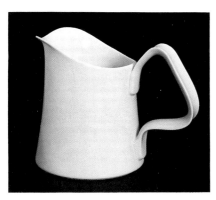

75 Jug △
Porcelain, undecorated
Made by Bing & Grøndahl; designed by Henning Koppel
1965
Given by the maker
C. 138-1987
Mark three towers and B&G COPENHAGEN PORCELAIN
MADE IN DENMARK 445 printed in green
W. 20

76 Part of a tableware range 'Blue Line' △
Earthenware with painted decoration of a thin blue/grey
line
Made by Royal Copenhagen; designed by Grethe Meyer
1965
Given by the maker
Circ. 508&A, 509&A, 510&A, 511, 512&A, 513&A,
514&A, 515&A, 516&A, 517, 518, 519-1973
Tea pot and lid, milk jug and lid, tea cup and saucer, plate,
sugar pot and cover, 2 coffee cups and saucers, tea cup
and saucer, coffee pot and lid, tray, tea pot stand, plate
Mark on tea pot and tray A, three wavy lines and DEN-
MARK, the designer's monogram and shape number
printed in green/grey; on everything else ROYAL
COPENHAGEN around a crown, 3 wavy lines, FAJANCE,
designer's monogram and on tea pot 3005, on milk
3062, on tea cups 3074, on plates 3067, on sugar 3063,
on coffee cups 3042, on coffee pot 3058, on tray 3048,
on stand 3088 printed in black and incised
H. coffee pot 12
Shapes 3005 (teapot), 3062 (milk), 3074 (tea cups),
3067 (plates), 3063 (sugar), 3042 (coffee cups), 3058
(coffee pot), 3048 (tray), 3088 (stand)

This range was given a Danish Industrial Design award and
was chosen by Finn Juhl, on behalf of Landsforeningen
Dansk Kunsthåndvaerk, for the exhibition 'Two Centuries of

Danish Design' held at this Museum in 1968. Grethe Meyer
trained as an architect and this discipline became her
established career. Nevertheless, she has ventured with an
unerring and confident touch into other design areas. She
brings an architect's understanding of mass and balance to
the design of industrially made ceramics.

77 Part of a tableware range 'Domino' ▽
Porcelain with printed decoration in matt brown
Made by Royal Copenhagen; designed by Anne Marie
Trolle 1970
Given by the maker
C. 127&A, 128&A, 129&A-1986
Coffee pot and lid, coffee cup and saucer, hot water jug
and lid
Mark on coffee pot ROYAL COPENHAGEN DENMARK
around a crown and DOMINO printed in green, three wavy
lines and AT in monogram printed in blue; VX painted
in blue
H. coffee pot 18
Model no. 149-01; shapes 14935, 14910, 14909;
pattern 36

This range was awarded gold medals at Faenza, 1971, and
Jablonic, 1973. In production since 1970, this same shape
is also made with blue decoration, titled 'Indigo', which was
introduced in 1975.

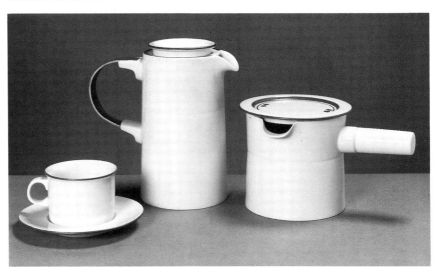

78 Dish ▽

Stoneware with combed decoration outside and painted glaze decoration of fish inside in grey/white and brown
Made by Myre Vasegaard, Copenhagen, 1970
Circ. 509-1972
Mark MV in monogram painted in brown
D. 42

Exhibited in 'International Ceramics' held in the Museum in 1972 (catalogue: Denmark no. 12).

79 Bowl

Earthenware with slip-trailed decoration of panels and a profile face in various colours
Designed and decorated by Bjørn Wiinblad at Nymølle 1971
Given by the artist
C. 179-1988
Mark BJØRN WIINBLAD 71 DANMARK painted in black
D. 38

80 Tureen and cover △

Earthenware with slip trailed decoration in blues and greens on a dark green ground and with a lime green lid
Designed and decorated by Bjørn Wiinblad at Nymølle 1972
Given by the artist
C. 177&A-1988
Mark BJØRN WIINBLAD 72 DANMARK painted in black
H. 40

During the year following his first exhibition in 1944 (see cat. no. 63), Wiinblad developed a highly personal style, most usually characterised as 'rococo' (see cat. no. 66). His slip trailed earthenwares have always demonstrated a more vigorous version of this. Following his association with the German company Rosenthal, Wiinblad's enormous popularity has been overwhelming not only in ceramic design but in the myriad decorations for the theatre, opera and ballet, for interiors and even more especially, in poster design. His success in these fields has been phenomenal, particularly in America, and continues unabated.

81 Tureen and cover

Earthenware with slip trailed decoration in blues, greens and yellow on a dark ground
Designed and decorated by Bjørn Wiinblad at Nymølle 1972
Given by the artist
C. 178&A-1988
Mark BJØRN WIINBLAD 72 DANMARK painted in black
H. 73

82 Part of a tableware range 'Delfi' ▷

Porcelain with hand-painted decoration in underglaze blue
Made by Bing & Grøndahl; shape designed by Martin Hunt; pattern designed by Carl Harry Stålhane; in production c. 1974
Given by the maker
C. 148&A, 149&A, 150&A, 151, 152, 153-1979
Tea pot and cover, coffee pot and cover, cup and saucer, plate, cream jug, sugar bowl
Mark three towers and B&G within a circle of the words COPENHAGEN PORCELAIN MADE IN DENMARK printed in green; 47 painted in underglaze blue; on tea pot 656, on coffee pot 301, on cup and saucer 305, on plate 325, on cream jug 303, on sugar bowl 302 printed in green
D. plate 24. 7
Shapes 656 (tea pot), 301 (coffee pot), 305 (cup and saucer), 325 (plate), 303 (cream jug), 302 (sugar bowl)

83 Tea pot and cover and tea cup 'Tea for One'

Porcelain with printed decoration of brown lines
Made by Bing & Grøndahl; designed by Martin Hunt; in production c. 1974
Given by the maker
C. 154&A, 155-1979
Mark three towers and B&G within a circle of the words COPENHAGEN PORCELAIN MADE IN DENMARK printed in green; on tea pot 653 printed in green
W. tea pot 20
Shape 653 (tea pot)

The cup is designed to stack upside-down on top of the teapot.

84 Set of three nesting bowls

Porcelain with printed decoration of a brown line
Made by Bing & Grøndahl; designed by Martin Hunt; in production c. 1974
Given by the maker
C. 156&A&B-1979
Mark three towers and B&G within a circle of the words COPENHAGEN PORCELAIN MADE IN DENMARK printed in green
W. largest 14. 6

85 Part of a tableware range 'Konkylie' (Triton) ▽

Porcelain, in various shapes freely based on shell, water and ripple forms, some pieces painted in pink
Made by Royal Copenhagen c. 1984-5; designed by Arje Griegst 1977
Given by the maker
C. 114&A, 115, 116, 117&A, 118&A-1986
Tureen and cover (pink), sauce boat (pink), dish (pink), tea pot and cover (white), cup and saucer (white)
Mark ROYAL COPENHAGEN DENMARK around a crown and A.G. printed in green, three wavy lines and LD printed in blue; on tureen and cover 14180, on sauce boat 14192, on tea pot 14165, on cup and saucer 14194 printed in green
L. tea pot 33
Shapes 14180, 14192, 14193, 14165, 14194

The model from which this service was developed was made by Arje Griegst in 1975-6. The service was produced first with a pink glaze from 1977. The plain white service was introduced in 1984-5. By 1987 only part of the white service was still in production. This tea pot was made especially to order for the Museum.

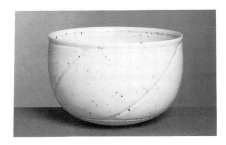

86 Bowl △
Stoneware with resist decoration and speckled grey glaze
Made by Royal Copenhagen; designed by Alev Siesbye
1977
Given by the maker
C. 130-1986
Mark three wavy lines and 22. 655, ALEV/500 printed
in blue; 229 painted in blue
D. 12. 4

Number 229 of a limited edition of 500.

87 Bowl △
Porcelain with a silkscreen decoration of brown spots and
darkening blue glaze on the inside
Made by Royal Copenhagen; designed by Anne Marie
Trolle 1977
Given by the maker
C. 131-1986
Mark ROYAL COPENHAGEN GALLERY 5385, three wavy
lines, AT in monogram and /500 printed in blue; 166
painted in blue
L. 34. 6
Model no. 5385

Number 166 of an edition of 500.

88 Bowl △
Stoneware with resist and blue glaze decoration
Made by Alev Siesbye, Copenhagen, 1979
C. 107-1979
Mark ALEV 79 incised
D. 15. 7

Purchased from an untitled exhibition held at Kettle's Yard,
Cambridge, June, 1979 (no. 256).

89 Table and decorative ware, 'Facet' series ○
Porcelain, oval shapes, relief moulded and with
underglaze painted decoration
Made by Bing & Grøndahl; designed by Bodil Manz 1982
Given by the maker
C. 142&A-R-1987
Vase, dish, cream jug and lid, vase, salt box and lid, vase,
vase or box and lid, sugar box and lid, four octagonal
bowls, oval tureen and lid, tray
Mark three towers and B&G COPENHAGEN PORCELAIN
BING & GRØNDAHL DENMARK DESIGN printed in black,
BODIL MANZ printed in underglaze blue
D. dish 31

The studies for this delicately textured relief decoration
were collages of papers and card cut-outs, layered, some
corrugated, folded and stamped, which were then
impressed into plaster to form a mould. Like many Danish
potters Bodil Manz's concerns are with finely balanced
geometric relationships of shapes, colour and texture.

90 Tea caddy and lid and box or vase, 'Floreana'
series △
Porcelain with moulded and painted decoration in
underglaze blue and green
Made by Royal Copenhagen; designed by Anne Marie
Trolle 1982
Given by the maker
C. 119&A, 120-1986
Mark ROYAL COPENHAGEN DENMARK around a crown,
three wavy lines, FLOREANA and AT in monogram printed
in blue; three wavy lines and decorator's symbol painted
in blue in the decoration; on caddy 258/5579, on box
259/5576 printed in blue; inside caddy lid 258/5579,
three wavy lines and decorator's symbol painted in blue
H. jar 17. 2
Shapes 258/5579, 261/5578

Part of a series of repeated shapes produced in a choice of
patterns based on leaves and spotted fruits. Trolle recorded
that this was inspired by a study trip to the Galapagos
Islands, the decoration - and to some extent the shapes -
reflect Danish artists' traditional and instinctive response
to oriental influences.

91 Part of a tableware range 'Picnic' C
Porcelain with printed decoration of motifs in various
colours
Made by Royal Copenhagen; shape designed by Grethe
Meyer c. 1982-3; decoration designed by Ole Kortzau
c. 1982-3
Given by the maker
C. 121, 122, 123, 124-1986
Plate (bicycles), wallplate (a sunshade on a grassy
seashore), box (waves), mug (spinnakers at sea)
Mark OK printed in the decoration; ROYAL COPENHAGEN
DENMARK around a crown printed in green, three wavy
lines and GM in monogram printed in blue
D. plate 19. 2
Shapes 107/6298, 108/6273, 103/6275, 104/6228

The tableware comes in a choice of six different patterns.
These were among the first brightly coloured, highly graphic
decorations that, in the early 1980s, became internation-
ally popular and applied to every possible type of surface
from mugs to postcards. The range also includes a packag-
ing box for each item decorated with a printed pattern in
colours of an apple tree, ladder and basket designed by Ole
Kortzau.

92 Vase
Stoneware with celadon glaze
Made by Edith Sonne Bruun at Bing & Grøndahl 1984
Given by the maker
C. 128-1987
Mark SONNE 1665 incised; three towers, and B&G
impressed; 186-84 painted in black
D. 11. 4

Edith Sonne Bruun, senior artist-in-residence at Bing &
Grøndahl, has now transferred to studios at Royal
Copenhagen following the recent merger. She works single-
mindedly, exploring glazes colour by colour, achieving a
subtle intensity. The continuing consistency of her latest
work, under changed circumstances, demonstrates an
inner strength. Here, she threw the initial shape on a wheel
and then formed this into the final lobed vase. See also
cat. no. 97.

93 Deep bowl 🄲

*Stoneware, hand-built, decorated with a geometric
pattern in sprayed coloured slips and salt-glazed
Made by Bente Hansen, Copenhagen, 1985
C. 165-1987
Mark BH in monogram and 85 painted in black
W. 47. 5*

Bente Hansen combines a typically Danish preoccupation
with geometric patterning and a distinctively robust
technique. The results are strong, assertive pots with unex-
pectedly sensitive and sensual surfaces.

94 Dish or plaque

*Porcelain with moulded decoration and blue, green and
purplish glazes
Original shape made by and moulded cast decorated by
Jacqui Poncelet at Bing & Grøndahl 1985
Given by the maker
C. 125-1987
Mark on side: three towers and B&G printed in green;
on reverse: three towers, B&G DENMARK UNIK 1985 and
JP in monogram printed in black
L. 31*

Bing & Grøndahl have maintained a prestigious reputation
for inviting and attracting visiting artists. Jacqui Poncelet
is one of a group of important British designer/artists to be
associated with the factory (others are Martin Hunt and
Elizabeth Fritsch). With these plaques, she has taken
advantage of the technical opportunities afforded by an
industrial manufacturer, the fine white porcelain and the
Bing & Grøndahl range of glazes. Jacqui Poncelet's own
studio work is represented in this Museum's collections and
she has contributed to two important exhibitions, both
arranged by the Museum's Department of Circulation,
'International Ceramics', 1972, and a travelling exhibition,
'Six Studio Potters', in 1976, as well as to many other mixed
exhibitions in the Museum.

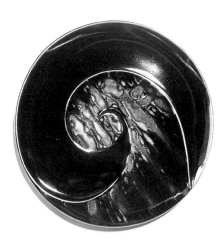

95 Dish or plaque △

*Porcelain, round, with moulded decoration and black,
brown and green/yellow glazes
Original shape made by and moulded cast decorated by
Jacqui Poncelet at Bing & Grøndahl 1985
Given by the maker
C. 126-1987
Mark three towers and B&G COPENHAGEN PORCELAIN
MADE IN DENMARK printed in green; three towers, B&G
DENMARK UNIK 1985 and JP in monogram printed in
black
D. 35. 1*

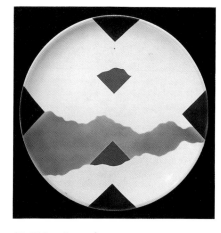

96 Dish or plaque △

*Porcelain with printed decoration in red, blue and greys
Made by Bing & Grøndahl; designed and decorated by
Hans Christian Rasmussen 1985
Given by the maker
C. 136-1987
Mark three towers and B&G COPENHAGEN PORCELAIN
MADE IN DENMARK printed in green; HCR in monogram
41/85 painted in black
D. 42*

Developing from such 'unique' pieces, Hans Christian Ras-
mussen has also designed equally delicately ordered and
precise decoration for tableware in series production such
as the 'Orchid' tableware pattern.

97 Dish ▽

*Stoneware with mottled blue glaze
Made by Edith Sonne Bruun at Bing & Grøndahl 1985
Given by the maker
C. 127-1987
Mark SONNE 2075 (indistinct) incised; three towers,
B&G impressed; 93-85 painted in black
L. 31. 5*

Edith Sonne Bruun is one of the few Danish potters still
working in the classic Saxbo tradition of strong yet elegant
shapes combined with finely textured glazes and slips,
many of them richly coloured. Each piece is conceived indi-
vidually and each demands special and concentrated at-
tention. All Sonne Bruun's work is carefully considered and
imbued with her own highly personal understanding of the
materials. As cat. no. 92, an initial circular shape was
thrown and the oval then formed. In the mark, '2075' repre-
sents the clay number and '93-85' represents the number
of the piece fired in 1985.

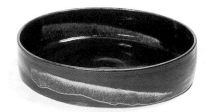

98 Vase

*Stoneware, flattened globular shape with speckled
semi-matt purplish glaze
Made by Edith Sonne Bruun at Bing & Grøndahl 1985
Given by the maker
C. 129-1987
Mark SONNE 1665 incised; three towers and B&G
impressed; 38-85 painted in black
D. 11. 6*

See cat. no. 97.

99 Box and cover ○

*Stoneware with painted geometric decoration
Made by Gertrud Vasegaard, Copenhagen, 1985
C. 40&A-1987
Mark GV in monogram and 1985 incised
H. 22*

The apparently effortless synthesis of glaze, colour and
body and the luxuriant depths achieved are all the result
of extremely exacting standards which lead Gertrud
Vasegaard to exhibit only rarely and to permit only a very
carefully selected proportion of her output to leave her
workshop.

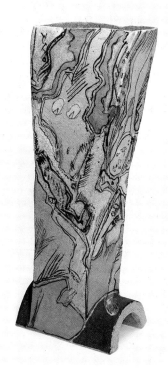

100 Vase or form △

*Brown stoneware with inlaid, incised and glazed
decoration in pink, green and grey
Made by Sten Lykke Madsen at Bing & Grøndahl 1986
Given by the maker
C. 131-1987
Mark STEN B&G 1986 incised; 4. 1986 painted in black
H. 56. 5*

Sten Lykke Madsen's idiosyncratic work pursues an inde-
pendent path, with recognisable references to a more
primitive world of strange beasts and a disturbing humour
not always as innocently whimsical as it appears. His com-
plicated and convoluted method of construction adds to the
ever-present sense of anarchy.

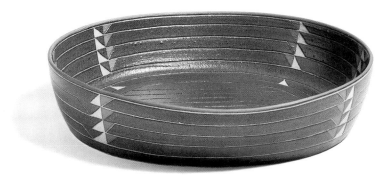

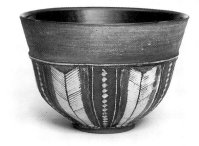

101 Dish △

Buff stoneware with coloured slip and carved decoration
Made by Malene Müllertz, Copenhagen, 1986
C. 37-1987
Mark MALENE 86 incised
L. 43

Carefully ordered yet instinctive geometry pervades much of Danish studio ceramics. Malene Müllertz has developed an individual technique, of highly disciplined and controlled carving unusual in ceramics, with a closely considered and limited colour range achieving an almost metallic appearance. In the past she has used gold finishes to effect.

102 Vase ●

Stoneware, globular body, with pitted pink, purple and brown glaze
Made by Edith Sonne Bruun at Bing & Grøndahl 1986
Given by the maker
C. 130-1987
Mark SONNE 207 (or 3?) 5V incised; three towers and B&G impressed; 55-86 painted in black
D. 9. 6

See cat. no. 97.

103 Bowl △

Earthenware with slip decoration, carved and incised and partly glazed
Made by Lisbeth Munch-Petersen, Gudhjem, 1987-8
C. 163-1988
Mark LMP in monogram incised
D. 22

This bowl was included in the exhibition 'Nutidig Dansk Lertøj', Haderslev Museum, Haderslev Kunstforeningen, 1988. Lisbeth Munch-Petersen digs her own local clay and specialises in this kind of carefully ordered and constructed pot, frequently with slip and carved decoration in chequered or diapered patterning.

GLASS

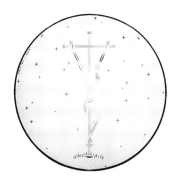

104 Plate △

Clear colourless glass with engraved decoration of the Crucifixion
Made by Holmegaard; designed by Jacob Bang c. 1931
Circ. 182-1932
Unmarked
D. 19. 5

105 Vase ▷

Clear colourless glass with deep cut unpolished decoration
Made by Holmegaard; designed by Jacob Bang c. 1932
Circ. 181-1932
Unmarked
H. 21
Model no. 4459/210/64

On his appointment to Holmegaard in 1926 Jacob Bang introduced, firstly, freely blown liquid shapes in light colours. By 1930 he had added a vigorous modernist style to his repertoire, as well as more abstract decoration to free-blown forms. Holmegaard was associated with Royal Copenhagen from 1923 for retailing purposes and this vase and the plate, cat. no. 104, were bought together with two porcelain figures by Arno Malinowski as examples of the high quality and style of Danish glass and ceramics of the period. This vase of 1932 heralds Bang's move into the more dynamic decoration of the mid-1930s.

106 Vase 'Naebvase' (Beak-vase) ▷

Clear colourless glass
Made by Holmegaard; designed by Per Lütken 1951
Given by the maker
Circ. 45-1952
Mark HOLMEGAARD PL in monogram 1951 incised
H. 18

Per Lütken has been Holmegaard's senior designer for many years. He specialises in very freely flowing shapes in his art wares, and has been able to transfer this style successfully into his designs for serial production. There are a number of different versions of this 'Naebvase' form. This example was included in and acquired following the exhibition 'Scandinavia at Table' arranged by the Council of Industrial Design and held at the Museum in 1951.

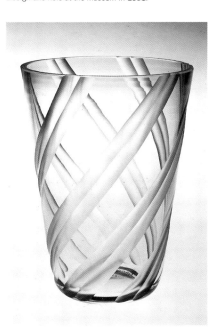

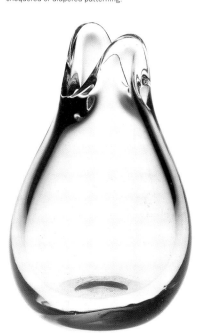

107 Bowl 'Provence' ○

Clear blue tinted glass
Made by Holmegaard 1986; designed by Per Lütken c. 1956
C. 157-1987
Given by the maker
Unmarked
D. 32. 3
Model no. 351. 29. 23

This shape derives from the 'Arne' range of 1955 which, made in many colours, was in production until 1965. The series was introduced again in 1985 in clear glass and under the name 'Provence'.

108 Jug 'Martini' ▷
Clear grey glass, mould-blown
Made by Holmegaard; designed by Per Lütken 1957;
in production from 1958-c.1970
C. 113-1988
Unmarked
H. 24. 5

109 Dish ▽
Clear colourless glass, with threads of orange and purple
and central purple area
Made by Holmegaard; designed by Per Lütken 1962
Circ. 197-1963
Mark HOLMEGAARD PL in monogram and 1962 3008
incised
D. 41. 5

One of Lütken's strengths has been in his combinations of
coloured and clear colourless glass. He also used this
particular colour combination thinly trailed, as here, on
cylindrical vases.

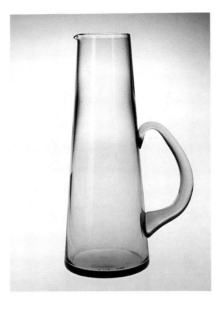

110 Form **C**
Semi-opaque white glass, free-blown into an egg shape,
with streaks of brown, red and blue
Made by Holmegaard; designed by Per Lütken 1970
Circ. 113-1971
Unmarked
L. 30

This form was selected by Lütken for the Museum from an
exhibition at Danasco Ltd, London, 1971.

111 Vase 'Lava-glass' △
Clear colourless and brown/grey streaked glass
Made by Holmegaard; designed by Per Lütken c. 1970
C. 162-1987
Given by the maker
Mark HOLMEGAARD and PL in monogram incised
H. 19. 6

'Lava-glass' was first introduced in 1969. Its best use was
in shapes made in wet clay moulds which picked up and
retained impurities, and where the mould itself could be
re-fashioned in the course of production.

112 Bowl △
Clear purple tinted glass with cut decoration
Made by Holmegaard; designed by Kylle Svanlund
c. 1970-5
C. 160-1987
Given by the maker
Mark HOLMEGAARD 1973 KS 7606 incised
D. 25

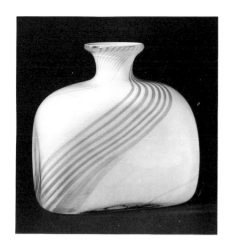

113 Vase △
Opaque white glass with blue. yellow and tan stripes
Made by Holmegaard; designed by Kylle Svanlund
c. 1970-5
C. 161-1987
Given by the maker
Mark HOLMEGAARD KS incised
W. 14. 6

115 Centrepiece 'Vintergaek' (Snowdrop) ▷
Clear colourless glass with opaque white and green
streaks
Made by Holmegaard 1986; designed by Per Lütken
1978-82
C. 156-1987
Given by the maker
Unmarked
H. 27. 8
Model no. 341. 47. 60

The 'Vintergaek' series in green streaked and opaline glass
was first introduced in 1978 and has been added to at inter-
vals since then. This centrepiece, with a plain opaline foot,
derives from a form in the first series.

116 Vase, 'Atlantis' series ▽
Opaque white glass with blue and grey streaks
Made by Holmegaard; designed by Michael Bang 1981
C. 158-1987
Given by the maker
Unmarked
D. 22
Model no. 341. 08. 06

The 'Atlantis' series comprises many different vase and
candlestick forms.

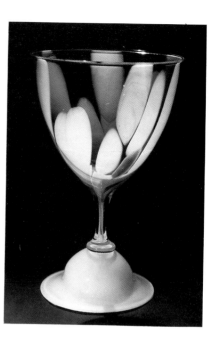

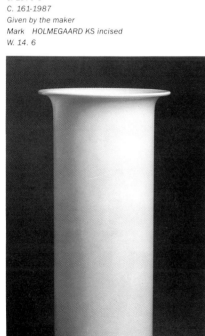

114 Vase △
Yellow glass encasing white glass, mould-blown
Made by Holmegaard; designed by Michael Bang 1971
C. 112-1988
Mark MD 7278 DG incised
H. 17

This vase is one of a series of cylindrical shapes none of
which was marked by the factory. On this example the mark
was incised by the distributor or agent, thought to be a
company named 'MorDan'.

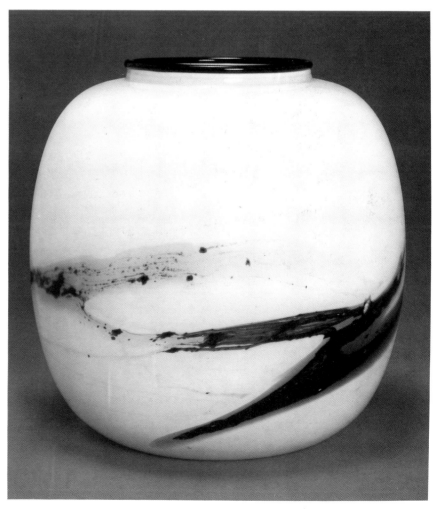

117 Plate △
Opalescent glass, free-blown, with coloured glass canes
Made by Darryle Hinz at Bornholm 1981
C. 93-1982
Mark D HINZ 1981 HO WP incised
D. 42. 4

Darryle Hinz was one of the founder members of the glass
workshop established on the island of Bornholm.

**118 Carafe with stopper and red wine glass
 'Xanadu'** ▷
Clear colourless glass
Made by Holmegaard; designed by Arje Griegst 1983
C. 159&A&B-1987
Given by the maker
Unmarked
H. carafe with stopper 40. 2
Shapes 331 35 36, 315 05 00

Designed to accompany 'Konkylie' tableware by Arje Griegst
for Royal Copenhagen (cat. no. 85), this glassware is
named from the poem 'Kubla Khan' of 1816 by Samuel
Coleridge Taylor. Verses from the poem are invoked as an
accompanying text in the publicity for the glass: 'In Xanadu
did Kubla Khan/ A stately pleasure-dome decree/... For he
on honey dew hath fed,/ And drunk the milk of Paradise'.

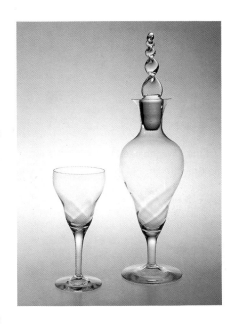

119 Panel 'Frej ved Bifrost' (Frey at Bifrost) △
Painted enamel on copper
Designed and made by Finn Brandstrup, Aulum, 1980
C. 106-1981
Unmarked
L. 185

The design, from Norse mythology, represents Frey the fer-
tility goddess at the Bifrost, or Rainbow Bridge, to Åsgard.

120 Coffee ware ▷
Black ABS plastic
Made by Stelton; designed by Erik Magnussen
from c. 1976
Given by the maker
C. 193&A-H-1987
*Vacuum jug and stopper (litre), vacuum jug (½ litre),
creamer and lid, sugar pot and lid, tray*
*Mark STELTON DESIGN ERIK MAGNUSSEN MADE IN
DENMARK moulded; on inside of lid: PATENT PENDING
moulded*
H. vacuum jug (litre) 30. 2
Shapes 930, 935, 1030, 1130, 730

ABS plastic is a combination of acrylonitrile, butadiene and
styrene. The litre jug was awarded the ID-Prize 1977 by the
Danish Society of Industrial Design. The stopper, which in-
corporates a unique rocker design, opens automatically
when the jug is tilted forward and closes when the jug is
upright. Other parts of the set have been designed since
1977; the ½-litre jug was introduced in 1986. The set is
also made in red, white and in metallised plastic.

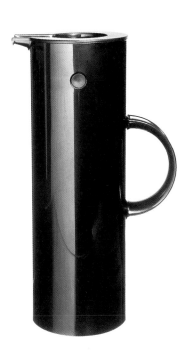

FINLAND

Of all the Scandinavian countries Finland has had the most chequered history and evidence of this still survives in a dual language system and a population which continues to be very conscious of its various roots. In 1809 after seven hundred years of Swedish rule Finland and the Ahvenanmaa (Åland) Islands were surrendered by Sweden to Russia and became the Grand Duchy of Finland. From then until the middle of the century, the constitution as it was under Sweden continued with Finnish bureaucrats headed by a Russian governor-general. Parts of Finland ceded to Russia by Sweden in 1721 and 1743 were restored to Finland. The political centre was settled in Helsinki which was chosen as the capital.

The period was marked by both reforms and repression. Finland was largely agrarian and was kept that way long after industrialisation had been established in Sweden and Denmark. The rural population was poorly educated and the spread of liberal, national and cultural ideas was effectively prevented since Finnish language publications were restricted to a selected and limited number of approved religious or practical economic subjects. Despite the transfer to Russia, Swedish-speaking Finns of perhaps several generations' standing, preserved their local domination of cultural and economic activities, gaining from the newly available and vast Russian market. Swedish was the only language allowed within the Finnish administration and in secondary and university education. Coupled with the ban on Finnish literature, the division between the greater population and those that ruled it was complete. Such class distinction was bitterly resented and provoked a growing rebellion. By the end of the century the search for a national identity which engulfed most of Scandinavia was particularly poignant in Finland where even such basic communications as street name signs were shown in Finnish, Swedish and Russian. Even today town names are doubled, the first name in Finnish, the second in Swedish, and also factories' names, where the owners were originally Swedish-speaking Finns. For each of the different sections of the Finnish population the last hundred years have been a confusing and unsettling period which is still not fully resolved and which still leaves a legacy of resentment and defensiveness.

While a worsening of the relations between Finland and Russia during the 1890s had encouraged the already emerging national movement, Russia's defeat by Japan in the Russo-Japanese war of 1904-5 gave Finland a brief respite from 'Russification'. In 1906, the parliamentary system was reformed and provided one chamber government and equal franchise for men and women. With this reform Finland moved from arguably the most backward system of government in Scandinavia to the most enlightened. The new freedom gave an articulate voice to social and economic problems and a national liberation movement took shape. Moves to bring Finland close to Russia precipitated action by the Finns who took advantage of the European confrontation to ask for assistance from the belligerent Germany. This aggressive manoeuvre suited neither side in the embattled Russian conflict, and in 1917 the by then precariously victorious Bolsheviks announced recognition of independent Finland. With independence came internal political strife which quickly erupted into civil war between the left-wing radicals and the right-wing coalition government set up in 1917. In April 1918, General Carl Gustaf Mannerheim led the government

troops in the decisive battle at Tampere. A new constitution was drawn up by Mannerheim and confirmed in 1919. From this period onwards Finnish political preoccupations were chiefly to do with: the realignment of farming land ownership in what was still mainly an agrarian society; a bitterly contested battle between Finnish and Swedish language supporters; and the delicate balance of Finland's position between Sweden and Russia with the related tensions over the Ahvenanmaa Islands and the Eastern Karelian territories, both of which were claimed by Finland's sensitive and more powerful neighbours.

Nationalistic movements in the arts led to efforts to preserve endangered Finnish literature, folklore and traditions. As early as 1849 Elias Lönnrot published 'the Kalevala', a collection of popular narrative songs assembled into an epic poem. During the later part of the century further steps were achieved. The Slöjdskolan (Handicraft School) opened in 1871 and the Suomen Taideteollisuusyhdistys (Finnish Society of Crafts and Design) was founded in 1875 with Suomen Käsityön Ystävät (Friends of Finnish Handicrafts) following in 1879. In the 1890s the nationalist cause was taken up by intellectual society in music, painting and literature while architects began using local stone in a consciously Finnish style derived from traditonal motifs and rural buildings.

21 Cover of a catalogue, Iris AB
Reprinted from the original of 1901
Issued by Porvoo Museum, 1979

In the applied arts the movement was crystallised by the Iris workshops. These were opened in 1897 by the Swedish-born Louis Sparre and the Swedish-Finn painter, Axel Gallén. Gallén converted his name to the Finnish Akseli Gallen-Kallela in 1905 to demonstrate his commitment to Finnish nationalism. With the Anglo-Belgian Alfred William Finch, they founded the company with the stated aim of refining public taste and establishing an essentially Finnish design school of quality domestic objects (Fig.21). Although short-lived (1897-1902), the ambitious venture scored some impressive successes. Important commissions in Finland and Russia were secured and completed; and through Finch's contacts they sold the ceramics in Samuel (Siegfried) Bing's 'L'Art Nouveau' and Julius Meier Graefe's 'La Maison Moderne', both influential and avant-garde shops in Paris. At the international exhibition in Paris, 1900, the Iris room furnishings won Gallen-Kallela a gold medal. However, like many such missionary ventures, the Iris project had little impact on the general population. Finch's elegant and sophisticated designs cleverly combined with simple, traditional domestic forms, appealed to the knowledgeable élite for a short while but scarcely at all to working Finns.

22 Tray
Earthenware; made by Arabia, designed by Greta-Lisa Jäderholm-Snellman, 1936
Cat. no. 131

The leading industrial pottery in Finland then, as now, was Arabia. The factory had been founded by the Swedish company Rörstrand in Finland to take advantage of the vast, potentially lucrative and highly attractive Russian market. Production started in 1874 and for 25 years Arabia made table and decorative wares in a generally standard European style, with transfer prints supplied by the parent company, Rörstrand. The Swede Thure Öberg was taken on as art director in 1896 and under his encouragement Finnish subjects and landscapes were introduced as hand-painted decoration. Four years later Arabia was awarded a gold medal in Paris. After the turn of the century the factory built up a range of simple, pleasing designs in a fresh, unsophisticated manner which, nevertheless, reflect a familiarity with the general international design vocabulary of the time. Of more interest in the context of Finnish cultural identity and the success of the country's contribution to the international exhibition, Paris, 1900, is the 'Fennia' series of vases produced by Arabia from about 1900. Commissioned by an American importer wanting Finnish patterns by a 'famous

Finnish artist', this series was presumably the direct result of the 1900 exhibition success. No clues have emerged as to the designer or designers of this stylish range of some 30 patterns although many of them demonstrate a very clear familiarity with the work of Herman Gesellius, Armas Lindgren and Eliel Saarinen, the architects of the Finnish Pavilion at the 1900 exhibition.

Separated from Rörstrand by 1916, from the late 1920s Arabia's contribution to the contemporary movement lay in the designs of Greta-Lisa Jäderholm-Snellman. Her work is distinguished by a stylish and elegant classicism (with more than a hint of exoticism) combined with inexpensive production (Fig.22). However, the establishment of the Arabia art studio under Kurt Ekholm was of greater long-term importance and more fundamentally progressive. On his arrival in 1932 at the youthful age of 25 after a training in Sweden, Ekholm was energetic and positive. In the first year he set up an art department enabling artists to work within the factory independently, using all the facilities that a major industrial company could offer. Within a few years, the factory, with the art department, had in effect become the Finnish centre for both mass production and studio ceramics. Toini Muona, who joined Arabia in 1931, was awarded a gold medal at the first Milan Triennale in 1933, thus confirming Arabia's own role as a sponsor of ceramic creativity and her own importance as one of the factory's earliest 'star' artists.

In the serial production, Ekholm's concerns accorded with Jäderholm-Snellman's. Both worked to produce attractive yet inexpensive daily domestic ware. But where her solution was to spice up such practical considerations with curvy shapes and lightly decorative patterns, Ekholm's personal inclination was towards a more severe functionalism. Most typical is his 'Sinivalko' (cat. no. 132) pattern which is the Finnish equivalent of the Swedish Gustavsberg's 'Praktika' range (cat.no. 349). Both were inexpensive, functional, stackable and part of the Scandinavian and international movement linking design with social concerns.

The course taken by glass design was rather different. In 1905 a competition had been organised by Nuutajärvi glassworks specifically to arouse the interest of artists in the possibilities of glass design. This enterprising gesture by the factory was not followed up. In 1920 Riihimäki encouraged artists to produce 'forms for simple functional glass which were in harmony with the times' and in 1928 the same glassworks ran a competition resulting in a series of engraved pieces designed by Henry Ericsson for the World Fair in Barcelona, 1929. Technically highly skilful and elegantly conceived, they were, nevertheless, very much part of the school of Edward Hald and Simon Gate at Orrefors in Sweden.

However, in 1932 a competition was organised by the Karhula glassworks which took Finland into a leading position in international modernism. The entry by Aino Aalto for the utility pressed glass section was of great significance (cat. no. 188). Her entry of a pitcher, tumblers and plates in ribbed forms was awarded second prize, and four years later at the Milan Triennale 1936 it won a gold medal. The Aaltos, husband and wife, are of seminal importance to Finnish and international design of the late 1920s and 1930s. In 1933, with the help of the English critic P. Morton Shand, the Aaltos arranged a highly successful exhibition of bent plywood experiments and glass designs in London. As a result of this success, Shand formed the company Finmar to market the Aalto's furniture in England. Two

years later, in 1935 the Aaltos together with two friends founded Artek, the retailing company to produce and market their furniture and to promote Finnish modern design in Finland and abroad. Among the first stores in Britain to sell Aalto furniture were Bowman's of Camden Town, Heal's of Tottenham Court Road and Dunn's of Bromley. Between 1929 and 1932 Aalto had evolved and perfected his fluid shapes for plywood furniture. In 1933, he entered a competition organised by the Riihimäki factory to which he submitted a functional and minimalist set of stacking vessels. In 1936, in the Karhula-littala competition to find glass designs for the international exhibition, Paris, 1937, he won first prize with a set of designs of which probably the most famous is the 'Savoy' vase (cat. no. 190). This was part of the furnishings for the Savoy Restaurant which he had designed in 1936. At this time his vocabulary of flowing organic liquid forms translated into glass perhaps even more naturally than they had into wood. Such was their success that several have remained in almost continuous production ever since.

Meanwhile other designers were emerging as individual talents specialising in glass. Like ceramics, the art glass production came entirely from within a factory context and was concentrated between the few important glassworks. From these a few significant names emerged: Yrjö Rosola at Karhula glassworks, Arttu Brummer at Riihimäki, who was important as a teacher as well as for his own free-blown glass, and Gunnel Nyman who began as a furniture designer and trained under Arttu Brummer. It was through Brummer that she was introduced to the glassworks at Riihimäki. She worked there as well as at littala, Nuutajärvi and Karhula, until her early death in 1948. During the 1930s she had produced some fine and individual work, but it was from 1940 onwards that her most distinctive concepts emerged, particularly in her last years when she showed a fully mature style which in many ways foreshadowed the earliest organic forms of the 1950s.

23 'Satula'
Glass; made by littala, designed by Timo Sarpaneva, 1969
Cat. no. 224

The approaching hostilities in 1938 followed by the defeat of Poland in 1939 again unsettled Finland's hard-won and precariously sustained political and economic balance. Russia, anxious about the vulnerability of its own borders, demanded Finnish land to support its Leningrad defences. The Finnish refusal led to a Russian attack and, after the bitter 'Winter War', a victory for Russia which was followed by the Treaty of Moscow under which Finland surrendered parts of Eastern Karelia and leased out more.

Finland, a neutral, like Sweden, took no side in the European war and allowed transit of German troops. As a result the country was drawn into the conflict when Germany attacked Russia. Since Finland had therefore been implicated in Germany's belligerence, with scores of its own against Russia to repay, at the end of the war it was charged with costly war reparations to the Soviet Union. The Treaty of Moscow was re-confirmed and additional land-leasing imposed. The resulting disruption made refugees of some Karelian families and split others. The enormous bill was paid and Finland, with supreme diplomacy, pursued an actively friendly policy with its neighbour. Once the debts were settled, Russia proved to be Finland's most lucrative single market.

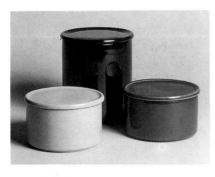

24 Jars, 'IS' series
Earthenware; made by Arabia, designed by Kaj Franck, c. 1948
Cat. no. 140

Amazingly, cultural contacts and activities were maintained during the war years. Against all the odds, Finnish designers set to and used whatever materials were to hand. With imagination and determination, fabrics, even clothes and shoes, were woven from paper and birch bark. Even more surprisingly, exhibitions of Finnish design were held in Copenhagen, where the Danes were especially supportive of Finland, and also in

Stockholm in 1940 and 1941. These were arranged by Ornamo (Esperanto for 'ornament' and the abbreviation for Suomen Koristetaiteilijain Liitto Ornamo — Society of Decorative Artists) originally founded in 1911. The Society continued throughout the war years to arrange exhibitions and displays.

Finland burst upon the international design scene in the early 1950s with spectacular success. This may have been the result of a national determination, born during survival of the most severe war-time privations, plus a naturally outward-looking national personality. Finland, geographically in the path of influences from Sweden and eastern Europe, could not afford to be introspective or submissive. A full-scale Milan Triennale was held in 1951. The financial backing for the Finnish display was achieved from various sources by Professor Olof Gummerus, then head of the Finnish Society of Crafts and Design, and of Public Relations at Arabia. The fortunate timing of an exhibition of Finnish design at the Zurich Kunstgewer-bemuseum in 1951 meant that the contents of the exhibition could be moved directly to Milan to form the nucleus of the award-winning display. In all, Finnish design won six grand prix awards as well as four diplômes d'honneur, seven gold medals and eight silver medals. It was after this that the Victoria and Albert Museum made contact in the person of Hugh Wakefield and established a productive friendship and correspondence with Gummerus. As a result of an extensive trip to Finland by Wakefield in 1953 and of a carefully selected exhibition 'Modern Art in Finland', travelling under the auspices of the Arts Council, many of the acquisitions were made that are included in this catalogue.

Tapio Wirkkala arrived at Iittala in 1946 and Timo Sarpaneva in 1950. During the 1950s the two Iittala artists between them created some of the most supremely elegant and sophisti-cated designs. They, and Sarpaneva in particular, made the major leap from useful object to pure art object. No longer were works intended for use as a vase or bowl: in some cases such as Sarpaneva's 'Lansetti', 'Nukkuva Lintu' (cat. nos 202, 210) and the later 'Satula' (Fig. 23) or Wirkkala's 'Paaderin Jää' (cat. no. 214), this would have been impossible despite the formality of an interior surface. From the beginning they were displayed as art objects, complete in their own right.

The move into the design of art objects or sculpture produced some very serious discussion and, to some extent, it was seen to be counterbalanced by the rise of Kaj Franck as a designer of practical, functional, inexpensive ware who positively shunned the 'star' treatment. His reputation now is firmly rooted in an image of austere disciplined functionalism, based on a highly principled ideology. In the late 1940s Finland was faced with shortages both in material and technical possibilities and a restricted market. Only inexpensive production was viable and Franck narrowed his attention down to a few, carefully analysed concerns, which combined utility, simplicity and a positive under-standing of the manufacturing process. The first result was the 'Kilta' service for Arabia (cat. no. 139), and he followed this with other designs equally based on such demanding principles (Fig. 24).

However, this view does not recognise the qualities of warmth with visual and tactile pleasure which make all Franck's designs eminently approachable and usable. Nor does it fully account for his multi-coloured goblets in which all three principles form an intimate part but which are richly decorative vessels — both utilitarian and ornamental. In addition, like

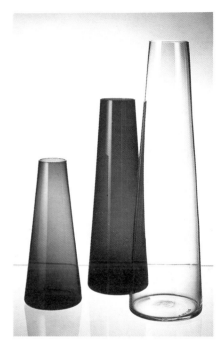

25 Group of vases
Glass; made by Nuutajärvi, designed by Saara Hopea, 1953
Cat. no. 203

26 Dish 'Kastehelmi' range
*Glass; made by Nuutajärvi, designed by Oiva Toikka,
1964
Cat. no. 218*

27 Vase
*Stoneware; made by Kylliki Salmenhaara at Arabia,
c. 1952
Cat. no. 145*

Sarpaneva and Wirkkala, Franck also created classically beautiful sculptural objects in Nuutajärvi's clear and coloured glass. Sarpaneva and Wirkkala, too, were versatile enough to design tableware, candlesticks and bottles for the most inexpensive of mass production.

At Nuutajärvi and Arabia Kaj Franck assembled a team of designers. Foremost among these were Kaarina Aho, Ulla Procopé and Saara Hopea. The first two worked solely at Arabia where Aho's light and humorous touch was counterbalanced at the beginning of the 1960s by Procopé's soundly proportioned, almost sculptural table and ovenwares. Saara Hopea, the most versatile of the three, designed for ceramics, glass and enamels as well as for silver, her original training and family profession. In the context of this catalogue her particular speciality was in glass in which she produced clean shapes for multiple production which were both functional and made use of Nuutajärvi's wide selection of coloured glass (Fig.25). For decorative art glass she took obvious pleasure in luxurious, liquid, flowing shapes in which she combined clear and coloured glass with trapped air to produce different visual effects. Her enamelled bowls, a technique learned after her marriage to the enamellist Oppi Untracht, are richly coloured, basically simple forms.

The work of artists such as Wirkkala and Sarpaneva, compared with that of Franck and Hopea, demonstrates an important point about the two glassworks for which they designed. During the 1950s Nuutajärvi differed radically from Iittala in the use of coloured glass. In Iittala art wares, a colour was occasionally introduced although usually with restraint. The finest designs were for clear colourless glass. In Nuutajärvi coloured glass was almost standard and used with relish by all the designers.

Oiva Toikka came to Nuutajärvi in 1963 and still works there today. A survivor of the war-time and post-war situations in Eastern Karelia, his family's home, he belongs to a world somewhere between folklore and the international art scene. His vision is pictorial, he sees line, outline and colour and, in his art glass, uses them in a fanciful constantly surprising way, fashioning whole forests of sprouting, burgeoning forms, energetically twisting and shaping them into absurdly appealing beings with skill and confidence. In company with the established artist-designers Toikka also has a serious commitment to good design for mass production, and his 'Kastehelmi' (Fig. 26) and 'Pioni' tablewares in moulded glass have been Nuutajärvi's most successful patterns.

At Arabia, throughout the decade, in utilitarian and particularly in art works, two important figures were Birger Kaipiainen and Kyllikki Salmenhaara. Kaipiainen epitomised the unexpectedly whimsical side of Finnish culture, the side that revels in pattern, rich effects and unashamed elaboration which he used in many forms. Kyllikki Salmenhaara was the studio potter in the Arabia team. Her influence is recognisable through succeeding generations to the present day, in the work of Francesca Lindh and Kati Tuominen. She used the rich red Arabia stoneware with sensitivity and produced intensely strong pots alive with surface texture (Fig.27).

Equally individual is the work of Rut Bryk. Like Kaipiainen and also Stig Lindberg in Sweden and Bjørn Wiinblad in Denmark, her starting point was in narrative, pictorial subjects with a folklore background. She joined Arabia in 1942 and her early work consisted of relief scenes and images – mothers, butterflies, plants – sometimes in tiny enclosed spaces and

with jewel-like coloured glazes. Gradually she concentrated more on the relief, reducing the pictorial element until her work evolved into an exploration of positive and negative forms, relief and recess, shadow and light (cat. no. 165).

Throughout the 1950s Finland collected the major proportion of awards at the prestigious Milan Triennales. In 1954 these went to Wirkkala again, to Timo Sarpaneva for his glass sculpture (cat. no. 202), to Kaj Franck and to Saara Hopea for her stacking tumblers (cat. no. 205). In 1957 an even larger number of the prizes was awarded to Finnish designers.

Like other Scandinavian countries, the late 1960s and the 1970s proved to be less internationally successful for Finland. The design world's focus shifted to Italy and the increasing expense of ceramic and glass production forced more aggressive competition with Germany, America and then Japan and Eastern Europe. Finland, so closely identified with the huge successes of the 1950s, has found the reversal difficult to come to terms with. For some individuals however, the adjustment has hardly been necessary and in their pre-eminence they have been accorded a 'star' status, a peculiarly Finnish elevation which far out-strips the recognition given to Danish, Swedish or Norwegian designer-artists by their countrymen. Both Tapio Wirkkala and Timo Sarpaneva were in demand internationally. Both designed for the increasingly successful Studio Line of Rosenthal, the German company. Wirkkala spent a productive period with the Venetian glass firm of Venini; Sarpaneva has recently been working at both Venini and Corning, USA. Both designers, with Kaj Franck, were adaptable enough to diversify their activities in Finland. All three worked for a number of different companies in various materials as well as designing exhibition display and installation, graphics of various types and posters. For Wirkkala a major project was the design of the Finnish Glass Museum at the Riihimäki glassworks which opened in 1981.

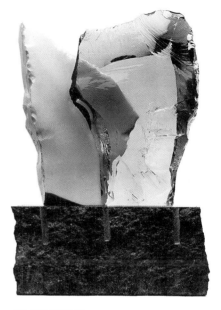

28 'Lancett-35, II'
Glass and granite; made by Timo Sarpaneva at Iittala, 1985
Photo: Harri Kosonen

Wirkkala's abiding image is of a rough-hewn character whose affinity with the wilds of northern Finland and the unforgiving Finnish winters gave him some kind of natural and unique instinct for creative design. Despite the by-now clichéd metaphors, there is no escaping the fondness for frost or ice-like surfaces and the all-pervading influence of wind, weather and natural surroundings, which are more pronounced in Finland than anywhere else and are possibly most closely identified with Wirkkala. Some aspects of his design style are in any case common to other Finnish designers. However, a wider view of his work reveals him to be a designer of great contrasts. His celebrated love of the isolated north and the Lappish culture, and the resulting preoccupation with ice-effects and the artefacts associated with survival in such extreme conditions, are balanced by an elegance and delicacy in conception as wide-ranging as the 'Kantarelli' (cat. no. 196) and his engraved pictorial decorations on window and table glass.

Timo Sarpaneva also uses these elemental metaphors with ease and intimacy. His passion for textures has led to a repertoire which includes a stone-like smoothness, a vigorous and crusty bark-effect achieved with burnt wood moulds (a speciality which he developed and perfected), a frosty ice-effect or else the purely glassy liquid properties of the material itself. His particular skill has been to use these different effects in a classically elegant manner while maintaining a highly sensitive contact with the natural form or texture of the original inspiration. Additionally, over the last six years he has explored the effects of chiselling in a totally sculptural manner (Fig. 28), of pouring the molten glass in huge swirls and of combining it with metals. This period of experiment has led him far from the cool

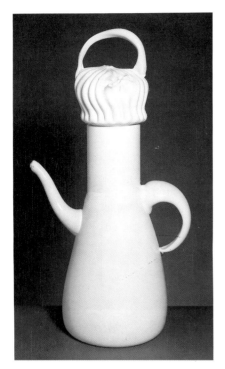

29 'Snow Castle'
Glass; made by Nuutajärvi, designed by Oiva Toikka, 1980
Cat. no. 236

30 Group of sculptures, assembled for the exhibition 'Oiva Toikka: Lasia', Finnish Glass Museum, 1988
Photo: Finnish Glass Museum

and considered designs with which he was formerly identified. The first signs of a freer and more interpretive approach are seen in his earlier, textural works such as the 'Finlandia' series of 1964 (cat. no. 217) which provide a conceptual link with this comparatively recent development.

Oiva Toikka, like Sarpaneva, is pushing forward personal boundaries. A lively cross-current of younger artists, in Finland and abroad, has forced both senior men to see the importance of using the glass in a more aggressive manner, in employing a more physical interaction with the material. While Sarpaneva has moved into an expressionist phase, Toikka, who exhibits both independently and with a younger generation of glassmakers, pursues an individual and anarchic route, constructing temporary assemblages of single forms which he re-designs for each new show (Figs 29, 30). At Nuutajärvi, apart from the ever-inventive Toikka and the more quietly productive, much respected, Kerttu Nurminen, new stars are Heikki Orvola and Markku Salo. Orvola has used Nuutjärvi's coloured and lustred glass to provide the factory with a wide range of decorative wares. He has also designed for Rörstrand in Sweden and for the fabric company Marimekko. Markku Salo has been hailed as one of the newest stars in Finnish glassmaking. His first one-man exhibition held at the Galleria Bronda in 1987 demonstrated his fully developed sense of form and colour and his use of highly personal techniques which are now an established trademark. He uses sand-blasting to produce a variety of carefully controlled surface patterns on coloured glass (cat. no. 262) and specialises in enclosing the glass in wire metal frames which sets up a physical tension as the liquid glass is contained within the restraining bars.

In Finland there ìs still frequent debate on the future direction of arts, crafts and design. Design is still seen in terms of a proper combination of utility and beauty, a goal eminently worth pursuing and one which Finland still achieves in many fields. In craft and art the debate is necessarily more complex. The creation by individuals of objects which may or may not combine utility, decorativeness or a political concept, has provided a testing ground for much of the intellectual expression of the last two decades. The younger generation of Finnish artists were as affected by the social and political concerns of the late 1960s, the 1970s and early 1980s as artists elsewhere in Scandinavia. For some this meant a direct involvement or statement. For others it meant the more indirect return to the search for a Finnish identity in a world of changing values and increasing universality. Such a climate has favoured the establishment of growing numbers of glass and ceramic artists in individual workshops or in colonies such as the mixed community of artists and craftspeople at Pot Viapori on the island of Suomenlinna outside Helsinki. A comparatively recent development is the exhibition of their work in commercial galleries which also show paintings and sculpture, and in museums. These venues, together with a network of supportive journals, publications and societies, provide a serious showcase for an increasingly successful generation of artists.

121 Two-handled bowl and mug ▽
*Earthenware, incised and with slip decoration in green,
blue and white*
Made by A. W. Finch at the Iris Workshop, Porvoo, c. 1900
Circ. 758, 759-1966
Mark AWF IRIS FINLAND and other indistinct marks
incised; LMM in monogram, impressed
D. bowl 34. 7

Finch probably met the designer and painter Henri van de
Velde about 1885 through their mutual membership of 'Les
Vingts'. Through him, Finch was introduced to a circle which
included Julius Meier-Graefe who founded 'La Maison Mod-
erne' in Paris in 1899. Finch sold Iris Workshops pottery
through Meier-Graefe's shop and also 'L'Art Nouveau', the
shop owned by Siegfried (Samuel) Bing. Both shops were
devoted to promulgating the new art and design styles. The
bowl and mug are both marked with La Maison Moderne's
monogram. Exhibited in 'Forty Years of Modern Design',
Bethnal Green Museum, 1966 (no catalogue).

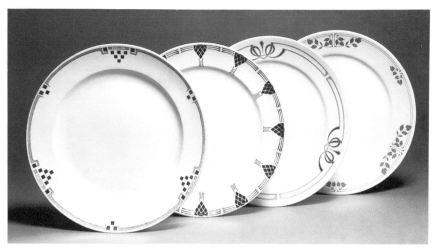

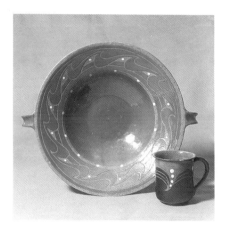

Left to right 124, 123, 122, 125

122 Plate 'Capella'
*Earthenware with printed decoration of interlaced forms
in blue/green*
Made by Arabia; designer unknown; in production
1906-14
Given by the maker
C. 51-1988
Mark ARABIA and a 'whiplash' line printed in blue/
green, 2 printed in black; CK ARABIA OPAK A 41
impressed
D. 24. 3

This pattern was designed for the dinner service model DZ.

123 Plate 'Arne'
*Earthenware with printed decoration of triangles in
fir-cone shapes in blue/green*
Made by Arabia; designer unknown; in production
1909-30
Given by the maker
C. 51A-1988
Mark ARABIA underlined and 4 printed in blue/green
D. 23. 5

124 Plate 'Hildur'
*Earthenware with printed decoration of squares in blue/
green*
Made by Arabia; designer unknown; in production
1912-30
Given by the maker
C. 51B-1988
Mark ARABIA underlined and 4 printed in blue/green
D. 23. 7

125 Plate 'Isak'
Earthenware with printed decoration of leaves in brown
Made by Arabia; designer unknown; in production
1914-17
Given by the maker
C. 51C-1988
Mark ARABIA underlined printed in brown, IQI printed in
black; N ARABIA underlined CH 1219 impressed
D. 27

This pattern was designed for the dinner service model FT.

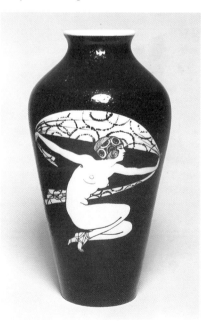

126 Vase △
*Porcelain with a crouching female nude flourishing a
scarf reserved in a painted black background*
Made by Arabia; designed and painted by Thure Öberg
c. 1925
C. 6-1988
Mark MADE IN FINLAND ARABIA and TÖ in monogram
painted in black
H. 26. 7

127 Jar and cover ▽
Porcelain with black glaze
Made by Arabia; designed by Greta-Lisa Jäderholm-
Snellman 1930
Given by the maker
C. 46&A-1988
Mark A incised; AA impressed
H. 25. 6

Greta-Lisa Jäderholm-Snellman was one of the best Finnish
exponents of the international classical style, using it with
a sophisticated simplicity. She exhibited her work in Eng-
land and France as well as Finland, with great success.

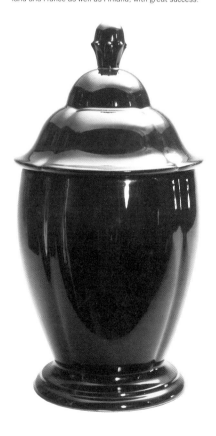

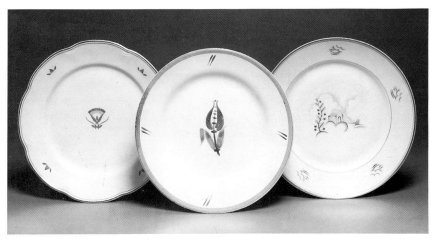

Left to right 129, 128, 130

128 Plate 'Koti'
Earthenware with painted decoration of a central flower,
leaves and banded border in red, brown and green
Made by Arabia; shape and decoration designed by
Greta-Lisa Jäderholm-Snellman 1932
Given by the maker
C. 51D-1988
Mark ARABIA, factory building and SUOMI FINLANDIA
printed in green/blue, KÄSINMAALATTU HANDMÅLAD
'KOTI' printed in lustre
D. 22. 9

129 Plate 'Egypti', shape FQ
Porcelain printed with papyrus-like motifs, lines and
leaves in red, grey, black and gold
Made by Arabia; designer unknown; in production 1934-9
Given by the maker
C. 51E-1988
Mark ARABIA,factory building and SUOMI FINLANDIA II
printed in gold; 20 impressed
D. 23. 7

130 Plate 'Mökki' (Cottage), shape AB
Porcelain with printed decoration of a house and a tree
against clouds in grey, black and gold
Made by Arabia; designer unknown; in production
1934-44
Given by the maker
C. 51F-1988
Mark ARABIA, factory building and SUOMI FINLANDIA
22 printed in orange; 3 ARABIA G36 impressed
D. 23. 7

131 Tray ○
Earthenware, metal-mounted, with painted decoration of
flowers and leaves in green, black and blue
Made by Arabia; designed by Greta-Lisa Jäderholm-
Snellman 1936
Given by the artist
C. 58-1937
Mark signed on front: PINXIT. G. L. J. 1936. ARABIA-
FINLANDIA-; on reverse: 17 ARABIA H.13 impressed
D. 33

Greta-Lisa Jäderholm (who married the painter Eero
Snellman) drew on her wide experience of ceramic
techniques. Craquelé, as used on this tray, was a
favourite effect. The tray was shown in an exhibition at Heal's, Lon-
don, in 1937, the year in which she moved with her family
to France. She worked for a time at the Sèvres factory be-
fore the family returned to Finland at the outbreak of war.

132 Plate 'Sinivalko' (Blue ribbon), shape AR
Stoneware with printed decoration of blue banding
Made by Arabia; designed by Kurt Ekholm; in production
1936-40
Given by the maker
C. 51G-1988
Mark ARABIA, factory building and SUOMI FINLANDIA
printed in green; II incised; 53 (indistinct) impressed
D. 22. 3

133 Dish △
Porcelain with brown/grey glaze
Made by Arabia; designed by Greta-Lisa Jäderholm-
Snellman c. 1940
Circ. 7-1940
Mark 17 ARABIA LH CS 9 (indistinct) impressed; G. L. J.
ARABIA FINLAND painted in black
D. 37. 5

134 Vase C
Porcelain with a high temperature mottled red glaze
Made by Toini Muona at Arabia c. 1940-52
Circ. 323-1955
Mark TM in monogram incised
H. 42. 5

Tuoni Muona studied under A. W. Finch, sharing his experi-
ments into transmutation glazes and firing techniques. She
joined Arabia in 1931 under Kurt Ekholm, the art director
who established the Arabia Studio. This vase is one of a
series of 'Heinämaljakoitavuosilta' ('Grass' vases) which
she began in about 1940 and continued, as a form, to de-
velop during the 1950s, increasing them in size from the
earlier 36-38 cms to over a metre in height. With the vases
by Kyllikki Salmenhaara and Aune Siimes (cat. nos
145,146), this vase was chosen by the Museum from the
exhibition 'Modern Art in Finland' which travelled to
London, Leeds, Brighton and Dublin in 1953.

135 Plate 'Suomen Kukka' (Finnflower), shape AS
Stoneware with printed decoration of flowers and flower
sprigs in blue
Made by Arabia; shape designed by Reinhart Richter;
decoration designer unknown; in production 1941-54
Given by the maker
C. 51H-1988
Mark a crown and ARABIA MADE IN FINLAND LASITTEEN
SUOJAAMA KORISTE/DEKOREN SKYDDAD AV BLASYR
DECOR PROTECTED BY GLAZE FINNFLOWER 7 printed in
green
D. 23. 1

136 Plate 'Blue Rose', shape R
Stoneware painted in underglaze blue with decoration of
a rose and a two-handled vase
Made by Arabia; designed by Olga Osol; in production
1944-5
Given by the maker
C. 51L-1988
Mark a crown and ARABIA MADE IN FINLAND 9 printed
in green; 64 (indistinct) 949 impressed
D. 25. 7

137 Part of a tableware range, shape TM ▽
White porcelain
Made by Arabia c. 1957; designed by Kaj Franck 1948;
in production 1953-63
Given by the maker
Circ. 52&A-1964; C. 237&A-E-1985
Four cups and saucers
Unmarked
H. cup 4. 5

This set was originally on loan to the Museum's Department of Circulation which arranged a travelling exhibition of Scandinavian ceramics in 1957. See cat. no. 138 for the same shape, model TM with 'Northern Lights' decoration. Kaj Franck designed the TM cup for thin porcelain, as smaller than an ordinary coffee cup but larger than a mocha cup. The steep rimmed saucer made a hollow for the cup unnecessary. These non-standard features meant that the shape was not welcomed at first by the factory's marketing department. Eventually it was accepted since it provided a surface that would be easily decorated, although Franck's intention was that the simple white porcelain, undecorated, should be set off solely by the black coffee contents.

138 Part of a tableware range 'Northern Lights'
Porcelain with printed decoration in red, blue and yellow
Made by Arabia; cups and saucers shape TM designed by
Kaj Franck 1948; decoration designed by Raija
Uosikkinen 1956
Circ. 48&A, 49&A, 50&A, 51, 52-1957
Three cups and saucers, two plates
Mark a crown and ARABIA MADE IN FINLAND 103 on
some (105 on others) printed in gold
D. plate 23.5

The TM cups and saucers were designed by Kaj Franck in 1948 to be produced in undecorated white porcelain (see cat. no. 137). His intention was 'an intimate tête-à-tête between the black coffee in a plain cup and you'. The 'Northern Lights' printed decoration was added later by Raija Uosikkinen (and possibly another designer for the plates) at the marketing department's request and without Franck's consent, following normal procedure in industrial production. Raija Uosikkinen was Arabia's most prolific pattern designer during the 1950s and 1960s, providing the majority of the factory's printed decorations from 1947.

139 Part of a series of dishes 'Kilta' (Guild) [C]
Earthenware with green, blue, clear, black and yellow
coloured glazes
Made by Arabia 1957; designed by Kaj Franck 1948;
in production 1952-74
Given by the maker
Circ. 51, 52-1957; Circ. 26, 27, 30, 31, 32, 33&A, 34&A,
36, 48, 49-1964
Two plates, rectangular dish, square dish, one plate, one
small dish, bowl, sugar bowl and cover, tea cup and
saucer, jug, two square dishes
Mark a crown and ARABIA MADE IN FINLAND printed in
yellow/brown on white or white on coloured glazes; UUNI
UGN OVEN and an oven door shape with radiating lines
printed in green on white or white on coloured glazes
L. rectangular dish 30. 7

The basic hard white earthenware 'Kilta' range was launched in 1952 by Kaj Franck and issued in a limited range of colours – white, black, green, blue and yellow. In the post-war austerity years the range was intended as an inexpensive basic choice which would - and did - become standard everyday ware in many Finnish homes. It was designed to be once-fired, keeping production costs to a minimum. Franck used basic geometric forms – squares, spheres or hemispheres, cylinders, cones etc. Some of the shapes could be used for different purposes. The small dish, for instance, could also act as a saucer for the cup. He intended that the individual items should be anonymous enough to be used in any combination and with designs other than the 'Kilta' series. The series also included hemispherical bowls, not acquired by the Museum. In addition, the factory produced new or separate shapes by Franck, which were not part of the 'Kilta' series, and also some by others in the design team such as Ulla Procopé (see cat. no. 147), using the 'Kilta' glazes and marketing these with the 'Kilta' range. In 1981 the range was com-

pletely reworked by Franck and reissued as 'Teema' (cat. no. 174).

This set was originally on loan to the Museum's Department of Circulation which arranged a travelling exhibition of Scandinavian ceramics in 1957. The initial selection was made at Finmar, the retailers for Finnish and other Scandinavian products, by Hugh Wakefield of the Museum with advice from Professor H.O.Gummerus of the Konstflitföreningen, Helsinki.

140 Three jars and covers, 'IS' series ○
Earthenware with blue, green and brown glazes
Made by Arabia c. 1957; designed by Kaj Franck c. 1948
Given by the maker
Circ. 28&A, 29&A, 35&A-1964
Mark a crown and ARABIA MADE IN FINLAND printed in
white; on brown and green jars UUNI UGN OVEN and an
oven door shape with radiating lines printed in white
H. 12. 4

'IS' jars were made in a number of bright colours intended to indicate the contents. They were designed by Franck as all-purpose containers for use in the kitchen or anywhere else in the house, and were among his earliest designs for Arabia after his appointment in 1945 as head of the Design Department for Utility Wares. Like the 'Kilta' series, these jars were originally on loan to the Museum's Department of Circulation which arranged a travelling exhibition of Scandinavian ceramics in 1957.

141 Plate 'Sointu' (Chord), shape RNA
Blue/grey porcelain
Made by Arabia; designed by Kaj Franck; in production
1949-60
Given by the maker
C. 51M-1988
Mark a crown and ARABIA MADE IN FINLAND printed in
brown; 68 1053 impressed
D. 25. 6

This plate is from a range made in soft pastel tinted porcelains. On Franck's arrival at Arabia he found that many of the decorations were bought in from abroad. He introduced four simple sets with relief decoration – in porcelain, earthenware and stoneware – some of which, like this single example from a coffee and tea service, had pastel coloured bodies.

142 Tureen and cover, dish and two egg rings △
Earthenware with brown, clear, yellow and green glazes
Made by Arabia· designed by Kaj Franck between
c. 1950-5
Given by the maker
Circ. 37&A, 50, 53, 54-1964
Mark a crown and ARABIA MADE IN FINLAND printed in
white on tureen and in brown on dish; on tureen also UUNI
UGN OVEN and an oven door shape with radiating lines
printed in white
D. tureen 19. 9

Kaj Franck produced a number of individual designs for utilitarian wares during the early and mid-1950s. This tureen (shape EE), dish (shape G) and the egg rings were in production from about 1957 for about 10 years. Like the 'IS' jars , cat. no. 140, they were advertised with the 'Kilta' series and were decorated with 'Kilta' glazes. With the jars and 'Kilta' series these were included in a travelling exhibition of Scandinavian tableware arranged by the Museum's Department of Circulation in 1957.

143 Two cream bottles with cork stoppers, shapes MK and MM △
Porcelain (shape MK) and earthenware (shape MM) with
clear glazes
Made by Arabia c. 1957; designed by Kaj Franck
c. 1950-5
Given by the maker
Circ. 38, 41-1964
Mark on shape MM only a crown and ARABIA MADE IN
FINLAND printed in white
H. shape MK without stopper 12. 2

These two cream bottles are part of an experimental and restricted series designed by Kaj Franck. They were put into limited production only but, nevertheless, were acquired by the Museum as part of the group loan from Arabia for inclusion in the travelling exhibition of Scandinavian tableware arranged by the Department of Circulation in 1957.

144 Egg dish and cover 🅒
Earthenware in the shape of a hen, with diaper
decoration in black and yellow
Made by Arabia 1957; designed by Kaarina Aho 1952
Given by the maker
Circ. 42&A-1964
Mark a crown and ARABIA MADE IN FINLAND 2 printed
in black
L. 18. 5

This egg container, or egg-hen, was designed to be accompanied by matching egg rings. It was originally on loan to the museum's Department of Circulation which arranged a travelling exhibition of Scandinavian ceramics in 1957.

145 Vase ○
Chamotte stoneware with speckled glaze and red/brown
iron spots
Made by Kyllikki Salmenhaara at Arabia c. 1952
Circ. 325-1955
Mark ARABIA KS incised
H. 42. 5

Salmenhaara was awarded a diplôme d'honneur at the Milan Triennale 1954, the year this vase was made. She occupies a central position in the development of the Arabia Studio and her influence is still acknowledged today. In 1952-4 she made a series of bottles of classical proportions, such as this example, employing local Finnish materials with finesse and sensitivity. With the vases by Toini Muona and Aune Siimes (cat. nos. 134, 146), this vase was chosen by the Museum from the exhibition 'Modern Art in Finland' which travelled to London, Leeds, Brighton and Dublin in 1953.

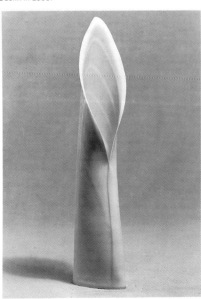

146 Vase △
Porcelain
Made by Aune Siimes at Arabia c. 1952
Circ. 324-1955
Mark AS in monogram and ARABIA incised on side
H. 33

Aune Siimes specialised in finely cast porcelains and extended this technique to the production of jewellery. Her 1954 collection was awarded a gold medal at the Milan Triennale. With the vases by Toini Muona and Kyllikki Salmenhaara (cat. nos 134, 145), this vase was chosen by the Museum from the exhibition 'Modern Art in Finland' which travelled to London, Leeds, Brighton and Dublin in 1953.

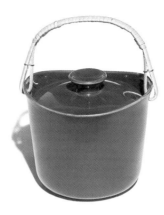

147 Marmalade jar and cover △
Earthenware with green glaze; cane handle
Made by Arabia c. 1957; designed by Ulla Procopé 1953
Given by the maker
Circ. 45&A-1964
Mark a crown and ARABIA MADE IN FINLAND printed in
white
H. 8. 9

This jar was issued by the factory with a 'Kilta' glaze (see cat. no. 139) and was marketed in conjunction with the 'Kilta' series and other designs. It was originally on loan to the Museum's Department of Circulation for a travelling exhibition of Scandinavian ceramics arranged in 1957.

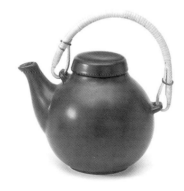

148 Two tea pots and lids, shape GA △
Porcelain with semi-matt black glaze; cane handles
Made by Arabia 1957; designed by Ulla Procopé 1953
Given by the maker
Circ. 46&A, 47&A-1964
Mark a crown and ARABIA MADE IN FINLAND printed in
white
H. 15

These tea pots were originally on loan to the Museum's Department of Circulation which arranged a travelling exhibition of Scandinavian ceramics in 1957. After Kaj Franck, Procopé was Arabia's most successful designer of domestic series, specialising in industrially-produced wares in a 'hand-made' style. See also 'Liekki' and 'Ruska', cat. nos 159, 161.

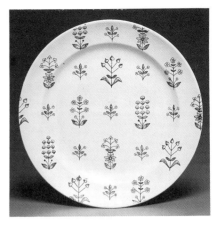

149 Plate 'Tapetti' (Tapestry), shape R △
Stoneware with printed decoration of formalised flower
sprigs in blue
Made by Arabia; shape designed by Olga Osol; decoration
designed by Birger Kaipiainen; in production 1953-64
Given by the maker
C. 51I-1988
Mark a crown and ARABIA MADE IN FINLAND printed in
green; 105 impressed twice
D. 24. 2

150 Plate 'Polaris', shape B
Stoneware with printed decoration of growing flowers and
plants in greens
Made by Arabia; shape designed by Kaj Franck; decora-
tion designed by Raija Uosikkinen; in production 1953-66
Given by the maker
C. 51J-1988
Mark a crown and ARABIA MADE IN FINLAND POLARIS
LASITEEN SUOJAAMA KORISTE DEKOREN SKYDDAD AV
GLASYR DECOR PROTECTED BY GLAZE printed in brown
D. 23. 1

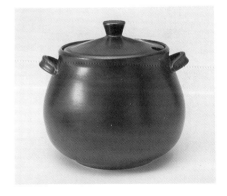

151 Soup tureen and cover △
Stoneware with semi-matt black glaze on the outside
Made by Kupittaan Saviosareyhtiö; designed by Marjukka
Paasivirta 1954
Given by the maker
Circ. 55&A-1964
Unmarked
D. 22. 3

During the 1950s Kupittaan Saviosaryhtiö produced a series of well-designed, functional and aesthetically pleasing domestic wares, the work of three designers - Marjukka Paasivirta, Linnea Lehtonen and Laine Taitto - and later, in the early 1960s, of Heidi Blomstedt. The

Museum has examples of work by the first two designers. The factory, established as a supplier to the building and chemical industries, also produced basic wares during the 1930s. Its industrial market meant that it already used a high quality stoneware which is the basis of these cooking pots. This soup tureen as well as the soup bowl and mashing pot (cat. no. 152) were originally on loan to the Museum's Department of Circulation which arranged a travelling exhibition of Scandinavian ceramics in 1957. Kupittaan Saviosareytiö was awarded a silver medal, Milan Triennale 1954.

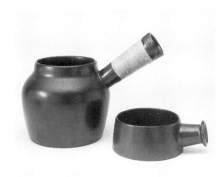

152 Soup bowl and mashing pot △
Stoneware with semi-matt black glaze; mashing pot with cane-bound handle
Made by Kupittaan Saviosareyhtiö 1957; designed by Linnea Lehtonen 1954
Given by the maker
Circ. 56, 57-1964
Unmarked
H. pot including handle 19. 6

See soup tureen and cover, cat. no. 151.

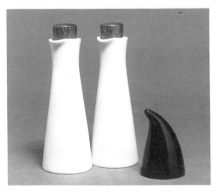

153 Cruet ware △
Porcelain with clear and black glazes
Made by Arabia; designed by Kaj Franck c. 1955
Given by the maker
Circ. 39-1964; C. 175&A-1988; Circ. 40-1964
Oil and vinegar bottles with teak stoppers, pepperhorn
Mark on pepperhorn ARABIA MADE IN FINLAND printed in white
H. bottles without stoppers 12. 4

These designs were also advertised in combination with 'Kilta' range wares (see cat. no. 139). The complete set should include a white salthorn, a mustard jar and a teak tray. Like the Museum's 'Kilta' range, these were originally on loan to the Museum's Department of Circulation which arranged a travelling exhibition of Scandinavian ceramics in 1957.

154 Bowl ▽
Porcelain with pierced 'rice' decoration infilled with glaze
Made by Arabia 1974; designed by Friedl Holzer-Kjellberg c. 1955
C. 55-1987
Given by the maker
Mark 27. 12. 1974 printed in gold; ARABIA F H KJ FINLAND incised
D. 12. 8

Kjellberg designed the first 'rice pattern' bowl for Arabia in the early 1940s after 10 years' experimenting to perfect the technique. On its launch it was an instant success. The technique was employed in a large number of forms including tea wares, and was in production until about 1974. Production was restarted in 1986.

155 Cutting board ▽
Porcelain with yellow glaze
Made by Arabia; designed by Kaarina Aho 1956
Given by the maker
Circ. 51-1964
Mark a crown and ARABIA MADE IN FINLAND 106 printed in green/yellow
L. 27. 5

Kaarina Aho was an assistant to Kaj Franck but brought her own brand of fanciful whimsy to the most basic of kitchen wares. This board was originally on loan to the Museum's Department of Circulation which arranged a travelling exhibition of Scandinavian ceramics in 1957.

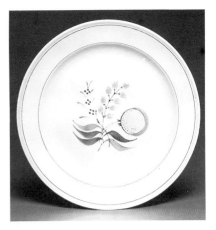

156 Plate 'Windflower', shape R △
Stoneware with painted decoration of flowers, leaves and seed pods in several colours
Made by Arabia; designed by Olga Osol; in production 1956-66
Given by the maker
C. 51K-1988
Mark 'WINDFLOWER', a crown and ARABIA MADE IN FINLAND printed in green; 105 451 impressed; HANDPAINTED UM in monogram painted in green
D. 24. 5

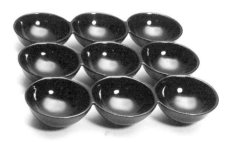

157 Hors-d'oeuvres tray 'Astarte' △
Earthenware with black slip glaze
Made by Arabia; designed by Saara Hopea 1957
Given by Oppi Untracht
C. 174-1988
Mark a crown and ARABIA MADE IN FINLAND 12-1 printed in white
30.6 sq.

'Astarte' was named after the multi-breasted Phoenician goddess of fertility and sexual love, suggested by the underside of the tray. It is one of the few ceramic objects designed by Saara Hopea while working at Arabia as an associate of Kaj Franck.

158 Child's plate and cup 'Zoo'
Porcelain with animals printed in several colours
Made by Arabia; designed by Anja Juurikkala 1957
Given by the maker
Circ. 43, 44-1964
Mark a crown and ARABIA MADE IN FINLAND printed in green/yellow; on cup VARI 2387 'ZOO' painted in gold
D. 18. 7

Arabia's design and artist team has always included individuals who have been concerned with the relationship of ceramics to children's needs.

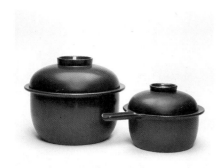

'Ruska' is still in production today and is among Arabia's most successful lines. Its attractiveness lies as much in the unique, mottled stoneware glaze, giving each piece an individual 'hand-made' appearance, as in the highly sophisticated and well-conceived shapes. The concept of 'oven-to-table' ware emerged in the late 1950s and Arabia, like many manufacturers across Europe and in America, introduced specially designed cooking and serving dishes in oven-proof, high temperature resistant material which were also good-looking enough to be part of a dinner table setting. Apart from the coffee pot, which was a gift from the maker in 1988, this set was one of a number of purchases by the Museum from Heal's, London, which, from the 1930s had been one of the select number of progressive London shops selling well designed domestic furnishings from Scandinavia. In the mark the pot inside an oven indicates 'oven-to-tableware'.

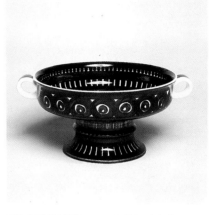

159 Part of a cooking set 'Liekki' (Flame) △
Stoneware with brown glaze
Made by Arabia; designed by Ulla Procopé; in production 1957-78
Given by the maker
C.45&A-C-1988
Two cooking pots and covers
Mark ARABIA WÄRTSILÄ FINLAND, a crown and a cooking pot within a flame printed in green; on large pot 10-74 2, on small pot 11-73 3 printed in green
D. larger 22. 3

160 Plate 'Heini', shape AR
Stoneware with printed decoration of arrow-like motifs in grey
Made by Arabia; shape designed by Kaarina Aho; decoration designed by Raija Uosikkinen; in production 1958-66
Given by the maker
C. 51N-1988
Mark a crown and ARABIA MADE IN FINLAND LASITTEEN SUOJAAMA KORISTE DEKOREN SKYDDAD AV GLASYR DECOR PROTECTED BY GLAZE HEINI 4 printed in black
D. 23. 7

161 Part of a tableware range 'Ruska' ▽
Stoneware with mottled brown glaze
Made by Arabia c. 1968 (coffee pot 1986-7); designed by Ulla Procopé 1960
Circ. 453&A, 454, 455, 456&A, 457&A-1969; C. 49&A-1988
Soup tureen and cover, bowl (baker), plate, sugar bowl and cover, cup and saucer, coffee pot and lid
Mark a pot inside an oven, a crown and ARABIA FINLAND 9-68 printed in white; on coffee pot a crown and ARABIA FINLAND RUSKA DISHWASHER-PROOF printed in white
D. plate 20

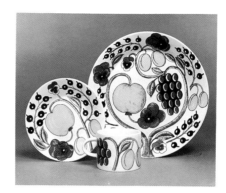

162 Part of a tableware range 'Paratiisi' (Paradise) △
Stoneware with printed decoration of fruits in yellow, purple, blue and green
Made by Arabia 1987; designed by Birger Kaipiainen c. 1960
Given by the maker
C.50&A-B-1988
Coffee mug, saucer and plate
Mark a crown, ARABIA FINLAND PARATIISI, OVEN TO TABLE DISHWASHER SAFE and spray of blackcurrants printed in black
D. plate 26

'Paratiisi', originally in Arabia's earthenware, was reissued in 1987 in their higher-fired stoneware.

163 Part of a tableware range 'Valencia' △
Earthenware with decoration in underglaze blue
Made by Arabia; designed by Ulla Procopé c. 1960
Circ. 458&A, 459, 460, 662&A-1969; C. 234&A-1985
Tea pot and lid, standing dish, plate, cup and saucer, cup and saucer
Mark ARABIA FINLAND UP in monogram painted in blue; on plate MS, on standing dish SM, on tea pot SR painted in blue
D. plate 19

Like many of Ulla Procope's designs, 'Valencia' has been in continuous production since its introduction. Atypical for Procopé, whose concerns were more usually with smoothly functional shapes and earthy glazes, it nevertheless falls within the alternative Arabia production of highly decorative, richly painted wares in a more folk-traditional style.

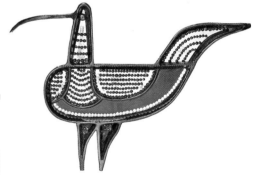

164 Wall plaque in the shape of a bird, probably a woodcock △
Earthenware with black glaze, applied mirror glass and black glazed 'pearls'
Made by Birger Kaipiainen at Arabia c. 1960
C. 261-1987
Mark KAIPIAINEN incised
L. 48

This particular long-beaked bird has been a favourite motif for Kaipiainen. He also made several three-dimensional versions during the 1960s known as 'bead-birds' or 'pearl-birds' into some of which he incorporated watch- or clock-faces, another favourite motif. Very similar bird plaques and also two 'pearl-birds' were included in the exhibition 'Finlandia' held in the Museum in 1961.

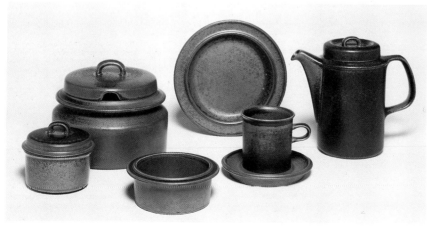

165 Panel of 23 tiles ▽
*Red earthenware partially covered with blue, green,
purple and brown glazes, the tiles moulded and stamped
in relief, mounted on board
Made by Rut Bryk at Arabia c. 1960
Circ. 101-1963
Mark none visible
48 sq.*

Throughout her increasingly prestigious career at Arabia's
art department Rut Bryk has concentrated on decorative
panels. Her early work was based on folkloric motifs de-
picted in raised outline and a rich combination of glaze and
impressed patterns. Her later work explores, in a totally dis-
ciplined manner, opposing positive and negative forces
and the contrasting effects of light and shade, surface and
depth. This panel represents the transition between the two
periods: it is still firmly rooted in the rich, tapestry-like de-
coration of Rut Bryk's earlier years yet foreshadows her
later interest in geometric raised and impressed patterns.
Very similar panels were included in the exhibition
'Finlandia' held at the Museum in 1961. In that exhibition
they were assembled as a floor, with, at intervals, standing
boxes or 'houses' constructed in individual tiles.

166 Plate 'Ali', shape FC
*Stoneware with printed decoration of arabesques and
flowers in several blues
Made by Arabia; shape designed by Kaarina Aho;
decoration designed by Raija Uosikkinen; in production
1964-74
Given by the maker
C. 510-1988
Mark a crown and ARABIA WÄRTSILÄ FINLAND ALI
RESTAA KONEPESUN TÅL MASKINDISK DISHWASHER-
PROOF 7 printed in green
D. 25*

167 Plate 'Talvikki', shape C
*Earthenware with printed decoration of a border of
flowers in black
Made by Arabia; shape designed by Richard Lindh;
decoration designed by Raija Uosikkinen; in production
1967-74
Given by the maker
C. 51P-1988
Mark a crown and ARABIA WÄRTSILÄ FINLAND TALVIKKI
KESTÄÄ KONEPESUN TÅL MASKINDISK DISHWASHER-
PROOF printed in black
D. 24. 3*

Shape C was launched in 1967 and was made in the new
material 'Poslit', a hard earthenware especially developed
by Arabia.

168 Plate 'Sotka' (Scaup duck), shape E ▷
*Earthenware with broadly painted repeating decoration
in underglaze blue
Made by Arabia; shape designed by Göran Bäck;
decoration designed by Raija Uosikkinen; in production
1968-74
Given by the maker
C. 51Q-1988
Mark a crown and ARABIA WÄRTSILÄ FINLAND SOTKA
HANDPAINTED KESTÄÄ KONEPESUN TÅL MASKINDISK
DISHWASHER-PROOF 13 printed in green
D. 23. 2*

169 Dish ▽
*Stoneware with printed and incised decoration in semi-
matt and glossy black glazes
Made by Toini Muona at Arabia c. 1968-70
Given by the maker
C. 57-1987
Mark TM in monogram and ARABIA incised
D. 37. 5*

This dish was made at the end of Muona's long career at
Arabia and is a testament both to her skill in using the
factory's fine stoneware and to her freshness of vision in
producing a design that accurately represents the stylistic
preoccupations of the late 1960s.

170 Plate 'Lido', shape X
*Porcelain with printed decoration of diamonds in
gold/brown
Made by Arabia; shape designed by Kaarina Aho;
decoration designed by Raija Uosikkinen; in production
1969-74
Given by the maker
C. 51R-1988
Mark a crown and ARABIA MADE IN FINLAND 10-69
printed in green
D. 23. 7*

171 Plate 'Black Ribbon', shape 'Faenza' ▷
*Earthenware printed in black
Made by Arabia; designed by Peter Winquist 1970;
in production 1970-9
Given by the maker
C. 51S-1988
Mark a crown and ARABIA WÄRTSILÄ FINLAND FAENZA
KESTÄÄ KONESPESUN TÅL MASKINDISK DISHWASHER
PROOF printed in brown
D. 25. 7*

This service (the shape code-named EH), decorated with
Black Ribbon' won a gold medal, Faenza, 1971. It was also
produced in yellow, another pattern (see cat. no. 172) and
undecorated. The manufacturer drew attention to the
range's dishwasher-proof features: runnels under the cups
to let water drain off and bevelled edges to strengthen the
flatware.

**172 Part of a tableware range 'Sinikukka' (Blue
flower), shape 'Faenza'** △
*Earthenware with printed decoration of closely packed
flowers in blue
Made by Arabia; shape designed by Peter Winquist 1970;
decoration designed by Inkeri Seppälä c. 1970
Circ. 162, 163, 164, 165, 166, 167, 168&A, 169&A,
170&A, 171&A, 172&A, 173, 174-1974
Three plates, two soup plates, baker, coffee pot and lid,
two coffee cups, two tea cups, cream jug, sugar bowl
Mark a crown and ARABIA WÄRTSILÄ FINLAND FAENZA
KESTÄÄ KONEPESUN TÅL MASKINDISK DISHWASHER
PROOF printed in green
D. plate 19. 7*

This shape won a gold medal, Faenza, 1971 (see cat. no.
171 for award-winning pattern). Purchased from Danasco,
London, for inclusion in 'Design Review', a travelling exhib-
ition arranged by the Museum's Department of Circulation.

173 Two dolls 'Lepo' (Resting) and 'Liike' (Motion)
Earthenware, partly glazed with painted glaze decoration
Made by Heljä Liukko-Sundström at Arabia 1971
Circ. 624&A-1972
Mark none visible
L. 'Resting' 51, H. 'Motion' 39

Each doll is in the form of a 'rag doll', one lying with its head on a pillow and with a coverlet, the other walking with arms outstretched. They were exhibited in 'International Ceramics' held in the Museum in 1972 (catalogue: Finland no. 8).

174 Coffee pot and lid from the range 'Teema' (Theme)
Earthenware
Made by Arabia; designed by Kaj Franck; in production from 1981
Given by the maker
C. 48&A-1988
Mark a crown and ARABIA FINLAND TEEMA printed in green
H. 15. 2

The 'Teema' range (also called BAU) is a reworking by Franck of his 'Kilta' range (see cat. no. 139).

178 Vase ◁
Mixed clays with impressed grasses
Made by Francesca Lindh at Arabia c. 1983
C. 54-1988
Mark F LINDH ARABIA impressed
H. 40. 7

The techniques employed in this three-sided vase are typical of Francesca Lindh's work. Coming from Italy in 1949, she studied at the Helsinki Institute of Industrial Arts and joined the Arabia Studio in 1955 under Kyllikki Salmenhaara. Like Salmenhaara, Francesca Lindh is interested in the contrasting qualities of different clays, and her own distinctive technique has established her as one of Finland's leading potters. She was awarded an honourable mention in the Milan Triennale 1957, and gold medals at Faenza, 1973 and 1977.

179 Form 'Signs of Storm' ▽
Chamotte stoneware, thrown, hand-built and worked
Made by Kati Tuominen at Arabia, 1984
C. 55-1988
Mark ARABIA FINLAND KT in monogram incised
H. 41. 4

Kati Tuominen was a pupil of Kyllikki Salmenhaara and continues the tradition of experiment and expertise in the use of Arabia's distinctive materials. Her work combines a number of different techniques including throwing and casting with warm, earthy and, sometimes, coloured glazes. This vase-like sculpture was made at a particularly strong and energetic period in her career, for the opening exhibition of the gallery of the Arabia factory's museum. It also signals her current move towards a more sculptural development.

175 Sculpture 'Sipulit' (Onions) △
Stoneware with incised and coloured texturing
Made by Gunvor Olin-Gronqvist at Arabia c. 1982-4
C. 53&A&B-1988
Mark G O G ARABIA incised
Each piece 20 x 21

Gunvor Olin-Grönquist joined Arabia in 1951 and specialised in pattern design for serial production. She also makes unique works which are strongly characterised sculptural forms. She made a series of vegetables and fruit, such as these onions, for her solo exhibition 'Harvest Time' held at Arabia in 1982.

176 Part of a tableware range 'Tuuli' (Wind)
Stoneware with moulded decoration
Made by Arabia; designed by Heljä Liukko-Sundström 1983
Given by the maker
C. 66&A, 67, 70-1987
Cup and saucer, soup dish, bowl
Mark a crown and ARABIA FINLAND TUULI printed in black
D. bowl 21. 5

Heljä Liukko-Sundström's decorative work is frequently drawn from the Finnish countryside. This service is based on shapes deriving from the windswept landscape and waters. It is neatly complemented by her decoration in the 'Merituuli' range (see cat. no. 177).

177 Part of a tableware range 'Merituuli' (Sea wind), shape 'Tuuli' ▽
Stoneware with moulded and printed decoration
Made by Arabia; designed by Heljä Liukko-Sundström 1983
Given by the maker
C. 68&A, 69-1987
Cup and saucer, plate
Mark a crown and ARABIA FINLAND TUULI printed in black
D. plate 17

See cat. no. 176.

180 Part of a tableware range 'Forte' △
Stoneware
Made by Arabia; designed by Jussi Ahola 1985
Given by the makers
C. 58&A, 59&A, 60, 61, 62, 63, 64, 65-1987
Cup and saucer, cup and saucer, cream jug, bowl(large), bowl(mid), bowl(small), plate(mid), plate(small)
Mark a crown and ARABIA FINLAND FORTE OVEN TO TABLE DISHWASHER SAFE MICRO & FREEZER SAFE printed in black
D. large bowl 15. 5

'Forte' was specifically designed for public catering services and, as such, particular attention was directed towards storage and stacking qualities, the relationship of cutlery to plate and saucer rims, and to durability. It is a highly successful range in use in a large number of Finnish cafeterias and restaurants.

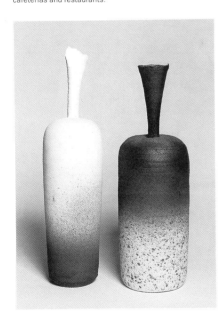

181 Pair of bottles △
Stoneware, thrown and formed with sprayed brown/black glazes
Made by Pekka Paikkari at Arabia 1985
C. 56&A-1988
Mark PEKKA incised
H. 38. 8

These elegant and delicate bottles were shown in Paikkari's exhibition 'Varjoostuksia', Arabia Gallery, 1985, and were featured in the gallery's publicity material. Since then, Paikkari has had a successful exhibition at the Galleria Bronda, Helsinki.

182 Part of a tableware range 'Arctica' ▽
Stoneware
Made by Arabia; designed by Inkeri Leivo c. 1985
Given by the maker
C. 71&A, 72, 73-1987
Cup and saucer, soup bowl, handled bowl
Mark a crown and ARABIA FINLAND ARCTICA and DISHWASHER SAFE MICROWAVE SAFE OVEN TO TABLE printed in black
L. handled bowl 19. 6

'Arctica' has a related design, 'Arctica Resta', one of a number of Arabia designs for public catering services. With its curved outlines, 'Arctica' has been well received, and Inkeri Leivo has since designed matching glassware for Nuutajärvi and enamel cookware for Järvenpää Enamel.

183 Part of a tableware range 'Kombi', shape 'Saaristo' (Island blockade)
Grey stoneware with stripes in blue, grey and yellow
Made by Arabia; shape designed by Inkeri Leivo; decoration designed by Kati Tuominen c. 1985
Given by the maker
C. 74&A, 75, 76&A, 77&A, 78, 79,80, 81-1987
Tea pot (with metal handle) and lid, bowl, tea cup and saucer, coffee cup and saucer, plate (mid), plate (small), serving plate, sauce boat
Mark a crown and ARABIA FINLAND printed in black; on bowl SAARISTO and two curved-V symbols, on cups and saucers, plates and sauce boat KOMBI, 99 40 printed in black
L. serving plate 36

184 Plaque 'Joki' (River) △
Stoneware with printed decoration
Made by Arabia 1986; designed by Heljä Liukko-Sundström
C. 56-1987
Given by the maker
Mark on face: HELJÄ LIUKKO-SUNDSTRÖM ARABIA 86; incised on reverse: a crown and ARABIA FINLAND printed in gold
L. 25.3

Heljä Liukko-Sundström is now Arabia's most prolific and successful designer of small-scale decorative plaques for domestic use. This plaque (design no. 04623) is one of four depicting different Finnish scenes of autumn and winter.

185 Sculpture 'Omenanlohko' (Apple slice) ▽
Stoneware incised and with coloured glazes
Made by Gunvor Olin-Grönqvist at Arabia 1986
C. 52-1988
Mark GUNVOR OLIN GRÖNQVIST ARABIA FINLAND incised
L. 53. 3

Gunvor Olin Grönquist has continued to specialise in natural forms, following her earlier exhibition 'Harvest Time' (see cat. no. 175). With this crisp sculptural work she has moved from using the looser textured earthenware to porcelain thus capitalising on the materials dense, smooth surface and clean, clear colour as more appropriate for an apple.

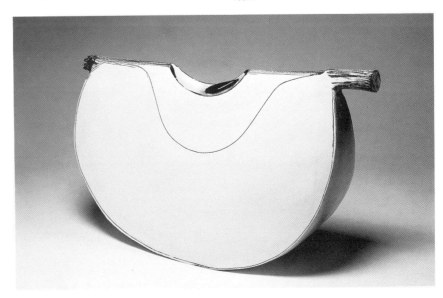

G L A S S

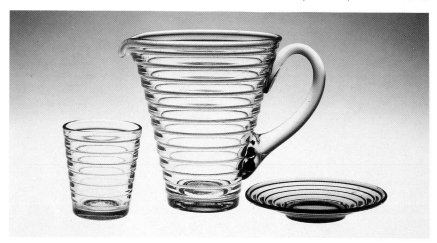

186 Part of a tableware range 'Domino'
Stoneware
Made by Arabia; designed by Kati Tuominen and Pekka Paikkari 1986; in production from 1987
C. 47&A-D-1988
Tea pot and lid, cup and saucer, jug
Mark a crown and ARABIA FINLAND DOMINO printed in black
H. tea pot 15

This service is the work of two of Arabia's present team of artists. Tuominen and Paikkari combine individual art work with design for serial production.

187 Two forms 'Puutarhakäärmen Juomaastia' (Drinking bowl of the garden snake); and 'Puutarhakäärme' (Garden snake) ◁
Stoneware with yellow slips and clear lustred glazes
Made by Åsa Hellman, Helsinki, 1987
C. 1&A-1989
Mark on upper surface of bowl: potter's monogram impressed; on reverse: ÅSA HELLMAN FINLAND painted in black; on snake ÅSA HELLMAN incised
D. 47

Åsa Hellman is one of the members of the colony of workshops, Pot Viapori, on the island of Suomenlinna, Helsinki. These two forms were included in an exhibition held at the Museum of Applied Art in Helsinki in 1987-8, arranged by the Finnish Association of Craftsmen, TAIKO.

188 Part of a range 'Bölgeblick' ▽
Blue, green and grey/green clear glass, with moulded ribbing
Made by Karhula; designed by Aino Aalto, jug and plate 1932, tumbler 1936
Given by Peter Sederholm
C. 228&A&B-1987
Jug, tumbler, plate
Unmarked
H. jug 16. 7

This range was awarded second prize in the pressed glass entries to the 1932 competition at the Karhula glassworks. The complete range consisted of tumbler, pitcher, sugar bowl, creamer, with plates and bowls of various sizes. Four years later, with slight modifications, it was awarded a gold medal at the Milan Triennale 1936. It was in production until the mid-1950s and part of the range has recently been reissued.

189 Vase 'Savoy' 🄲
Light green bottle glass, mould-blown
Made by Karhula 1937; designed by Alvar Aalto 1936
C. 226-1987
Mark KARHULA 22 IX 37 etched
W. 21
Shape 9750

This shape was designed by Aalto and used in the Savoy Restaurant which is on the top floor of the Ahlström building in Helsinki. Aalto was commissioned to design the restaurant and its furnishings by Ahlström, head of the corporation which included the Karhula and Iittala glassworks. The vase is part of a group of designs for glass which Aalto codenamed 'Eskmoerindens Skinnbuxa' (Eskimo woman's leather pants) and which won first prize in a competition organised by Karhula Iittala in 1936. The series was first shown internationally at Paris in 1937. 'Savoy' was made in the Karhula factory's bottle glass and blown into a wooden mould, the two factors which give this original example its particularly soft and fluid appearance. See also cat. nos 190, 191 for recently made examples in the same series.

190 Vase 'Savoy' or 'Aalto'
Dark green glass, mould blown
Made by Iittala 1986; designed by Alvar Aalto 1936
Given by the maker
C. 194-1987
Mark A. AALTO 1936 1986 IITTALA E 5441/8000 incised
W. 21
Shape 3030

This shape has been in almost continuous production since 1937 (see cat. no. 189) and has been made in clear, green, red and, later, in opal, blue, light blue and amber glass. From 1949 production was moved from Karhula to the Iittala works (both factories were part of the Ahlström corporation) and since 1954 the design has been blown into a cast-iron mould. It was reissued in a numbered batch of 8,000 in 1986, in a darker green than the original, in celebration of its 50th anniversary. This is number 5441. Various other numbered batches have been produced for the retailers Artek (see cat. no. 191) and to commemorate the centenary of Iittala in 1981. A red batch was made 1954-5 by using gold as the colouring agent: it was therefore very expensive and was not included in the factory's catalogues.

191 Vase
Clear colourless glass, mould-blown
Made by Iittala 1986; designed by Alvar Aalto 1937
Given by the maker
C. 195-1987
Mark ALVAR AALTO incised
H. 36
Shape 3032

This shape was one of the group of designs code-named by Aalto 'Eskimoerindens Skinnbuxa' (see cat. no. 189). It has been in almost continuous production since 1937. Some designs from this group were made only to special order from Artek, the retailing and furnishing company founded by Alvar Aalto, Aino Aalto, Nils-Gustaf Hahl and Maire Gullichsen, now trading in Keskukatu, Helsinki.

192 Jar and cover
Blue glass, cut
Made by Riihimäki; designed by Greta-Lisa Jäderholm-
Snellman 1937
Given by the artist
C. 59&A-1937
Unmarked
D. 13. 5

This jar with cover was included in an exhibition of Greta-Lisa Jäderholm-Snellman's work in glass and ceramics at Heal's, London, in 1937. The earthenware tray, cat. no. 131, was also exhibited.

193 Vase or lamp base ▷
Amber glass with deeply stepped cut sides
Made by Riihimäki; designed by Greta-Lisa Jäderholm-
Snellman c. 1937
Circ. 6-1940
Unmarked
D. 23

Greta-Lisa Jäderholm-Snellman designed for ceramics as well as glass. Her work was exhibited in Heal's Mansard Gallery in London. This lamp base and a small group of tablewares (cat. no. 194) were purchased by the Museum from this design-conscious retailer.

194 Set of table glasses
Blue glass
Made by Riihimäki; designed by Greta-Lisa Jäderholm-
Snellman c. 1937
Circ. 8, 9, 10, 11, 12-1940
Tumbler, three cocktail glasses, finger bowl
Unmarked
H. tumbler 12. 2

production in 1987 in five sizes (model no. 2043, sizes 5, 12, 20, 28, 36 cl.). Examples of the 'Riihimäki-kukka' and the only known examples of three of the original stacking glasses may be seen at the Riihimäki Glass Museum. Both designs were probably included in the Finnish display in the Milan Triennale 1933; they were on sale in London in 1933. The more elaborate version, 'Aalto-kukka' was designed for the World Fair, New York, 1939. Between the earlier versions and this come the 'Savoy' or 'Aalto' vase (cat. no. 189) and its related group of glasses of organic forms which show the progression towards these expansive and fluid outlines.

195 Set of vases/dishes 'Aalto-kukka'
(Aalto flower) △
Clear colourless glass
Made by Iittala 1981-6: designed by Alvar Aalto 1939
Given by the maker
C. 196&A-C-1987
Mark on large dish ALVAR AALTO 53/1986 incised; on
three smaller vases ALVAR AALTO IITTALA 14/1981
incised
W. largest 40. 5
Model no. 3025

This version was developed from the earlier design 'Riihimäki-kukka', a three-part set of containers with a fourth part, a central tumbler, in plain, flared shapes. It was designed in 1933 for Riihimäki's design competition for domestic glassware and won second prize. In turn, the 'Riihimäki-kukka' was closely related to a contemporary design by Aalto for four stacking drinking glasses, also part of Aalto's entry for the competition. These were put into

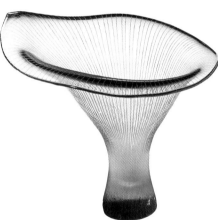

196 Vase 'Kantarelli' (Chanterelle) △
Clear colourless glass, blown, with cut unpolished
decoration
Made by Iittala; designed by Tapio Wirkkala 1946
Circ. 457-1954
Mark TAPIO WIRKKALA - IITTALA 25/50 incised
W. 21. 4

Two series of 50 vases each were made to this design, both numbered. Later some un-numbered runs were produced. This example is from the first series. Following its success at the Milan Triennale 1951 where it was part of Wirrkala's glass display which won a grand prix, 'Kantarelli' has been one of the most frequently quoted symbols of Finnish art glass of the 1950s. Another version was also produced, in greater numbers. This vase, with Sarpaneva's 'Lansetti II', cat. no. 202, was purchased from the exhibition 'Modern Art in Finland' which travelled to London, Leeds, Brighton and Dublin in 1953.

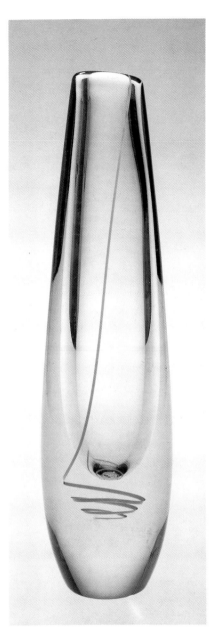

197 Vase 'Serpentiini' (Serpentine) △
Clear colourless glass with an opaque white glass spiral
Made by Nuutajärvi 1952; designed by Gunnel Nyman
1947
C. 164-1987
Mark G. NYMAN NUUTAJÄRVI NOTSJÖ - 52 incised
H. 39

This vase was one of the last of Gunnel Nyman's designs before her early death in 1948. Although her career was brief, she created some crucially influential glasses, using techniques which foreshadowed the later classic works of Wirkkala and Sarpaneva. Her particular interests were in the combination of heavy crystal glass with trapped complementary effects such as bubbles or, as in this case, opaque white glass. Her subjects, such as 'Simpukka' or 'Calla', also heralded the subsequent interpretation of natural forms and textures.

198 Vase 'Jäävuori' (Iceberg) ▽
Clear colourless glass, mould-blown
Made by Iittala; designed by Tapio Wirkkala 1950;
in production 1952-69
Circ. 438-1964
Mark TAPIO WIRKKALA J3825 incised
H. 20. 2

Wirkkala's designs were generally drawn from the Finnish
countryside, more particularly from Lapland where, in
1961, he built his own wooden house in traditional style.
This design and 'Jääpala', cat. no. 199, and four other
glasses by Wirkkala, Sarpaneva and Still were in the
exhibition 'Finlandia' which toured Europe and was held in
the museum in 1961. It was followed by the travelling
exhibition 'Glass Today' organised by the Museum's
Department of Circulation in 1963.

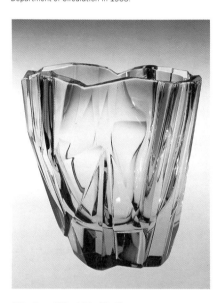

199 Vase 'Jääpala' (Iceblock)
Clear colourless glass, mould-blown
Made by Iittala; designed by Tapio Wirkkala 1950;
in production 1952-69
Circ. 439-1964
Mark TAPIO WIRKKALA 3847 incised
W. 22. 2

Awarded a grand prix at the Milan Triennale 1951 with
'Jäävuori' (cat. no. 198). A number of Wirkkala's 1951 Milan
Triennale designs were previewed at the Kunstgewer-
bemuseum, Zurich, under the directorship of the
ex-Bauhaus teacher, Johannes Itten. Wirkkala insisted on
designing the exhibition display and his work was given
Itten's valuable approval. Iittala had many production
difficulties with this vase and 'Jäävuori'. Only a small
proportion from each batch was accepted as satisfactory.

200 Vase 'Tuonen Virta' (Stream of Tuonela) ●
Clear colourless glass with cut vertical lines
Made by Iittala; designed by Tapio Wirkkala 1951
C. 227-1987
Mark TAPIO WIRKKALA IITTALA incised
H. 37. 6

Tuonela is the Hades of Finnish mythology. This vase is one
of a series of plant-like forms arising from the 'Kantarelli'
shape (see cat. no. 196) launched in 1946. The theme de-
rives from the Kalevala, the Finnish national epic poem that
was popular in the National Romantic movement at the turn
of the century.

201 Vase 'Saippuakupla' (Soap bubble) ▷
Green tinted glass, free-blown
Made by Nuutajärvi 1955; designed by Kaj Franck 1952
Circ. 326-1955
Mark K FRANCK NUUTAJÄRVI NOTSJÖ -55 incised
H. 18

The deceptive simplicity of this most basic blown-glass
shape illustrates Franck's superlative sense of balance and
his skill at establishing the most productive rapport with
the glass-blower. 'Saippuakupla' is an early design for
Nuutajärvi, for which glassworks Franck's first designs were
made in 1951, and it is in some contrast to the functional,
geometric wares such as the elegantly formed carafes and
tumblers of 1954-6 and the ceramic 'Kilta' service
(see cat. no. 139).

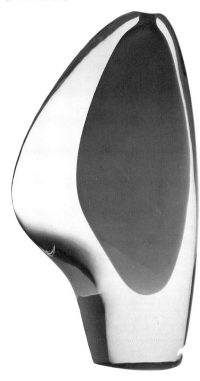

202 Sculpture 'Lansetti II' (Lancet II) △
Clear colourless glass encasing opaque white glass
Made by Iittala; designed by Timo Sarpaneva 1952
Circ. 458-1954
Mark TIMO SARPANEVA - IITTALA incised
H. 25. 5

If Wirkkala's 'Kantarelli' (cat. no. 196) is one of the most
familiar images in Finnish art glass of the 1950s, Sar-
paneva's 'Lansetti' is the other. Made in two versions, 'Lan-
setti I' does not have the slimmed foot or base of 'Lansetti
II'. Its classic simplicity depends on perfect proportion and
the balanced tension between the opaque white glass and
the outer clear glass casing. Both 'Lansetti I' and 'II' were
in production until 1960. Since then Sarpaneva has gone
on to develop the sculptural qualities of this form in further
versions, breaking away from the highly precise manner
used here and instead employing the diametrically oppos-
ing technique of chiselling and cutting the glass. 'Lansetti
II' was purchased with Wirkkala's 'Kantarelli' and ceramics
from Arabia, from the exhibition 'Modern Art in Finland'
which travelled to London, Leeds, Brighton and Dublin in
1953. The sculpture was awarded a grand prix at the Milan
Triennale 1954.

203 Three vases ○
Clear colourless blue and olive/mustard glass, turn
mould-blown, with cut rims
Made by Nuutajärvi; designed by Saara Hopea 1953
Given by Oppi Untracht
C. 120&A&B-1988
Unmarked
H. tallest 33
Shape 1404, (also SH105)

204 Carafe ▽
Clear blue/violet glass, turn mould-blown
Made by Nuutajärvi; designed by Kaj Franck 1954;
in production 1955-60
C. 42-1988
Mark 5323 incised
H. 22

Kaj Franck's carafes were each a solution to his search for
a functional shape which would avoid the time-consuming
and expensive production of a handle. Here the container
is waisted, slim enough to be held firmly in one hand. This
and other simply shaped carafes and tumblers of the same
period were made in clear colourless glass as well as rich
red, blue, amber, two greens and grey glass.

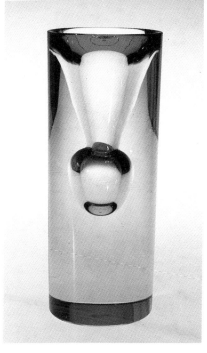

205 Pitcher and 27 stacking tumblers △
Clear green glass, mould-blown
Made by Nuutajärvi; designed by Saara Hopea 1954
Given by Oppi Untracht (one tumbler from the maker)
C. 39, 118&A-Z-1988
*Mark on pitcher SH NUUTAJÄRVI NOTSJÖ incised; on
one tumbler 4068 incised*
H. pitcher 17

This design won a silver medal at the Milan Triennale 1954.
It was in production until 1968. The pitcher here and a
number of the tumblers were formerly owned by Armi Ratia,
the founder of the Marimekko clothing and fabric company.

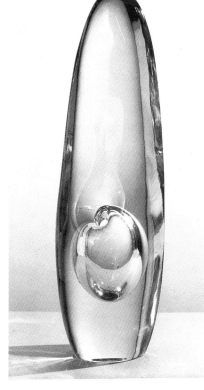

206 Vase 'Pantteri' (Panther) △
*Clear colourless glass, free-blown, enclosing purple
glass spots and trapped bubbles*
*Made by Nuutajärvi 1955; designed by Saara Hopea
1954*
Given by Oppi Untracht
C. 119-1988
Mark S HOPEA NUUTAJÄRVI NOTSJÖ - 55 incised
H. 19. 1
Shape SH109

This tapered vase was made in three basic sizes with green
or purple spots, and in a cylindrical version (SH100).

207 Sculpture 'Orkidea' (Orchid) △
Clear colourless glass, mould-blown
Made by Iittala; designed by Timo Sarpaneva 1954
Circ. 459-1954
Mark TIMO SARPANEVA - IITTALA incised
H. 38

'The most significant object of the year' (*House Beautiful*,
1954). This, and 'Lansetti II', cat. no. 202, are described
as 'art objects'. They are conceived as sculpture and, de-
spite the convention of an interior space, they are in no
sense vases. They were both included in Sarpaneva's con-
tribution to the Finnish section in the Milan Triennale 1954,
for which he was awarded a grand prix.

208 Vase 'Tokio' △
*Clear colourless glass, turn mould-blown, with inserted
bubble*
Made by Iittala 1955; designed by Tapio Wirkkala 1954
Circ. 264-1963
Mark TAPIO WIRKKALA IITTALA 55 incised
H. 22. 5

A series of 'art pieces' was designed around this motif and
included 'Tokio' and 'Marsalkansauva' (Marshal's baton).
The series won a grand prix at the Milan Triennale 1954.
The Museum's example is a variation on the 'Tokio' series,
possibly designed immediately after the Milan success.

209 Two tumblers △
Blue glass, turn mould-blown
*Made by Nuutajärvi 1962-3; designed by Kaj Franck
c. 1956*
Circ. 267, 268-1963
Unmarked
D. 7. 5

Intended to accompany the carafes, cat. nos 204, 211,
and others designed by Franck at this time.

73

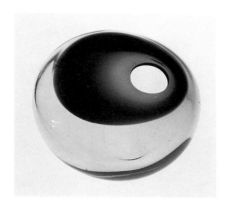

**210 Vase/sculpture 'Nukkuva Lintu'
 (Sleeping bird)** △

Clear colourless and blue glass, steam-blown
Made by Iittala 1962; designed by Timo Sarpaneva 1957
Circ. 261-1963
Mark TIMO SARPANEVA IITTALA 62-59/77 incised
L. 19. 2

This design was exhibited at the Milan Triennale 1960. In it
Sarpaneva has combined his fascination with birds and his
skill at creating these introspective, watchful yet restful
forms.

211 Two carafes and stoppers ▷

Grey/blue glass, mould-blown, the stoppers in the form of
cockerels of speckled glass in pink, red, grey and blue
Made by Nuutajärvi 1962-3; designed by Kaj Franck 1958
Circ. 194&A-1963; Circ. 139A-1964
Mark K FRANCK NUUTAJÄRVI NOTSJÖ incised; on one
62, on the other 63 incised
H. 33. 5 including stopper

These carafes are fitted with cockerel stoppers as the 'roos-
ter always stands on top'. Franck has also commented that
they should have been photographed singly. 'They don't like
competitors'.

212 Vase △

Blue glass encased in clear colourless glass
Made by Nuutajärvi 1961; designed by Kaj Franck 1959
Circ. 196-1963
Mark KJ FRANCK NUUTAJÄRVI - NOTSJÖ - 61 incised
D. 18

This vase was probably acquired for the travelling exhibition
'Glass Today', organised by the Museum's Department of
Circulation in 1963.

213 Set of four bottles ▷

Two clear blue and two clear colourless glass, blown
Made by Iittala; designed by Timo Sarpaneva 1959
Circ. 257, 258, 259, 260-1963
Mark T. SARPANEVA 2509 incised
H. 15. 2

This design, also produced in red, derives from earlier
series including both straight-sided and rounded bottles.
The inspiration is Sarpaneva's interest in old glass shapes
and his affection for birds, hence the bottles' zoomorphic
form and beak-like rim. These stacking bottles were given
the International Design Award (The American Institute of
Interior Designers) in 1963.

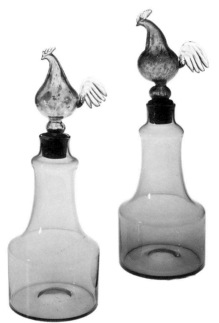

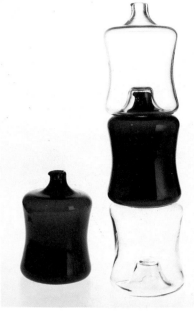

214 Sculptures 'Paaderin jää' (Paader's ice) ▽

Clear colourless glass, mould-blown
Made by Iittala 1962; designed by Tapio Wirkkala 1960
Circ. 262, 263-1963
Mark on larger TAPIO WIRKKALA - 3; on smaller TAPIO
WIRKKALA – IITTALA – 62 86/96 incised
L. larger 26

In the 1960 Milan Triennale Wirkkala was awarded medals
for designs for incandescent lamps, other glass and cast
iron. The 'Paaderin jää' series, which won a gold medal,
originates from a design of 1955. In it Wirkkala has
continued his preoccupation with Finnish natural forms
although, as always, he skilfully trades on the visual and
tactile interplay between ice and glass. Paader is the name
of a Lappish lake and is probably a figure in Finnish Lapland
mythology.

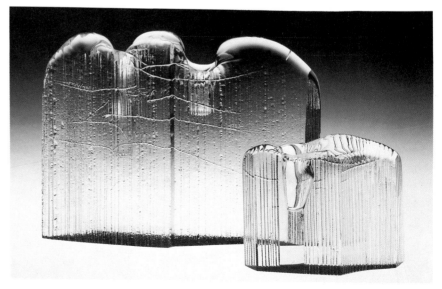

215 Two candlesticks 'Ambra' ▷
Amber glass, turn mould-blown
Made by Riihimäki; designed by Nanny Still 1961
Given by the maker
Circ. 248, 249-1963
Mark NANNY STILL RIIHIMÄEN LASI OY incised
D. larger 19. 8
Shape nos 6468, 6469

This candlestick design was in the exhibition 'Finlandia'
which toured Europe and was shown at the Museum in
1961-2. These two candlesticks were acquired by the
Museum's Department of Circulation for a travelling exhib-
ition of modern glass, 'Glass Today'.

216 Sculpture 'Kurkkupurkki'
(Pickle or cucumber jar) △
Opaque grey-brown glass, free-blown
Made by Nuutajärvi; designed by Oiva Toikka 1963
Circ. 462-1969
Mark OIVA TOIKKA NUUTAJÄRVI NOTSJÖ incised
H. 49

Oiva Toikka's pickle jars were included in his first exhibition
in 1963, held in Wärtsilä's new display rooms on Helsinki's
North Esplanade. They were his first unique works in glass.
This and 'Lollipop Isle', cat. no. 225, were bought from an
exhibition of Finnish arts and crafts held at Heal's Mansard
Gallery 1969.

217 Sculpture 'Purkaus' (Eruption),
'Finlandia' series ▷
Clear colourless glass, mould-blown and cast
Made by Iittala; designed by Timo Sarpaneva 1964
Circ. 356-1965
Mark TIMO SARPANEVA incised
H. 51

Sarpaneva developed a method which combined part blow-
ing and part casting into carved and fired alderwood
moulds. Sculptural glass was first made by this technique
in 1963. Since the process of casting the molten glass
causes a reaction between glass and wood, each piece is
unique. The moulds were further burned and re-formed
each time they were used. Sarpaneva took the experiment
one stage further and presented the moulds as sculptures
in their own right. Variations on this particular shape were
produced as a vast relief of 500 sections entitled 'Drift Ice'
for the Montreal World Fair, 'Expo '67'. The relief, owned by
the city of Tampere, was remodelled in 1988 by Sarpaneva
and has been mounted in the 'Koskikeskus' shopping
centre in Tampere.

218 Dish from the range 'Kastehelmi' (Dewdrop) ○
Clear colourless glass, pressed
Made by Nuutajärvi c. 1986; designed by Oiva Toikka
1964; still in production
Given by the maker
C. 34-1988
Unmarked
D. 24. 7

This design has been one of Nuutajärvi's and Oiva Toikka's
most successful and popular and is still in production. It
employs the most basic of pressed glass techniques in a
pattern of beaded droplets. The range includes plates,
bowls and candlesticks and has been made in a wide vari-
ety of colours including clear, grey, red, brown, blue,
emerald green and green.

219 Goblet 'Pokal' △
Clear coloured and silvered glass, free-blown with hollow
stem
Made by Nuutajärvi; designed by Kaj Franck c. 1965
C. 123-1988
Mark KAJ FRANCK NUUTAJÄRVI NOTSJÖ incised
H. 17

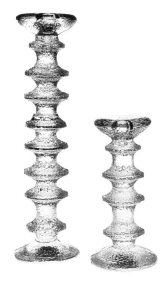

220 Two candlesticks 'Festivo' △
Clear colourless glass with moulded texturing
Made by Iittala 1987; designed by Timo Sarpaneva 1967
Given by the maker
C. 203&A-1987
Unmarked
H. taller 31. 3
Model no. 2665

The 'Festivo' range of candlesticks has been one of Sar-
paneva's most popular designs and a long-term bestseller
for Iittala. The range was first titled 'Juhlalasi' (Festival
glass) and then re-named the more international 'Festivo',
by which name it is known in Finland and for export. The
candlesticks, which come in eight different sizes, were
originally made in a charred wood mould. The texturing is
an effective shorthand which may be read as wood or bark
or as an icy frosting.

221 Two glasses from the range 'Prisma'
Clear colourless glass, pressed
Made by Nuutajärvi c. 1987; designed by Kaj Franck
1968; in production 1968-79 and from 1987
Given by the maker
C. 35&A-1988
Unmarked
H. 9

Nuutajärvi acquired automatic glass-pressing equipment in the early 1960s. Kaj Franck made several tumbler designs for the new process. 'Prisma' was one of the first selected, chosen for its optic and stacking qualities. In production by 1968, the range is a classic example of Franck's disciplined style.

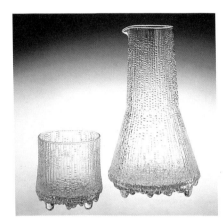

222 Jug and tumbler from the range 'Ultima Thule' △
Clear colourless glass, moulded
Made by littala 1986; designed by Tapio Wirkkala
1968-70
Given by the maker
C. 205&A-1987
Unmarked
H. carafe 21. 8
Shapes 2532, 2032

The 'Ultima Thule' range was designed for Finnair to celebrate the commencement of Atlantic flights in 1967. The original design was for a smaller tumbler, and was restricted exclusively to the airline's use for the first year. The range was introduced into the commercial market in 1968, and it was added to continuously thereafter: the tumbler was part of the introductory range of 1968, the carafe was launched in 1970. The original series was shown in the Milan Triennale 1968.

223 Part of a range 'Luna'
Clear colourless and amber glass, pressed
Made by Nuutajärvi 1987; designed by Kaj Franck
c. 1968; in production from 1972
Given by the maker
C. 36&A-E-1988
Amber bowl, tumbler and plate; colourless bowl, bowl
and plate
Mark on amber bowl 5898, on amber tumbler 5920,
on amber plate 5908 incised
D. plates 20
Shapes 5898, 5920, 5908

Kaj Franck has been dedicated to the ideal of anonymous, entirely functional design. The 'Luna' range, made using the most inexpensive, basic technique, demonstrates his commitment to this ideal and was one of the several designs proposed by Franck in the 1960s for the then new

automatic glass-pressing equipment (see cat. no. 221). Taken up later than the first choice, 'Prisma', it is the result of a ruthless rationality. It is also a perfect demonstration of the concept that functionalism, by definition, equates with aesthetic perfection. The range was issued first in colourless, amber and green glass.

224 Sculpture 'Satula' (Saddle) ○
Clear colourless glass, mould-blown
Made by littala; designed by Timo Sarpaneva 1969
Circ. 461-1969
Unmarked
L. 37. 5

This sculpture was selected for purchase by the Museum from an exhibition of Finnish arts and crafts held at Heal's Mansard Gallery in 1969, in company with work by Oiva Toikka and ceramics from Arabia.

225 Sculpture 'Lollipop Isle' 🄲
Clear and coloured glass, moulded and free-blown
Made by Nuutajärvi 1969; designed by Oiva Toikka 1969
Given by the maker
Circ. 444-1969
Mark OIVA TOIKKA NUUTAJÄRVI-NOTSJÖ incised
38 sq.

This appears to be one of the earliest examples of a favourite Toikka theme. Three years after this the artist produced a sculpture 'Lasimetsä' constructed of upright tubes and loosely fitting splayed and ballooning tops in clear colourless glass. 'Lollipop Isle' is a deceptive piece – tightly conceived but achieving its joyous effect from apparent spontaneity and Toikka's typically extravagant use of colour. It was chosen by the Museum from an exhibition of Finnish arts and crafts held at Heal's Mansard Gallery in 1969. It foreshadows Toikka's move into increasingly adventurous art forms in glass.

226 Two bottles △
Clear colourless glass, machine mould-blown
Made by littala 1987-8; designed by Tapio Wirkkala, the
litre bottle 1969-70, the flat bottle c. 1978; both in
production from 1978
Given by J. Opie
C. 114&A-1988
Mark on litre bottle LIQUOR BOTTLE FINLAND
1.0L moulded
H. litre bottle 30

Made for Alko Ltd, Helsinki, producers of Finlandia Vodka. The label was designed by Matti Viherjuuri with Eero Syvarioja of the advertising and design agency Markkinointi Viherjuuri 1969-70.

227 Two glasses 'Delfol' △
Clear colourless glass, pressed
Made by Nuutajärvi 1981; designed by Kaj Franck 1976;
in production 1980-1
Given by the maker
C. 37&A-1988
Mark on wine 4717, on liqueur 4708 incised
H. 14. 5

These glasses were designed to celebrate the 100th anniversary of the Finnish Society of Crafts and Design in 1976. They were made in full lead glass and its expensive production was terminated in 1981 after one year. The diagonal lines were designed in imitation of traditional glass cutting although the resulting appearance, in the pressed glass technique, is unmistakably modern. Franck designed a seven-sided stem in order to maximise the brilliant effect. The glasses were not designed as a set, but were intended for use with plain glass, or else alone.

228 Sculpture 'Vuosikuutiot' (Year cubes) 🄲
Coloured glass, blown, cased in clear colourless glass,
cast, and sides cut; nine cubes assembled as a unit
Made by Nuutajärvi; designed by Oiva Toikka from 1977
C. 40-1988
Mark OIVA TOIKKA NUUTAJÄRVI NOTSJÖ incised
L. 24. 3

Toikka has made the well-established 'paperweight' technique a speciality of his own at Nuutajärvi. The tiny brightly coloured images encapsulate Toikka's particular love of effervescent springing forms. Two thousand numbered pieces are made annually as 'year blocks'. Toikka uses combinations of these blocks to create unique works such as this.

229 Two mugs from the range 'Paula'
Clear colourless glass, mould-blown, with steel handles
Made by littala 1986; designed by Jorma Vennola 1977
Given by the maker
C. 208&A-1987
Unmarked
H. taller 11. 5
Shapes 2010, 2011

The 'Paula' range is one of many series of such drinking glasses made by littala. Waisted tumblers were produced as early as 1956 (by Sarpaneva) but here Jorma Vennola has re-thought the basic shape and given it a new role by the addition of a metal handle: the 'Paula' range can be used for hot punch as well as for cold drinks and includes a matching punch bowl and metal-handled glass ladle.

230 Vase 'Blues', 'Jurmo' series ▷
Opaque blue and white glass, blown
Made by Iittala 1985; designed by Timo Sarpaneva 1978
Given by the maker
C. 199-1987
Mark TIMO SARPANEVA 2/1985 incised
H. 24. 4
Shape 3037

The 'Blues' range was introduced in 1980 at an exhibition entitled 'Keskiyön Maalauksia' (Midnight paintings) and combines dark blue/black with opaque white. 'Jurmo' shapes were developed six years earlier and include this vase in four different sizes, a series of bowls, a decanter and drinking glasses. 'Jurmo' is the name of an island in the Finnish archipelago, a favourite source of ideas for many Finnish designers. The pebble-like 'Jurmo' shapes are drawn from the smooth surfaces of sea-washed rocks and stones.

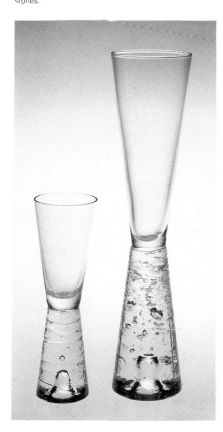

231 Two glasses 'Arkipelago' (Archipelago) △
Clear colourless glass, mould-blown, with cast stem
Made by Iittala 1987; designed by Timo Sarpaneva 1978
Given by the maker
C. 202&A-1987
Champagne, schnapps
Unmarked
H. champagne 23
Model no. 2143, shapes 2/10, 2/27

The title of this series is taken from the group of tiny islands off the Finnish coast. The 'Arkipelago' technique was launched in an exhibition at Suomenlinna Castle in 1979. By this technique it was possible to control the suspension of clear bubbles of different sizes within the body of the glass and also to produce a waved surface patterning. See also cat. no. 238, 239.

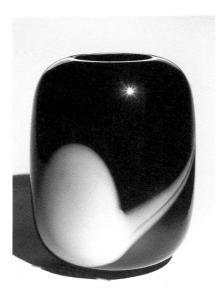

232 Three drinking glasses from the range 'Kartano' (Estate)
Clear colourless glass
Made by Iittala; designed by Tapio Wirkkala 1978;
in production 1979-83
Given by the artist
C. 15&A&B-1980
Unmarked
D. largest 8. 8
Model no. 2138

At the time of its acquisition, during the first year of its production 1979-80, this design was available to museums only. Production for general sale was from 1980-3. The design was also known as 'Kalansilma' (Fish eye).

233 Two drinking glasses from the range 'Primavera'
Clear colourless glass
Made by Iittala; designed by Tapio Wirkkala c. 1978;
in production 1979 only
Given by the artist
C. 16&A-1980
Unmarked
H. 6. 8
Model no. 2003

This and the 'Kartano' glass, cat. no. 232, were offered by Wirkkala as examples of his work for Iittala, at a time when the Museum was exhibiting his designs for Venini and Rosenthal. 'Primavera' was withdrawn from production after one year following a request from Rosenthal, who insisted that the design was too close to Wirkkala's work for them.

234 Bowl 'Huulivaasi' (Lips vase) ▷
Clear colourless glass, sand-blasted, with opaque white glass 'lips'
Made by Nuutajärvi; designed by Inkeri Toikka 1979
C. 43-1988
Mark INKERI TOIKKA NUUTAJÄRVI NOTSJÖ
H. 12

This bowl was evolved from a unique experimental vase in clear colourless glass with opaque white glass 'lips'. Inkeri Toikka has specialised in jugs and pitchers for mass production at Nuutajärvi, and carries the form into her art glass, not always retaining the functional role.

235 Three wine goblets 'Kaveri' ▽
Clear colourless glass, turn mould-blown, with interchangeable plastic stems in red, white and black
Made by Iittala; designed by Jorma Vennola 1979;
in production from 1980
Given by the maker
C. 210&A-E-1987
Mark on plastic stems IITTALA I FINLAND moulded
H. taller with stem 13. 5
Shapes 2000, 2001

Jorma Vennola has specialised in combining glass with complementary materials such as metal (see cat. no. 229) and plastic. In each case, his thoughtfully conceived and well constructed solutions have raised the finished production above what might otherwise appear to be a temporarily fashionable novelty. From 1980 the design was in production in clear colourless glass with black, white, blue and red plastic stems. From 1985-8 the design was made in white and black glass with black and white plastic stems.

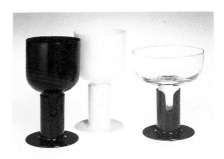

236 Sculpture 'Snow Castle' ○
Opaque white glass, blown and cast
Made by Nuutajärvi; designed by Oiva Toikka 1980
C. 41&A-1988
Mark OIVA TOIKKA NUUTAJÄRVI NOTSJÖ incised
H. 87. 5

One of a number of related sculptures with interchangeable parts which Toikka reassembles and retitles for each new exhibition. Toikka's glass has always contained a strong element of pure art. Forms such as this may have as their starting point a recognisable functional shape, but may be freely transformed, as here, into an inspired sculpture of ruched and crumpled white glass which Toikka exhibits with equal justification in an art gallery or a glassworks display. Toikka takes advantage of the special quality of opaque white glass which makes it difficult to form into precise shapes. His method of working depends on his close relationship with the glass-blowers Jarkko Niemi and Olavi Nurminen.

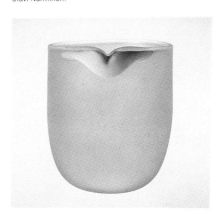

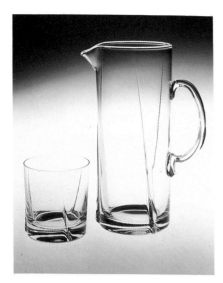

237 Part of a range 'Viva' △
Clear colourless glass, still mould-blown
Made by Iittala; designed by Tapio Wirkkala, tumbler
1980, jug 1984
Given by the maker
C. 206&A-1987
Jug and tumbler
Unmarked
H. jug 22. 5
Shapes 2445, 2045

The tumbler was put into production in 1984. The jug was the last design by Wirkkala for Iittala and was put into production in 1985.

**238 Candleholder, 'Arkipelago' (Archipelago)
series** △
Clear colourless glass, cast
Made by Iittala; designed by Timo Sarpaneva 1981
Given by the maker
C. 201-1987
Mark TIMO SARPANEVA printed
L. 21

Made in the same technique as the earlier drinking glasses, cat. no. 231, Sarpaneva's 'Arkipelago' candleholders are based on a group of his large-scale sculptures.

239 Vase 'Koh-i-Noor' ▽
Clear colourless glass, cast and cut
Made by Iittala 1984; designed by Timo Sarpaneva 1982
Given by the maker
C. 200-1987
Mark TIMO SARPANEVA 12/1984 incised
H. 18. 2
Shape 3536

This is an 'art piece'-Iittala limited production deriving from a unique sculpture. 'Koh-i-Noor' was derived from 'Gateway to Dreams' made in 1979-81 also in the 'Arkipelago' technique of suspending bubbles (see cat. no. 231). 'Gateway to Dreams' was awarded the Colin King Grand Prix (International Council of Industrial Design) 1981. The sculpture was presented to the designer Raymond Loewy.

240 Plate 'Kuusi' (Pine)
Clear colourless glass, moulded
Made by Iittala; designed by Jorma Vennola 1982
Given by the maker
C. 211-1987
Unmarked
D. 30. 2
Shape 2246

241 Sculpture, 'Claritas' series ▷
Clear colourless glass, free-blown, with bubbles in an
ovoid form, cased and lobed
Made by Iittala 1984; designed by Timo Sarpaneva 1983
Given by the maker
C. 197-1987
Mark TIMO SARPANEVA IITTALA 1984 C437 incised
H. 25. 5
Shape 3601

The 'Claritas' series - the designs and the technical method - was created in 1983. Sixty-six variations were developed, and into these have been read images of nebulae in outer space, ancient masks and mysterious beings, or of the suspended life of air, glass and light. The sculptures were first exhibited in 1984 and since then have been shown singly and in groups in exhibitions throughout Europe. The series is designed around a combination of black (reflecting dark blue), white, opal, silver blister (as in this case) and clear colourless glass. Within these disciplined limits Sarpaneva has achieved a remarkably varied collection.

242 Sculpture, 'Claritas' series △
Black glass with bubbles, cased within clear colourless
glass, free-blown
Made by Iittala 1985; designed by Timo Sarpaneva 1983
Given by the maker
C. 198-1987
Mark TIMO SARPANEVA Z/1985 incised
H. 22
Shape 3621

See also cat. nos 241, 243.

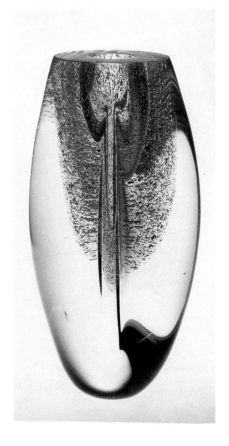

243 Sculpture, 'Claritas' series ▽
*Clear colourless glass with bubbles over opaque white
discs, cased in clear colourless glass, free-blown*
Made by Iittala; designed by Timo Sarpaneva 1983
Given by the artist
C. 234-1987
Mark TIMO SARPANEVA IITTALA incised
H. 26. 5

This unique sculpture was selected for the Museum from
the exhibition 'Timo Sarpaneva Lasiveistoksia' (glass
sculptures), Retretti, Punkaharju, 1987. See also cat. nos
241, 242.

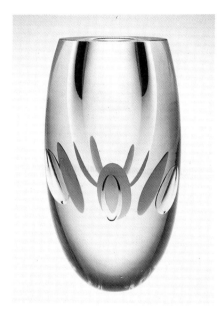

244 Vase 'Pallas'
*Clear colourless glass with random ribbed and bubbled
moulded decoration*
Made by Iittala; designed by Tapio Wirkkala 1983
Given by the maker
C. 204-1987
Unmarked
H. 26
Shape 2786

In this vase Wirkkala has continued with his preoccupation
with moulded forms reflecting dramatically textured wood
and ice effects. The vase is produced in three sizes of which
this is the largest.

245 Part of a range 'Nautilus' ▷
Clear colourless glass, still mould-blown
Made by Nuutajärvi; designed by Markku Salo 1984
Given by the maker
C. 32&A-C-1988
Mark on liqueur 8602, on tumbler 8597, on beer 8587,
on plate 8579 incised
D. plate 16
Model nos 490 (glasses), 496 (plate); shapes
004-04, 024-04, 038-04, 160-02

Although reminiscent of Kaj Franck's 'Delfoi' of 1976
(cat. no. 227), Salo has here developed the theme of wide-
stemmed glasses, comfortable as tumblers but with the
elegance of stem-ware and introduced a contrasting effect
with diagonally moulded lines combined with plain
untextured surfaces.

246 Three tumblers from the range 'Claudia' △
Clear colourless glass, partly sand-blasted
Made by Iittala; designed by Jorma Vennola 1984
Given by the maker
C. 209&A&B-1987
Schnapps, cocktail, whisky sour
Unmarked
H. tallest 10
Model no. 2044; shapes 2/50, 2/21, 2/12

247 Tumbler from the range 'Kelo' △
Clear colourless glass with twisted textured moulding
Made by Iittala; designed by Tapio Wirkkala 1984
Given by the maker
C. 207-1987
Unmarked
H. 14
Shape 2039

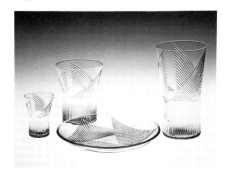

248 Part of a range 'Lumikuru' (Snow canyon) ▽
Pressed colourless glass, partly sand-blasted
Made by Nuutajärvi; designed by Kerttu Nurminen 1985
Given by the maker
C. 33&A-1988
Fondue dish, deep plate
Unmarked
D. fondue dish 25. 2

Designed by Kerttu Nurminen as a replacement for Kaj
Franck's 'Luna' range of 1971, the 'Lumikuru' range wide-
ned the choice of shapes available, to include a fondue dish
and an egg cup. It is also made without the sand-blasted
finish, under the name 'Kuru' (Canyon).

249 Sculpture 'Pyramidi' (Pyramid) 🄲
*Red glass, turn-moulded, cased in colourless glass
and sand-blasted*
Made by Nuutajärvi; designed by Heikki Orvola 1985
C. 44&A-1988
Mark HEIKKI ORVOLA NUUTAJÄRVI NOTSJÖ incised
H. 39

This is a unique piece, one of a number made by Heikki Or-
vola in 1985. He experimented with sand-blasting and with
lustrous metallic finishes, and exhibited these pyramids
with his designs for Marimekko textiles in 1985.

250 Vase 'Pastoraali'
*Green opaque glass, cased in clear colourless glass,
with glass powder between, mould-blown*
Made by Nuutajärvi; designed by Inkeri Toikka 1985
Given by the maker
C. 38-1988
Unmarked
H. 18. 4
Shape 813

251 Form 'Rubiini' 🄲
*Clear red glass with yellow glass spirals, cased in clear
colourless glass, turn mould-blown; the top of iridescent
and clear red glass*
Made at Nuutajärvi 1987; designed by Markku Salo 1987
C. 12&A-1988
Mark MARKKU SALO NUUTAJÄRVI NOTSJÖ incised
H. 60. 2

See cat. no. 252.

252 Form 'Farokin Majakka' (Farok's lighthouse) 🄲
*Purple/black glass with white glass spirals, cased in clear
colourless glass, turn mould-blown and with sand-blasted
decoration*
Made at Nuutajärvi 1987; designed by Markku Salo 1987
C. 13&A-1988
Mark MARKKU SALO NUUTAJÄRVI NOTSJÖ incised
H. 59. 7

One of a collection of forms by Salo inspired by the light-
houses of the Finnish archipelago. See also cat. no. 251.
Salo uses a variety of glass techniques to achieve his
effects. In this piece he has contrasted the regular repeat
of a mesh-like grid with irregular fluttering shapes reminis-
cent of flags. In other works he uses the same surface
effects and then restrains the entire glass form within a
metal frame, thus setting up further formal tensions.

253 Bowl ▷

Orange, pink and green enamel on copper
Made by Saara Hopea-Untracht, New York, 1960-2
Given by Oppi Untracht
C. 121-1988
Mark SAARA incised
D. 20. 8

This bowl was made by Saara Hopea in New York, after her
marriage in 1960 to the American, Oppi Untracht. It is one
of a large number of bowls and plates which were made for
the retailers Potter and Mellen Inc., Georg Jensen and
others. Saara Hopea-Untracht learned the enamelling
technique from her husband, himself a skilled practitioner
and teacher in enamelling. She quickly developed her own
special style of broad and sweeping decoration that
achieved its effect by the overlap of one transparent colour
on another, multiplying a carefully limited range of basic
colours into a rich and varied palette.

254 Dish ▽

Orange, pink, green and pearl/blue enamel on copper
Made by Saara Hopea-Untracht, Porvoo, 1980
Given by Oppi Untracht
C. 122-1988
Mark SAARA incised
D. 24. 8

The Untrachts returned to Finland in 1967 and Saara con-
tinued enamelling until 1980. Her work was sold through
the Hopea family's silver shop, Ossian Hopea-Kultasepän-
liike, Porvoo, Stockmann department store, Helsinki and
Illums Bolighus, Copenhagen, Denmark.

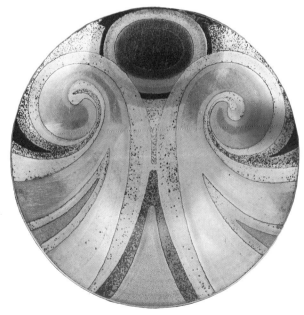

Norway's position within Scandinavia must be seen in terms of its alternating relationships with Sweden and Denmark and, more than for any of the other countries, in terms of its unique geographical peculiarities. It is a long narrow mountainous country within which communications tend to be more successful from north to south than from west to east. External contacts tend to be made most successfully through coastal routes, by sea. Traditionally therefore, the most potent influences have been from Denmark, and also from Britain across the North Sea, rather than from Sweden against which Norway lies back to back, its moutainous spine hindering any easy communication with its larger neighbour.

As in other countries, the course of political and social changes was governed by the rise in nationalist interests. The beginning of the 19th century signalled a major change in status. In 1814, under the Treaty of Kiel, Norway seceded from Denmark after four hundred years of rule and for most of the century its major struggle was in asserting its domestic, political and cultural independence from Sweden and Denmark while maintaining its status within the union with Sweden. As in Finland, Norway's own language had been ousted for administrative and executive purposes (in Norway's case by Danish) and the struggle to re-instate it became part of the nationalistic movement.

From about 1860, dissatisfaction with the Swedish-Norwegian union, under which the union's King resided in Sweden and Norway was headed locally by a governor-general, increasingly forced a polarisation of political opinion within Norway. The nationalistic Venstre party became the dominant political force. The situation finally came to a head in 1905 when the Norwegian Parliament declared the impossibility of functioning under a King whose role was purely Swedish but whose existence prevented Norway from conducting its own affairs, particularly, at this stage, its own foreign policy. In September 1905 the Swedish-Norwegian union was legally dissolved and Prince Charles of Denmark was formally adopted as Haakon VII of Norway.

Along with growing nationalism, industrialisation developed rapidly from 1860 onwards. While all the Scandinavian countries experienced a rise in population, followed by immigration to the New World, both events were particularly pronounced in Norway. The shortage of farming land coupled with a slump in exports of wood to Britain caused serious difficulties in the early 19th century. However, improvements in farming methods, an increasing market for the herring fisheries and an enormous expansion of merchant shipping all provided a basis for industrialisation. The combination of emigration of large numbers of the population with changed circumstances for those that remained and had to adjust to new employment, forced the pace of demands for social improvements and the nationalist pressure for the rights of Norwegians struggling for an identity of their own. In the early years of the 20th century Norway's industrial expansion continued apace largely based on its unequalled resource, water power. Concerns over foreign investment and ownership of Norwegian resources, coupled with the nationalist movement, formed the political opinions of the day and forced a gradual improvement in conditions throughout Norwegian society. Demand for good design stimulated industry and created an aesthetic ideology

that eventually, in 1918, resulted in the formation of an organisation to improve standards both in industry and the crafts.

Norway, as the source for many of the traditional Norse motifs adopted in neighbouring Sweden, also turned to its own heritage for inspiration although less in ceramics and glass than in other materials. In the international exhibition, Paris, 1900, Norway's most imaginative contributions were the narrative tapestries by the painter Gerhard Munthe based on Norse legends, which rivalled those in the Finnish Pavilion by Axel Gallen-Kallela, and the important enamels by the firms Tostrup and David-Andersen.

In 1901 Rose Martin was appointed as technical director at Porsgrund. A Dane, Rose Martin introduced the technique of underglaze painting perfected in Copenhagen by the Danish factories. Gerhard Munthe designed at least one pattern for Porsgrund in 1897-8 and other designs were supplied by the Symbolist painter, Thorolf Holmboe (cat. no. 257), the illustrator Theodor Kittelsen and the architect Henrik Bull (cat. no. 256). Employing the new painting technique, these patterns and, in Kittelsen's case, scenic landscapes were produced very much in a generally Nordic style but with an unmistakably Norwegian flavour. Munthe and Bull's versions of the Nordic or Viking style were distinctively spiky and medieval while Holmboe leaned towards a more decorative interpretation that was noticeably indebted to the influence of European Art Nouveau. Other patterns were based on Norwegian flowers and plants, a formula common to many factories at the time. The painter Kitty Kielland designed such patterns for the domestic earthenware factory of Egersund, and these parallel the similar subjects and style employed by Gunnar Wennerberg at Gustavsberg in Sweden.

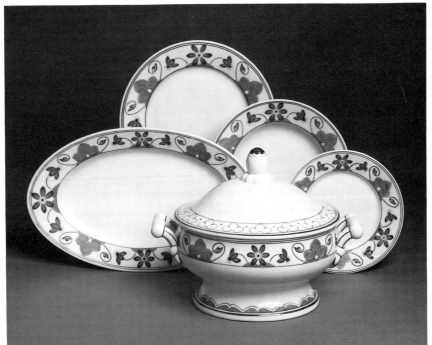

31 Tableware 'Blaaveis'
Porcelain; made by Porsgrund, designed by Hans Flygenring, c. 1921
Cat. no. 258

In the two or three years immediately before the outbreak of the First World War, the newly found impetus in design direction at Porsgrund was beginning to slow down. By 1920, although production had been little disturbed by the war, almost no progressively new designs had been obtained for the factory for nearly 10 years. In 1918 Foreningen Brukskunst (Society of Arts, Crafts and Industrial Design) was founded and as a result ideology and practical backing combined to provide pressure on Norwegian manufacturing industries to improve the standard of their design. The leaders in the new organisation were Thor Kielland, curator and later director of the Kunstindustrimuseum in Oslo and Jakob Prytz, head of the goldsmiths J. Tostrup, and teacher, later principal of the Statens Hånd-verks-og Kunstindustriskole (National College of Art and Design) An important exhibition was held by the new society, in Ullevål in 1920, concentrating on domestic objects, probably in emulation of the influential 'Hemutställningen', Stockholm 1917. In this newly vigorous and critical climate Hans Flygenring was appointed as art director at Porsgrund. Another

Dane, he had spent some time at Royal Copenhagen where he had trained under Arnold Krog. Flygenring spent seven years at Porsgrund and during that time produced designs both for decorative and useful wares. His forms tended to be firmly rounded, robust and positive (Fig. 31), reflecting his background of Danish Skønvirke, while their linear decoration hinted at richly oriental influences yet keeping their comfortable individuality.

When he left Porsgrund in 1927 Flygenring had provided an extensive stock of designs for the factory. On his departure, the impending prospect of an exhibition section by the Foreningen Brukskunst at the Bergen trade fair in 1928 provoked positive action in finding a suitable replacement. Nora Gulbrandsen was recommended by Kielland and Prytz and joined the company in 1928. Two years earlier Sverre Pettersen had joined Hadeland. In 1928 he was promoted to art director, a move which was also the result of active pressure from Kielland and Prytz.

The background to these developments in Norway was in some ways similar to that in other Scandinavian countries. The Depression of the 1920s and early 1930s had resulted in an unemployment rate of over 30 per cent. Those in work demanded improvements in working conditions. The early 1930s were disrupted by such disputes and Porsgrund was affected particularly badly. Despite this the designers at the Norwegian factories seem to have been less exercised by an ideological need to produce an inexpensive, utilitarian or functionalist style than their contemporaries in Sweden and Finland. They did not feel impelled to follow the difficult and frequently unrewarding route travelled by the Finns and Swedes, of raising the quality of daily life through the ideologically sound design of tablewares described as 'for everyday use'. Under Gulbrandsen and Pettersen, the two main factories were undoubtedly aware of the contemporary forms associated with functionalism and classicism, but there is no sense of a social principle behind these, more an appreciation of the forms for their own sake and an interest in producing attractive wares, which would sell, capable of being manufactured by inexpensive mass production methods.

From the moment of his appointment, Sverre Pettersen transformed Hadeland from being a glassworks producing unremarkable wares to one in the forefront in Norway of the new design styles, particularly those stemming from the Bauhaus. These were interpreted as simple functional forms often in thin unadorned glass. Pettersen was a versatile designer and also provided Hadeland with a series of graceful forms embellished with light and elegant cut decoration. Later he adopted a more monumental style using thicker glass and flat, polished cutting (cat. no. 296), a style particularly employed by his fellow designer, Ståle Kyllingstad. At Porsgrund, Nora Gulbrandsen made an equally effective start and long-term impact. Throughout the 1930s she supplied the factory with a stock of designs for decorative and tablewares. Always aware of the more geometric and architectural qualities in modernist design and, like Pettersen, showing a familiarity with German, even specifically Bauhaus design, Gulbrandsen also had an affection for a rather more Jazz Modern (or Art Deco) style in shape design (cat. nos 259, 260). Like Flygenring, she was highly successful in combining the twin roles of shape designer, with pattern designer, and her skills in this ranged from delicate floral patterns, through modern stripes to a distinctly graphic style which recognises the advanced thinking in lettering and lay-out achieved at the time in Germany and also in Soviet Russia (cat. no. 261).

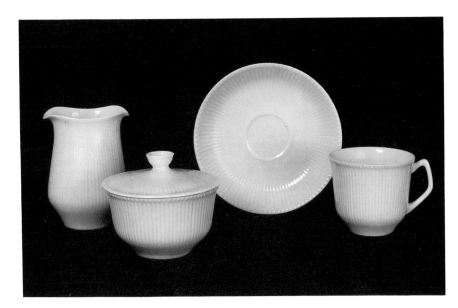

32 Tableware 'Det Riflete'
*Porcelain; made by Porsgrund, designed by Tias Eckhoff,
1949*
Cat. no. 263

33 Carafe
*Glass; made by Hadeland, designed by Herman Bongard,
1954*
Cat. no. 297

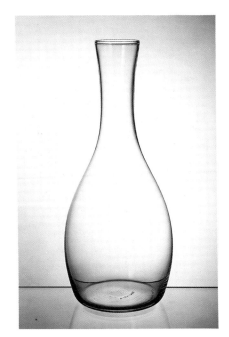

By 1937, both Porsgrund and Hadeland were exhibiting at the international exhibition in Paris and attracting favourable comments for Pettersen's graceful designs and Porsgund's display of Gulbrandsen's 'modernist' porcelain. Towards the end of the 1930s Porsgrund entered a new period of stability and success, as did much of Norwegian industry. Nora Gulbrandsen had moved into a more mature design style in which the shapes became less aggressive and more rounded, while factory production improved with more refined materials and techniques.

From April 1940 Norway was occupied by German forces, despite early attempts to form a neutral bloc with its Scandinavian neighbours. Porsgrund was put over to military production by the occupation authorities and, unlike the situation in Finland and Denmark, no Norwegian production or international cultural links were maintained or attempted for five years. After the war, the new director at Porsgrund, Jacob Aall Møller worked to re-establish Porsgrund's pre-war design and production role. Nora Gulbrandsen had left to set up independently and there was a hiatus until the promotion of Tias Eckhoff in 1952 (Fig.32). His fellow designers during this period, crucial in Porsgrund's post-war development, were Konrad Galaaen and Anne Marie Ødegaard. On Eckhoff's departure in 1957, Eystein Sandnes became art director. During this period, at the Milan Triennales in 1954, 1957 and 1960, Porsgrund won three gold medals and one silver medal for tableware designed by Tias Eckhoff and Eystein Sandnes. In this invigorating climate Porsgrund was able to move into a post-war 'golden era'. In this it was accompanied by the smaller factories of Figgjo Fajansefabrik and Stavangerflint. On the glass side, Hadeland too re-entered the international sphere with a new team of designers achieving successes at the Milan Triennales. In 1954 Willy Johansson's glass attracted a diplôme d'honneur. He repeated this success with a gold medal in 1957 when, in an extraordinary display by Arne Korsmo, glass and other objects were placed in an 'aerial frame'. He also won a silver medal in 1960. At the same time, like many of his contemporaries he was able to provide a steady stream of designs for useful wares which supplied the factory's serial production needs.

Johansson was one of Hadeland's most important designers. He had joined the glassworks in 1936 following in the footsteps of his grandfather, who had come from the Swedish glass

district of Småland, and his father, who had been a senior glass-blower at the Hadeland works. Willy Johansson served an apprenticeship under Ståle Kyllingstad, learning the art of sand-blasting and then, later, of engraving, at the Christiana Glasmagasin. He was appointed to replace Kyllingstad in 1947. Within the next five to 10 years the Hadeland team was increased to include the major star Norwegian glass designers Hermann Bongard, Arne Jon Jutrem and Severin Brørby.

Bongard was a senior figure in Norwegian design, contributing elegant and witty designs to a wide range of products from cane furniture to book illustration. He trained under Sverre Pettersen at the NCAD where he was also taught by the painter Per Krohg. He was able to apply this experience of both three-dimensional form and two-dimensional line drawing with great versatility to almost any form of commercial or art design. He began designing for glass in 1947 when he was appointed to Hadeland by Sverre Pettersen. Bongard supplied clear pure shapes (Fig.33) and also designs for decoration by either sand-blasting or engraving. His versatility led to designs for Stavangerflint and Figgjo Fajanse.

All of these individual designers contributed to what became an identifiable and rounded Norwegian design style, mainly based on functional wares. This unpretentious, even simple taste owed a great deal to practical commonsense but nevertheless was also concerned with a lightness of touch and fondness for curves which sets it apart from that of its Danish and Swedish neighbours.

Norway had made a late entrance onto the scene of international success of Scandinavian design in the 1950s. Its recovery from the war was slower, not so much in material terms but more in psychological attitude. There were deep divisions within Norwegian society following the experience of the Occupation and the country's initial inclination was to hark back to pre-war unity and successes with a positive call to Norwegian designers and artists to return to traditional arts as a means of re-establishing a new Norwegian identity. In 1960 in a conscious attempt to encourage Norwegian design, Hermann Bongard became artistic manager of the new design workshops, Plus, established in 1958 and installed in the old fortress town of Fredrikstad. It was intended to supply industry with models and designers. However, in a climate that favoured an interest in tradition and crafts, Plus soon changed to a less assertive role, to workshops for craftspeople specialising in various materials. As such the Plus workshops provided a base and facilities for a number of Norwegian artists of whom one of the most influential was Benny Motzfeldt.

34 Egg Form
Glass; made at Plus Glasshytte, designed by Benny Motzfeldt, 1978
Cat. no. 304

Motzfeldt was the first of the individual studio glass artists, a field which even now is occupied by only a very few in Norway. Previously a water-colourist, illustrator and commercial artist, she began as a designer at Hadeland in 1955 and subsequently at Randsfjord glassworks in 1967, a much smaller factory nearby where she was able to work far more informally. In 1970 she joined the Plus group as manager of the glassmaking section. She is best known for her freely formed bubbled glass, clear, colourless and coloured, into which she adds a mixture of metal threads, metal gauze and fibre glass shapes in an apparently spontaneous manner. These attract and direct the movement of the bubbles within the molten glass creating depth and rhythm in a manner which is distinctively her own and has been very influential on a generation of younger Norwegian glassmakers (Fig.34).

Following the establishment of the Plus complex a number of other workshops sprang up. The old Foreningen Brukskunst, which had become the Landsforbundet Norske Brukskunst was forced to re-evaluate its approach and to address what were perceived as the different needs of crafts and industry while at the same time attempting to display a unified, balanced front. This change of gear was common right across Scandinavia, as the training of craftspeople and designers was criticised and re-structured following the dwindling status of Scandinavian design and the re-emergence of crafts internationally. By the 1970s the debate between crafts and industry had resulted in an effective polarisation between the two.

Norwegian craftspeople were particularly successful. They formed co-operative groups which provided a support network and re-shaped the entire structure from training to the working environment and marketing. Organised in a group, the Norske Kunsthåndverkere (Association of Norwegian Craftsmen), they achieved a major breakthrough which was unique in Scandinavia. Representing both crafts and 'fine' arts, the group negotiated as a trade union and won legislated support from the government. A guaranteed minimum income for a small but nevertheless significant group of artist-craftspeople was agreed. This policy has been fundamental to the great progress that studio ceramics, glass and enamels have made in the last two decades. Norway now has an established dynasty of studio potters, glassmakers and enamellists starting with teachers and influential artists in their own right like Erik Pløen, Benny Motzfeldt and Grete Prytz. Today glass artists such as Karen Klim and Ulla Mari Brantenberg, with potters Kristina Andreassen and Marit Tingleff (Fig.35) are pointing their chosen materials in technically and artistically new directions. Others such as Jorun Kraft Mo are experimenting with mixed materials — perspex (cat. no. 287), wood, feathers — widening the possibilities previously aired by the perfectly attuned colourists Lisbeth Daehlin and Bente Saetrang who work as a team, producing superbly decorative tea pots (cat. no. 294). Arne Åse and Kari Christensen have been the standard bearers of Norwegian ceramics internationally for many years and are established senior names.

35 Bowl
Earthenware; made by Marit Tingleff, c. 1987-8
Cat. no. 293

In recent years, designers and artists in Norway have had to face the same challenges as their counterparts abroad, as have those responsible for promoting them. Design in Norway has had to find new outlets, since the pioneering days of Kielland, who as director of the Kunstindustrimuseet, was positive about the role which his museum should play. During the 1930s he set up a permanent exhibition space within the museum for the display and promotion of industrially-made Norwegian goods, accompanied by an impressive series of catalogues and year books. For a museum of the industrial arts he saw this innovative step, now discontinued, as a natural and logical function. Other support groups were formed. In 1955 the ID Norsk Gruppe for Industriell Formgivning (ID Norwegian Group for Industrial Design) was founded. The Artists' House, opened in Oslo in 1930 and the main showcase for the activities of the Landsforbundet Norske Brukskunst, provided exhibition space for the new group within the Brukskunst society's own autumn exhibition in 1955. Nevertheless, the ID group operated independently. It arranged the 1957 Milan Triennale display. It established a photo library for design productions and a design prize from 1961. Two years later a major exhibition was held in the Kunstindustrimuseet in Oslo, and the Norsk Designcentrum (Norwegian Design Centre) was set up in 1965. From then on this administered the awards with the aim of promoting good Norwegian design and quality in the same spirit as

national design centres elsewhere. Eystein Sandnes was awarded the prize in 1965 (for 'As-keladden' and 'Jubilaeum' cat. no.273), and in 1970 (for 'Eystein', cat. no. 276). Tias Eck-hoff also received the award in 1965 (for 'Regent', cat. no. 274), Konrad Galaaen in 1967 (for ashtrays) and Anne Marie Ødegaard in 1969 (for 'Ceylon').

The divisions between art and design, once clearly identified, no longer seem so divisive. Hadeland and Porsgrund both maintain an art or unique wares production. Hadeland have recently returned to an experimental series by their long-term designer, Gro Bergslien, while Arne Jon Jutrem (Fig.36) and Willy Johansson continue to work with the clean colours and shapes which they have long since perfected. At Porsgrund, under the direction of the Dane Poul Jensen, a strong team of designers works on serial production. Each designer also produces individual ceramics made as studio wares within the factory. Eystein Sand-nes, now the senior figure on the team, has provided the factory with generations of well formed, sturdy tablewares based firmly on commonsense and an eye for strong forms and positive colour. In his own work he has been experimenting with bowls and dishes with freely brushed decoration. Poul Jensen himself makes unique pieces at the factory and, totally independently, wood-fired porcelain at a small pottery near Oslo (cat. nos 286, 290). Leif Helge Enger provides a complementary combination of rugged stonewares and elegant porcelains (Fig.37). Grete Rønning also concentrates on porcelain tableware production as well as making grandly conceived unique works like the recent porcelain fish dishes. The factory management has also, very recently, followed the highly creditable Scandinavian tradition of attracting an artist-in-residence. Established and of proven mutual benefit to artist and factory at Arabia, Bing & Grøndahl and Royal Copenhagen, this is a new departure for Porsgrund. They hope to establish this as a regular arrangement with invited artists.

In 1963 Alf Bøe, writing on 'Norwegian Industrial Design', analysed the then current state of industrial design of all materials in Norway. At that juncture he said that industry stood alone without any competition from the crafts and he hoped for a greater refinement in de-sign and ideology. Twenty-five years later, competition from the crafts has not been a threat or a reality. Rather, in some cases, the two have been married successfully. Leif Enger's stonewares, for instance, have been sensitively translated into attractive serial production (cat. nos 275, 278).

Norway has achieved an interesting balance between unobtrusive support and freedom for its creative artists. Its factories pride themselves on combining successful business sense with a shrewd generosity towards their artists. Porsgrund is experimenting with porcelain ski-slope surfaces at the same time as planning a second artist-in-residence invitation. Hadeland, like many factories, runs a successful visitor industry against a background of steady production and the launch, in 1988, of a new range of decorative wares by Gro Bergs-lien. In looking more to the international market, Norway hopes to expand commercially, while the studio artists are now establishing a reputation abroad.

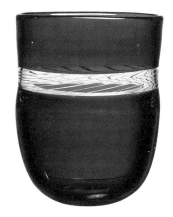

36 Vase
Glass; made by Hadeland, designed by Arne Jon Jutrem, 1988
Cat. no. 318

37 Tableware
Porcelain; made by Leif Helge Enger at Porsgrund, 1984
Cat. no. 284

255　Plate 'Höstblader' (Autumn leaves),
shape 'Feston'　△

Porcelain with transfer-printed decoration of leaves
painted in browns and greens
Made by Porsgrund between 1911-37; designer unknown
c. 1900
Given by the Porsgrunn Bymuseum from the factory
collection
C. 129-1988
Mark　PP either side of an anchor printed in green
D. 22. 2

Although anonymous, this design typifies the simple
unpretentious patterns of the early 1900s.

256　Plate　▽

Porcelain with printed decoration of Nordic motifs in blue
Made by Porsgrund; designed by Henrik Bull c. 1900-5
Given by the Porsgrunn Bymuseum from the factory
collection
C. 127-1988
Mark　PP either side of an anchor printed in underglaze
blue
D. 24

Henrik Bull was an architect and one of several independent
designers associated with Porsgrund at the turn of the
century. He was interested in and influenced by a number
of different stylistic movements particularly medieval
Nordic forms, like others of his generation. He based his
own 'Uvdal nye Kirke', 1893, on the Norwegian stave-
church. Similarly, the motifs on this plate are related to the
decoration found on such medieval Norwegian stave-
churches. The plate was produced under Porsgrund's tech-
nical director Rose Martin who, as a Dane, brought to
Porsgrund the tradition of decoration in underglaze blue as
practised by the Copenhagen factories.

257　Coffee cup, saucer and plate　▽

Porcelain, moulded and with painted decoration in under-
glaze blue
Made by Porsgrund c. 1911; designed by Thorolf Holmboe
c. 1908
Given by the Porsgrunn Bymuseum from the factory
collection
C. 128&A&B-1988
Mark　PP either side of an anchor: on coffee cup printed
in green; on saucer and plate printed in underglaze blue
D. plate 17. 1
Shapes 332-4 (cup), 1250 (saucer)

Like Henrik Bull (see cat. no. 256), Thorolf Holmboe was an
independent artist who was associated with Porsgrund
early this century. He was a Symbolist painter and a book
illustrator as well as a designer for the pottery from
1908-11.

258　Part of a tableware range 'Blaavels'
(Blue anemone)　○

Porcelain with printed decoration of stylised leaves and
flowers in underglaze blue
Made by Porsgrund 1923; designed by Hans Flygenring
c. 1921
Given by the Porsgrunn Bymuseum from the factory
collection
C. 130&A-E-1988
Small plate, deep plate, large plate, oval plate, tureen
and cover
Mark　PP either side of an anchor and BLAAVEIS printed
in green
L. oval plate 31. 8

Flygenring's generous and comfortable style is exemplified
in this service. It is tempting to compare this, as the work
of a Danish-born designer, with the more angular, nervy
manner of the Norwegians Bull and, later, Gulbrandsen.

259　Part of a tableware range　🅲

Porcelain with sprayed and painted decoration of banding
in grey/black, yellow and orange
Made by Porsgrund; designed by Nora Gulbrandsen
c. 1929-31
Given by the maker
C. 144&A-D-1987
Coffee pot and lid, sugar bowl and lid, cream jug
Mark　PP either side of an anchor and PORSGRUNN
NORGE printed in green; 1877 incised; 1877/777 N.G.
painted in red
H. coffee pot 21
Shape 1877(?)

On her arrival following Flygenring's departure in 1927,
Gulbrandsen revolutionised Porsgrund's image, entirely
rejecting the rounded forms of Flygenring and opting for
a modernist, architectural look.

260　Part of a tableware range　△

Porcelain with painted decoration of banding in green,
black and gold
Made by Porsgrund; designed by Nora Gulbrandsen
c. 1929-31
Given by the maker
C. 145&A-C-1987
Tea cup and saucer, side plate
Mark　PP either side of an anchor printed in green; 1877
incised
D. plate 16. 7　Shape 1877(?)

261　Plate　🅲

Porcelain with painted decoration of a view of the
Porsgrund factory in red and black
Made by Porsgrund; designed by Nora Gulbrandsen
c. 1928-30
Given by the Porsgrunn Bymuseum from the factory
collection
C. 132-1988
Mark　PP either side of an anchor and PORSGRUND
NORGE printed in green within a circle
D. 26. 7

The similarity of this to Soviet ceramics shows
Gulbrandsen's interests in trends abroad. Possibly
designed at the time of the Bergen exhibition, 1928.

262　Tureen and cover　△

Earthenware with white tin glaze and painted decoration
of checks and flowers in pink
Probably made by Carl Christensen at Sidsel Hartwig
Jensen's workshop, Oslo, c. 1947; designed and painted
by Sidsel Hartwig Jensen c. 1947
Given by Dr Ada Polak
C. 176&A-1981
Mark　SIDSEL hand-painted in pink
W. 19

Almost nothing is known of Carl Christensen; he is believed
to have been Danish and it is assumed that he was a thrower,
at this time working at Sidsel Hartwig Jensen's workshop.
Jensen's work is typical of the craftsman-like approach
pioneered by Jens von Lippe, with whom she trained.

263 Part of a tableware range 'Det Riflete' ('The fluted one') ○
Porcelain with moulded fluted decoration
Made by Porsgrund; designed by Tias Eckhoff 1949;
in production from 1952
Given by the maker
Circ. 136&A, 137&A, 142, 143&A-1960
Coffee cup and saucer, tea cup and saucer, cream jug,
sugar bowl and cover
Mark PP either side of an anchor and PORSGRUND NOR-
WAY printed in green on coffee cup 57, on coffee saucer
57, on tea cup 56, on cream jug 56 printed in green; on
tea saucer and sugar bowl PP either side of an anchor and
PORSGRUNN NORWAY 55 printed in green
D. saucer 12. 5
Model no. 2255

In 1954 Norway participated for the first time in the Milan
Triennales, in a display designed by Arne Korsmo who also
designed tableware produced by Porsgrund especially for
the 1954 exhibition. This set won a gold medal. It was
among a group of wares assembled first as loans for a
travelling exhibition 'Scandinavian Tablewares', arranged
by the Museum's Department of Circulation, 1956-7. (This
was one of two exhibitions, the other featuring designs
from Germany, Holland and Italy).

264 Coffee pot and cover 'Glohane' △
Porcelain with blue/black glaze
Made by Porsgrund; designed by Tias Eckhoff 1951;
in production 1955-9
Given by the maker
Circ. 141&A-1960
Unmarked
W. 25
Model no. 6065, 2476

'Glohane' was an oven-to-table range produced in simple
basic shapes and clean bright colours (black, blue and
yellow). The range was awarded a gold medal at the Milan
Triennale 1957. This coffee pot was acquired originally for
a travelling exhibition 'Scandinavian Tablewares' (see cat.
no. 263).

265 Vase ▷
Earthenware with incised decoration and white tin glaze
Made by Kongsberg; designed by Rolf Hansen 1951
Given by the maker
Circ. 46-1952
Mark KBG incised
H. 19. 9

Included in and acquired from the exhibition 'Scandinavia
at Table', arranged by the Council of Industrial Design at
the Museum, 1951.

266 Bowl
Earthenware with incised decoration and white tin glaze
Made by Kongsberg; designed by Rolf Hansen 1951
Given by the maker
Circ. 47-1952
Mark KBG incised
D. 10. 1

Included in and acquired from the exhibition 'Scandinavia
at Table', arranged by the Council of Industrial Design at
the Museum, 1951. See cat. no. 265.

267 Bowl on stem △
Earthenware, thrown and hand-built, with white glaze
decoration inside and black slip outside
Made by William Knutzen, Lysaker, 1951
Given by the artist
Circ. 57-1952
Mark WILLIAM handwritten in black slip
L. 23. 4

William Knutzen was part of the newly emerging studio
pottery movement in Norway in the early 1950s. He
pursued a varied career and also made several study trips
abroad to Germany, France and Italy. This bowl was included
in and acquired from the exhibition 'Scandinavia at Table',
arranged by the Council of Industrial Design at the
Museum, 1951.

268 Bowl △
Earthenware with black slip inside and white glaze
decoration outside
Made by William Knutzen, Lysaker, 1951
Given by the artist
Circ. 58-1952
Mark WILLIAM handwritten in black slip
D. 7. 3

Included in and acquired from the exhibition 'Scandinavia
at Table', arranged by the Council of Industrial Design at
the Museum, 1951.

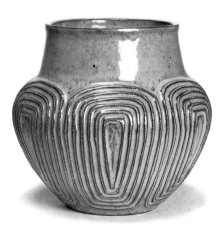

269 Vase △
Earthenware with carved relief decoration and green
glaze
Made by Kaare Fjeldsaa, Blommenholm, c. 1951
Given by the artist
Circ. 53-1952
Mark KBF in monogram and NORGE incised
D. 11. 7

Included in and acquired from the exhibition 'Scandinavia
at Table', arranged by the Council of Industrial Design at the
Museum, 1951. Kaare Fjeldsaa divided his time between
work for industrial factories including Royal Copenhagen,
Stavangerflint and Figgjo Fajanse, as well as running a
successful studio. He was awarded a gold medal at the
Milan Triennale 1954.

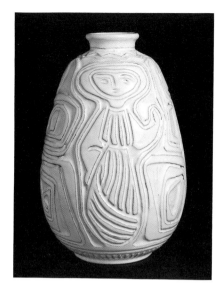

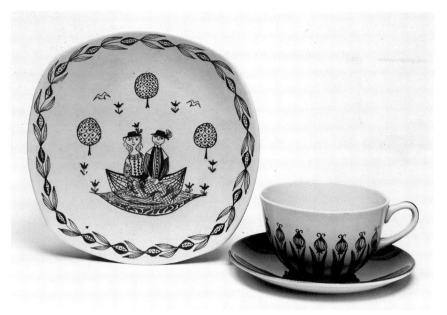

270 Vase △

Earthenware with relief decoration and white tin glaze
Made by Kaare Fjeldsaa, Blommenholm, c. 1951
Given by the artist
Circ. 54-1952
Mark KBF in monogram incised
H. 19. 4

Included in and acquired from the exhibition 'Scandinavia at Table', arranged by the Council of Industrial Design at the Museum, 1951.

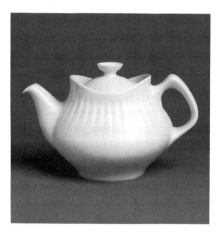

271 Part of a tableware range 'Spire' △

Porcelain with moulded decoration
Made by Porsgrund (tea pot 1987); designed by Konrad Galaaen 1952; in production from 1953
Given by the maker
Circ. 138&A, 139, 140, 144, 145-1960; C. 146&A-1987
Cup and saucer, dessert plate, soup bowl, cream jug, sugar bowl, tea pot and lid
Mark PP either side of an anchor and PORSGRUND NORWAY printed in green; on saucer 57, on plate 56, on soup bowl 56, on cream jug 57, on sugar bowl 56 printed in green
L. tea pot 22
Model no. 2275

Acquired originally for a travelling exhibition 'Scandinavian Tablewares' (see cat. no. 263).

272 Plate, cup and saucer △

Stoneware with silkscreened decoration in blue on a light blue ground
Made by Stavangerflint; decoration designed by Kari Nyquist c. 1955
Given by J. Wuidart & Co.
Circ. 167, 168&A-1960
Mark STAVANGERFLINT, a hammer and NORWAY KARI printed in blue
W. plate 26

Kari Nyquist was a designer/decorator who worked with Stavangerflint and Figgjo Fajanse as a freelance. Her style compares with early Wiinblad in Denmark and some of Stig Lindberg's work in Sweden (see cat. nos 66, 375). This set was acquired originally for a travelling exhibition 'Scandinavian Tablewares', arranged by the Museum's Department of Circulation, 1956-7 (see cat. no. 263).

273 Two cups from the tableware range 'Jubilaeum' ▽

Porcelain, one saucer with brown glaze
Made by Porsgrund 1964, 1967 and 1969; designed by Eystein Sandnes; in production from 1959
Given by the Porsgrunn Bymuseum from the factory collection
C. 131&A-C-1988
Mark PORSGRUND PP either side of an anchor and NORWAY printed in green; on one cup 64, on one cup 69, on white saucer 67 printed in green
D. saucer 14. 7
Model no. 2340

The service won a silver medal at the Milan Triennale 1960 and the Norsk Designcentrum award for good design, 1965. Eystein Sandnes took over from Tias Eckhoff as Porsgrund's art director in 1957. He has regularly provided the company with many of its best tableware designs over a period of nearly 30 years.

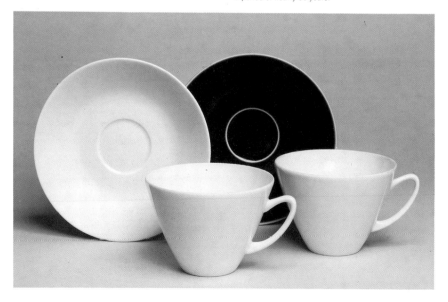

Dagny Hald works with her husband Finn. They specialise in figurative sculptures using motifs taken from Norwegian sagas, frequently with humorous interpretations. This was included in the exhibition 'International Ceramics' held at the Museum, 1972 (catalogue: Norway no. 6).

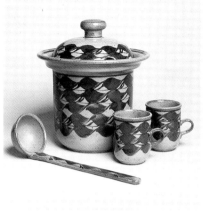

274 Part of a tableware range 'Regent' △
Porcelain
Made by Porsgrund; designed by Tias Eckhoff 1961
Given by the maker
C. 151&A-F-1987
Coffee pot and lid, cup and saucer, plate, creamer, sugar bowl
Mark PP either side of an anchor and PORSGRUND NORWAY printed in green
L. tea pot 31
Model no. 2365

A rather sturdier relative of this design but with a shorter spout and more angular handle (model no. 2350) was also produced as hotel ware from 1961. 'Regent' won a Norsk Designcentrum award in 1965. It is still in production.

275 Dish **C**
Stoneware with speckled glaze and painted decoration in blue
Made by Leif Helge Enger at Porsgrund 1965
Given by the maker
C. 133-1988
Mark LEIF NORWAY signed in black
D. 29

This dish is a prototype for one that was subsequently put into production as model no. 2391. Personal studio ware like this was the basis for factory production ranges such as 'Ballade' cat. no. 278.

276 Part of a tableware range 'Eystein-Saga', shape 'Eystein' ▷
Porcelain with painted decoration of banding in blue and green
Made by Porsgrund c. 1986; designed by Eystein Sandnes 1970
Given by the maker
C. 152&A-D-1987
Tea pot and lid, cup and saucer, side plate, bowl, plate, sugar bowl and lid, milk jug, egg cup, salt and pepper, tureen and cover
Mark PP either side of an anchor and PORSGRUND NORWAY HANDPAINTED printed in green
D. tureen 27. 5
Model no. 2440

In 1970 Eystein won both 'Die Gute Industriform' award, Hannover, and the Norsk Designcentrum award for good design.

277 'Woman in a Meadow' ▽
Stoneware figure of a woman seated on a bed of flowers, painted with coloured glazes
Made by Dagny Hald, Soon, 1972
Circ. 619-1972
Mark none visible
L. 46

278 Part of a glögg set 'Ballade' △
Stoneware with painted decoration; inside a printed recipe for glögg for 12 persons
Made by Porsgrund; designed by Leif Helge Enger 1977
Given by the maker
C. 148&A-D-1987
Pot and cover, ladle and two mugs
Mark PP either side of an anchor and PORSGRUND NORWAY HANDPAINTED printed in green; LHA in monogram painted in black
H. pot 26

Leif Enger makes individual studio wares in richly speckled stoneware and with freely painted calligraphic decoration (see cat. no. 275). This glögg set is the serial production version of the studio ware. Glögg, the traditional winter or Christmas drink in Scandinavia, is mulled wine spiked with vodka, nuts and raisins.

279 Panel of tiles ▷

*Earthenware with decoration of a woman in raised slip
outline and painted with coloured glazes
Made by Porsgrund; designed by Konrad Galaaen 1978
Given by the maker
C. 143-1987
Mark none visible on tiles; K. GALAAEN cut into frame
H. 53. 5*

One of several tile panels designed by Konrad Galaaen in
the late 1970s using this distinctive technique of a thick
trailed-slip outline filled in with clear, deeply coloured
glazes.

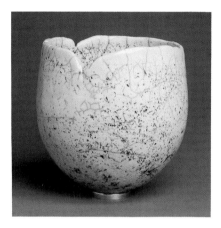

280 Bowl △

*Stoneware, raku-fired, with silver mounted foot
Made by Reidun Sissel Gjerdrum, Trondheim, 1982
C. 138-1988
Unmarked
D. 11*

Reidun Sissel Gjerdrum has specialised in raku-firing, a
traditional Japanese technique of firing pots by direct pro-
cess in a red-hot kiln. The ceramics are removed and cooled
rapidly using a variety of media, such as water, wet straw
or wood chippings. Gjerdrum has also worked with the gold
and silversmith Synnøve Korssjøen, and many of her works
are embellished with metal mounts or other additions.

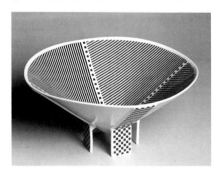

281 Bowl △

*Porcelain with printed decoration in grey/black
Made by Porsgrund; designed by Grete Rønning
c. 1982-3
Given by the maker
C. 149-1987
Unmarked
D. 18*

This shape is a prototype for the 'Saturn' series which
includes the tableware range cat. no. 282.

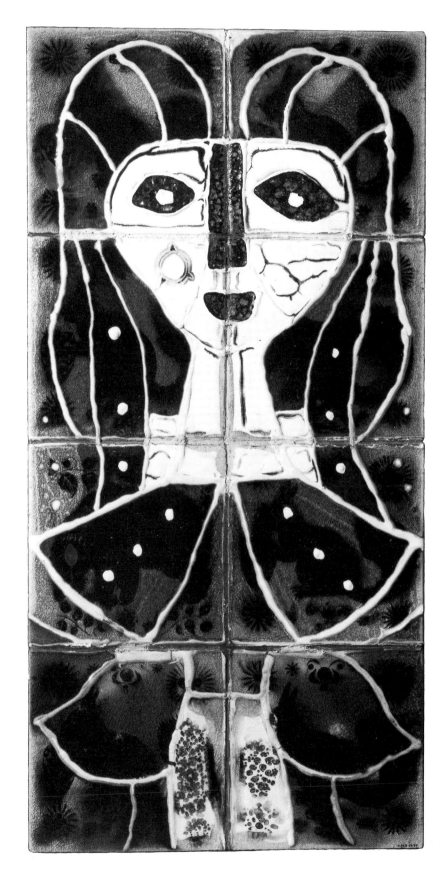

282 Part of a tableware range 'Comet', shape 'Saturn' ▷
Porcelain with ringed moulding
Made by Porsgrund; designed by Grete Rønning 1983
Given by the maker
C. 150&A-G-1987
Coffee pot and lid, cup and saucer, jug, sugar bowl, cream jug, plate
Mark PP either side of an anchor and PORSGRUND NORWAY printed in green
H. coffee pot 19.3
Model no. 2620

In 1984 this range, including its matching glassware cat. no. 313, was given the 'Form 84' award at the Frankfurt Fair.

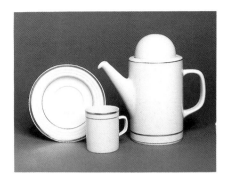

286 Vase ▽
Porcelain, cast, with incised and painted decoration
Made by Poul Jensen at Porsgrund 1985
Given by the maker
C. 153-1987
Mark POUL JENSEN .1985 incised; PJ 85 painted in black
L. 31

This is a factory 'studio' work made by Poul Jensen, the art director, who also makes his own work independently of the factory (see cat. no. 290). He has been exploring these complicated cast forms which he combines with lightly drawn incised decoration.

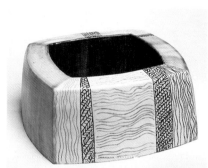

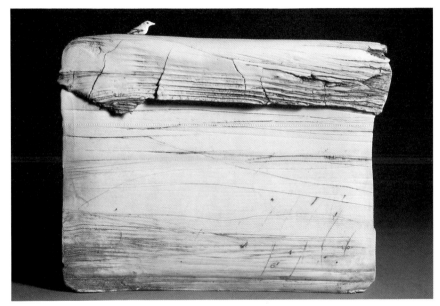

283 Sculpture 'Bølge og fugl' (Wave and bird) △
Porcelain, hand-built, with incised and slightly coloured texturing
Made by Kari Christensen, Oslo, 1984
C. 141-1988
Mark KC in monogram painted in black
L. 36

Kari Christensen has made a series of porcelain sculptures based on birds and wave forms. Her particular technique gives the porcelain a bleached, driftwood-like appearance. After this series she produced more humanoid birds, less whimsical and rather more sombre and demanding. Recently, she has also started working in stoneware.

284 Tea pot and lid, cup and saucer ○
Porcelain with splashed silkscreened decoration in underglaze blue
Made by Leif Helge Enger at Porsgrund 1984
Given by the maker
C. 180&A-C-1988
Mark PP either side of an anchor and PORSGRUND HÅNDVERKS STUDIO LEIF HELGE ENGER NORWAY printed in black
L. tea pot 23. 4

Leif Helge Enger is a stylish and elegant designer/potter who has been equally at home working in stoneware (see cat. no. 275) and in this finely conceived porcelain. This tea pot and cup and saucer are prototypes. Production of these designs is still under discussion.

287 Form ▽
Stoneware, raku-fired, with perspex top
Made by Jorun Kraft Mo, Trondheim, 1985
C. 140-1988
Unmarked: signed on wooden base JORUNN KRAFT MO, DRILLVEITA 3, 7000 TRONDHEIM
L. 26. 5

Like Gjerdrum (see cat. nos 280, 285), Jorunn Kraft Mo has specialised in raku-firing. She has concerned herself with mixed materials, embellishing her work with feathers, woven cord, etc., and has deliberately emulated Japanese forms. More recently she has added perspex and glass to her repertoire and now concentrates increasingly on these materials. This form, therefore, represents an interim stage in her development.

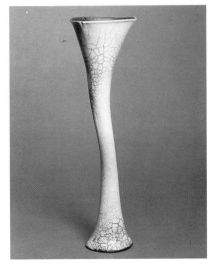

285 Form △
Stoneware, raku-fired
Made by Reidun Sissel Gjerdrum, Trondheim, 1985
C. 139-1988
Unmarked
H. 28

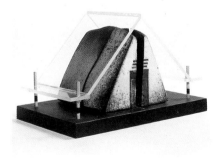

288 Bottle
Porcelain, in the form of a bird, partly with a black glaze, and with a cork
Made by Porsgrund; designed by Leif Helge Enger c. 1985
Given by the maker
C. 147-1987
Mark PP either side of an anchor and PORSGRUND HÅNDVERKS STUDIO NORWAY printed in black; LHE in monogram painted in black
H. 19. 5

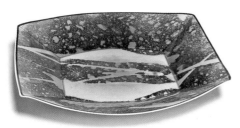

289 Dish △
Porcelain with splashed decoration in underglaze blue
Made by Leif Helge Enger at Porsgrund c. 1985
Given by the maker
C. 154-1987
Mark HÅNDVERKS - STUDIO NORWAY DESIGN LEIF HELGE ENGER HÅNDMALT printed in brown
L. 53. 5

290 Vase ▷
Porcelain, cast, with incised and painted decoration in rust-brown and blue
Made by Poul Jensen, Oslo, 1986
Given by the artist
C. 134-1988
Mark 1986 incised (none other visible)
20.1 sq.

This vase was included in an exhibition at Gallerie Føyner, Oslo, June 1988, with its companion vase, now in the Nordenfjeldske Museum, Trondheim. This is Poul Jensen's own work, made at a small wood-fired pottery independently of the Porsgrund factory where he is art director.

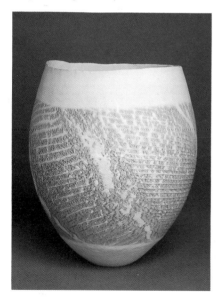

291 Vase △
Mixed coloured porcelains, hand-built
Made by Kristin Andreassen, Fredrikstad, 1987
C. 137-1988
Mark KRISTIN ANDREASSEN '87 incised
H. 26. 3

Kristin Andreassen completed her studies at the National College of Art and Design (NCAD) with the highest distinction ever. She has devised this intricate technique of mixed coloured porcelains which is instantly recognisable as her speciality.

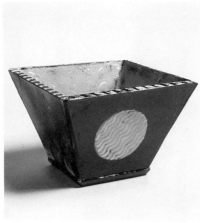

292 Vase △
Earthenware with painted and incised decoration of stripes, circles and whorls in black, white and pinks
Made by Ingrid Mortensen, Oslo, c. 1987-8
C. 148-1988
Mark INGRID M incised through white slip
23 sq.

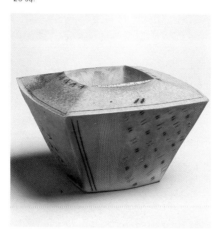

293 Bowl ○
Earthenware with incised and painted decoration
Made by Marit Tingleff, Hønefoss, c. 1987-8
C. 147-1988
Mark MT in monogram painted in pink slip
L. 32. 6

Marit Tingleff achieved international success with her contribution to the exhibition 'Scandinavian Craft Today' shown in Tokyo and New York, 1987. She has evolved this very distinctive style of nervously incised decoration with a highly worked painted surface.

294 Tea pot and lid C
Earthenware with matt blue slip surface, and with fabric-covered cane handle
Made by Lisbeth Daehlin, the handle decorated by Bente Saetrang, Frysja, 1988
C. 135&A-1988
Mark the artist's signature incised
H. with handle 35

Lisbeth Daehlin is Danish by birth and her particular trademark is this matt ultramarine slip which she uses characteristically on a dark red body and with a clear white glaze on the inside surface. She and Bente Saetrang both work at the Frysja workshops outside Oslo.

295 Dish ▽
Porcelain with relief decoration
Made by Arne Åse, Fagerstrand, c. 1988
C. 136-1988
Mark AA in monogram painted in green, 3 painted in red
D. 39. 1

Arne Åse is one of Norway's senior potters. His work is precise and economical and he has now pared down the various techniques with which he worked in the past to a minimal method of achieving a maximum effect. He has eschewed the lengthy experiments with glazes, ceramic bodies and kiln-firing temperatures which normally absorb a potter's time, and he now uses a porcelain which gives him as near to 'perfect' and characterless a material. This leaves him free to imprint his own personal artistic expression. He has evolved a simple, painterly technique involving the use of shellac varnish which he brushes on in parts as a resist, then sponges off the unvarnished areas. This procedure can be repeated until the final untouched area of porcelain reaches the limits of thinness and translucency.

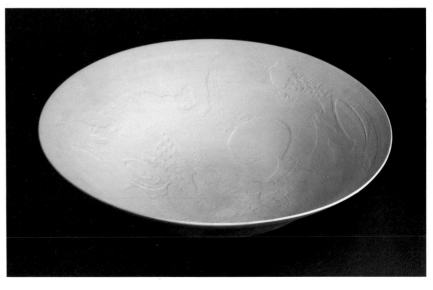

296 Decanter and stopper ▽
Clear colourless glass, mould-blown and cut, with dark green stopper and foot
Made by Hadeland; designed by Sverre Pettersen 1936
Given by the maker
C. 150&A-1988
Mark HADELAND SP 1936 70/1936 incised
H. with stopper 24. 4

In 1928, in direct response to pressure on the Norwegian factories to improve the quality of design, Sverre Pettersen was promoted to art director at Hadeland. His earlier designs were in a light and graceful style. By the mid-1930s he was working in this heavier, more architectural manner.

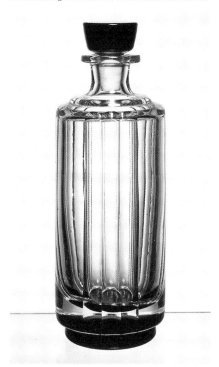

297 Carafe ○
Clear colourless glass
Made by Hadeland; designed by Hermann Bongard 1954
Given by the maker
C. 154-1988
Mark HADELAND H.B. 1954 incised
H. 24. 4

Bongard was awarded gold and silver medals at the Milan Triennale 1954. This carafe is part of a group of table glass included in the Triennale display and designed in a classically elegant yet totally functional style, entirely free of decoration or embellishment.

298 Two vases 🄲
Grey/blue glass, free-blown, one with yellow core, one with purple/pink core
Made by Hadeland, designed by Willy Johansson 1954
One given by the maker
Circ. 87-1957; C. 153-1988
Mark on taller vase HADELAND WJ 1954 incised
H. 18. 7

In 1954 Norway entered the Milan Triennale for the first time. This shape vase was shown together with other pieces by Willy Johansson, who was awarded a diplôme d'honneur for his glass designs.

299 Dish ▷
Brown glass, free-blown, shaded, with opaque white glass rim
Made by Hadeland; designed by Willy Johansson 1957
Given by the maker
C. 151-1988
Mark HADELAND W.J. 1957 incised
D. 48. 1

At this period Willy Johansson had moved into generously proportioned free-blown shapes in clear dark colours. This dish was part of his group of coloured glass that won a gold medal at the Milan Triennale 1957. The Norwegian section was displayed in a special 'aerial' framework designed by Arne Korsmo.

300 Vase 🄲
Clear dark blue/green glass, blown into a wooden mould
Made by Hadeland 1959; designed by Willy Johansson 1958
Given by the maker
C. 152-1988
Mark HADELAND 58 W.J. 20/1959 incised
H. 31

301 Bowl ▽
Pale olive green glass shading to deep blue, mould-blown, with a moulded diamond pattern and folded rim
Made by Hadeland; designed by Arne Jon Jutrem 1961-2
Circ. 195-1963
Mark HADELAND 4115 AJJ incised
D. 15
Shape K 4115

The decoration and form of this bowl recall moulded Roman and Egyptian glass of the 4th and 5th centuries. Jutrem has re-thought an early shape using Hadeland's coloured glass.

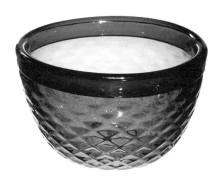

302 Vase ▷
Clear colourless glass, free-blown, and worked with acid-etched decoration
Made by Hadeland; designed and etched by Gerd Slang 1968
Given by the maker
C. 155-1988
Mark HADELAND 1968 G 717 G S 1444 HC 140/1968 incised
W. 31. 5

In a risk-taking technique, working spontaneously and freely with acids on both the inner and outer surfaces of glass, Gerd Slang made some of the more astonishing of Hadeland's decorated glass in the late 1960s.

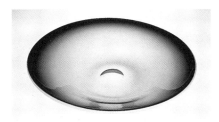

303 Three apple forms ▽
Opaque green glass with coloured glass inclusions, free-blown
Made by Hadeland 1987; designed by Gro Bergslien 1976
Given by the maker
C. 11&A-B-1988
Mark HADELAND GRO engraved
H. 10

304 Egg form ○
Clear colourless glass with white glass-fibre gauze and draped metal thread inclusions
Designed by Benny Motzfeldt, Plus Glasshytte, Fredrikstad; made 1978
C. 46-1980
Mark BM 78 incised
H. 17. 6

Benny Motzfeldt is the founding figure of the Norwegian studio glass movement. With a team of glass-blowers, she specialises in the carefully controlled inclusion of metal and glass-fibre threads and gauze, with a skill that gives her glass an effortless impression of spontaneity. This and four other pieces were purchased after lengthy negotiations with Motzfeldt, following an exhibition of her work in London, 1979 (see also cat. nos 307, 308, 309).

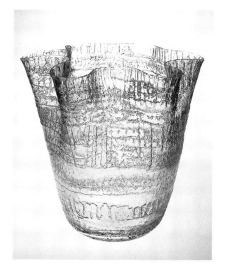

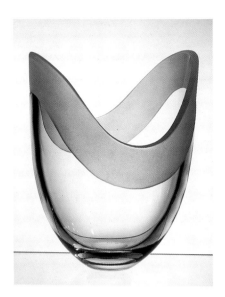

305 Vase △
Clear colourless glass with sand-blasted cut rim
Made by Hadeland; designed by Edla Freij 1979
Given by the maker
C. 156-1988
Mark HADELAND E.F. 1979 incised
H. 23

There are examples of this vase in the Kunstindustrimuseet in Oslo and the Nordenfjeldske Kunstindustrimuseum in Trondheim. The stylish design is also produced with a polished cut rim.

307 Egg form ▽
Opaque white and clear colourless glass with glass-fibre gauze and metal thread inclusions
Designed by Benny Motzfeldt, Plus Glasshytte, Fredrikstad; made 1979
C. 47-1980
Mark BM 79 incised
W. 13. 1

See cat. no. 304.

309 Open-topped cylinder △
Clear colourless glass with metal and glass-fibre thread inclusions
Designed by Benny Motzfeldt, Plus Glasshytte, Fredrikstad; made 1979
C. 49-1980
Mark BM 79 incised
H. 14. 5

See cat. no. 304.

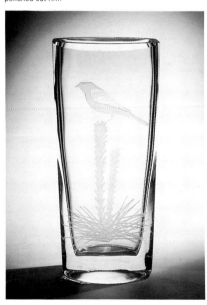

306 Vase 'Fefor' △
Clear colourless glass with cut and sand-blasted decoration of a bird perched on a plant
Made by Hadeland c. 1987; designed by Willy Johansson 1979
Given by the maker
C. 9-1988
Mark HADELAND engraved
H. 24

308 Drop form with iron butterflies △
Clear colourless glass with metal gauze inclusions
Designed by Benny Motzfeldt, Plus Glasshytte, Fredrikstad; made 1979
C. 48-1980
Mark BM 79 incised
H. 21. 5

See cat. no. 304.

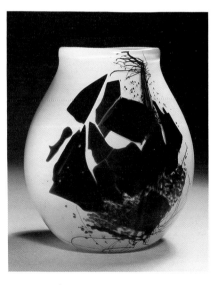

310 Vase △
Yellow glass encasing black glass, free-blown
Made by Hadeland; designed by Gro Bergslien 1982
Given by the maker
C. 157-1988
Mark HADELAND GRO 1982 incised
H. 28

Gro Bergslien is one of Norway's senior figures in the art glass movement. She has had a long association with Hadeland and has specialised in strongly coloured glass with striking contrasts.

311 Vase, 'Blå Marmor' (Blue marble) series
*Opaque and clear mottled blue glass, the lower body
blown into a wooden mould
Made by Hadeland; designed by Willy Johansson 1983
Given by the maker
C. 8-1988
Mark HADELAND WJ engraved
H. 17. 6*

312 Bowl 'Island' (Iceland)
*Clear colourless glass, bubbled, free-blown
Made by Hadeland; designed by Arvid Bakkene 1984
Given by the maker
C. 7-1988
Mark HADELAND engraved
D. 26. 6*

313 Part of the tableware range 'Saturn' ▷
*Clear colourless glass
Made by Hadeland; designed by Grete Rønning 1984
Given by the maker
C. 10&A-1988
Champagne, wine
Unmarked
H. champagne 15. 3*

Designed to accompany the tableware service 'Saturn' cat.
no. 282.

**314 Drinking goblet 'Torneroseglass' (Sleeping
beauty/Briar rose)** **C**
*Blue and yellow glass, free-blown, with applied glass
'rose thorns'
Made by Karen Klim, Frysja, 1985
C. 161-1988
Mark KAREN KLIM 1985 incised
H. 24. 6*

Karen Klim shares a studio with Ulla-Mari Brantenberg and
both artists have specialised in making drinking glasses.
This goblet and 'Slangeglass', cat. no. 315 are part of a
series which was included in an exhibition of drinking
glasses held at the Kunstindustrimuseet, Oslo, 1988.

**315 Drinking goblet 'Slangeglass'
(Snake glass)** **C**
*Red and black glass, free-blown
Made by Karen Klim, Frysja, 1987
C. 160-1988
Mark K K '87 incised
H. 26*

See cat. no. 314.

**316 Dish 'Fra Havets Bund' (From the bottom of the
sea)** ▷
*Clear colourless glass, free-blown, with opaque white
glass veiling and coloured glass and metal wire
inclusions
Made by Karen Klim, Frysja, c. 1987
Given by the artist
C. 159-1988
Unmarked
D. 45*

**317 Group of three wine glasses 'Tre Selvstendige Liv'
(Three Independent lives)** **C**
*Multi-coloured and painted glass, free-blown
Made by Ulla-Mari Brantenberg, Frysja, 1987-8
C. 149&A&B-1988
Mark ULLA MARI BRANTENBERG incised; on one - 87,
on two - 88 incised
H. 16*

Although made separately, these glasses have been
assembled as a group by the artist. Ulla-Mari Brantenberg
has specialised in drinking glasses and these are part of
a series which was included in the exhibition of drinking
glasses held at the Kunstindustrimuseet, Oslo, 1988.

318 Vase ○
*Blue glass with a clear colourless glass band and white
opaque glass decoration, free-blown
Made by Hadeland; designed by Arne Jon Jutrem 1988
Given by the maker
C. 158-1988
Mark HADELAND 1988 JUTREM incised
H. 18. 3*

Arne Jon Jutrem's first designs for glass using the Italian
'bolle' technique were made during the 1960s. In it the
bands or sections of glass are blown one colour at a time
and attached in turn while molten, as part of the blowing
process. He has recently returned to using the technique.

319 Dish or plaque ◁
*Mottled blue-green and white enamel on copper with
silver leaf
Made by Charlotte Block Hellum, Oslo, 1987-8
C. 146-1988
Mark CBH in monogram incised
L. 35. 7*

Charlotte Block Hellum has represented her adopted
country for many years (she was born in Germany) and has
exhibited at many major enamel competitions abroad.
She specialises in the use of silver and gold foils which, as
here, are used simply but with effect.

ENAMELS

SWEDEN

Towards the end of the 19th century Sweden's increasing economic strength was coupled with popular social movements which, by the beginning of the 20th century, had permeated Swedish politics and society. While industrialisation created new international markets, the factories were, nevertheless, unable to absorb the enormous surge in the birth rate which occurred in the early part of the century. Emigration was frequently the only option and large numbers of Swedes moved abroad, particularly to America. The remaining rural population left the land for the towns and manned the heavy engineering industries which were to form the basis of Sweden's new wealth. The move from a settled life of farming and forestry produced its share of social problems. From 1850 to 1880, a religious revival, the temperance movement, and the rise of the trade unions as part of the Labour Movement were all part of the response to these problems.

By the late 1870s these changes had brought a new consciousness of national identity. The many major shifts in national political power and status across Scandinavia had left all four countries striving to establish a cultural and political individuality. For Sweden this meant re-affirming a senior position. Throughout the 19th century, despite excursions into other historicist styles, neo-classicism had remained continuously popular with the middle classes and the aristocracy. In Sweden such styles, drawn from European sources, remained a constant taste. But in 1878 a new style had emerged to join the mix of historicist tastes and was shown in ceramics by Gustavsberg at the international exhibition held in Paris in that year. This was the revival of ancient Nordic or Viking symbolism – dragons, interlaced knots and saga motifs. Deriving from Norwegian rather than Swedish Viking traditions, such motifs were legitimately part of Sweden's new vocabulary of introspection and self-discovery, since Norway was still part of Sweden at this date. Designed for Gustavsberg by August Malmström among others, these strikingly patterned ceramics formed the company's own distinctive contribution to the national mood (Fig.38).

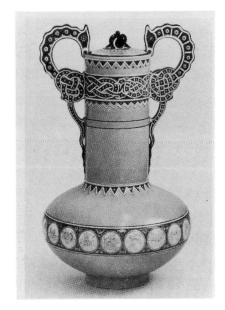

38 Vase
Made by Gustavsberg, designed by August Malmström, 1872
Photo: Gustavsberg museum

Many traditional crafts, techniques and subjects or motifs had been carefully and consciously supported and encouraged during the 19th century and were available for exploitation by artists, designers, theorists and writers hungry in the 1870s and later for an identity, a cause and a specifically Nordic, if not Swedish style. This active preservation of traditional skills and motifs was provided by the Tekniska afton-och Söndagsskolen (Handicrafts School) founded in 1844 in Stockholm by Nils Månsson Mandelgren, and by the Svenska Slöjdföreningen (Swedish Society of Industrial Design) which was established a year later to support the school and its descendent, the Konstfackskolan (now National College of Art, Craft and Design, NCAD).

Twenty years later this introspection was taking a very different form piloted by Gunnar Wennerberg at Gustavsberg. It was parallelled by a delight in a natural and traditional Swedish rural life-style, epitomised in the enormously popular watercolours of Carl Larsson. But, even as late as this, the 'dragon' style persisted, and the two are combined in the opening paragraphs of Larsson's *Et Hem (Our Home,* first published in 1899) in which

he describes the village children's liking for the carved wooden dragons on the roof of the family's farmhouse (Fig. 39).

Ceramic designs concentrated on home-grown patterns based on Swedish plants and motifs in simple repeats and these simple forms were the natural precursors of the 20th century movements. Alf Wallander joined Rörstrand in 1895. Gunnar Wennerberg, his junior by one year, joined Gustavsberg in the same year. Both men designed for Kosta glassworks – Wennerberg from 1898, Wallander from 1907. Between them they represented the two directions of ceramic design. Wallander made delicately wrought and modelled porcelains based on flower and plant forms (cat. nos 326, 327) in a style which reflected the international art nouveau manner fashionable in Europe, but painted in what had become the typical Scandinavian underglaze palette of blue-greys, pinks and greens. Wennerberg designed lightly enamelled repeating patterns based on snowdrops (cat. no. 322), lilies-of-the-valley (cat.no. 320) and other simple flowers which were exhibited firstly in the 'Konst och Industriutställningen (Art and Industry Exhibition) in Stockholm in 1897 and then in the international exhibition, Paris, 1900. For their displays Rörstrand was awarded a grand prix and Wallander was singled out for special comment in the French reports. Gustavsberg was given a gold medal but for its heavily ornamental wares. Wennerberg's simple flowers were probably too unsophisticated in the context of a major international setting, if they were included at all by the factory. If Wennerberg's designs were too simple and too specifically Swedish to attract European or foreign attention, Wallander's elegant and subtle Art Nouveau was restrained enough to appeal to British taste. The Victoria and Albert Museum bought a modest group of Wallander's porcelains following the exhibition – a cautious purchase by a national museum of the country that deeply disapproved of the apparently ungoverned extravagances of French or Belgian Art Nouveau. No Gustavsberg designs were acquired at all at the time.

39 View of the family home
Watercolour illustration for 'Et Hem' by Carl Larsson,
published 1899
Photo: Nationalmuseum, Stockholm

Sweden declared its neutrality at the beginning of the First World War. This proved to be a difficult and sensitive path to follow since Germany was the major purchaser of Sweden's raw materials. Internal political differences exacerbated the situation, and Sweden's economy experienced severe setbacks which encouraged debate on social reform. In 1917 an exhibition of major importance was held. For ceramics, it is regarded as a turning point in Swedish design. 'Hemutställningen' (Home Exhibition) was held in the Liljevalchs gallery, Djurgården, Stockholm. Organised by Svenska Slöjdföreningen, the exhibition for the first time addressed the problems of modern urban dwellings and home economics by featuring furnishings for limited living space and cost. A concern with raising the quality of life arose directly from the theories first aired in Sweden at this exhibition which were part of an international movement also centred in Germany, Austria and other European countries. These theories demanded that aesthetic satisfaction, regarded as an unarguable right at any social level, should be combined with functional practicality and appropriate cost. In a larger argument, into which ceramics, glass and all the applied arts entered, design and art were to be part of the fight for social improvement, a better quality of living for all, and designers and artists, with economists, scientists and politicians, were to bear an equal responsibility for society in general. Art and design were to be harnessed for the common good. This concern for social responsibility became a hallmark of Scandinavian design in general and, at this comparatively early date, of Swedish design in particular.

In 1917, Wilhelm Kåge in his first year at Gustavsberg, designed the Liljeblå service which

was shown at 'Hemutställiningen' and dubbed the 'Arbetarservis' (cat. no. 334). Its reception highlighted the fundamental problem which had bedevilled all such attempts to combine simple, disciplined design with inexpensive production in the expectation that it would appeal to a low-paid but aesthetically starved population. The service was praised by the theorists and ignored by potential customers who preferred more traditional lavishness in their decoration, however cheaply applied. Education, it was felt, had to begin at an earlier stage, with the customer, and over the next decades Sweden, more than most countries, came nearer to achieving this remarkable feat.

In 1919 Gregor Paulsson, director of Svenska Slöjdföreningen from 1920 to 1923 published *Vackrare Vardagsvara* which summed up the theory that Kåge with others had attempted to put into practice. 'Vackrare vardagsvara' (more beautiful things for everyday use) became a rallying call for a generation of designers and, under a paternalistic government which supported a radical democratic social code, design and the arts became as closely associated with the national mood as were social reforms and increasing economic equality. Nevertheless it would be a mistake to assume that functionalism was the only successful style. It was indeed the thread which lead directly to what is now typically regarded as the Swedish style, that of the 1950s. But in 1930 the far more decorative manner dubbed 'Swedish Grace' was equally acclaimed and probably more popular. This was very successfully shown in the Gothenburg exhibition of 1923 and in the international exhibition, Paris, 1925. This style straddled the twin vogues for classicism and a form of languid Art Deco. Many of the designers of this period trained or began their careers as painters — Hald, Percy, Kåge among them. Frequently this resulted in a use of art forms not normally employed by designers. With unusual confidence, these Swedish artists combined their familiarity with Matisse or Botticelli with the prevailing international classicism in the relaxed and elegant 'Swedish Grace' style. This classicism could equally be applied to simply decorated tin-glazed earthenware (Fig.40) or expensively engraved glass. In Paris, in 1925, the Orrefors glass designers Simon Gate and Edward Hald, and the Orrefors team of engravers, captivated their audiences with dazzling virtuosity.

40 Vase and flower grid
Earthenware; made by Gustavsberg, designed by Wilhelm Kåge. 1923
Cat. no. 337

Gate and Hald, like many of their contemporaries, Kåge among them, had led surprisingly split existences. From 1916 they designed functional glassware in traditional forms with restrained and simple embellishments, which were made at the Orrefors subsidiary Sandvik, in soda glass and softly muted colours. In contrast, both designers also specialised in engraved decoration of superb quality and stylish design such as Hald's 'Fyrverkeriskålen' (Fig.41). For the 1925 exhibition both designers produced spectacular and elaborately engraved works which demanded exceptional engraving skills. It was these superbly elegant works that earned the Swedish glass design the title 'Swedish Grace' from the English critic, Morton Shand. Yet, even within these élite productions, it is possible to detect a common cause with the simple designs for everyday use. Proportion, relationship of surface ornament to form and clarity of conception, are the critical ingredients applied with equal skill to both the functionalistic or the luxuriantly classical and both are distinguished by a clear and confident certainty.

By 1930 Sweden had made considerable progress in land and social reforms. Industrialisation had escalated and exports of wood, iron ore and iron and steel again provided the mainstay of increasing wealth. However, the world-wide economic slump in 1930 hit

Sweden as elsewhere. During this year the 'Stockholmsutställningen' (Stockholm exhibition), under the direction of Gregor Paulsson and Gunnar Asplund, set out to counter the Depression and to establish Sweden as a force in the modern design world. Far from simply repeating the medal-winning formula of the 1925 Paris exhibition, the Stockholm exhibition was thought by Morton Shand to be demonstrating a newly advanced turning point in Swedish design. In 1930, the skill and craftsmanship which had so excited audiences in Paris, where it was applied to a graceful classicism and neo-baroque or mannerist witticisms, was seen to be coming to terms with a more severe modernism arising from the Bauhaus theories. Shand singled out the architectural sections by Asplund particularly while the reporter from the *Pottery Gazette and Glass Trades Review* admired almost unreservedly the work of Wilhelm Kåge at Gustavsberg, Ewald Dahlskog at Bo Fajans and Arthur Percy at Gefle. He also praised Simon Gate's glass for Orrefors, Elis Bergh at Kosta and Gerda Strömberg at Eda.

41 Vase and stand 'Fyrverkeriskålen'
Glass; made by Orrefors, designed by Edward Hald, 1921
Cat. no. 443

In 1931 a reduced and somewhat altered version of the exhibition was brought to London where it was an influential success. The architect-designer Keith Murray acknowledged this at the time and his work for Stevens & Williams glassworks and for Wedgwood clearly demonstrates the influence the exhibition had on him and his contemporaries. Members of the British Design and Industries Association had travelled to Sweden in the early 1920s. Murray himself and other British designers had also seen the Swedish displays in Paris in 1925, and the London exhibition reinforced the Swedish experience.

For the rest of the decade Sweden consolidated the position it had reached in 1930 with ceramics and glass production continuing disciplined functionalism which suited the internationally modernist customer, and was aimed at both luxury and inexpensive markets. In the production of art wares, which included the ranges of decorative items such as bowls or vases and of sculptural figures, designers and artists allowed themselves a little more licence. Kåge introduced his luxurious silver-inlaid 'Argenta' (Fig. 42) in 1930. 'Farsta' ware (cat. nos 381, 384, 385, 389), experimental in the early 1920s, was included in the 'Argenta' line. By the late 1930s 'Farsta' was well established and accompanied by, from Gustavsberg, refined and elegantly glazed vases, bottles and bowls by Stig Lindberg and Berndt Friberg. The senior porcelain factory of Rörstrand contributed an understated yet graceful modernism through its productions by Gunnar Nylund and Louise Adelborg. Nylund also made strongly vigorous sculptures in a rough chamotte stoneware, and art wares which balanced the work by the Gustavsberg studio.

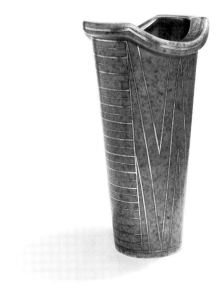

42 Vase 'Argenta' series
Stoneware; made by Gustavsberg, designed by Wilhelm Kåge, c. 1930-40
Cat. no. 347

During the war years some of the finest studio ranges were made in Sweden. Stig Lindberg produced fancifully and colourfully decorated faience wares while Kåge, in his last years at Gustavsberg played witty games with his cubist-style 'Surrea' (cat. no. 354) and painted wares in the manner of a Matisse or Picasso (cat. no. 359). However, despite being the least materially affected by the Second World War of the four Scandinavian countries, Sweden had been very isolated, and it was this and the time it took to rebuild international contacts that ensured that their apparent advantage was not without serious drawbacks. In fact, there was fierce competition with Denmark, where artists and designers had been able to work uninterruptedly despite the occupation. Finland, which was very seriously affected by the war and by economic stringencies afterwards, was, quite unpredictably, spurred into successes as early as the Milan Triennales of 1948 and particularly 1951. Sweden, while moving into an early lead (Lindberg and Friberg were both awarded gold medals at the Milan

Triennale in 1948), soon found that it was faced with considerable competition from its nearest neighbours.

The Swedes themselves, like many nations in the immediate post-war years, were torn between nostalgia for a golden past and commitment to a continuously improving future. The 1950s proved to be the start of a golden era for Sweden in which the vision of a life so winningly pictured by Carl Larsson — each family with its own rural cottage, with a boat and unspoilt countryside and lakes — became increasingly a reality. Accompanying this was a comfortable undemanding modernity in furnishings, ceramics and glassware which exactly matched the post-war mood in other countries. Its success secured Sweden, together with her Scandinavian neighbours, a reputation which the name 'Scandinavian Style' still evokes with accuracy.

Stig Lindberg was one of the most versatile of Sweden's designers at this date (Fig.43). His early work in painted faience had established his reputation among contemporaries. It was launched in 1942 as an exhibition entitled 'Fajanser målade i vår' (faiences painted this spring). In style, Lindberg was bracketed with Birger Kaipiainen and Bjørn Wiinblad, newly emerging in Denmark. However, the whimsical, decorative side of his work was one of several facets. He was responsible for studio wares of a totally different type, with gently elliptical forms and refined glazes . Finally, it was he that provided the majority of Gustavsberg's tableware ranges specialising in coolly elegant shapes, throughout the 1950s (Fig.44).

As Stig Lindberg had arrived to work under Wilhelm Kåge, so Karin Björquist formed the next link in the chain. She picked up the traditions of Kåge and Lindberg and took Gustavsberg confidently through the 1960s and into the troubled 1970s. Like her predecessors, Karin Björquist is a versatile artist who has been equally at home over her long career in a number of different techniques and in designing for different purposes. Unlike Kåge and Lindberg, she has not been accorded 'star status', partly because her work reflects her unassuming personality, balancing a dedication to every detail of design and production with a natural flair for elegance and style. Parallel with Gustavsberg, Rörstrand also pursued an interesting design course with the work of Hertha Bengtson, Marianne Westman and others who were included in an exhibition held in this museum in 1959.

At Gustavsberg a counter movement also had a deep influence, both on the factory and on Swedish ceramics generally. In 1947, Anders Liljefors was hired by the far-sighted Kåge to work in the Gustavsberg studio. He stayed intermittently for almost 10 years. Trained as a sculptor, Liljefors ignored the classical Swedish design goals of harmony, elegance and functionalism, and by the mid-1950s was producing sand-cast sculptures (cat. no. 408) which introduced an entirely revolutionary vocabulary of textures and abstract forms. The fundamental concept of ceramic production was uprooted, examined and opened to re-interpretation.

Hertha Hillfon followed closely behind Liljefors, and she too worked in a sculptural and freely creative manner, pushing forward the boundaries and frontiers into arenas never before investigated by ceramicists. Working entirely independently she is now seen as Sweden's most important ceramic sculptor. Her imaginative and highly personal vision has carried her through periods of extreme expressionism and lovingly controlled yet slightly disturbing realism. Her subjects have been as abstract as the visualisation of the moods

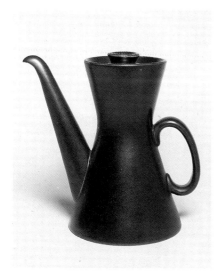

43 Salad bowl
Earthenware; made by Gustavsberg, designed by Stig Lindberg, 1950
Cat. no. 377

44 Coffee pot 'Terma' series
Stoneware; made by Gustavsberg, designed by Stig Lindberg. c. 1955
Cat. no. 399

induced by Bach or Bartók, as apparently prosaic as the meticulous representation of a baby's jacket, or as full of historic references as an archaic Greek or Etruscan chair, but all touched with more than a hint of dark and possibly mystical forces. Liljefors and Hillfon, jointly, were therefore responsible for a significant change of direction for Swedish ceramics.

A similar development, although rather later, occured in glass production where harmony and elegance were eventually counterbalanced by revolution and reinterpretation. Eric Höglund arrived at Boda glassworks and introduced thick, bubbly glass in the late 1950s in a deliberate attempt to rediscover an innocent and unsophisticated glass language. At Örrefors a form of classicism had prevailed during much of the decade. The chief masters were Nils Landberg, Sven Palmquist and Ingeborg Lundin. Each worked in a coolly elegant although individual style epitomised in Lundin's case by her most famous 'Äpple' and in Landberg's by his 'Tulpanglas' (Fig. 45). Vicke Lindstrand was also one of this group, designing strongly characterful pieces and frequently ahead of his time (Fig.46). By the mid-1960s this Orrefors tradition had been challenged. Gunnar Cyrén, as a comparative newcomer (he joined the company in 1959) brought a fresh perspective. Trained as a goldsmith, his sense of form was substantially different. He also introduced the use of bright opaque colours not previously identified with Orrefors and which caused something of a sensation on their launch in 1966. His attitude reflects his early training in precious materials, and even such apparently casual objects as the 'Pop' glasses of 1966 are perfectly calculated and considered, with nothing wasted. Over the years his glass designs have graduated to a classic and subtle perfection of form, relieved with decoration which entirely matches the significance of the object: a bowl in a shape reminiscent of a boat, with the faintest tinge of surface colour; a water or wine set of drinking glasses and a carafe in which the properties of the glass and of the liquid it contains are aptly reflected in the undulating surface, such as in the 'Helena' range (cat. no. 515).

Signe Persson-Melin is a distinguished potter who combined craft and sophistication in a supremely successful manner arising from her interest in Danish pottery. Also a glass designer, she joined the Boda Nova design company in 1970. She was responsible for the glass design of a range of fireproof wares combined with cork and wood fittings and with stoneware bowls, which was introduced in 1971. Bringing her already finely tuned aesthetics to the commission, it became part of the best of mainstream Swedish design, the effortless balance and practical values of the series making it a classic of its time.

A further counter-blast to this refinement at Kosta Boda was provided by Bertil Vallien and Ulrica Hydman-Vallien, their contemporaries and the younger generation in the studio glass movement. Like Liljefors, Bertil Vallien is naturally a sculptor and he brought to glass a freedom of expression and an enquiring mind, totally untrammelled by established tradition. Having mastered the possibilities and introduced techniques of his own, he upended the glass industry and created an entirely personal industry of his own. His all-encompassing versatility makes him one of Sweden's foremost individual glass artists and also a formidable supplier of ideas for multiple production to the extent that the entire Åfors factory is given over to making his and Ulrica Hydman-Vallien's designs. Ulrica Hydman-Vallien is the acknowledged 'mother figure' of a distinctive branch of Swedish glass art. Her innovative use of folk-loric images is accepted as a model from which all have been able to draw. Her work is frequently categorised as whimsical, magical and playful but there is at a deeper level a primitivism which hints darkly at more fundamental truths.

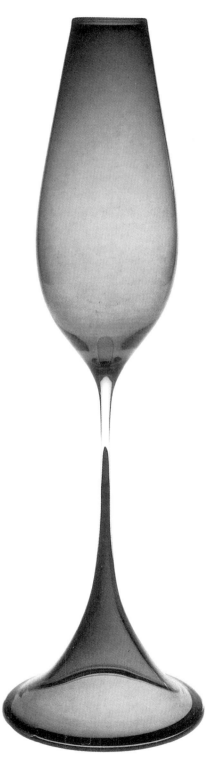

45 'Tulpanglas'
Glass; made by Orrefors. designed by Nils Landberg, 1957
Cat. no. 500

This level is explored by individual artists in all four countries, a common bond, in both independent studios and in the factory art departments.

During the 1970s, Swedish artists were increasingly concerned with the human situation, world economics and environmental tragedies. In the 1980s, this concern increased. Internal difficulties such as the growing pressure of international competition, particularly in terms of costs and the effects of the merging and closure of factories and workshops, all have had a fundamental bearing on the development of design. As always, the Swedes took their social responsibilites seriously; there was an increase in commissions and an interest in design for public spaces and for underpriviledged sections of the community such as the handicapped and the elderly. Economic pressures and developing theories on the subject of art-versus-industry produced a polarisation of factories versus outside artists, making cross-fertilisation much less possible. A number of artists left factories in order to free themselves for more independently creative work.

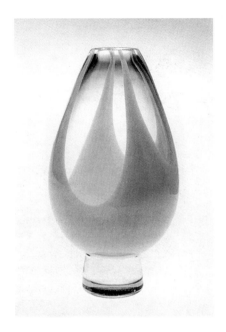

46 Vase
Glass; made by Kosta, designed by Vicke Lindstrand.
c. 1954
Cat. no. 498

47 Bowl
Glass; made at Transjö, designed and decorated by Ann Wärff (Wolff), c. 1982-3
Cat. no. 522

This movement has been accelerated by the changes in factory structures and groupings beginning in 1975 with the merger of Rörstrand with the Finnish company, Arabia, and the Norwegian pottery Egersund and more recently, with Gustavsberg. With a more extensive network of individual glass and ceramic artists the need for an organised structure became apparent. Workshops were, in any case, increasingly difficult to maintain and the late 1960s and early 1970s fashion for country collectives of all kinds hardened into business-like arrangements such as the shared gallery outlet, owned, managed and staffed in rotation by the artists themselves. The best known of such collectives now are Blås & Knada and Kao-Lin in Stockholm where emerging young artists, both potters and glassmakers, exhibit and sell their work in company with established names. Independent artists, such as Ann Wärff (now Wolff) (Fig.47) both invited and accepted visiting colleagues and students at their own workshops, thus strengthening the supportive structure. Many artists also teach, run seminars and travel abroad to lecture and attend courses, particularly in America from where the studio glass movement and the impact of the Pilchuck School has been especially influential. Glass artists such as Bertil Vallien and Göran Wärff travel and teach abroad regularly and represent a thriving studio glass movement based in factory studios. In the case of Åsa Brandt, Ulla Forsell and many others, influential Swedish studio glass is made by totally independent artists working in their own workshops and exhibiting internationally both in competitions and by invitation.

The recent merger of Swedish factories and their assimilation with Finnish companies will have a long-term, fundamental influence on the future course of industrial design and on the studio work dependent on it. Sweden is today having to adapt to a reversal of past roles in her relationship with Finland. While the opportunity for artists to work in different factories, even different countries, albeit for the same parent company, may well prove to be invigorating, the present transitional period is proving painful and unsettling.

320 Two plates 'Liljekonvalje' (Lily of the valley) △
Bone china with printed and enamelled decoration in
green and white
Made by Gustavsberg; designed by Gunnar Wennerberg
1897
Given by the maker
C. 134, 138-1986
Mark GUSTAFSBERG on a scroll across an anchor
printed in black; Q impressed
D. larger plate 26. 7
Model Q

Designed for 'Stockholmsutställningen', the exhibition of
art and industry, Stockholm, 1897. With this and other
designs first shown at the exhibition (see cat. nos 321,
322), Wennerberg led Gustavsberg away from a depen-
dence on European transfer prints into a fresh, independent
style based on the simple flowers and leaves of the Swedish
countryside.

321 Plate 'Lindlöf' (Limeleaf)
Bone china with printed decoration painted in greens
Made by Gustavsberg; designed by Gunnar Wennerberg
1897; in production 1905-10
Given by the maker
C. 136-1986
Mark GUSTAFSBERG above an anchor printed in green;
T (?indistinct) impressed; 6225 painted in black
D. 21. 5

Designed for 'Stockholmsutställningen', the exhibition of
art and industry, Stockholm, 1897 (see cat. no. 320).

322 Plate 'Snödroppe' (Snowdrop)
Bone china with printed and enamelled decoration in
green and white
Made by Gustavsberg; designed by Gunnar Wennerberg
c. 1897
Given by the maker
C. 137-1986
Mark GUSTAFSBERG on a scroll across an anchor with
GW in monogram printed in green; GUSTAFSBERG
impressed
D. 17. 7

Designed for 'Stockholmsutställningen', the exhibition of
art and industry, Stockholm, 1897 (see cat. no. 320).

323 Vase ▽
Porcelain with celandine flowers and foliage modelled in
slight relief and painted in mauve and green
Made by Rörstrand; possibly designed and decorated by
Waldemar Lindström c. 1900
1695-1900
Mark RÖRSTRAND and three crowns printed in green; M
P 4 1 impressed; WL painted in green
H. 17

There were three designers at Rörstrand at this date, any
one of whom could have been responsible for this vase and
each one of whom was named Lindström. However,
although Karl or Nils Lindström are known to have used
floral motifs, it appears from the signature 'WL' that it is by
Waldemar Lindström, better known for specialising in
animal subjects. This vase was purchased, with other
vases, from Samuel (Siegfried) Bing, 'L'Art Nouveau',
22 Rue de Provence, Paris (see cat. nos 324, 325, 326).

324 Vase
Porcelain with apple blossom modelled in slight relief and
painted in mauve and green
Made by Rörstrand; designer unknown c. 1900
1696-1900
Mark RÖRSTRAND and three crowns printed in green;
MP 21 impressed
H. 10

See cat. no. 323.

325 Vase
Porcelain with blossom modelled in slight relief and
painted in mauve and green
Made by Rörstrand; designer unknown c. 1900
1697-1900
Mark RÖRSTRAND and three crowns printed in green;
EG (?indistinct) incised; 21 impressed
H. 9. 8

See cat. no. 323.

326 Vase △
Porcelain with pansies modelled in slight relief, pierced
and painted in blue and green
Made by Rörstrand; probably designed by Alf Wallander
c. 1900
1694-1900
Mark RÖRSTRAND and three crowns printed in green;
JS incised; 337 (?indistinct) impressed
H. 21. 2

Alf Wallander specialised in delicately wrought porcelain
such as on this vase, reflecting the art nouveau style of the
time. His work was awarded a grand prix at the international
exhibition, Paris, 1900. Samuel (Siegfried) Bing, born in
Germany and settled in Paris, was one of the most impor-
tant retailers selling contemporary design and imported
oriental and 'exotic' goods in his shop 'L'Art Nouveau', 22
Rue de Provence. This vase is one of a group of
four purchased from Bing by the Museum following the Paris
exhibition (see cat. nos 323, 324, 325).

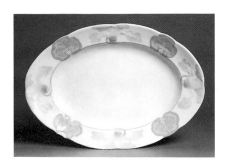

327 Dish △
*Porcelain with moulded flowers and leaves, decorated
with underglaze colours*
Made by Rörstrand; designed by Alf Wallander c. 1900
Given by Fenix Antik
C. 18-1988
*Mark RÖRSTRAND and three crowns printed in green;
RÖRSTRAND I 13 ZA impressed*
L. 31

328 Part of a tea range 🄲
*Porcelain with moulded dragonflies, decorated with
underglaze colours*
*Made by Rörstrand; designed by Alf Wallander c. 1900;
in production c. 20 years*
Anonymous gift
C. 102&A-F-1988
*Tea pot and lid, sugar bowl and lid, cup and saucer,
milk jug*
*Mark RÖRSTRAND and three crowns printed in brown;
MA C BO (? indistinct) impressed*
L. tea pot 23. 2

In 1897 Royal Copenhagen, the Danish porcelain company,
introduced a tableware range titled 'Marguerite' with bee
and dragonfly handles, designed by Arnold Krog. The
similarity between this Rörstrand range and the Royal
Copenhagen ware raises the possibility that Wallander saw
and was impressed by the Krog design.

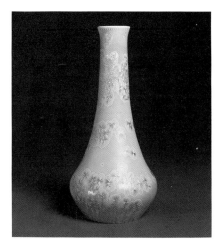

329 Vase △
Porcelain with green crystalline glaze
Made by Rörstrand; designer unknown c. 1900-10
Given by Lt-Col Kenneth Dingwall DSO
C. 220-1918
*Mark RÖRSTRAND and three crowns printed in green;
KKI and 7 impressed; 19 and three dots painted in brown*
H. 30. 1

330 Part of a range 'Gunnar' ▽
*Bone china with printed decoration of trefoil leaves in
greens*
*Made by Gustavsberg; designed by Gunnar Wennerberg
c. 1905; in production 1905-31*
Given by the maker
C. 135, 139&A-1986
Plate, cup and saucer
*Mark on plate and saucer 'GUNNAR' GUSTAFSBERG
across an anchor printed in green; on plate AL, on saucer
AE impressed; on plate 36 painted twice in blue and
brown*
D. plate 23. 7
Model Q

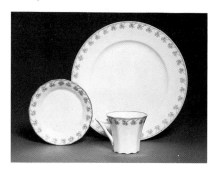

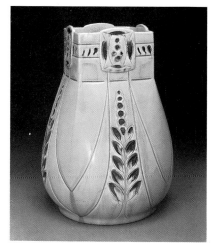

331 Vase △
Earthenware with moulded decoration and orange glaze
Made by Rörstrand; designed by Alf Wallander c. 1906-8
Anonymous gift
C. 103-1988
*Mark RÖRSTRAND and three crowns printed in green
(indistinct)*
H. 31. 2

332 Vase
Porcelain with blue crystalline glaze
Made by Rörstrand; designer unknown c. 1907
Given by Mrs F. C. Ormerod
Circ. 307-1953
*Mark RÖRSTRAND and three crowns printed in green;
KKI impressed*
H. 21

Mrs Ormerod was the daughter of William Burton, Manager
of Pilkington's Tile and Pottery Co., Clifton Junction. Burton
was a chemist and technical expert in the pottery industry.
His brother Joseph was responsible for glaze research. The

Burtons maintained lively contact with their contempo-
raries in other factories carrying out similar experiments,
and would have been extremely interested in the develop-
ment of crystalline glazes abroad. This vase was said to
have been given by Rörstrand to Burton in about 1907.

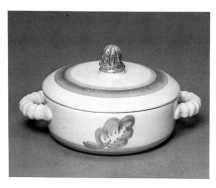

333 Bowl and lid △
*Earthenware with painted decoration of bands and leaves
in underglaze blue on a blue ground*
Made by Höganäs; designed by Edgar Böckman c. 1916
C. 2&A-1988
*Mark HB either side of an anchor and HÖGANÄS printed
in blue*
W. 23

Böckman joined Höganäs in 1915. His work for them was
first exhibited at the department store Nordiska Kompaniet
(NK) in 1916, and was included in the important exhibitions
'Hemutställningen' (home exhibition) and 'Verkstadens'
(workshop) held in the Liljevalchs Art Gallery, Stockholm,
1917 and 1920 respectively. 'Verkstadens' was a guild of
artists formed after the 1917 exhibition. They arranged
group exhibitions on a number of occasions.

Böckman's work was singled out by Gregor Paulsson,
director of the Svenska Slöjdföreningen (Swedish Society
of Industrial Design) and author of *Vackrare Vardagsvara*
(1919) that argued for better design in everyday goods.
Böckman, Kåge and several designers in other materials
responded to such new social concerns which were
associated with a marked change in the political climate in
Sweden during and after the First World War.

**334 Part of a tableware range 'Liljeblå'
(Blue lily)** ●
*High-fired earthenware with transfer-printed decoration
of a flower motif in underglaze blue on a grey/blue ground*
Made by Gustavsberg; designed by Wilhelm Kåge 1917
C. 190&A&B-1986
Soup plate, coffee or chocolate pot and lid
*Mark GUSTAVSBERG, an anchor and 1918 KINA
(indistinct) 853 A17 impressed; on plate GUSTAVSBERG,
an anchor and LILJEBLÅ printed in blue; on pot
GUSTAVSBERG ORIGINAL (indistinct) WC B impressed*
H. pot 20
Model KG

This range was shown in 'Hemutställningen' (home exhibi-
tion), held in the Liljevalchs Art Gallery, Stockholm, 1917,
and was in production until 1940. It is made in a high-fired
earthenware, equivalent to the English 'ironstone', and the
decoration is printed, avoiding costly hand-painting. Other
versions, such as 'Blå ros' (Blue rose), were also produced.
The range was a deliberate attempt by Kåge to produce
'good design', attractive yet inexpensive.

Known as the 'Arbetarservis' (Workers' service), like
many such attempts before and since, although acclaimed
by the theorists, it was ignored by the people for whom it
was intended.

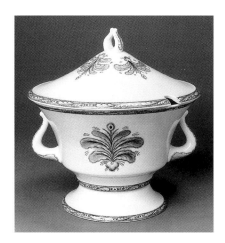

**335 Soup tureen and cover from the range
'Halda'** △
*Earthenware with transfer-printed decoration in blue
Made by Rörstrand; designed by Edward Hald 1919*
C. 189&A-1986
*Mark HALDA RÖRSTRAND and three crowns printed in
blue*
H. 26

Hald is well known for his elegant engraved glass designs
for Orrefors in the manner described as 'Swedish grace'.
The 'Halda range is an example of his equally light touch in
earthenware (ironstone) design for Rörstrand. The service
was illustrated by Gregor Paulsson in *Vackrare Vardagsvara*
(see cat. no. 333).

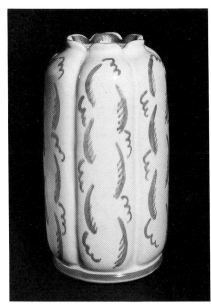

336 Vase △
*Earthenware with white tin glaze and painted decoration
in blue
Made by Gustavsberg; designed by Wilhelm Kåge 1920
Given by the maker*
C. 130-1984
*Mark WK in monogram incised; indistinct marks
impressed; G, an anchor and KÅGE 1920 JAN painted in
blue*
H. 21. 2

337 Vase and flower grid ○
*Earthenware with white tin glaze and painted decoration
in underglaze blue
Made by Gustavsberg 1923; designed and decorated by
Wilhelm Kåge 1919-23
Given by the maker*
C. 140&A-1986
*Mark 850 incised; KÅGE 1923 GUSTAVSBERG and an
anchor painted in underglaze blue*
L. 25. 9

Flower vases of this shape were illustrated by Gregor
Paulsson in *Vackrare Vardagsvara*, 1919 and displayed in
the 'Verkstadens' (the workshop) exhibition, Stockholm,
1920, arranged by 'Verkstadens' artists (see cat. no. 333).

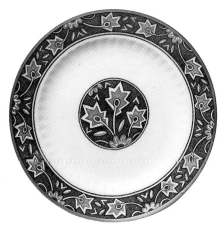

338 Plate 'Safir' (Sapphire) △
*Earthenware with printed decoration of stylised flowers
and leaves in dark blue and gold
Made by Gustavsberg; designed by Wilhelm Kåge 1921;
in production until 1940*
C. 3-1988
*Mark SAFIR GUSTAVSBERG and S.S.F. within a circle
printed in blue; GUSTAVSBERG, an anchor and 1921 OPAK
995W (indistinct) impressed; symbols (unidentified)
painted in red*
D. 24. 6
Model WK

The 'S.S.F.' in the mark stood for Svenska Slöjdföreningen
(Swedish Association of Arts and Crafts) and was in use
until 1931.

339 Part of a coffee range ▷
*Porcelain with printed decoration of stars in red and gold
Made by Lidköping 1924; designed by Einar Forseth 1924*
C. 1&A-1988
*Coffee pot and lid, cream jug, sugar pot and lid
Mark ALP within a shield surmounted by three stars and
LIDKÖPING 24 printed in green; DV incised; FO./N painted
in gold*
H. coffee pot 24. 2

Mainly known internationally for his work in stained glass
and mosaic, in the 1920s Forseth also produced simple
designs like this one, for Lidköping, Upsala-Ekeby and
Rörstrand.

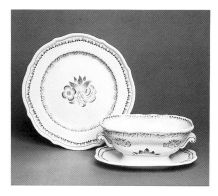

**340 Tureen and plate 'Tre Blommor'
(Three flowers)** △
*Earthenware with printed decoration in brown
Made by Gefle; designed by Arthur Percy 1924;
in production 1924-43
Margaret Bulley Bequest*
Misc. 2(119, 121)-1934
*Mark GEFLE and three smoking kilns within an oval
and MADE IN SWEDEN MODELL PERCY TRE BLOMMOR
printed in black and brown; on plate GEFLE three kilns
and 630 H impressed*
D. plate 25
Model Q

Model Q was the first dinner ware by Percy introduced with
the decoration 'Gefle', in 1924. 'Tre Blommor' was included
in the international exhibition, Paris, 1925. Less obviously,
but like the slightly later 'Exotica' cat. no. 342, the 'Tre
Blommor' pattern combines an appreciation of Mediterra-
nean or southern plant forms with a confident and expert
copper-plate engraving technique. See also cat. no. 343.

341 Dish and cover
*Stoneware with painted decoration in underglaze blue
Made by Gefle; designed by Arthur Percy c. 1927-30
Margaret Bulley Bequest*
Misc. 2(122)-1934
*Mark GEFLE and three smoking kilns within an oval
and MADE IN SWEDEN ELDFAST printed in black;
.P. impressed*
W. 15. 7

Like many of his contemporaries, Percy also designed
simple, attractive and inexpensive wares for everyday
household use, such as this dish and cover which are part
of a set of dishes and tureens. As this piece shows, he
never embraced a strict functionalism, always preferring
more sensuous rounded forms.

342 Plate 'Exotica' ●

Earthenware with transfer-printed decoration of a jungle scene in black
Made by Gefle; designed by Arthur Percy c. 1929-30; engraved by Herbert Perje; in production 1930-43
Given by Felicity Mallet
C. 126-1988
Mark three kilns and GEFLE MADE IN SWEDEN MODELL PERCY EXOTICA printed in black; three kilns and GEFLE 2371 impressed
D. 25. 6
Model Q

'Exotica' was first displayed in 'Stockholmsutställningen', the major exhibition of art and industry, Stockholm, 1930 and the following year in the London showing of part of the same exhibition at Dorland House, Regent Street, from which examples were acquired by Queen Mary. Percy trained as a painter in Stockholm and then lived in Paris and the South of France, experiences which proved influential. His work was distinctively southern or Mediterranean in its affection for lush colouring, rich images and ripe curves. He joined Gefle porcelain factory in 1923 and in 1925 was awarded a diplôme d'honneur at the international exhibition in Paris. In 1928 he produced decorative panels for the liner *M/S Kungsholm* in which semi-classical figures in Botticellian style were shown in a landscape filled with palm trees and other exotic plants. This theme was continued by him into his designs for ceramics, at times formed and decorated to the point of extravagance. Model Q was Percy's first dinner ware shape and its engraved copper-plate printing illustrates lush jungle peopled with leopards, crocodiles and natives.

Left to right 345, 344, 346

This range, 'Pyro', was designed by Kåge in 1930 to be inexpensive, well-designed, useful ovenproof ware, made in a heat-resistant earthenware named 'Pyromassa'. The storage jars were labelled for their contents: these two were to contain 'risgryn' (rice) and 'nejlikor' (cloves). The range was first shown, with painted decoration in brown,

344 Vase
Earthenware with clear glaze over a cream body and black enamel decoration
Made by Bo Fajans; designed by Ewald Dahlskog c. 1930
C. 171-1986
Mark BOFAJANS GEFLE MADE IN SWEDEN impressed; D 30-962 painted in black
H. 17. 7
Shape D 30; decoration no. 962

Gefle is the old spelling for the town, Gävle. Ewald Dahlskog joined Bo Fajans, Gävle, in 1929 and in his first year had produced a range of vases and bowls in this chunky architectural style. It was described as 'functionalist' in the contemporary Swedish press and several of his designs were included in 'Stockholmsutställningen', the major exhibition of art and industry, Stockholm, 1930, some of which were shown in London at Dorland House, Regent Street, the following year.

345 Vase
Earthenware with moulded ribbing and grey/blue shaded glaze
Made by Bo Fajans; designed by Ewald Dahlskog c. 1930
C. 172-1986
Mark BO/D. 7 incised; MADE IN SWEDEN impressed; 539 painted in grey/blue
H. 16. 1
Shape D7; decoration no. 539

This vase and the other in the same technique (cat. no. 346) were still in production in 1937. See also cat. no. 344.

343 Part of a table and kitchenware range 'Pyro' △

Earthenware with ribbed moulding and printed and painted decoration in blue
Made by Gustavsberg; designed by Wilhelm Kåge 1930
Margaret Bulley Bequest
Misc. 2(140-148)-1934
Coffee pot and lid, sugar pot and cover, milk jug, tea pot and lid, two tea cups and saucers, coffee cup and saucer, two storage jars and covers
Mark GUSTAVSBERG SWEDISH PRODUCE, an anchor and MARINA printed in black; indistinct marks and 6 impressed
H. coffee pot 22. 3

in 'Stockholmsutställningen', the major exhibition of art and industry, Stockholm, 1930. A reduced version of this exhibition was shown in London, in Dorland House, Regent Street, in the following year, 1931. The range was extremely successful and was made continuously for 25 years. The blue version, 'Marina', was introduced by 1933, the year in which this set was on loan to the Museum before its formal acquisition in 1934. It was designed by Wilhelm Kåge as a re-working of the earlier brown painted range. Margaret Bulley bequeathed these pieces, among a large number of 20th century objects, to the Museum. She collected contemporary design and was advised occasionally by Roger Fry, the art critic, painter and founder of the Omega Workshops.

346 Vase
Earthenware with moulded ribbing and grey/blue shaded glaze
Made by Bo Fajans; designed by Ewald Dahlskog c. 1930
C. 173-1986
Mark BO SWEDEN GEFLE impressed; D65-539 painted in black, ED-9 painted in blue
H. 19. 3
Shape D 65; decoration no. 539

See also cat. no. 345.

347 Vase, 'Argenta' series ○
*Stoneware with green glaze and a geometric pattern in
silver, inlaid
Made by Gustavsberg 1954; designed by Wilhelm Kåge
c. 1930-40
Given by the maker
C. 128-1984
Mark GUSTAVSBERG ARGENTA A16 Y and an anchor
painted in silver
H. 25. 5*

The 'Argenta' series was introduced in 1930 in
'Stockholmsutställingen', the major exhibition of art and
industry, Stockholm. It was always a luxury range for
exhibition and prestige commissions and sold in the most
expensive markets. Production continued into the 1950s.

348 Vase, 'Argenta' series △
*Stoneware with green glaze and a figure playing a
stringed instrument in silver, inlaid
Made by Gustavsberg 1954· designed by Wilhelm Kåge
c. 1930-40
Given by the maker
C. 129-1984
Mark ARGENTA 979 printed in silver; GUSTAVSBERG an
ar.chor and KÅGE HANDDREJAD Y impressed
H. 20. 4*

**349 Part of a range 'Praktika', decoration
'Weekend'** ●
*Earthenware with painted decoration of green banding
Made by Gustavsberg; designed by Wilhelm Kåge 1933
Given by the maker and Helena Dahlbäck Lutteman
C. 182&A-D-1988; C. 215-1985
Four stacking vegetable dishes and lids, plate
Mark GUSTAVSBERG and an anchor printed in black;
GUSTAVSBERG 1933, an anchor, 1325 and a symbol
(indistinct) impressed; on the smallest to the largest dish
in ascending order 1, 2, 3 and 4 painted in green; on
plate GUSTAVSBERG an anchor and PRAKTIKA WEEKEND
4 printed in black
D. 21. 5*

'Praktika' range was introduced in 1933 for basic kitchen
and everyday use. It was inexpensive to produce. The

'Weekend' decoration was hand-painted but minimal. Other
patterns were 'Camping' and 'Kokvrå' (Kitchenette). It was
Kåge's contribution to the functionalist style, as the latest
modernism was termed in Sweden. Made in a practical
high-fired earthenware for strength, the range was first
shown at an exhibition mounted by the Svenska
Slöjdföreningen in Oslo, 1933, where it was acclaimed by
the critics. Like the 'Arbetarservis' (cat. no. 334) before it,
'Praktika' was not a success with the ordinary customer but,
eventually, its basic usefulness ensured its acceptance. Its
space-saving stacking capability and easily cleaned simple
shapes were regarded as pioneering concepts in the early
1930s. Additions to the range, 'Praktika II', were made in
1945.

**350 Part of a tableware range 'Mjuka Formernas'
(Soft forms), decoration 'Grå Rånder'
(Grey line)** ▽
*Earthenware with painted decoration of grey banding
Made by Gustavsberg, probably c. 1960; shape designed
by Wilhelm Kåge 1938; decoration designed 1944;
in production 1945-69
Given by the maker
Circ. 42, 43, 44-1961
Jug, vegetable dish, plate
Mark GUSTAVSBERG, an anchor and FLINTPORSLIN GRÅ
RÄNDER SWEDEN GUSTAVSBERG printed in green; on jug
WB2, on bowl WB20 impressed; on jug and vegetable dish
19, on plate 25 printed in green
D. plate 24
Model WB*

The 'Mjuka Formernas' range is made in high-fired earthen-
ware and reflects the interest in organic shapes of the later
1930s, such as those explored by Alvar Aalto in Finland in
1936 (see cat. no. 189). It is an advanced design for its
time and foreshadows the typically elliptical forms of the
1950s. This and its related group of 1961 Museum acqui-
sitions from Gustavsberg and other factories were assem-
bled first as loans for a travelling exhibition 'Scandinavian
Tablewares', 1956-7, organised by the Museum's Depart-
ment of Circulation. It concentrated on kitchen and table-
wares produced as factory design, serially produced, 'in a
contemporary spirit'. It is interesting to note therefore that
this particular set was regarded as contemporary in spirit
nearly 20 years after Kåge's conception. An exhibition of
German, Dutch and Italian tablewares immediately
preceded 'Scandinavian Tablewares'.

351 Bowl, 'Argenta' series △
*Stoneware with green glaze and small flowers in silver,
inlaid
Made by Gustavsberg; designed by Wilhelm Kåge c. 1938
C. 144-1977
Mark GUSTAVSBERG, an anchor and ARGENTA 1094-
111 MADE IN SWEDEN printed in silver; H painted in silver
D. 15. 2*

See cat. no. 347.

352 Dish, 'Löv' (Leaf) △
*Earthenware with white tin glaze and painted decoration
of stripes in blue and black
Made by Gustavsberg 1952; designed by Stig Lindberg
1940
Given by the maker
C. 142-1986
Mark G and a hand and SWEDEN 22 painted in
underglaze blue, V painted in red
L. 20*

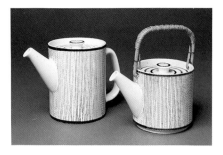

355 Tea pot and hot water jug △
Earthenware with white tin glaze and painted black lines
Made by Gustavsberg 1956-7; designed by Stig Lindberg
c. 1940
Given by the maker
C. 235&A-C-1985
Mark ST impressed; SWEDEN V/.7-100 G and a hand
painted in blue, a star painted in red
H. jug 13
Shape ST

Acquired originally by the Museum as a loan for a travelling
exhibition 'Scandinavian Tablewares' (see cat. no. 350).
The tea pot and lid stacks on top of the hot water jug.

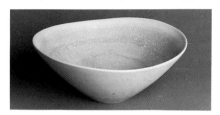

356 Bowl △
Stoneware with blue and speckled cream glazes
Made by Gustavsberg c. 1940; designed by Stig Lindberg
c. 1940
Given by J.V.G Mallet in memory of Sir Victor Mallet GCMG
to whom it belonged
C. 124-1988
Mark STIG L incised; G and a hand and STUDIO
impressed; STIG L incised
W. 22. 7

Gustavsberg glazes were developed by the company's
chemists in collaboration with the designers. Lindberg
would have selected these speckled glazes for this
elliptical bowl.

357 Bowl
Stoneware with mottled brown glaze
Made by Rörstrand c. 1940; designed by Gunnar Nylund
c. 1940
Given by J.V.G Mallet in memory of Sir Victor Mallet GCMG
to whom it belonged
C. 125-1988
Mark RÖRSTRAND, three crowns and G NYLUND incised
D. 19

Before he settled at Rörstrand in 1931, Gunnar Nylund
trained as an architect and then as a ceramicist in Denmark.
He was employed at Bing & Grøndahl in Copenhagen and
then ran a studio jointly with Nathalie Krebs at Islev. This
bowl reflects a respect for oriental glazes, an attitude which
may have been implanted during his time in Denmark where
such glazes were highly admired and emulated. However, in
the 1940s Nylund's Swedish contemporaries at Gefle and
Gustavsberg were also producing finely potted and glazed
wares such as this in 'oriental style'. See cat. nos 356, 367.

353 Bowl 'Cintra' △
Bone china with blue and brown glaze at foot rim
Made by Gustavsberg 1950; designed by Wilhelm Kåge
c. 1940
Circ. 127-1954
Mark G and a hand and KAGE CINTRA P painted in gold
H. 10. 2

'Cintra' was developed by 1938 and was first shown in Sweden
in 1940 after an earlier launch abroad. This example was
purchased from Gustavsberg with 13 others. The group was
to be included in 'school sets', small travelling displays
sent to art schools around Britain for the instruction of
British art students. The selection was made by Hugh
Wakefield of the Museum's Department of Circulation
during a visit to Gustavsberg in 1953.

354 Vase, 'Surrea' series ▷
Stoneware with white glaze
Made by Gustavsberg; designed by Wilhelm Kåge c. 1940
Given by the maker
C. 141-1986
Mark S (twice) impressed
H. 32. 2

Kåge produced a number of witty and elegant designs arising
from his familiarity with the modern movements in painting
and sculpture. Urbane and informed as always, here he is
referring, with gentle humour, to Cubism. The 'Surrea'
series included a wide range of cut and reassembled vases
and bowls, some partly coloured, some left undecorated.

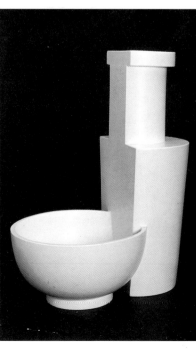

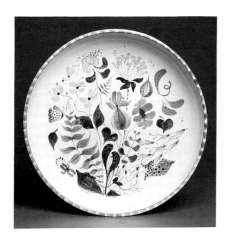

358 Dish △

*Earthenware with white tin glaze and painted decoration
of wild flowers and leaves in various colours
Made by Gustavsberg; designed by Stig Lindberg c. 1942
Given by the maker
C. 147-1986
Mark GUSTAVSBERG above an anchor and HANDDREIAD
within a rectangle impressed; G and a hand, a fish and
F152 painted in blue
D. 36. 6*

Stig Lindberg's painted faiences were first launched with
those by Wilhelm Kåge in an exhibition 'Fajanser målade i
vår' (faiences painted this spring), Stockholm, 1942.
Dishes like this were designed by him and decorated by a
painter in the Gustavsberg studio. In this case the painter
has used a fish as his/her personal symbol.

359 Dish, 'Kvinnoansikle' (Face) series C

*Earthenware with white tin glaze and painted decoration
of a female face in various colours
Made by Gustavsberg; designed and decorated by
Wilhelm Kåge 1943
Given by the maker
C. 146-1986
Mark GUSTAVSBERG above an anchor and HANDDREJAD
(indistinct) within a rectangle impressed; G and a hand
and KÅGE 1943 painted in black
D. 41. 3*

Kåge decorated a number of large dishes with faces
painted in a style reminiscent of Matisse. These and other
painted wares were launched in 1942 in an exhibition
'Fajanser målade i vår' (faiences painted this spring),
Stockholm, 1942 (see cat. no. 358).

360 Two plates, shape 'Colomba'

*Porcelain with printed decoration in grey
Made by Karlskrona; shape designed by Arthur Percy
1943
Given by the maker
Circ. 55, 56-1952
Mark KARLSKRONA within a ribbon, KP either side of an
anchor and SWEDEN PERCY printed in grey
D. 23. 3*

Included in and acquired following the exhibition
'Scandinavia at Table', arranged by the Council for
Industrial Design at the Museum in 1951. This shape
was intended by Percy to be undecorated but the company
issued it over a period of time with several patterns, one of
which is seen here.

361 Part of a tableware range LB ▷

*Bone china
Made by Gustavsberg c. 1956; designed by Stig Lindberg
1945
Given by the maker
Circ. 38&A, 39&A-1961
Cup and saucer, mocha pot and lid
Mark GUSTAVSBERG, an anchor and SWEDEN
BENPORSLIN LB printed in gold; on saucer 114 LB
impressed
H. mocha pot 19. 5*

Model LB was produced in plain undecorated porcelain, as
here, and also with painted decoration in black and gold
under the title 'Bankett' (Banquet). Acquired for a travelling
exhibition 'Scandinavian Tablewares' (see cat. no. 350).

362 Bowl △

*Stoneware with dark blue glaze
Made by Rörstrand; designed by Gunnar Nylund 1945
Given by the maker
C. 54-1987
Mark RÖRSTRAND R, three crowns and NYLUND incised
L. 16. 2*

363 Vase △

*Stoneware with figured glaze
Made by Gustavsberg; designed by Stig Lindberg c. 1945
Given by the maker
Circ. 129-1954
Mark G and a hand and X STIG L (partly obscured)
incised
H. 38*

364 Bowl

*Stoneware with mottled glaze and incised decoration of
faces
Made by Gustavsberg; designed by Stig Lindberg 1945-9
Given by the maker
Circ. 131-1954
Mark STIG L incised; G STUDIO and a hand impressed
H. 9*

365 Part of a tableware range 'Tebe' △

*Porcelain with moulded vertical fluting
Made by Karlskrona; designed by Arthur Percy 1946;
in production from 1952
Given by the maker
Circ. 58&A, 59&A, 60, 61-1961
Coffee pot and lid, cup and saucer, bowl, jug
Mark KARLSKRONA, a crown and anchor and K P
SWEDEN PERCY printed in green
H. 25
Model no. 55*

Acquired for a travelling exhibition 'Scandinavian Table-
wares' (see cat. no. 350).

366 Bowl and cover 'Spektralöv' (Spectrum leaf) C

*Earthenware with white tin glaze and painted decoration
in black and a graduated spectrum of browns, pinks,
purple, blues, green and yellow
Made by Gustavsberg; designed by Stig Lindberg 1947
Given by the maker
Circ. 133&A-1954
Mark G and a hand and SWEDEN 166-5 painted in blue,
a six-pointed star painted in yellow
H. 23
Shape 166*

This bowl and cover was produced decorated with various
different painted patterns.

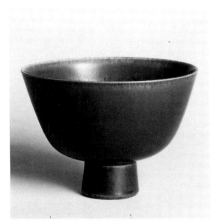

367 Bowl △
Earthenware with blue slightly crystalline glaze
Made by Gefle; designed by Arthur Percy c. 1948
Circ. 194-1954
Mark none visible
H. 8

Stoneware glazes, such as the one used here, have to be
fired at a higher temperature than earthenware glazes. They
are normally used on a stoneware body but in this case the
bowl is made of an earthenware able to withstand the
higher temperature necessary for the glaze firing. This bowl
is one of a group of nine pieces purchased by the Museum's
Department of Circulation from various factories within the
Upsala-Ekeby company. It was selected by Hugh Wakefield,
who visited Sweden and Finland in 1953, for inclusion in
travelling displays to be sent to British art schools.

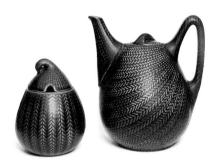

368 Part of a tableware range 'Blå Eld'
(Blue fire) △
Earthenware with moulded decoration and blue glaze
Made by Rörstrand; designed by Hertha Bengtson 1949;
in production 1951-71
Given by, separately, Mrs Fireman, J V G Mallet and the
maker
Circ. 27, 28-1961; C. 101&A, 102&A-1978
Oval dish (clear glaze), oval dish (blue glaze), tea pot and
lid (blue glaze), jam pot and cover (blue glaze)
Mark RÖRSTRAND MADE IN SWEDEN (C) RÖRSTRAND
INC and three crowns impressed
L. blue oval dish 39. 7

This range was made in a creamware body ('flintgods') and
originally produced in blue and white, the two colours
intended to be used in combination. Subsequently other
colour combinations, including red and grey, were put into
production. This range was included in the exhibition
'Three Centuries of Swedish Pottery', held at the Museum
in 1959 (catalogue: group no. 217). The two oval dishes
were acquired from that exhibition.

369 Part of a tableware range SA ▽
Bone china
Made by Gustavsberg c. 1956; designed by Stig Lindberg
c. 1949
Given by the maker
Circ. 34, 35, 36&A, 37&A-1961
Jug, bowl, coffee pot and lid, cup and saucer
Mark GUSTAVSBERG, an anchor and SWEDEN BEN
PORSLIN SA printed in gold; on saucer 446 impressed
H. coffee pot 20. 3

Acquired for a travelling exhibition 'Scandinavian Table-
wares' (see cat. no. 350).

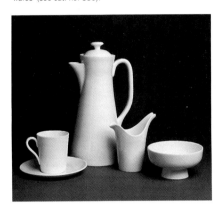

370 Part of a range 'Koka blå' (Boil blue) ▽
Stoneware with incised and painted decoration
Made by Rörstrand c. 1959; designed by Hertha
Bengtson c. 1950
Given by the maker
Circ. 26&A-1961
Coffee pot and lid
Mark KOKA, three crowns and RÖRSTRAND SWEDEN 27
printed in black
H. 18
Model KA

This range was included in the exhibition 'Three Centuries
of Swedish Pottery, Rörstrand and Marieberg', held at the
Museum in 1959 (catalogue: group no. 217). 'Koka' was
a comprehensive range made in various colours, and
included tea and coffee wares and also ovenware. Hertha
Bengtson was influential in Sweden in replacing the
conventional table service with a more flexible series of
individual yet harmoniously shaped pieces which could be
used singly or in matching groups.

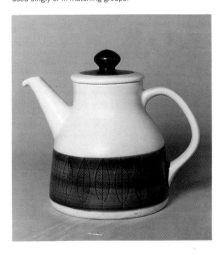

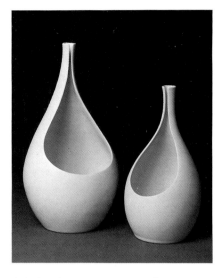

371 Pair of vases 'Pungo' (Pouch) △
White stoneware with matt colourless glaze
Made by Gustavsberg: designed by Stig Lindberg c. 1950
Given by the maker
Circ. 136&A-1954
Mark GUSTAVSBERG, an anchor and SWEDEN
impressed
H. 24. 2
Shapes 280, 283

This ware was given the name 'carrara' to describe its
marble-like surface.

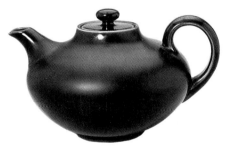

372 Tea pot and lid 'Cuprino' △
Earthenware with blue glaze
Made by Rörstrand; designed by Gunnar Nylund c. 1950
Given by the maker
Circ. 60&A-1952
Mark three crowns and RÖRSTRAND SVERIGE printed in
black
L. tea pot 21. 5

Included in and acquired following the exhibition
'Scandinavia at Table', arranged by the Council of
Industrial Design and held at the Museum in 1951.

373 Bowl
Stoneware with figured glaze
Made by Gustavsberg; designed by Berndt Friberg 1951
Given by the maker
Circ. 132-1954
Mark FRIBERG V incised; G STUDIO and a hand and
GUSTAVSBERG impressed
W. 17

374 Part of a tableware range 'Piké' ▷
Bone china with painted decoration
Made by Gustavsberg 1951; designed by Stig Lindberg
1951; in production 1951-65
Given by the maker
Circ. 48, 49&A-1952
Jug, coffee cup and saucer
Mark GUSTAVSBERG BEN PORSLIN PIKÉ and an anchor
printed in grey
H. jug 19. 1

Included in and acquired following the exhibition
'Scandinavia at Table', arranged by the Council for
Industrial Design and held at the Museum in 1951.

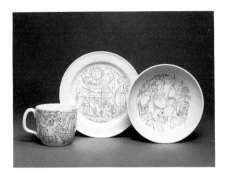

375 Child's plate, bowl and mug 'Sagoland' (Fairytale
country) △
Earthenware with printed decoration in blue
Made by Gustavsberg 1951; designed by Stig Lindberg
1951; in production until 1957
Given by the maker
Circ. 50&A&B-1952
Mark GUSTAVSBERG, an anchor and SAGOLAND STIG L
printed in blue
D. plate 19. 6

Included in and acquired following the exhibition
'Scandinavia at Table', arranged by the Council for
Industrial Design and held at the Museum in 1951.

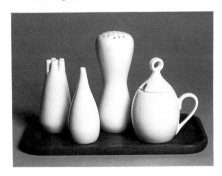

376 Cruet set and tray △
Bone china
Made by Gustavsberg 1951; designed by Stig Lindberg
1951
Given by the maker
Circ. 51&A-C, E&F-1952
Mark GUSTAVSBERG, an anchor and BEN PORSLIN
printed in black
H. caster 11

Included in and acquired following the exhibition
'Scandinavia at Table', arranged by the Council for
Industrial Design and held at the Museum in 1951.

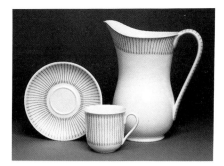

377 Salad bowl ○
Earthenware with white tin glaze and painted and incised
decoration in green/brown, yellow and pink
Made by Gustavsberg 1951; designed by Stig Lindberg
1950
Given by the maker
Circ. 52-1952
Mark F3 impressed; G, a hand, SWEDEN 3 and an
umbrella (or JD in monogram?) painted in blue
L. 25

Included in and acquired following the exhibition
'Scandinavia at Table', arranged by the Council for
Industrial Design and held at the Museum in 1951. The
painter using an umbrella mark (or JD) is unidentified.

378 Dish △
Chamotte earthenware with glazed slip and painted
decoration of a female face
Made by Upsala-Ekeby; designed and decorated by Mari
Simmulson 1951
Circ. 192-1954
Mark UE in monogram, 4062 and MARI S impressed;
MARI SIMMULSON DEK. A painted in black on a white
glazed rectangle
21.6 sq.

This and the vase by Mari Simmulson, cat. no. 393, were
purchased following a visit to Sweden and Finland by Hugh
Wakefield of the Museum's Department of Circulation in
1953 (see cat. no. 367).

379 Three vases 'Amalfi' ▷
Porcelain
Made by Karlskrona; designed by Sven Erik Skawonius
1951
Given by the maker
Circ. 198&A&B-1954
Mark UPSALA-EKEBY KARLSKRONA SWEDEN around a
crown and anchor and SKAWONIUS printed in green
H. tallest 28. 2

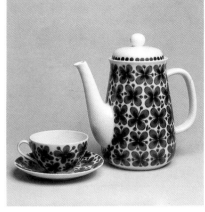

380 Part of a tableware range 'Mon Amie' △
Porcelain with printed decoration of repeated flowers in
blue
Made by Rörstrand c. 1986; designed by Marianne
Westman 1951; still in production
Given by the maker
C. 51&A, 52&A-1987
Coffee pot, cup and saucer
Mark V D N P555 MON AMIE, two flowers, RÖRSTRAND,
three crowns and SWEDEN printed in blue
H. coffee pot 20

The range was included in the exhibition 'Three Centuries
of Swedish Pottery' held at the Museum in 1959
(catalogue: group no. 219). 'VDN' in the printed mark
represents the Swedish Institute for Informative Labelling.
'P555' shows that: the ware is made of feldspar porcelain;
there is no risk of cracking; the pattern and glaze are resis-
tent to any chemical substance in the food; and the pattern
and glaze are fully dishwasherproof.

381 Vase, 'Farsta' series ▷
Stoneware with crystalline glaze and incised decoration
Made by Gustavsberg 1951; designed by Wilhelm Kåge
c. 1951
Given by the maker
Circ. 128-1954
Mark FARSTA incised; GUSTAVSBERG impressed
H. 10. 2

This crystalline glaze was called 'Snakeskin' by the factory.
See cat. no. 389.

382 Bowl 'Lansettblad' (Lancet blade)
Earthenware with white tin glaze and painted decoration
in greens and black
Made by Gustavsberg 1951; designed by Stig Lindberg
c. 1951
Given by the maker
Circ. 134-1954
Mark G and a hand and SWEDEN 168 (indistinct) .E.10
painted in blue, a V-shape painted in yellow
L. 27

383 Tea cup and saucer 'Aroma'
Porcelain
Made by Rörstrand; designed by Gunnar Nylund c. 1951
Given by the maker
Circ. 59&A-1952
Mark R, three crowns and SWEDEN MODEL NYLUND
printed in blue; W painted in black
D. saucer 17. 3

Included in and acquired following the exhibition
'Scandinavia at Table', arranged by the Council of
Industrial Design and held at the Museum in 1951.

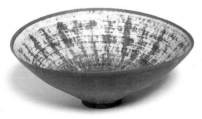

384 Bowl, 'Farsta' series △
Stoneware with incised and partly glazed decoration
Made by Gustavsberg 1953; designed by Wilhelm Kåge
1952
Given by the maker
Circ. 125-1954
Mark KÅGE V incised; G and a hand and STUDIO
impressed
D. 13. 8

See cat. no. 389.

385 Bowl, 'Farsta' series
Stoneware with incised, cut and partly glazed decoration
Made by Gustavsberg; designed by Wilhelm Kåge 1952
Given by the maker
Circ. 126-1954
Mark G and a hand and STUDIO impressed
D. 13. 2

See cat. no. 389.

386 Vase ▷
Stoneware with blue mottled glaze
Made by Gustavsberg; designed by Stig Lindberg 1952
Given by the maker
Circ. 130-1954
Mark G and a hand and STIG L V incised
H. 17. 6

387 Two pairs of dishes, shape FX
Earthenware with blue and dark brown/black semi-matt
glazes
Made by Gefle; designed by Arthur Percy c. 1952
Circ. 195&A, 196&A-1954
Mark UPSALA-EKEBY GEFLE, three smoking kilns and
MADE IN SWEDEN printed in yellows
L. 23

The dish or plate shape FX was in production between
1952-5. There were no other shapes to accompany it. The
dark brown/black glaze was named 'Mangania'. See cat. no.
367.

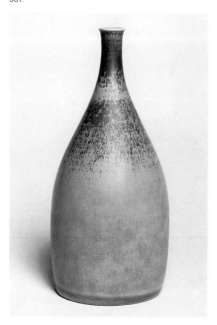

388 Ice water jug ▽
Earthenware with red glaze
Made by Gefle 1953; designed by Ingrid Atterberg 1953
Circ. 197-1954
Mark UPSALA-EKEBY GEFLE, three smoking kilns and
MADE IN SWEDEN printed in white; A22 incised
H. 24

The Gefle works were part of the Upsala-Ekeby combine by
this date. The red glaze was named 'Carmol' by the factory.

389 Vase, 'Farsta-Arktic' series △
Stoneware with incised and partly glazed decoration
Made by Gustavsberg; designed by Wilhelm Kåge 1953
Given by the maker
Circ. 124-1954
Mark KÅGE incised; G and a hand, STUDIO
GUSTAVSBERG and FARSTA (twice) impressed
H 17. 5

The 'Farsta' series was named after the landscape of the
locality 'Farsta' where the Gustavsberg factory is situated.
It featured dark red stoneware and glazed, relief and in-
cised decoration evocative of the rocky outcrops peculiar
to this area. The first experimental pieces were made in
1926 and the series was then launched in 1930 and shown
at exhibitions in 1933 and 1940. The 'Farsta-Arktic' wares
were distinguished by a thick, pale, snow-like glaze, and
this example was illustrated in the book *Wilhelm Kåge* by
Nils Palmgren (1953, p. 225).

390 Handled pot and cover 'Gefyr' (Fire) △
Stoneware with blue slip and colourless glazes
Made by Gustavsberg 1953; designed by Stig Lindberg
1953
Given by the maker
Circ. 137&A-1954
Mark GUSTAVSBERG, an anchor and ELDFAST GEFYR 40
82 printed in black
L. 22

This was the first 'fireproof' ware designed by Stig Lindberg.
Its name 'Gefyr' means 'fire' as in shooting. Perhaps
Lindberg intended this pot to be used for game?

391 Cup △
Chamotte earthenware, unglazed outside and with clear
glaze inside
Made by Grete Möller, Stockholm, 1953
Given by the artist
Circ. 1-1954
Mark GRETE and a heart painted in red
H. 16. 5

Grete Möller worked in Denmark with Edith Sonne Bruun
and was influenced by the classic Danish tradition of the
Saxbo pottery.

392 Dish
Earthenware with blue glaze and stencilled decoration of
six bulls in black
Made by Tom Möller, Stockholm, 1953
Circ. 2-1954
Mark TOM SWEDEN and a bull painted in black
D. 25

393 Vase ▽
Earthenware with black glaze outside and painted decora-
tion in pink, blue and white inside
Made by Upsala-Ekeby 1953; designed by Mari
Simmulson 1953
Circ. 193-1954
Mark UE in monogram and MARIS impressed; MARIS
(?indistinct) incised in inside rim
H. 24

See cat. no. 378.

394 Part of a range 'Stella' ▷
Porcelain with light green and clear glazes and moulded
ribbing
Made by Kariskrona; designed by Sven Erik Skawonlus
1953
Dish and jug given by the maker
Circ. 199, 200-1954; Circ. 48, 47-1961
Three dishes, jug
Mark KP, a crown and anchor and UPSALA-EKEBY
KARLSKRONA SKAWONIUS SWEDEN printed in green
W. 26

'Stella' range was developed following the issue of the first
shape, a small fruit plate. The range was made in a number
of colours. The 1961 acquisitions (one dish and the jug)
were among a large group intended for a travelling exhibi-
tion 'Scandinavian Tablewares' (see cat. no. 350).

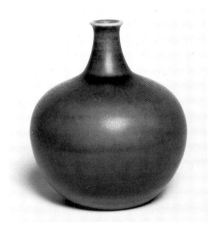

395 Vase △
Stoneware with green figured glaze
Made by Erich and Ingrid Triller, Tobo, 1953
Given by the artists
Circ. 17-1954
Mark TOBO painted in black
H. 10. 8

Erich Triller was born in Germany and he and his Swedish
wife Ingrid Triller first exhibited their work in Stockholm in
1036. It was a critical success and was subsequently
collected by King Gustavus VI Adolphus. The King's early
interest in Chinese ceramics led to an appreciation of
contemporary studio ceramics and, with the advice of Nils
Palmgren, he assembled a large and important collection
which includes some 15 pieces by the Trillers.

396 Pot and cover
Earthenware with white tin glaze and painted decoration
in yellows and black
Made by Gustavsberg; designed by Stig Lindberg c. 1953
Given by the maker
Circ. 135&A-1954
Mark G and a hand and SWEDEN 14-N-18 painted in
blue, a square painted in yellow
H. 19. 3
Shape 14

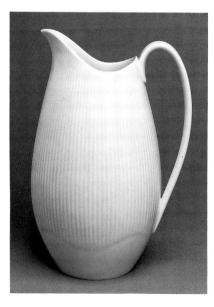

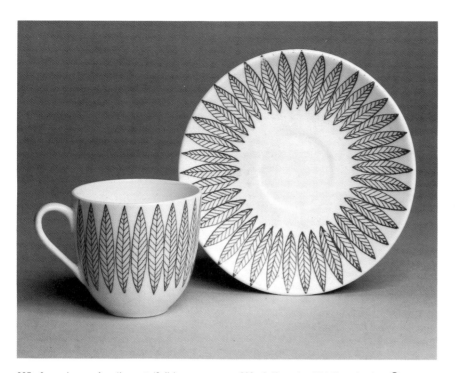

401 Soup tureen 'Indiana' △
Earthenware with matt black glaze outside and blue glaze inside
Made by Upsala-Ekeby; designed by Arthur Percy 1955
Given by the maker
Circ. 62&A-1961
Mark BE impressed
H. 24. 2
Model BE

The 'Indiana' series of dishes, plates and a jug was glazed with blue 'Turkos'. Only the soup tureen had the contrasting matt black 'Negro' glaze. The series was launched at the exhibition 'H55', Helsingborg, 1955. This tureen was acquired for a travelling exhibition 'Scandinavian Tablewares' (see cat. no. 350).

397 Cup and saucer from the range 'Salix' (Sallow) △
Bone china with printed decoration of leaves in red
Made by Gustavsberg 1954-6; shape designed by Stig Lindberg; decoration designed by Bibi Breger 1954; in production until 1965
Given by the maker
C. 233&A-1985
Mark GUSTAVSBERG and an anchor printed in red; SWEDEN BENPORSLIN SALIX painted in red
D. saucer 12. 8
Model SE

Acquired originally on loan for a travelling exhibition 'Scandinavian Tablewares' (see cat. no. 350).

399 Coffee pot and lid, 'Terma' series ○
Stoneware with a semi-matt brown glaze
Made by Gustavsberg 1955; designed by Stig Lindberg c. 1955; in production 1955-79
Given by the maker
Circ. 40&A-1961
Mark GUSTAVSBERG, an anchor and SWEDEN... (indistinct) ELDFAST TERMA 10 49 printed in brown; 12 impressed
H. 20

'Terma' ware (oven and fireproof ware with a distinctive brown glaze) was launched at the exhibition 'H55' held at Helsingborg in 1955 and was awarded a gold medal at the Milan Triennale,1957. Acquired for a travelling exhibition 'Scandinavian Tablewares' (see cat. no. 350).

402 Part of a tableware range 'Svart Ruter' (Black diamond) ▽
High-fired earthenware with painted decoration in black
Made by Gustavsberg c. 1955-6; designed by Karin Björquist c. 1955
Given by the maker
Circ. 45&A, 46&A-1961
Tea pot and lid, cup and saucer
Mark GUSTAVSBERG, an anchor and SWEDEN FLINTPORSLIN SVART RUTER printed in green
H. tea pot 17

'Flintporslin' is the equivalent of the English 'ironstone', a strengthened form of earthenware fired at a higher temperature than for normal earthenware. Acquired for a travelling exhibition 'Scandinavian Tablewares' (see cat. no. 350).

398 Plate and bowl from the range 'Pencil' △
Bone china with painted decoration in black
Made by Gustavsberg 1956; designed by Stig Lindberg 1955; in production until 1965
Given by the maker
Circ. 32, 33-1961
Mark GUSTAVSBERG, an anchor and SWEDEN BEN PORSLIN PENCIL HANDMÅLÅD 13 printed in green
D. plate 24
Shape LF

Acquired for a travelling exhibition 'Scandinavian Tablewares' (see cat. no. 350).

400 Frying pan 'Terma' △
Stoneware with matt brown glaze
Made by Gustavsberg; designed by Stig Lindberg 1955
Given by the maker
C. 236-1985
Mark GUSTAVSBERG, an anchor and SWEDEN FLAM ELDFAST TERMA 24 printed in brown; X painted in black
L. 29

Acquired originally on loan for a travelling exhibition 'Scandinavian Tablewares' (see cat. no. 350), this pan is one of two examples of 'Terma' ware in the Museum's collection (see also cat. no. 399).

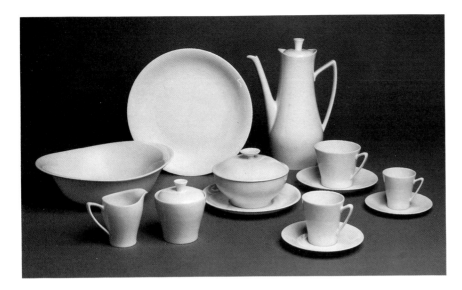

403 Part of a tableware range 'Karla' △
Porcelain
Made by Karlskrona; designed by Sven Erik Skawonius
c. 1955
Given by the maker
Circ. 49&A, 50&A, 51&A, 52, 53&A, 54&A&B, 55, 56,
57&A-1961
Three cups and saucers, cream jug, coffee pot and lid,
bowl and cover and stand, vegetable dish, plate, sugar
bowl and cover
Mark UPSALA-EKEBY KARLSKRONA, a crown and an-
chor and KP SKAWONIUS SWEDEN printed in green
H. 25. 3

Karlskrona was owned by the Upsala-Ekeby combine at this
time. Acquired for a travelling exhibition 'Scandinavian
Tablewares' (see cat. no. 350).

407 Part of a range 'Picknick' △
Earthenware with printed decoration of vegetables
and herbs painted in various colours, and with a green
glazed lid
Made by Rörstrand; designed by Marianne Westman
1956; in production until 1969
Given by the maker
Circ. 23&A, 24-1961
Cooking pot and cover, cheese dish
Mark PICKNICK, a peapod, three crowns and
RÖRSTRAND SWEDEN HANDPAINTED 106 ... ENWARE
(obscured) printed in black
L. cooking pot 26. 9

Included in two exhibitions held at the Museum: 'Three Cen-
turies of Swedish Pottery', 1959 (catalogue: group no. 219)
and 'Liberty's 1875-1975', 1975 (catalogue no. G27A&B).
This popular design apparently influenced the production
of other factories. Egersund in Norway produced a very
similar printed and painted pattern on ovenwares.

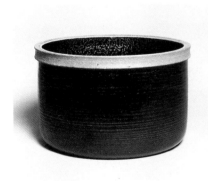

405 Plate 'Smögen' △
Earthenware, clear glaze on the underside, green/blue
glaze on the upper surface
Made by Upsala-Ekeby; designed by Ingrid Atterberg
1956
Given by the maker
Circ. 63-1961
Mark 223 A69 (indistinct) incised; UE SWEDEN
impressed
D. 23. 5

Smögen is a fishing village on the west coast of Sweden.
Acquired for a travelling exhibition 'Scandinavian Table-
wares' (see cat. no. 350).

404 Pot △
Chamotte stoneware with brown/black glaze
Made at Gustavsberg by Karin Björquist c. 1955-60
Given by the maker
C. 148-1986
Mark G STUDIO and a hand and GUSTAVSBERG KARIN
within a rectangle impressed
D. 24. 8

Karin Björquist studied under the potter Edgar Böckman at the
Tekniska Skolan (National College of Art, Craft and Design)
and subsequently with Wilhelm Kåge at Gustavsberg. Her
experience has been wide and her production varied:
compare this strongly conceived pot with the elegant
'Stockholm', cat. no. 434.

406 Part of a tableware range 'Elips'
Earthenware with painted decoration in brown
Made by Gustavsberg 1956; designed by Stig Lindberg
1956
Given by the maker
Circ. 29, 30, 31-1961
Two plates, jug
Mark GUSTAVSBERG, an anchor and SWEDEN
FLINTPORSLIN ELIPS BRUN 59. 27 59 printed in pink
D. plate 23. 5
Model LA

Acquired for a travelling exhibition 'Scandinavian
Tablewares' (see cat. no. 350).

408 Butterfly △
Stoneware, sand-cast and partly glazed
Made by Gustavsberg; modelled by Anders Liljefors
c. 1956
Given by the maker
C. 145-1986
Mark G and a hand and GUSTAVSBERG A.B.L. incised
W. 21. 2

Liljefors worked at Gustavsberg for the first time from 1947-
53. He returned again between 1955-7 and, breaking away
from the decorative and ornamental tradition, he worked
directly on sand-cast figures and also totally non-represen-
tational forms with results that were regarded as almost
anarchical.

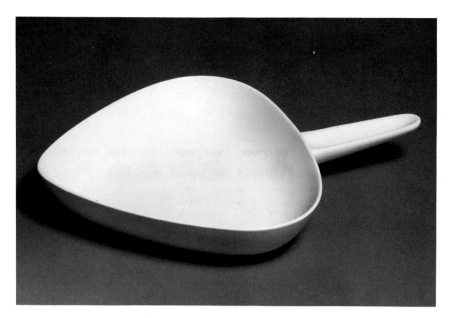

411 Vase ▽

Buff stoneware with streaked and mottled grey/green glaze
Designed and probably made by Carl Harry Stålhane at Rörstrand 1957
Given by the maker
Circ. 265-1959
Mark three crowns and CH STÅLHANE (indistinct) 57 SWEDEN incised
D. 27

Stålhane's career began as an assistant to the painter Isaac Grünewald, making colourful tin-glazed earthenwares. Stålhane soon went on to specialise in stoneware. He trained in painting and sculpture and much of his work for Rörstrand was sculptural and shows the influence of his interest in French and Italian abstract art. This vase was included in and acquired following the exhibition 'Three Centuries of Swedish Pottery', held at the Museum, 1959 (no. 208).

409 Handled dish 'Gourmet' △

Bone china
Made by Gustavsberg c. 1956; designed by Stig Lindberg c. 1956
Given by the maker
Circ. 41-1961
Unmarked
L. 24

Acquired for a travelling exhibition 'Scandinavian Tablewares' (see cat. no. 350).

410 Pan 'Pomona' ▽

Porcelain with painted decoration in black, blue, red and yellow
Made by Rörstrand 1956; designed by Marianne Westman c. 1956; in production until 1971
Given by the maker
Circ. 25-1961
Mark an apple, POMONA, three crowns and RÖRSTRAND SWEDEN UGNS ELDFAST printed in black and painted in red
L. 22. 5

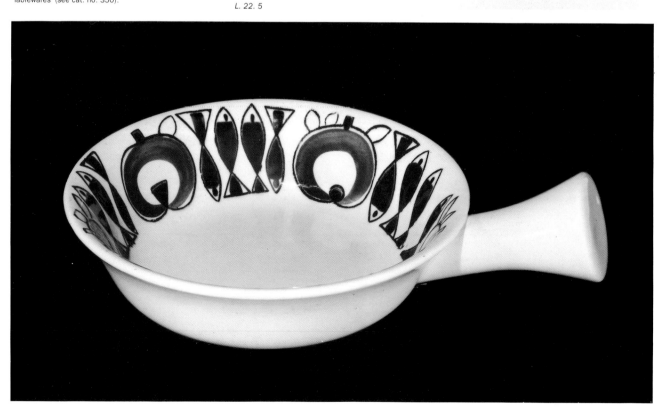

412 Part of a tableware range 'Berså' ▷
High-fired earthenware with printed decoration in green and black
Made by Gustavsberg; designed by Stig Lindberg 1960; in production until 1974
Given by the maker
C. 137&A-C-1984
Jug, cup and saucer, plate
Mark GUSTAVSBERG V.D.N. F555 BERSÅ FLINTGODS STIG L MADE IN SWEDEN printed in black within a circle of leaves printed in green
D. jug 15. 1
Model LL

'V D N F555' is the Swedish standards mark (see cat. no. 380). The 'F' stands for 'flintgods', a high-fired earthenware known in Britain as 'creamware'.

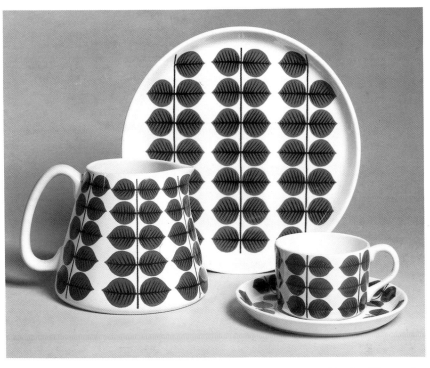

413 Mask △
Stoneware, modelled, with red and green glaze
Made by Hertha Hillfon, Stockholm, 1962
C. 181-1988
Mark H. HILLFON 1962 painted in black
H. 19. 4

In 1962 Hertha Hillfon was awarded the Lunning Prize. She is a sculptress who works exclusively in clay using a potter's techniques. She began in 1958 with freely assembled constructions over which the glazes spread unrestrainedly. By 1962 her work was typically formed of thin strips built into complex formations. In this mask only the hair is treated in this way. Since then she has gone on to smoother and more monumental forms.

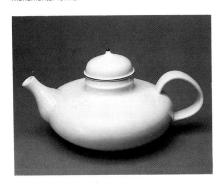

The most popular and successful version of this was made with a brilliant red glaze; it was also made in rich green, blue and yellow glazes.

414 Part of a tableware range 'Röd Kant' (Red edge), shape 'Åttkant' (Eight edge) △
Earthenware with screenprinted decoration
Made by Gustavsberg; designed by Karin Björquist 1968
Given by Helena Dahlbäck Lutteman
C. 213&A, 214&A-1985; C. 143, 144-1986
Two cups and saucers, two plates
Mark RÖD KANT DESIGN K. BJÖRQUIST DESIGN around GUSTAVSBERG and an anchor, all within a circle, and FLINTGODS V D N F555 MADE IN SWEDEN within a rectangle printed in red
D. large plate 27. 1

'V D N F555' is the Swedish standards mark (see. cat. no. 380). The 'F' stands for 'flintgods', a high-fired earthenware known in Britain as 'creamware'.

415 Tea pot and lid from the range 'Pop' ◁
Porcelain
Made by Rörstrand; designed by Inger Persson 1968; in production until c. 1981
Given by the maker
C. 53&A-1987
Mark R, three crowns and P: SWEDEN printed in black
L. 25. 8

416 Vase △
Stoneware with relief decoration and mottled glazes
Made by Gustavsberg; designed by Stig Lindberg
c. 1970-5
Given by the maker
C. 135-1984
Mark G and a hand and STIG L incised
D. 18. 6

One of three vases (see also cat. nos 420, 421) made late in Stig Lindberg's career at Gustavsberg when he returned to simple shapes and Oriental-style glazes.

417 Bowl △
*Stoneware with hand-pressed decoration inside and run
glazing outside
Made by Märit Lindberg-Freund, Västerås, c. 1972
Circ. 618-1972
Mark MARIT incised
D. 26. 5*

This bowl was included in the exhibition 'International
Ceramics', held at the Museum, 1972 (catalogue: Sweden
no. 4).

418 Part of a tableware range 'Birka' ▽
*Stoneware with speckled glaze and painted black lines at
the rims
Made by Gustavsberg; designed by Stig Lindberg 1973
Given by the maker
C. 138&A-G-1984
Large rectangular dish, large bowl, small rectangular
dish, square dish, soup bowl, small plate, medium plate,
large plate
Mark UGNSSAKERT STENGODS DESIGN: STIG
LINDBERG SWEDEN, OVEN - TABLE - DISHWASHER - BIRKA
GUSTAVSBERG and an anchor all within a double circle
printed in grey; V D N S555 GUSTAVSBERG and an anchor
impressed
L. rectangular dish 38. 6
Model LT*

Birka decoration is named after the earliest city in Sweden,
founded by the Swedish Vikings on an island in Lake Mälaren
and abandoned in the 11th century. Birka, like Berså and
Åttkant (cat. nos 412, 414), was introduced as part of
Gustavsberg's range of 'everyday wares' and is made in ser-
vicable stoneware. It demonstrates Lindberg's capacity,
33 years after his first tableware design, to keep abreast
of contemporary stylistic trends. 'V D N S555' is the
Swedish standards mark (see cat. no. 380). The 'S' stands
for 'stengods' (stoneware).

This is a unique piece made at a time, very late in Lindberg's
career, when he was returning to simple shapes and glazes
inspired by Japanese and Chinese originals, an interest
which he had first pursued immediately on his arrival at
Gustavsberg in 1940. See also cat. nos 356, 363.

421 Vase △
*Stoneware with relief decoration and brown/black glaze
Made at Gustavberg by Stig Lindberg c. 1975
Given by the maker
C. 134-1984
Mark G and a hand and STIG L incised
H. 18. 2*

Like the two other pieces in this late group (see cat. nos 416,
420), this vase shows Lindberg's return to an early interest
in Chinese glazes. The brown/black glaze, originally from
the Chinese Song period, is known today by the Japanese
name 'tenmoku' and can be applied to materials as
different as rough stoneware and porcelain. Karin Björquist
used the same glaze on her stoneware pot (cat. no. 404)
of c. 1955-60; Paul Hoff now works with porcelain and a
tenmoku glaze as in his bowl (cat. no. 440), thus con-
tinuing the tradition at Gustavsberg of interest in such
classic Chinese glazes.

419 Flower pot 'Oktavius' ◁
*Bone china
Made by Gustavsberg; designed by Karin Björquist
1975-80
Given by the maker
C. 132-1984
Mark OKTAVIUS below a spray of leaves and a flower, and
GUSTAVSBERG MADE IN SWEDEN around an anchor all
printed in black
D. 27. 2*

420 Bowl ▷
*Stoneware with flambé purple glaze
Made by Gustavsberg 1975-80; designed by Stig
Lindberg 1975-80
Given by the maker
C. 136-1984
Mark STIG L, G and a hand incised
D. 10. 7*

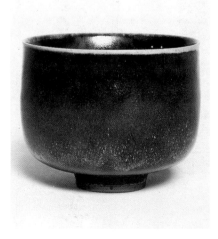

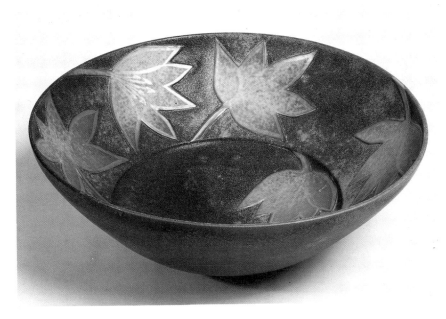

china. Due to close trade connections with England, in particular in materials for the ceramics industry, Gustavsberg is the only factory outside England which makes the otherwise exclusively English bone china.

424 Bowl 'Spisa' (Eat) △
High-fired earthenware with moulded fluting and brown glaze
Made by Rörstrand; designed by Inger Persson
c. 1978-80
Given by the maker
C. 50-1987
Mark RÖRSTRAND, three crowns and SWEDEN SPISA V D N F555 c OVENPROOF MICROSAFE IPE printed in black, 17 impressed
D. 21. 5

'Spisa' (eat) is an early Swedish word. This design won a Design Plus award at the international fair, Frankfurt, 1984. 'V D N F555' is the Swedish standards mark (see cat. no. 380). The 'F' stands for 'flintgods', a strengthened high-fired earthenware known in Britain as 'creamware'.

422 Bowl △
Stoneware with leaves in relief, covered with mottled pink and grey glaze and enriched with silver
Made at Gustavsberg by Margareta Hennix 1976
Given by the maker
C. 149-1986
Mark M HENNIX GUSTAVSBERG ATELJE SWEDEN incised
D. 44. 8

Margareta Hennix has produced a range of richly decorative unique wares as well as a number of patterns for series production at Gustavsberg where she has worked intermittently since 1967.

423 Part of a tableware range 'Blanche' ▽
Bone china
Made by Gustavsberg; designed by Karin Björquist 1978
Given by the maker
C. 139&A-C-1984
Two mugs, bowl and plate
Mark GUSTAVSBERG BENPORSLIN V D N - B555 and an anchor printed in black
D. bowl 21. 5
Shape BV

'V D N B555' is the Swedish standards mark (see cat. no. 480). The 'B' stands for 'benporslin', in Britain known as bone

425 Part of a tableware range 'Bell' △
Stoneware with printed decoration in blue
Made by Gustavsberg; designed by Karin Björquist 1979
Given by the maker
C. 140&A-M-1984
Large dish, oval bowl, two large cups and saucers, three medium cups and saucers, one small cup and saucer
Mark GUSTAVSBERG, an anchor and OVEN. TABLE. DISHWASHER V D N S555 BELL SWEDEN DESIGN. KARIN BJÖRQUIST printed in blue; GUSTAVSBERG SWEDEN BV-8 impressed
L. large dish 40. 2
Shape BV

Shape BV is made in both bone china, as in the 'Blanche' range cat. no. 423, and stoneware, as here. 'V D N S555' is the Swedish standards mark (see cat. no. 380). The 'S' stands for 'stengods' (stoneware).

426 Coffee pot and lid, cup and saucer from the range 'Primeur' △
Porcelain with printed decoration in blue
Made at Rörstrand; designed by Signe Persson-Melin
1980
Given by the maker
C. 46&A, 47&A-1987
Mark RÖRSTRAND, three crowns and SWEDEN
PRIMEUR SIGNE PERSSON-MELIN V D N P555 880
printed in brown
H. 19. 4

Signe Persson-Melin is a long-established potter and an elegant designer of both glass and ceramics. The slim shape of 'Primeur' and the deft, minimal flare to the rim are typical and echo her previous designs for Kosta Boda's heat-resistant glassware. 'V D N P555' is the Swedish standards mark (see cat. no. 380). The 'P' stands for 'porslin' which is feldspar porcelain.

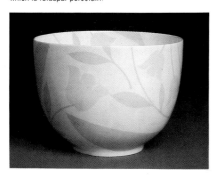

427 Bowl △
Bone china with printed decoration in pink and greens
Made by Gustavsberg; designed by Pia Rönndahl 1983
Given by the maker
C. 131-1984
Mark PIA R.83 GUSTAVSBERG SWEDEN painted in green
D. 15. 2

Pia Rönndahl was one of Gustavsberg's youngest designers, arriving there in 1980. In this bowl she has used the pastel palette typical of the late 1970s and early 1980s.

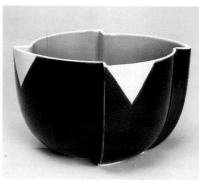

428 Bowl 'Valenzuela' △
Stoneware with spray decoration of a geometric pattern in black and grey glazes
Made by Gustavsberg; designed by Margareta Hennix
c. 1983
Given by the maker
C. 141-1984
Mark MARGARETA HENNIX VALENZUELA GUSTAVSBERG
SWEDEN painted in blue
D. 19

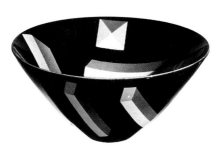

429 Bowl ▽
Red earthenware with black slip inside
Made by Ingegerd Råman, Stockholm, 1984
C. 166-1987
Mark on side: IR in monogram impressed; on base: IR in monogram and 26/10 84 painted in black
D. 45

Ingegerd Råman only makes pots for use. She is not interested in decorative wares and only uses decoration sparingly and in the most disciplined way. She limits her colour range to clay-red, clay-white and black. Nevertheless, within her own closely defined range she has allowed the warmth of red earthenware and the richness of black slip glaze a generous freedom.

430 Tea pot and lid ▽
Stoneware with blue glaze and printed flecked decoration in blue and gold
Made by Rörstrand; designed by Signe Persson-Melin
c. 1984
Given by the maker
C. 45&A-1987
Mark R, three crowns and SIGNE PERSSON-MELIN 213 incised
W. 19. 5

In 1985 Rörstrand issued a numbered collection of tea pots via Rosenthal's Studio House outlets. The collection consisted of 80 different variations by four Swedish designers associated with the design company Kosta Boda (see also cat. no. 436). This tea pot is numbered 213 of its design.

431 Bowl, 'Atlantis' series ◁
Porcelain with printed decoration in black, greys and white
Made by Rörstrand; designed by Rolf Sinnemark c. 1984
Given by the maker
C. 49-1987
Mark RÖRSTRAND, three crowns and SWEDEN ROLF SINNEMARK printed in black; 5 impressed
D. 31. 2

The 'Atlantis' series is related to the tea pot design cat. no. 436 and was used for a number of bowl and dish shapes.

434 Part of a tableware range 'Stockholm' ▽
Bone china
Made by Gustavsberg; designed by Karin Björquist 1985
Given by the maker
C. 191&A-D-1987
Sugar pot and lid, coffee cup and saucer, cream jug
Mark BONE CHINA MADE IN SWEDEN STOCKHOLM and
KARIN BJÖRQUIST in script within a lozenge,
GUSTAVSBERG and an anchor printed in blue
H. sugar pot with lid 8. 8
Model BA

This model is marketed undecorated under the name 'Stockholm'. It is also made in a range of different decorations, see cat. nos. 432, 433, 435.

435 Part of a tableware range 'New York' △
Bone china with printed decoration of a triangle in gold
and a black line
Made by Gustavsberg; shape designed by Karin Björquist;
decoration designed by Jonas Lindkvist 1985
Given by the maker
C. 192&A-C-1987
Oval serving dish, vegetable dish, coffee cup and saucer
Mark BONE CHINA MADE IN SWEDEN NEW YORK DECOR
and JONAS LINDKVIST in script within a lozenge and
GUSTAVSBERG and an anchor printed in gold;
5 impressed
L. serving dish 27. 7
Model BA

Like Lena Boije (see cat. no. 433), Jonas Lindkvist is an independent designer and not a member of the Gustavsberg design team.

432 Part of a tableware range 'Paris' △
Bone china with celadon glaze and a gold line
Made by Gustavsberg; designed by Karin Björquist 1985
Given by the maker
C. 189&D-F-1987
Salad bowl, milk jug, cream jug, tea cup and saucer,
coffee cup and saucer
Mark BONE CHINA MADE IN SWEDEN PARIS and KARIN
BJÖRQUIST in script within a lozenge and GUSTAVSBERG
and an anchor printed in gold
D. salad bowl 25. 4
Model BA

'Paris' is Karin Björquist's decorated version of her own shape design, model BA (see cat. no. 434).

433 Part of a tableware range 'Caprifolium'
Bone china with printed decoration of honeysuckle in
pink, greens and yellow
Made by Gustavsberg; shape designed by Karin Björquist;
decoration designed by Lena Boije 1985
Given by the maker
C. 190&A-D-1987
Plate, vegetable dish, salad bowl, coffee cup and saucer
Mark BONE CHINA MADE IN SWEDEN CAPRIFOLIUM
DECOR and LENA BOIJE in script within a lozenge
and GUSTAVSBERG and an anchor printed in green;
GUSTAVSBERG, an anchor and SWEDEN 863 impressed
D. plate 25. 5
Model BA

Lena Boije owns her own design company and provided this pattern for Gustavsberg as an independent commission.

436 Tea pot and lid ◁
Porcelain with printed geometric decoration in black,
greys and white
Made by Rörstrand; designed by Rolf Sinnemark c. 1985
Given by the maker
C. 48&A-1987
Mark R, three crowns and ROLF SINNEMARK printed in
black; 404 painted in black
W. 26. 4

Number 404 of a limited edition, this tea pot was launched at special exhibitions in Europe by Rosenthal's outlet, Studio House, in 1985. See cat. no. 431.

437 Dish 'Soltecken' (Suntoken) C
Earthenware with painted decoration of a face surrounded by radiating 'flames' in slip colours and gold
Made by Hertha Hillfon, Stockholm, 1986
C. 293-1987
Mark HERTHA HILLFON 1986 painted in brown; H. 86
incised
D. 57

This strongly painted bowl of monumental proportions representing a recent return to her first forms, illustrates Hertha Hillfon's deeply-held feeling for early classical and archaic subjects and for sculptural forms.

438 Jug ▷
Stoneware with semi-crystalline, semi-matt black glaze
Made by Ingegerd Råman, Stockholm, 1986
C. 167-1987
Mark IR in monogram impressed
H. 27

Recently Ingegerd Råman has moved from earthenware to concentrate on stoneware combined with a strong but elegant crystalline glaze, a practical decision based on the material's greater strength. She continues to work within a disciplined range (see cat. no. 429).

439 Figure 'Havstrut' (Seagull) ▽
Mixed stonewares, hand-built, scattered with coarse sand and partly glazed
Made by Henrik Allert, Gothenburg, 1987
C. 105-1988
Mark H. ALLERT incised
L. 56

Henrik Allert was employed briefly at Rörstrand before opening his own studio and beginning a career as a sculptor/ceramicist. His subjects have been drawn from nature, and seagulls have been a favourite motif for many years. He has always seen an individual expressiveness and character in each figure and has recently pushed his acute perception of this towards more primitive and

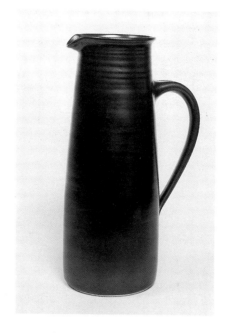

powerful images in which feathers and fur are reduced to a bleached, bone-like effect and, yet further, to a study of the skull beneath. His technique of using mixed clays with sand and grit heightens the impression of ancient and primitive mystery.

440 Bowl ▽
Bone china with brown/black glaze
Made by Gustavsberg 1988; designed by Paul Hoff 1987
Given by the maker
C. 104-1988
Mark PAUL HOFF GUSTAVSBERG SWEDEN 1988 UNIK painted in brown, 247 painted in black
L. 41

A factory-made 'unique' piece, this is 247 of a numbered series in which the natural variations in the glazing make each bowl individual. Paul Hoff has had a highly successful career as a glass designer at Kosta Boda as well as in his work in ceramics for Gustavsberg and, since 1988, for the combined Rörstrand-Gustavsberg AB. This bowl amply illustrates his sculptural skill and his particular interest in wildlife and plants. Its identity is curiously ambiguous, open to interpretation either as a leaf-like bird or a bird-like leaf. This bowl was issued in both this brown/black tenmoku-type glaze (see cat. no. 421) and in plain white.

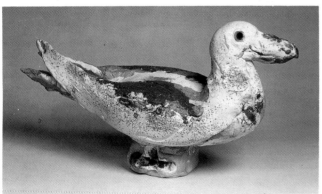

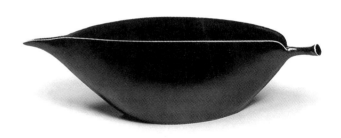

441 Carafe ▷
Clear, grey/brown soda glass, mould-blown
Made by Orrefors; designed by Edward Hald c. 1918
C. 5-1988
Unmarked
H. 19. 7
Model HS 165

This carafe was designed with an accompanying tumbler. Some of Hald's designs were made between 1920 and 1930 at the Sandvik glassworks which had been taken over by Orrefors in 1918. All the forms were soft, graceful shapes, most for useful wares, undecorated apart from fluting or ribbing, as in this carafe, and occasionally with a little free-worked decoration. Towards the end of the 1920s Hald devised more cleanly functional shapes to be produced as pressed glass.

442 Window panel ●
Stained glass, painted to show Christ bearing the Cross
Designed by Einar Forseth 1919; decorated by Gustaf Ringström
Given by The Swedish Society B.V. (Berserks and Vikings)
C. 60-1930
Mark E. FORSETH PINX. G.R.INV. 1919 painted
W. 79

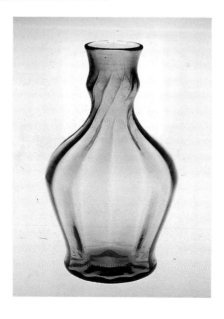

This is a replica of a window made for the church in Frövi, Sweden. The panel was acquired by the Museum with a number of designs on paper following an exhibition of Einar Forseth's glass, mosaics and paintings held at the the Fine Art Society in 1930. Forseth is best known for his mosaic decoration in the 'Golden Hall' in Ragnar Östberg's Stockholm Town Hall of 1923.

443 Vase and stand 'Fyrverkeriskålen' (Fireworks bowl) ○
Clear colourless glass with copper-wheel engraved decoration of fireworks above a fairground
Made by Orrefors 1930; designed by Edward Hald 1921; engraved by Karl Rössler
Circ. 52&A-1931
Mark OF30 H 248 KR incised
D. 27. 6

Purchased with other glasses by Orrefors from the 'Exhibition of Swedish Industrial Art' held at Dorland House, Regent Street, March 1931. The exhibition was drawn from the much larger, major exhibition of art and industry, 'Stockholmsutställningen', in Stockholm the previous year. Hald's education as a painter, including a period in Paris studying with Matisse and meeting many influential artists of the Paris school, was undoubtedly a formative one.

In much of his engraved work an awareness of modern style and contemporary subjects combined with a natural flair give his designs a totally distinctive freshness. This vase is one of Hald's best known designs of the 1920s.

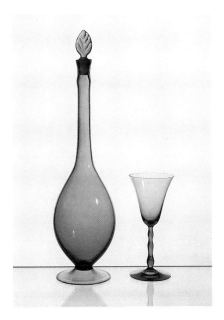

444 Parts of two ranges △
Clear glass, one colourless, one brown, the decanters with leaf-like stoppers, the glasses with ribbed stems
Made by Orrefors, brown glass 1948, colourless glass 1965; designed by Simon Gate 1922; in production 1922-65
Circ. 137, 138&A-1949; Circ. 611&A, 612, 613, 614, 615, 616, 617-1966
White wine (brown), decanter and stopper (brown), decanter and stopper (colourless), tumbler (colourless), liqueur (colourless), cocktail (colourless), champagne (colourless), white wine (colourless), goblet (colourless)
Unmarked
H. decanter with stopper 38. 2
Model GS 634, GS521

This model was included in the Jubilee exhibition, Gothenburg, 1923.

445 Tumbler
Clear colourless glass
Made c. 1928; factory and designer unknown
Margaret Bulley Bequest
Misc. 2(124)-1934
Unmarked
H. 7. 7

See cat. no. 454.

446 Bowl 'Simson och Lejonet'
 (Samson and the lion) ▷
Green glass with copper-wheel engraved decoration
Made by Orrefors 1930; designed by Vicke Lindstrand 1929; engraved by Wilhelm Eisert
Circ. 59-1931
Mark OF.L.54.30.W.E. incised
W. 13. 4

This bowl is in Orrefors' 'Sea green' glass and was purchased with seven other pieces from the 'Exhibition of Swedish Industrial Art' (see cat. no. 443).

447 Bowl 'Vallmo' (Poppy) series ▽
Grey/brown clear glass with copper-wheel engraved and cut decoration
Made by Eda 1931; designed by Gerda Strömberg 1929
Circ. 142-1931
Mark EDA 31 incised
D. 24. 5

This is one of a number of vases and bowls designed by Gerda Strömberg for Eda that experiments with related forms and decoration. A vase of this shape was exhibited in 'Straw' colour in the 'Exhibition of Swedish Industrial Art' (see cat. no. 443), and this bowl was subsequently ordered by the Museum through Soane & Smith, Knights-bridge, distributing
agents for the exhibition. It was especially made in 'Smoke' instead of 'Straw' colour, although no reason is given for this in the Museum records.

448 Bowl and cover 'Glob' (Globe) ▷
Clear grey-tinted glass with copper-wheel engraved decoration of a chequered pattern
Made by Eda; designed by Gerda Strömberg c. 1929-30
Circ. 143&A-1931
Mark EDA 30 incised
H. 19

Intended for sweets or honey, this 'bonbon' globe was ordered by the Museum from the 'Exhibition of Swedish Industrial Art' (see cat. no. 443). It demonstrates a remarkably controlled technique. The glass is extremely thin and, additionally, has been engraved overall with a very high degree of skill. The colour number is 613.

449 Vase △
Clear, colourless glass with black glass foot and rim
Made by Orrefors 1930; designed by Simon Gate 1930
Circ. 54-1931
Mark ORREFORS 1930 G.U.67 incised
H. 26

Purchased with seven others from the 'Exhibition of Swedish Industrial Art' (see cat. no. 443) and illustrated in the catalogue.

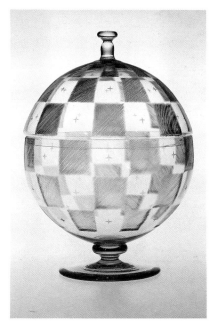

450 Tray 'Mor och barn' (Mother and child)
Clear grey/brown tinted glass, with copper-wheel engraved decoration of a mother and child
Made by Orrefors 1930; designed by Simon Gate 1930; engraved by Arthur Diessner
Circ. 55-1931
Mark 541 ORREFORS.S.GATE.A.DIESSNER 1930 incised
22.6 sq.

Purchased from the 'Exhibition of Swedish Industrial Art' (see cat. no. 443).

451 Vase ▷
Clear, colourless glass with cut decoration of flared
vertical ribs and flutes
Made by Orrefors; designed by Simon Gate 1930
Circ. 127-1949
Mark ORREFORS GA 270 incised
H. 13. 5

452 Vase ▽
Clear green-tinted glass
Made by Orrefors 1930; designed by Edward Hald 1930
Circ. 53-1931
Mark ORREFORS 1930 H.Z.48
D. 18

Purchased with seven others from the 'Exhibition of
Swedish Industrial Art' (see cat. no. 443).

453 Pair of cigarette tumblers
Clear grey/brown glass with flat cut decoration
Made by Orrefors 1930; designed by Edward Hald 1930
Margaret Bulley Bequest
Misc. 2(138, 139)-1934
Mark OF.30.H.A.303 incised
D. 8. 5

See cat. no. 454.

454 Pair of vases ▷
Clear green glass, flat cut
Made by Orrefors 1931; designed by Edward Hald 1930
Margaret Bulley Bequest
Misc. 2(157, 158)-1934
Mark OF.31.HA.289 incised
D. 11

Margaret Bulley collected contemporary design during the
second decade of the century taking advice from, among
others, Roger Fry, the art critic, painter and founder of the
Omega Workshops. Her collection included some extremely
modest pieces of Swedish glass, some of them
unattributed to any designer, as well as a number of more
interesting works from other countries. The Margaret Bulley
collection was on loan exhibition to the Museum during
the 1920s and was formally acquired as a bequest in 1934.
First exhibited in the Museum's North Court in 1929 with
the modern collections of the British Institute of Industrial
Art, it was moved to Bethnal Green Museum in 1930. The
Bethnal Green Museum, as a branch of the Victoria and
Albert Museum, displayed the 20th century collections
during the 1920s and 1930s and after the war until the
late 1960s, culminating in the exhibition 'Forty Years
of Modern Design', 1966.

455 Vase ▷
Opaque colourless glass, the surface etched and painted
to show three female nudes, 'Think no evil, Hear no evil,
See no evil', in black
Made by Orrefors 1930; designed by Vicke Lindstrand
1930
Circ. 56-1931
Mark OF 30 LI 53 incised
H. 14. 1

Vicke Lindstrand's painted glass was made especially for
'Stockholmsutställningen', the major exhibition of art and
industry, Stockholm, 1930, but was discontinued shortly
afterwards. This example was purchased with seven others
from the 'Exhibition of Swedish Industrial Art' (see cat. no.
443).

456 Vase 'Trångt I Luften' (Crowded skies) ▷
Clear colourless glass with copper-wheel engraved
decoration of factory chimneys and telegraph wires
Made by Orrefors 1931; designed by Vicke Lindstrand
1930; engraved by Karl Rössler
The gift of Colin and Morna Anderson
C. 302-1976
Mark OF.L.103.31.KR incised
H. 23

This vase was bought by the donor's father in Stockholm.
The factory records identify the vase as having been
designed in 1930, which suggests that it may have been
intended for inclusion in the major Stockholm exhibition of
art and industry of that year, 'Stockholmsutställningen'.

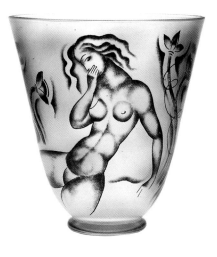

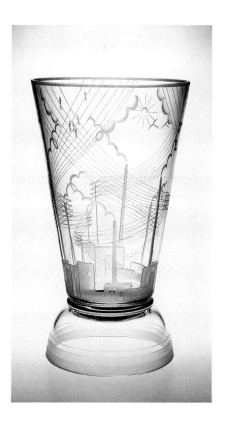

457 Dish △
Clear grey/brown glass with flat cut decoration
Made by Eda 1931; probably designed by Gerda
Strömberg c. 1930
Miss M. Palsford Bequest
Circ. 478-1960
Mark EDA 1931 incised
D. 39. 5

Edward Strömberg, husband of Gerda Strömberg, was technical manager at Eda before the couple took over Lindefors in 1933 and renamed it Strömbergshyttan. Gerda Strömberg, entirely self-taught, devised a range of designs for both glassworks, varying from a brilliant, brittle style, as here, to the more chunky monumentality of 'Vallmo' cat. no. 447 and the thick-walled Strömbergshyttan productions.

458 Bowl and cover △
Clear brown soda glass
Made by Orrefors; designer unknown c. 1930-1
Circ. 130&A-1937
Unmarked
H. 12. 2
Shape ES1227

This bowl and cover is described as 'a bonbon' in the acquisition records. It was probably made at Orrefors' Sandvik glassworks, which, as part of the Orrefors company, concentrated on the production of inexpensive household items of unpretentious, functional yet graceful shapes, many of which were designed by Simon Gate and Edward Hald. It was part of the group of Swedish glass purchased for the instruction of English glass students (see cat. no. 464).

459 Bottle and stopper ▽
Clear brown soda glass
Made by Orrefors; designer unknown c. 1930-1
Circ. 131&A-1937
Unmarked
H. 16. 2
Shape ES1287

Possibly designed in the 1920s by Gerda Strömberg for Orrefors' Sandvik factory (see also cat. no. 464).

460 Vase, 'Graal' series C
Clear blue and pink glass, blown, with decoration of
bluebell-like flowers in 'Graal' technique
Made by Orrefors 1931; designed by Simon Gate 1931;
blown by Gustav Bergkvist
Circ. 58-1931
Mark S GRAAL ORREFORS 1931 GB 3284 SG incised
H. 13

This vase is made in the celebrated 'Graal' technique (named after the Holy Grail), invented and developed at Orrefors, and for many years an exclusive speciality. Examples in the technique were made as early as 1916. The technique is complex and expensive. First, a thick-walled bubble of clear glass is formed, which is then 'cased' with a thin layer of molten, coloured glass. This bubble is then cooled slowly to room temperature in an annealing kiln. The design is created by cutting away the unwanted part of the solid colour layer, leaving the design surrounded by the now exposed underlaying clear glass. This cutting-away can be done by directly engraving, or else painting the design in a masking material, such as asphalt, which is left untouched by sand-blasting or acid-cutting. When the design is complete, the piece is again slowly heated up. Exposure to fire smooths over what would otherwise be the frosted surface. The bubble is then cased with an outer layer of clear glass and is finally blown out to full size and the desired shape.
 Purchased with seven others from the 'Exhibition of Swedish Industrial Art' (see cat. no. 443).

461 Pipe-bowl ▽
Clear grey/black glass, cut in broad concentric grooves
Made by Orrefors; designed by Simon Gate 1933
Circ. 121-1934
Mark OF.GA.400/2 incised
D. 14. 9

This bowl was purchased with several other items from Heal's, Tottenham Court Road. Heal's was one of the progressive London retailers specialising in advanced design, and Scandinavian production was stocked regularly and exhibited in the Mansard Gallery on the shop's top floor. The Museum bought from Heal's at regular intervals and had close contacts with the staff and management there, several of whom were on Museum and exhibition committees during the 1920s and 1930s.

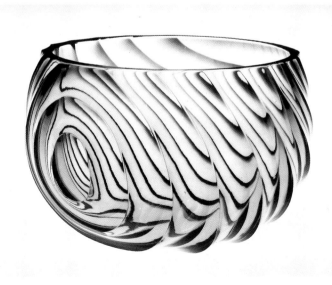

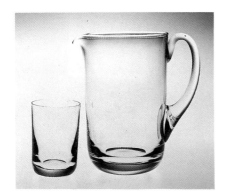

462 Jug and tumbler 'Persika' (Peach) △
Clear colourless glass, the jug with an applied handle
Made by Orrefors probably c. 1948; designed by Vicke
Lindstrand 1933
Circ. 135, 136-1949
Mark ORREFORS incised
H. jug 10
Model LU155

Lindstrand left Orrefors in 1940 but the company continued
to make several of his designs for many years.

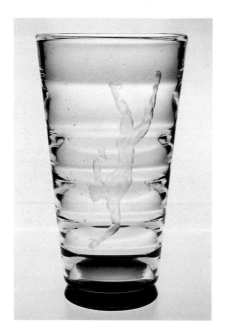

463 Vase 'Dykaren' (The diver) △
Clear colourless and opaque black glass with copper-
wheel engraved decoration
Made by Orrefors 1934; designed by Vicke Lindstrand
1934; engraved by Emil Goldman
Circ. 120-1934
Mark ORREFORS L. 1343 34 EG incised
H. 28. 8

Lindstrand arrived at Orrefors in 1928 and designed for the
same engraving technique used by Simon Gate and Edward
Hald. Like Gate and Hald he trained abroad in France and
Italy and brought a sculptor's and draughtsman's skills to
his designs for glass. This vase is one among a series by
Lindstrand designed during the 1930s and related in
theme: The diver, The pearl fishers, The shark killer.

464 Vase ▽
Clear greyish glass and black opaque glass base, blown,
with copper-wheel engraved decoration of a female nude
on a fish
Made by Orrefors 1935; designed by Vicke Lindstrand
1934; engraved by Gösta Elgström
Circ. 129-1937
Mark ORREFORS LINDSTRAND 1369 A1 G.E. incised
H. 20. 8

This vase was purchased as part of a group of Swedish
glass to be sent by the Museum's Department of Circulation
as a loan exhibition to art schools in Stourbridge and
Bromley for the instruction of their glass students (see
cat. nos 458, 459, 467). See cat. no. 466.

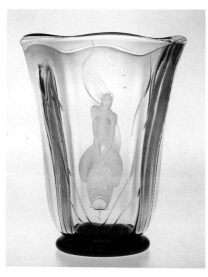

465 Wine glass and two tumblers
Clear colourless glass with flat cut decoration
Possibly made by Kosta; possibly designed by Elis Bergh
c. 1934
Margaret Bulley Bequest
Misc. 2 (65, 125, 126)-1934
Unmarked
H. wine 14. 2

Glasses similar to these were shown in the 'Exhibition of
Swedish Industrial Art' (see cat. no. 443).

466 Bowl △
Clear grey/black glass
Made by Strömbergshyttan; designed by H. J. Dunne-
Cooke c. 1934
Circ. 123-1934
Unmarked
D. 28. 6

Designs attributed to Dunne-Cooke are likely to have been
in the form of suggestions to the designer at Ström-
bergshyttan, Gerda Strömberg. See also cat. no. 461.

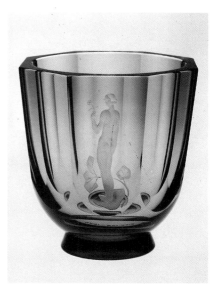

467 Vase △
Clear grey tinted glass with flat cut facets and copper-
wheel engraved decoration of a female nude holding a
flower
Made by Orrefors 1937; shape designed by Simon Gate
1935; decoration designed by Nils Landberg 1936;
engraved by Hugo Williamsson
Circ. 133-1937
Mark ORREFORS N 1621. A3 HW OF GA 1439 incised
H. 11. 4
Shape L1369

This vase was part of the group of Swedish glass purchased
for the instruction of English glass students (see cat. no.
464).

468 Bowl 'Acqua' △
Clear greenish glass with polished copper-wheel cut
decoration
Made by Pukeberg; designed by Carl Hermelin c. 1936-7
Given by A/B Arv. Böhlmarks Lampfabric
Circ. 134-1937
Unmarked
D. 23
Shape 11714

A/B Arv. Böhlmarks Lampfabric was the parent company of
Pukeberg. Baron Carl Hermelin was works manager at
Orrefors-Sandvik, 1926-30, and then at Pukeberg, 1930-40.

469 Vase ▷

Clear colourless glass, turned inside, cut outside
Made by Orrefors; designed by Edvin Öhrström 1937
Circ. 128-1949
Mark ORREFORS FA 1884 incised
H. 14. 5
Shape 1884

The interior of this vase was decorated with a turn-mould, a technique developed by Öhrström. A fireclay form is inserted into a gather of hot glass and then withdrawn, in the normal way. Then decoration is made in the hot glass by incising with the turn-mould, which is similar to a metal 'comb'. In the mark, 'F' is the code letter used for Öhrström and 'A' refers to the technique. Surprisingly, perhaps, this design was not commercially successful and production was therefore limited.

470 Bowl ▽

Clear blue tinted glass
Made by Orrefors; designed by Edvin Öhrström 1937
Circ. 337-1976
Mark ORREFORS FU/1739 incised
D. 27. 5

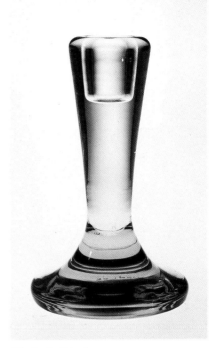

471 Vase ▷

Clear blue tinted glass with copper-wheel engraved
decoration of a female nude and a flower
Made by Orrefors 1949; designed by Nils Landberg 1938
Circ. 129-1949
Mark ORREFORS. N. 1976. 036 NL (?indistinct)
ORREFORS incised
H. 16. 2

472 Wine glass

Clear colourless glass
Made by Strömbergshyttan; designed by H. J.
Dunne-Cooke c. 1938
Given by the designer
Circ. 426-1948
Unmarked
H. 13. 2

473 Candlestick

Clear brown tinted glass
Made by Strömbergshyttan; designed by Gerda
Strömberg c. 1938
Given by Capt. H. J. Dunne-Cooke
Circ. 31-1950
Unmarked
D. 23

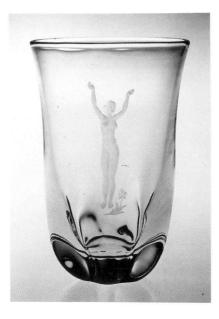

474 Candlestick △

Clear greyish glass
Made by Strömbergshyttan; designed by Gerda
Strömberg c. 1938
Given by Capt. H.J.Dunne-Cooke
Circ. 32-1950
Unmarked
H. 15. 3

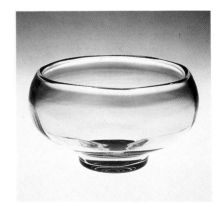

475 Bowl △

Clear greyish glass
Made by Strömbergshyttan; designed by H. J.
Dunne-Cooke c. 1938-48
Circ. 505-1948
Unmarked
D. 21. 7

This glass is part of a group which was chosen by Hugh Wakefield for travelling exhibitions arranged by the Museum's Department of Circulation. A duplicate set was sent to Australia and divided between the National Gallery of Victoria, Melbourne, and the National Gallery of South Australia, Adelaide. See cat. no. 466.

476 Decanter and stopper ▷
Clear brown tinted glass
Made by Strömbergshyttan; designed by H. J.
Dunne-Cooke c. 1938-48
Circ. 506&A-1948
Mark ELFVERSON R.O. 7615 77 incised
H. 22

This decanter bears the name only of the retailing agent, Elfverson. The design is very closely related to a brandy bottle 'Falun' by Gerda Strömberg for Eda, 1930. See also cat. no. 466.

477 Sherry glass
Clear brown tinted glass
Made by Strömbergshytten; designed by Gerda
Strömberg c. 1938-48
Circ. 507-1948
Unmarked
H. 6

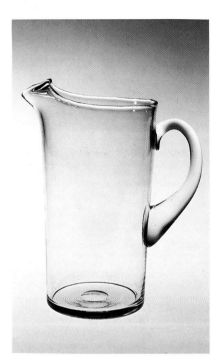

478 Jug △
Clear colourless glass
Made by Orrefors 1985; designed by Nils Landberg 1939;
still in production
Given by the maker
C. 78-1985
Mark OF incised
H. 27
Shape 5528. 951

A long-term production, this jug is one of several designed by Landberg using a distinctive although simply formed pouring lip.

479 Vase ▷
Clear green glass, mould-blown
Made by Reijmyre; designed by Monica Bratt 1940-50
Given by the maker
Circ. 16-1954
Unmarked
H. 18. 2

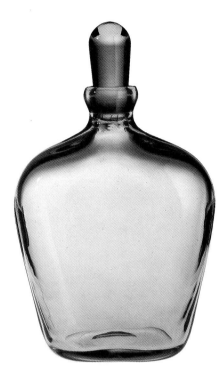

480 Vase 'Fasett'
Clear blue tinted glass with cut decoration
Made by Orrefors; designed by Sven Palmqvist 1941
Circ. 130-1949
Mark ORREFORS incised
H. 22. 2
Model PA 2414

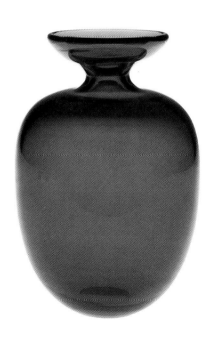

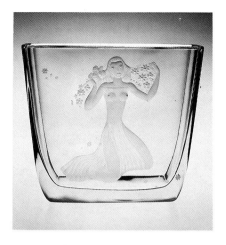

481 Vase △
Clear blue tinted glass with copper-wheel engraved
decoration of a female figure with spring flowers in
her hair
Made by Orrefors 1949; designed by Sven Palmqvist
1941; engraved by Arthur Roos
Circ. 131-1949
Mark ORREFORS. PALMQVIST. 2522. B6. A. R. incised
W. 22. 5

Palmqvist studied at the Academie Ranson in Paris under the sculptors Paul Cornet and Aristide Maillol. Palmqvist's skill in figure drawing has been successfully applied in this stylised and decorative subject.

482 Bowl ▽
Clear blue tinted glass with cut decoration
Made by Orrefors; designed by Edvin Öhrström 1943
Circ. 134-1949
Unmarked
D. 27
Model FA2854

While Öhrström is now most famous for his 'Ariel' series, he was also versatile enough to design the simplest undecorated shapes for domestic use.

483 Vase
Clear colourless glass with copper-wheel engraved
decoration of a female nude, seated, clasping
her knees
Made by Orrefors 1949; designed by Edvin Öhrström
1944; engraved by Thure Löfgren
Circ. 132-1949
Mark ORREFORS ÖHRSTRÖM 2930 TL B. 6 incised
H. 21

This design, for Orrefors' commercial production, reflects Öhrström's training as a sculptor and his varied experience abroad including time at an art school run by Fernand Léger.

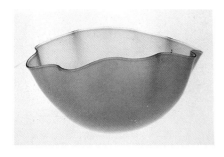

484 Bowl 'Kantara' (Song) △
White semi-opaque glass
Made by Orrefors; designed by Sven Palmqvist 1944
Circ. 133-1949
Mark ORREFORS 3023/1 S PALMQVIST incised
L. 16

In this modest but delicate bowl Palmqvist demonstrates his interest in natural forms, an interest common to many glass designers at that time.

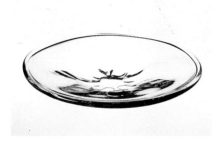

485 Dish △
Clear blue tinted glass
Made by Kosta; designed by Elis Bergh c. 1947
Circ. 454-1948
Mark B1828 (indistinct) incised
D. 31. 9
Shape B1828

This dish, in Kosta's 'Arctic blue', was selected by Hugh Wakefield and W. B. Honey of the Museum's Departments of Circulation and Ceramics, respectively. Two duplicates were also ordered for the National Galleries in Adelaide and Melbourne, Australia.

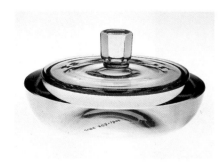

486 Powder bowl and cover △
Clear greyish glass with flat cut decoration
Made by Strömbergshyttan; designed by H. J. Dunne-Cooke c. 1947
Circ. 503&A-1948
Unmarked
D. 18

487 Bowl ▽
Clear grey tinted glass with flat cut decoration
Made by Strömbergshyttan; designed by H. J. Dunne-Cooke c. 1947
Circ. 504-1948
Unmarked
D. 26. 6

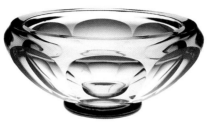

488 Vase ▽
Clear blue tinted glass
Made by Strömbergshyttan; designed by Gerda Strömberg 1948
Circ. 501-1948
Unmarked
H. 22. 6

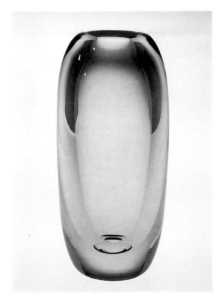

489 Vase
Clear blue tinted glass
Made by Strömbergshyttan; designed by Gerda Strömberg 1948
Circ. 502-1948
Unmarked
H. 12

490 Ashtray
Blue tinted glass, blown
Made by Gullaskruf; designed by Hugo Gehlin 1950
Given by the maker
Circ. 14-1954
Mark GEHLIN G-F incised
L. 13. 7

Gehlin was the chief designer at Gullaskruf for nearly 30 years.

491 Vase 'Träd I Dimma' (Trees In mist) **C**
Clear colourless glass encasing opalescent white and opaque black glass
Made by Kosta; designed by Vicke Lindstrand c. 1950
C. 163-1987
Mark KOSTA LU 2005 V incised
H. 33. 7

Vicke Lindstrand began designing for Kosta in 1950, after 12 years at Orrefors. This vase is an early example of his work at the new factory. He used the motif of trees more than once: this and a version showing trees in autumn, with scattered leaves in reds and yellows, are the best known.

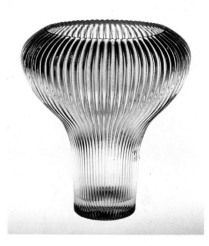

492 Vase, 'Reffla' (Grooves) series △
Clear colourless glass, press-moulded
Made by Gullaskruf; designed by Arthur Percy 1952
C. 4-1988
Unmarked
W. 16. 5

Arthur Percy had a varied career. He began as a house-painter and became a full-time art student in 1907. He designed for ceramics and textiles as well as continuing to paint throughout his life. He joined Gullaskruf when he was 65. The 'Reffla' series is regarded as one of the most successful of his designs during the seven years he spent at Gullaskruf. The glassworks appear to have used a paper label only and not to have marked their glass in any more permanent way.

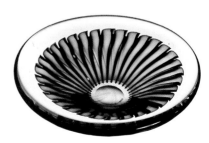

493 Bowl △
Clear colourless glass encasing brown glass
Made by Kosta 1953; designed by Vicke Lindstrand 1953
Given by the maker
Circ. 13-1954
Mark LINDSTRAND KOSTA printed
L. 18. 9

494 Bowl, 'Ravenna' series ▷
*Clear blue glass with interior stained pattern in red
on blue*
*Made by Orrefors 1953; designed by Sven Palmqvist
1953*
Given by the maker
Circ. 518-1954
*Mark ORREFORS SWEDEN RAVENNA No391 SVEN
PALMQVIST incised*
L. 23. 7
Shape 391

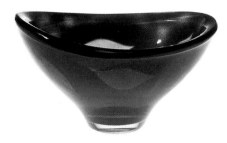

Sven Palmqvist joined Orrefors in the 1920s and graduated
through studies under Simon Gate, Edward Hald and
various art schools in France and Stockholm. He created
several new glass techniques, including the mosaic-like
'Ravenna' technique (given this name following a visit by
Palmqvist to that city). This was launched by Orrefors in
1948. Like many Orrefors artists, Palmqvist designed with
equal skill both for ornamental wares and for major public
and government commissions.

495 Vase ▷
*Clear blue tinted glass with copper-wheel cut unpolished
line decoration*
Made by Gullaskruf; designed by Arthur Percy 1953
Given by the maker
Circ. 15-1954
Unmarked
H. 16. 4

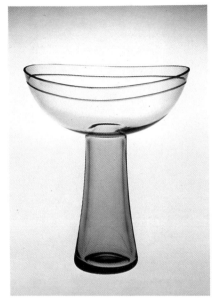

496 Bowl ▽
*Clear colourless glass with spiralled blue and brown
stripes*
Made by Kosta; designed by Vicke Lindstrand c. 1954
Given by the maker
Circ. 2-1955
Mark LINDSTRAND KOSTA printed
L. 21

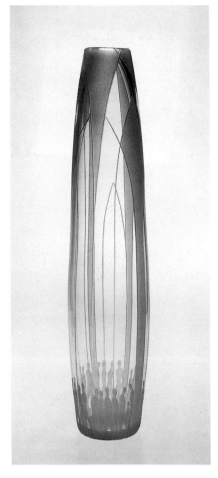

497 Vase △
*Clear colourless glass with cut and sand-blasted
decoration*
Made by Kosta; designed by Vicke Lindstrand c. 1954
Given by the maker
Circ. 3-1955
Unmarked
H. 38. 5

Vicke Lindstrand had a varied career in a number of different
disciplines including textiles and book illustration. He
brought this wide experience to glass design and his skill
was such that this combination of illustrative decoration
with a vase shape of exaggerated proportions
appears effortless.

498 Vase ○
*Clear colourles glass with semi-opaque white glass
decoration, free-blown*
Made by Kosta; designed by Vicke Lindstrand c. 1954
Given by the maker
Circ. 4-1955
Mark VICKE LINDSTRAND KOSTA LH.131/HO62 incised
H. 22

Moving with equal skill from engraved decoration to the free
use of clear and coloured glass, Lindstrand here created a
sculptural shape which both reflected contemporary interests
in organic and bud-like forms and also anticipated some
Italian glass of the 1960s.

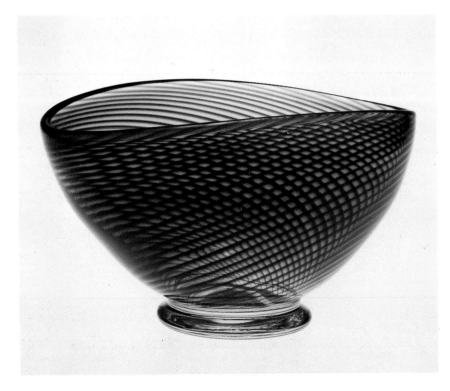

499 Vase 'Blå Bubblor' (Blue bubbles) ▷
Clear blue glass, blown with trapped air bubbles
Made by Boda; designed by Eric Höglund c. 1956-60
Given by J. Wuidart & Co.
Circ. 281-1963
Mark H961/90 incised
H. 10. 3

This vase is typical of Höglund's pioneering work in combin-ing early forms with simple bubbled soda glass, allowing – even encouraging – impurities to give the glass a natural look, and presenting these in strong colours. This was a new and entirely contemporary style, introduced in 1953. The first series was in greens and browns. This blue series was introduced in 1956. In 1960 Höglund introduced reds, and later orange and turquoise. He was awarded the Lunning Prize in 1957 for his work in glass and also in wood, clay, iron and bronze.

500 Vase, 'Tulpanglas' (Tulip glass) series ○
Clear colourless glass partly encasing grey/blue opaque underlay
Made by Orrefors; designed by Nils Landberg 1957
C. 170-1987
Mark ORREFORS EXPO NU 312-57 incised
H. 41. 3

This is one from a series of varying proportions and colours which were in production until 1981. Made over a period lasting nearly 25 years, they are regarded as classic Orrefors shapes.

501 Vase
Clear glass, colourless shading to blue, mould-blown
Made by Johansfors; designed by Bengt Orup 1957
Given by the designer
Circ. 631-1968
Mark J'FORS ORUP 1957 incised
H. 15. 7

See also cat. no. 507.

502 Form 'Lapp med Ren'
 (Laplander with reindeer) △
Green cullet glass with polished and unpolished cut decoration
Made by Kosta; designed by Vicke Lindstrand c. 1960
Given by Mr B. Mason
C. 101-1988
Mark KOSTA VICKE LINDSTRAND and HU (? indistinct) engraved
L. 26

The early examples, like this, of engraved cullet were made using waste (cullet) glass from the Emma Boda window glass factory. Later, 'cullet-like' glass was especially manufactured.

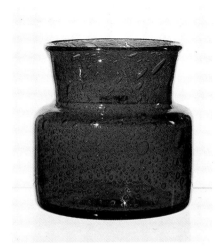

503 Bowl and tumbler ▽
Clear smoke tinted glass with moulded decoration
Made by Skruf; designed by Bengt Edenfalk 1964
Circ. 374, 373-1964
Unmarked
H. 14. 7

Bengt Edenfalk was appointed as Skruf's first full-time designer in 1953. He stayed there until 1978 when he joined Kosta. Like most glass designers, he works on both useful domestic wares such as these and also major commissions for public buildings.

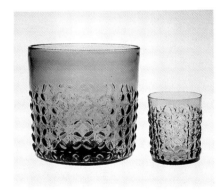

504 Vase
Clear colourless glass with copper-wheel engraved decoration
Made by Reijmyre; designed by Tom Möller 1964; decorated by an engraver named Lindberg, otherwise unidentified
Circ. 375-1964
Mark REIMYRE TOM GRAV. LINDBERG incised
H. 16. 4

Tom Möller was a designer for Reijmyre from 1960 to 1967 and also ran a studio with his wife, the potter Grete Möller (see cat. no. 391).

505 Vase ▷
Clear colourless glass with sand-blasted decoration
Made by Reijmyre; designed by Tom Möller 1964
Circ. 376-1964
Mark REIJMYRE TOM incised
H. 12. 6

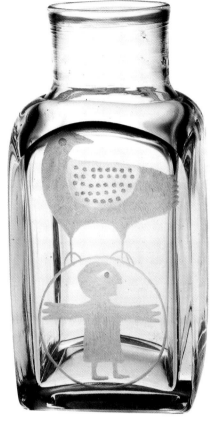

506 Bottle △
Clear colourless glass with copper-wheel engraved decoration
Made by Boda; designed by Bertil Vallien 1964
Circ. 372-1964
Mark V. 104 B VALLIEN BODA ÅFORS incised
H. 13. 8

Bertil Vallien's designs and unique works are made at Boda's Åfors factory.

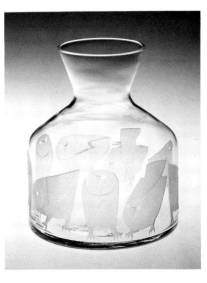

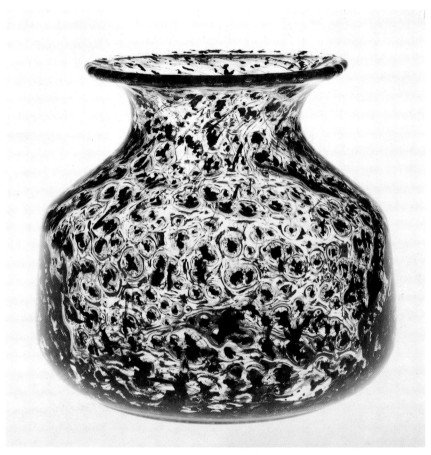

507 Vase △
Clear colourless glass with speckles of grey metallic oxide (iron slag or ferro-silica), blown
Made by Johansfors; designed by Bengt Orup 1967
Given by the artist
Circ. 630-1968
Mark ORUP JOHANSFORS SWEDEN 1967 incised
D. 20. 4

Bengt Orup was Visiting Professor at London's Royal College of Art during 1967 and was in touch with the Museum's Department of Circulation at that time. This gift included a vase of 1957 and a wine glass of 1967 and shows Orup's work for the domestic production side of Johansfors' output (see cat. nos 501, 508).

508 Wine glass
Clear colourless glass
Made by Johansfors; designed by Bengt Orup 1967
Given by the artist
Circ. 632-1968
Mark ORUP JOHANSFORS SWEDEN 1967 incised
H. 16. 5

509 Goblet from the range 'Mâtta' or 'Margit' ▷
Clear colourless glass
Made by Orrefors; designed by Gunnar Cyrén c. 1969
Given by the maker
C. 77-1985
Unmarked
H. 11. 4
Model no. 7000; shape 201

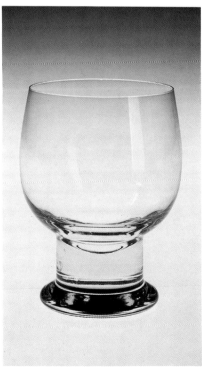

510 Bowl 'Tintomara' ▽
Clear colourless glass with coloured glass flecks
Made by Boda; designed by Ulrica Hydman-Vallien 1974
Circ. 455-1974
Mark BODA ÅFORS ATELJE 4 ULRICA incised
D. 19

This bowl is named after a female elf, changeable and bubble-light, from the mid-19th century play *The Queen's Jewel* by Jonas Love Almqvist.

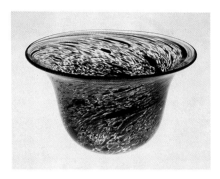

511 Sculpture 'Förbrylla' (Puzzle) [C]
Clear glass, various colours, sand-cast, fitting in a wooden base
Made by Boda; designed by Bertil Vallien 1974
Circ. 453-1974
Mark BODA ÅFORS B. VALLIEN UNIK 2377
H. 25. 4

Bertil Vallien has made a speciality of cast sculptures. Many of these are extremely intricate and elaborate, involving repeated castings. The moulds are formed of fine-ground English silica sand mixed with other materials. He began making 'puzzles' in 1972: the glass component can be removed from the wooden stand with which it interlocks. This sculpture, like all Vallien's work, was made at Boda's Åfors factory.

512 Bowl △
Opaque glass, purple shading to turquoise with an iridescent finish, mould-blown
Made by Boda; designed by Bertil Vallien 1974
Circ. 456-1974
Mark BODA ÅFORS ATELJE 47 B VALLIEN incised
D. 11. 5

Made at Boda's Åfors factory, this is one of their 'studio' works probably deriving from a unique piece and sold as 'art ware'.

513 Form 'Glasberg' (Glass mountain) ▽
Clear colourless and coloured glass, sand-cast
Made by Boda; designed by Bertil Vallien c. 1974
Circ. 454-1974
Mark BODA ÅFORS ATELJE 20 B VALLIEN incised
W. 29. 7

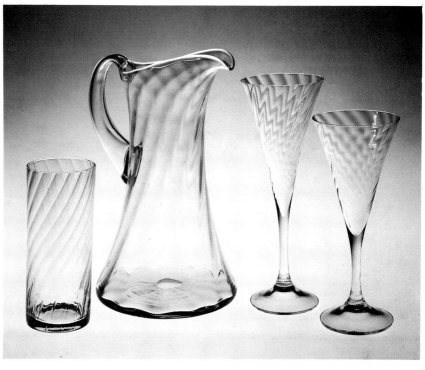

515 Part of a tableware range 'Helena' △
Clear colourless glass
Made by Orrefors; designed by Nils Landberg 1977
Given by the maker
C. 79, 80, 81, 82-1985
Jug, tumbler, champagne, claret
Mark OF incised
H. 25. 3
Model no. 2447; shapes 891, 361, 141, 181

This service was included in the exhibition 'Svensk Form', held at the Museum, 1980.

517 Two sea shells
Opaque pale pink and dark pink glass, free-blown and cut
Made by Boda; designed by Monica Backström 1981
Given by Astrid Sampe
C. 105&A-1981
Unmarked
W. 12. 2

518 Pair of candlesticks
Clear colourless glass, blown
Made by Skruf; designed by Ingegerd Råman c. 1981-5
C. 168&A-C-1987
Unmarked
H. 21. 5

Each candlestick is in two parts, the tops are removable and the candlesticks convert into stem vases.

**514 Vase 'Molnvasen' (Flying clouds vase), 'Ariel'
series** △
*Light and dark blue opaque glass with trapped air
decoration*
Made by Orrefors 1978; designed by Olle Alberius 1977
C. 75-1979
*Mark ORREFORS ARIEL NR 233-E8 OLLE ALBERIUS
incised*
H. 17. 3

The 'Ariel' technique was developed in the later 1930s by Edvin Öhrström with Vicke Lindstrand and the master glass-blower Gustav Bergkvist. It is based on the 'Graal' technique (see cat. no. 460 made by Gustav Bergkvist) but incorporates a design formed with trapped air in addition to a layer or layers of different coloured glass.

516 Bowl, 'Graal' series △
*Clear colourless glass enclosing pink glass decoration of
flowers*
Made by Orrefors 1978; designed by Olle Alberius 1978
C. 76-1979
*Mark ORREFORS GRAAL A 733-78 OLLE ALBERIUS
incised*
D. 16

See cat. no. 460 for a description of the 'Graal' technique.

519 Bowl 'Symfoni' (Symphony) △
*Clear colourless glass, with cut and sand-blasted
decoration*
Made by Orrefors 1982; designed by Gunnar Cyrén 1982
Given by the maker
C. 72-1985
*Mark ORREFORS 9045872 GUNNAR CYRÉN B C
GALLERY 6-82 incised*
L. 22. 4

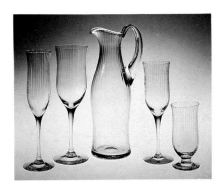

520 Part of a tableware range 'Blanche' △
Clear colourless glass
Made by Orrefors; designed by Gunnar Cyrén 1982
Given by the maker
C. 83, 84, 85, 86, 87-1985
Sherry, cocktail, champagne, goblet, jug
Mark OF incised
H. jug 28. 5
Model no. 2534, shapes 161, 381, 141, 201, 901

521 Two jugs 'Black Diamond' ▽
*Clear glass, free-blown, with trailed and applied clear and
coloured glass*
*Made by Kosta Boda; designed by Bertil Vallien; blown by
Roland Johansson 1982*
C. 109&A-1988
Mark KOSTA BODA B VALLIEN ATELJE 82 incised
H. taller 18

These jugs were awarded a prize in the utility and ornamen-
tal glass section of a competition organised by the National
Swedish Industrial Board (SIND), 1983.

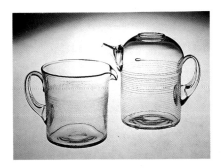

522 Bowl ○
Coloured glass, cased and etched
*Designed and decorated by Ann Wärff; blown by Wilke
Adolfsson, Transjö, c. 1982-3*
C. 162-1984
Mark ANN WÄRFF: WILKE incised
D. 30. 4

Ann Wärff began her career in Sweden at the Kosta
glassworks. In 1978, with Wilke Adolfsson, she established
an independent studio, 'Stenhytta', in a bakery and brewery
which was once part of her farm at Transjö. This became
a glassmaking centre for Swedish and international glass
artists. Wilke Adolfsson was a master glass-blower who
had trained at Orrefors, and was skilled in the special
techniques associated with 'Graal', 'Ariel' and 'Ravenna'
glass (see cat. nos 460, 514, 494). Working closely together,
Adolfsson was responsible for the hot glass processes while
Ann Wärff, as designer, directed and then continued the
work in a 'cold' studio, etching and sand-blasting.

523 Bowl and plate ▷
*Bowl: clear colourless and coloured glass with copper-
wheel engraved decoration. Plate; black glass*
Designed and decorated by Ann Wärff, Transjö.
c. 1982-3
C. 163&A-1984
Mark TRANSJÖ WR incised
D. 24. 5

524 Bowl 'Virvel' (Whirlpool) ▽
*Clear colourless glass 'flashed' with clear blue glass, cast
Made by Orrefors 1986; designed by Lars Hellsten 1983*
C. 191-1986
*Mark ORREFORS 902720 HELLSTEN GALLERY 1-86
incised*
D. 35. 6

Hellsten has designed a number of vases and bowls around
the subject of moving water, frequently a favourite motif
with glass artists. Other pieces by Hellsten based on this
motif are 'Havsvåg' (Seawave), also using this technique of
'flashing' coloured glass over clear glass, and 'Vattenspel'
(The play of water).

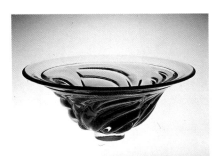

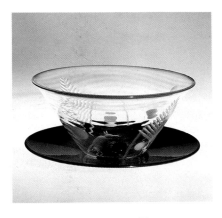

525 Sculpture 'Snäcka' (Shell) ▽
*Clear colourless glass, cast
Made by Orrefors 1984; designed by Lars Hellsten 1983*
C. 192-1986
*Mark ORREFORS 908520 LARS HELLSTEN GALLERY
5-84 incised*
L. 33

Lars Hellsten designs small domestic wares and major
decorative works for public buildings. 'Snäcka' is one of the
limited editions sold through the Orrefors Gallery and
illustrates Hellsten's training as a sculptor. The massive
work is cast in an aluminium mould, a technique in which
he has specialised. He makes the first model in clay or
plaster and then works with a team of mould-makers, glass-
blowers and cutters.

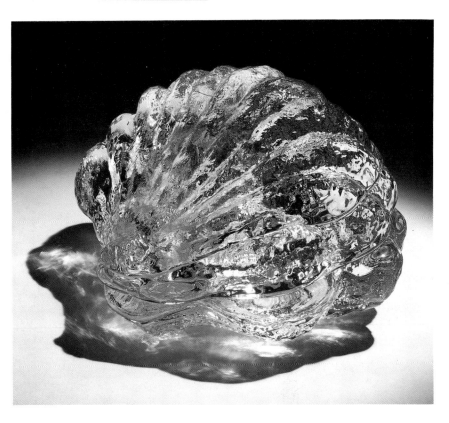

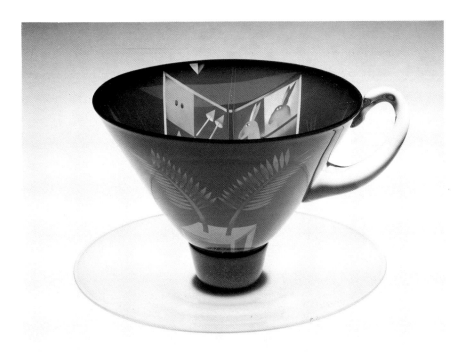

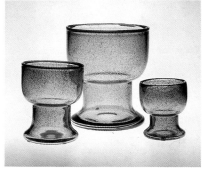

529 Three standing bowls △
Clear blue bubbled glass, blown and hand-sheared, the
rims edged in brown glass
Made by Kosta Boda 1985; designed by Signe Persson-
Melin 1984
Given by the maker
C. 201&A-B-1988
Mark KOSTA BODA ATELJE S.P.MELIN 12/85 incised;
on large 4030, on medium 4026, on small 4022 incised
H. tallest 20. 4

These designs were first made in 1984 for an exhibition at
Form Design Centre, Malmö. They are the result of several
years' work by the artist, producing similar forms both in
ceramics and glass.

526 'Numret ål Två' (The number is two), 'Sculpture-
 cup' series △
Layered glass, etched, engraved and coloured
Designed and decorated by Ann Wärff; probably blown by
Wilke Adolfsson, Transjö, 1983
C. 17&A-1987
Cup and saucer
Mark on saucer A WÄRFF 2-3 PS (? indistinct); on side
of cup ANN WÄRFF incised
D. saucer 24. 7

Wilke Adolfsson left Transjö in 1983 and shortly following
this Ann Wärff's work changed considerably in imagery,
style and technique in the use of different glass forms and
other materials such as metal. This cup and saucer date
from shortly before these changes and mark the end of an
earlier period of richly decorative works using domestic
objects in an unaccustomed context. Much of her imagery
is drawn from her view of female roles and the traps
formed by life and relationships around a woman's free
existence. Like Ulrica Hydman-Vallien, whose work she also
admires, no images are used lightly. In 1985 she changed
her name from Wärff to Wolff, after her grandmother whose
courage and strength she esteemed. Increasingly Wolff has
used pictorial symbols acquired from a folkloric past in
which heads of wolves, hares or foxes act as masks hiding
true intent and yet menacing the onlooker.

 She assembles these into pictorial sequences which may
be read in as many ways as there are viewers, and she gives
no precise explanation, preferring to allow the sequence to
assume a life of its own.

527 Sculpture 'Glas är Vätska' (Glass is liquid) ▷
Clear colourless glass, blown, worked and cut
Made by Kosta Boda; designed by Göran Wärff 1983
Given by the maker
C. 178-1986
Mark GÖRAN WÄRFF KOSTA incised
H. 30. 2

Göran Wärff is concerned with the liquid, natural properties
of glass and also the play of light within the material.

528 Part of a tableware range 'Maja' ▷
Clear colourless glass with painted decoration
Made by Orrefors 1985; designed by Eva Englund
c. 1983-4; painted by Arne Lindblom
Given by the maker
C. 73, 74, 75, 76-1985
Claret, tumbler, sherry, white wine
Mark EE. AL painted in green in the decoration
H. claret 17. 5
Model no. 2448; shapes 186, 346, 126, 166

Eva Englund introduced painting in enamels on glass to
Orrefors. The first glasses she painted were for her own
amusement, and she decorated them with flower studies.
When they proved popular with the Orrefors employees they
were taken up by the marketing department and the range
has since become a bestseller.

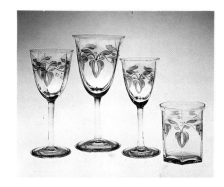

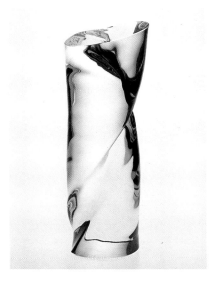

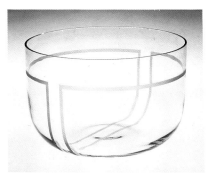

530 Bowl 'Mezzo' △
Clear colourless glass with sand-blasted decoration
Made by Skruf; designed by Ingegerd Råman 1984
C. 169-1987
Mark SKRUF 2230 I. RÅMAN incised
D. 23. 5

The 'Mezzo' series was awarded a prize at the Swedish
Crystal Designers' competition, Stockholm, 1984.

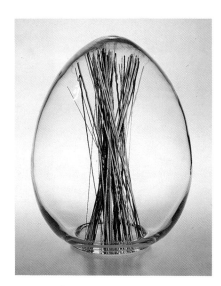

531 Form 'Ägg' (Egg) △
*Clear colourless glass, hand-blown, containing blue,
yellow, green and white glass rods, and with a perspex
base Made by Kosta Boda; designed by Monica
Backström 1985
Given by the designer*
C. 107-1988
*Mark ATELJE KOSTA BODA M BACKSTRÖM No.
206859610 incised*
H. 37. 5

This form was made especially for an exhibition of the ar-
tist's work held in Paris, 1985.

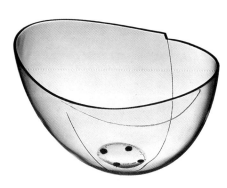

532 Bowl △
*Clear blue and peach tinted glass, cut
Made by Orrefors 1985; designed by Gunnar Cyrén 1985
Given by Rosenthal Studio House*
C. 174-1986
*Mark ORREFORS 917372 GUNNAR CYRÉN 1. 85
UNIQUE incised*
L. 21. 7

Gunnar Cyrén is a designer of precise and classical
simplicity, producing careful and detailed working drawings
for both glass and silver. He has developed two series of
elliptical bowls, one series of straightforward boat-shaped
forms and the other of thin-walled, slightly tinted bubble-
like shapes. In this bowl from the latter series the fine cut
lines define the otherwise elusive surface.

533 Vase 'Föralskade Ormar' (Snakes in love) ●
*Light green underlay glass cased in black glass with
sand-blasted decoration painted in enamels and fired
Made by Kosta Boda; designed by Ulrica Hydman-Vallien
c. 1985*
C. 179-1986
*Mark KOSTA UNIK B. 31 ULRICA H. V 350 851905
incised*
H. 25. 5
Shape 350 851905

Ulrica Hydman-Vallien is a painter and potter as well as a
glass designer. Her ceramics are as highly decorated as her
glass and, indeed, she believes they play a more important
part in her artistic life. She paints textiles and furniture
also, and finds security and pleasure in the richly vibrant
surfaces she creates. She acknowledges the influence of
painters such as Matisse and enjoys the exotic colours of
Mexico where she studied in the early 1960s. But she
has developed a distinctively individual style in which the
creatures she paints each symbolise particular elements
in human relationships. Her images can appear threatening
or amusing, depending as much on the receptiveness of
the viewer as on the intentions of the artist. For her, the
snake is the unknown. It never expresses anything but it
enjoys warmth and contact. The technique used in this vase
is her own speciality, titled 'jewel technique'.

534 Dish △
*Black glass over a clear colourless glass base
Made by Kosta Boda; designed by Gun Lindblad c. 1985*
C. 180-1986
*Mark KOSTA BODA ATELJE G. LINDBLAD 123867502
incised*
22.5 sq.
Shape 941 330 1-86

Gun Lindblad is a disciplined designer, setting herself
clear-cut limits of form and working in strong, bold colours.
The results can be as restrained and minimal as this dish,
and, although she does allow herself a little more licence
on occasion, all her designs have an unmistakable
elegance.

**535 Form 'Astronautens Termos'
(Astronaut's thermos)** ▷
*Four-part, in clear colourless, silvered, orange and black
glass
Made by Kosta Boda; designed by Monica Backström
1986
Given by the artist*
C. 108&A-C-1988
*Mark ATELJE KOSTA BODA M. BACKSTRÖM 206869657
incised on each section except the pinnacle*
H. 30

This form is one from a series of 'rymdobjekt' (space
sculptures) which were first shown in the influential depart-
ment store, NK, in Stockholm in 1986, a favoured venue
throughout the century for progressive design exhibitions.

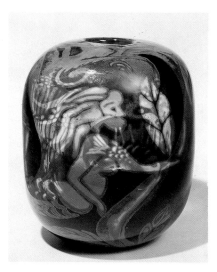

536 Vase 'Sjöjungfru' (The sea maid) △
*Clear colourless glass encasing coloured glass
Made, possibly by Wilke Adolfsson, at Orrefors 1986;
designed by Eva Englund 1986*
C. 181-1986
*Mark ORREFORS 9413 30 EVA ENGLUND GRAAL 1-86
incised*
H. 22. 4
Shape 123 867 502

This vase is made in the Orrefors 'Graal' technique (see cat.
no. 460). Eva Englund began by painting plant and flower
forms. Gradually she embarked on a series of more power-
ful and imaginative images and moved into the difficult and
prestigious 'Graal' technique. She is today the most
successful designer working in this famed Orrefors method.
The technique uses the skills of a team of people from the
designer and glass-blower to the engraver and acid-etcher
or sand-blaster.

537 Boat 'Bestämmelseort X' (Destination X) △
*Clear colourless glass with coloured glass and mixed
media inclusions, sand-cast, and set on a granite base
Made by Kosta Boda; designed by Bertil Vallien c. 1986
C. 110&A-1988
Mark B VALLIEN 305860254 KOSTA incised
L. 65. 5*

Like all glass designers, Vallien works with a team of
glassmakers and, with them, he has made sand-casting a
personal speciality. He uses this method since it allows him
the maximum freedom to change and adapt the work as he
goes along. At its simplest, he digs and presses out shapes
in a box of 'sand' and pours in the molten glass. The sand
is in reality a mixture of fine silica, ground clay, charcoal
and water. Vallien's imagery is a complex language of
forms. The symbolism of his motifs varies according to their
juxtaposition with each other. Early boat forms were made
in 1977, entitled 'Silent Journey' and 'Curragh'. Since then
there have been many with increasingly complex allusions
to the debris of a past life, such as the discarded outer skin
or disguises, and ladders or bridges, connecting or escaping.
The boats all have the obvious association with a Viking
burial and Vallien adds to this the curiosity of motifs
floating within them, as if in a watery grave.

538 Figure 'Kärleksgudinna' (Lovelady) 🅒
*Opaque orange glass cased in clear colourless glass, em-
bellished with black glass and painted with coloured
enamels, set on a painted metal base
Made at Kosta Boda; blown by Håkan Gunnarsson and
Mikael Svensson Kosta; designed and decorated by
Ulrica Hydman-Vallien 1986
Given by the artist
C. 106-1988
Mark KOSTA BODA ULRICA H V 310880248 incised
H. 58. 5*

'Kärleksgudinna' is one of a group of figures entitled
'Islanders', and was made for the exhibition 'Kosta Boda
sjätte sinne' (Kosta Boda sixth sense), held at Djurgården,
Stockholm, 1986. Ulrica Hydman-Vallien describes the
Islanders as 'all people around me – the Lovelady is the
strong and loving woman that dares to be proud of her self
and her strong expressions and to keep the men close, and
she has the nasty smile – between the smile of a madonna
and a witch'. While this figure is a unique piece, Hydman-
Vallien has, by sheer persistence, established her unique
style as part of the commercial serial production of Kosta
Boda's Åfors factory.

539 Form 'Hemlig Låda' (Secret box) ▽
*Coloured textured glass, blown as flat sections,
assembled around a blown glass shape and tied with
variously coloured cords
Made by Ulla Forsell, Stockholm, 1986
C. 35&A-1989
Mark ULLA FORSELL 1986 incised
H. 32*

This box is one of a series made by Ulla Forsell over several
years. The form continues to be a favourite one and is
something of a trademark. She has developed a unique
method of assembling her glasswork into constructions
using drilled holes. coloured cord and wire. She is fond of
positive colours and uses them boldly. Forsell is one of the
leading studio glass artists working in Stockholm, and her
work is represented in collections in Sweden, Norway,
Germany and the U S A.

540 Measuring jug and lid ◁
*Clear grey tinted SAN (styrenkrylnitril) plastic, injection-
moulded, with printed measures in black
Made by Gustavsberg Divisionplast; designed by Per-Olof
Landgren 1979
Given by the maker
C. 133&A-1984
Mark on base: GUSTAVSBERG around an anchor MADE
IN SWEDEN 1456; on lid: GUSTAVSBERG around an
anchor moulded
H. 19. 4*

This design was included in the exhibition 'Svensk Form',
held at the Museum, 1980.

ADDENDUM

Dish
Clear colourless glass, free blown
Made by Knut Bergkvist at Strömbergshyttan 1946
Given by Ada Polak
C.59-1976
Mark S-HYTTAN 24-5 46 incised
D. 24.2

PLASTIC

Numbers in bold refer to catalogue entries

259 **Tableware**
Porcelain; made by Porsgrund, designed by Nora Gulbrandsen, Norway, c. 1929-31

261 **Plate**
Porcelain; made by Porsgrund, designed by Nora Gulbrandsen, Norway, c. 1928-30

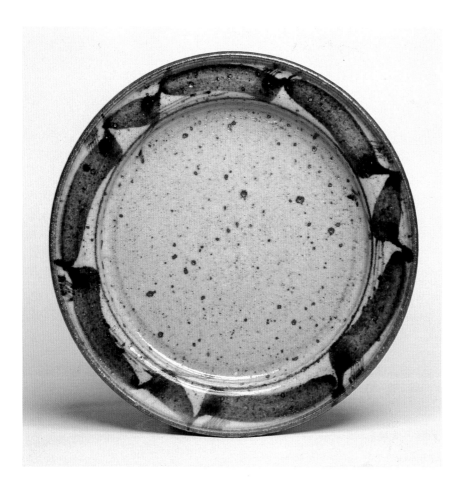

275 Dish
Stoneware; made by Leif Helge Enger at Porsgrund,
Norway, 1965

294 Tea pot and lid
Earthenware; made by Lisbeth Daehlin and Bente
Saetrang, Norway, 1988

Opposite
298 Two vases
Glass; made by Hadeland, designed by Willy Johansson,
Norway, 1954

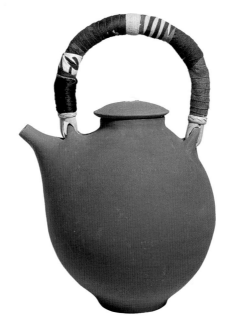

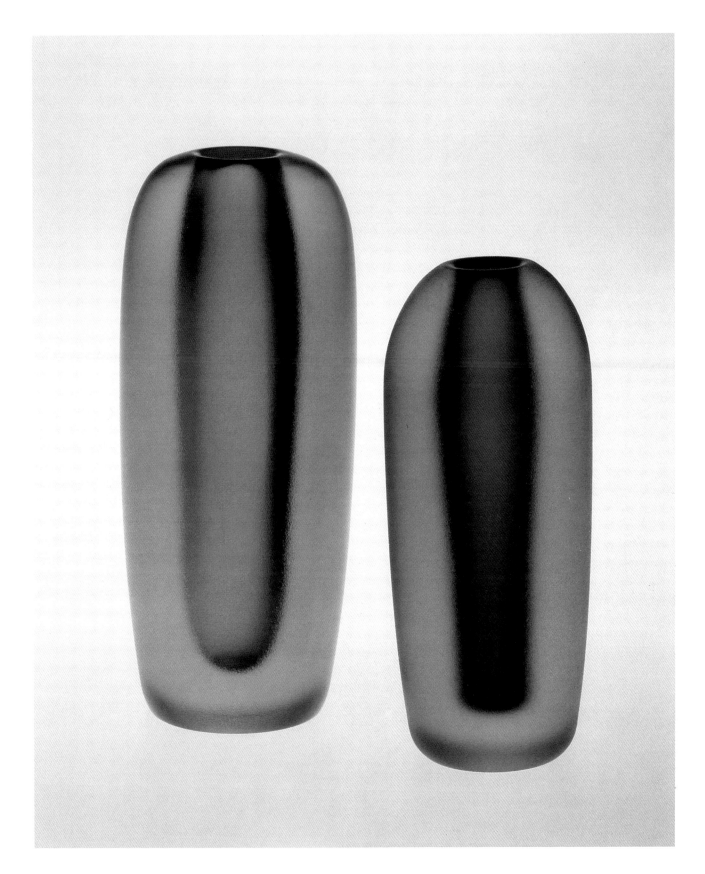

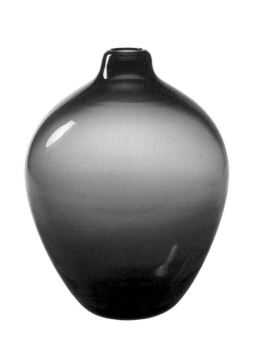

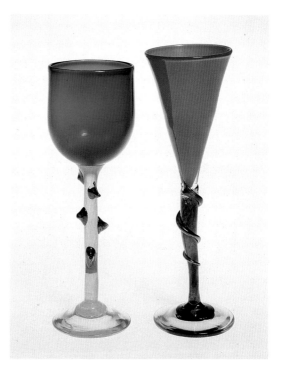

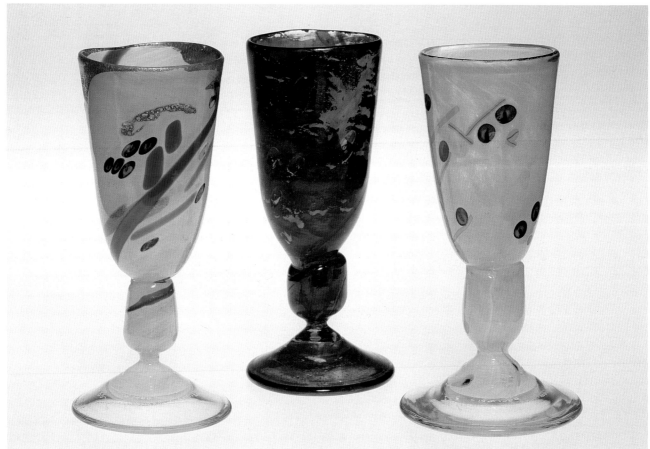

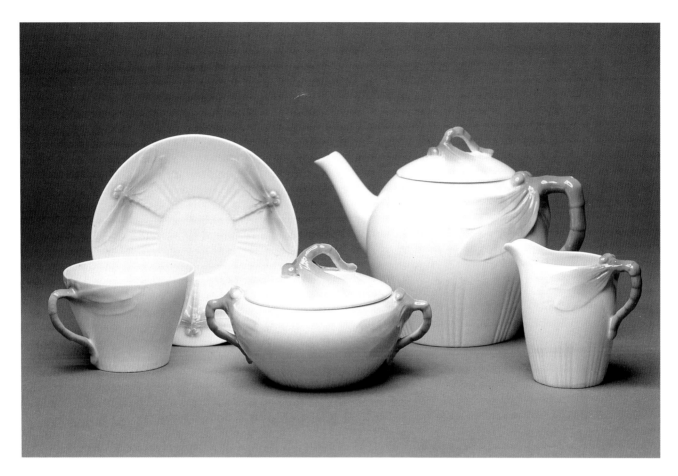

Opposite top
300 Vase
Glass; made by Hadeland, designed by Willy Johansson,
Norway, 1958

314, 315 Goblets 'Torneroseglass' and 'Slangeglass'
Glass; made by Karen Klim, Norway, 1985-7

Opposite bottom
317 Wine glasses 'Tre Selvstendige Liv'
Glass; made by Ulla-Mari Brantenberg, Norway, 1987-8

Above
328 Tableware
Porcelain; made by Rörstrand, designed by Alf Wallander,
Sweden, c. 1900

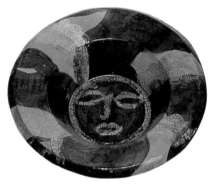

Top left
359 Dish 'Kvinnoansikle'
*Earthenware; made by Gustavsberg, designed and
decorated by Wilhelm Kåge, Sweden, 1943*

Left
366 Bowl and cover 'Spektralöv'
*Earthenware; made by Gustavsberg, designed by Stig
Lindberg, Sweden, 1947*

Above
437 Dish 'Soltecken'
Earthenware; made by Hertha Hillfon, Sweden, 1986

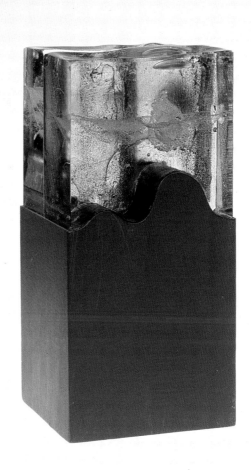

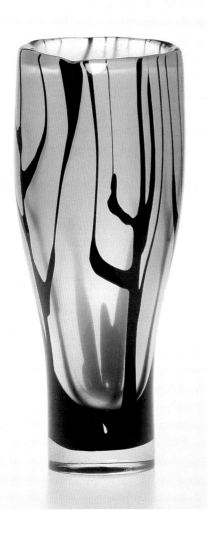

Top left
460 Vase 'Graal'
*Glass; made by Orrefors, designed by Simon Gate,
Sweden, 1931*

Left
491 Vase 'Träd i Dimma'
*Glass; made by Kosta, designed by Vicke Lindstrand,
Sweden, c. 1950*

Above
511 'Förbrylla'
*Glass; made by Boda, designed by Bertil Vallien, Sweden,
1974*

Overleaf
538 'Kärleksgudinna'
*Glass; made by Kosta Boda, designed and decorated by
Ulrica Hydman-Vallien, Sweden, 1986*

147

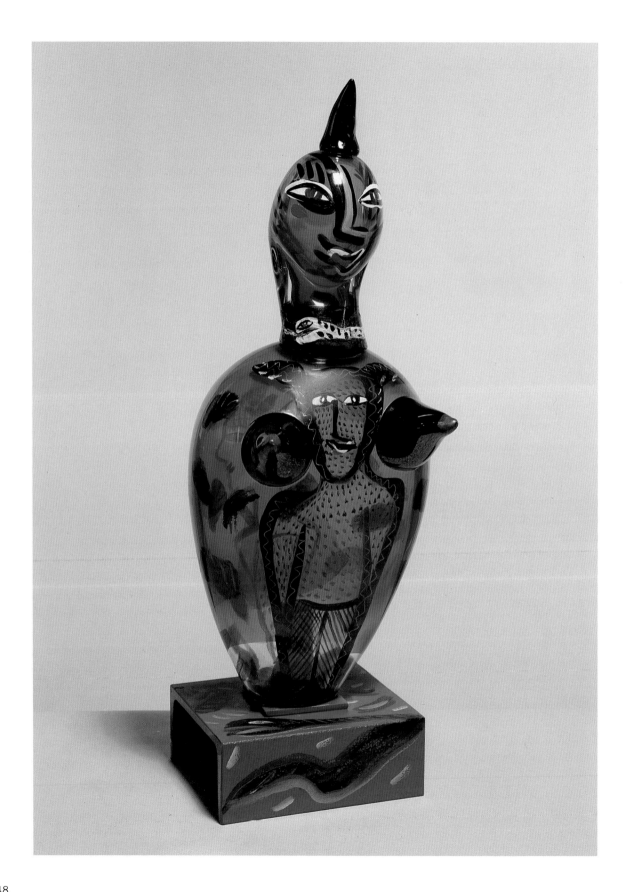

BIOGRAPHIES & FACTORY HISTORIES

In some cases it has not been possible to assemble all the necessary information to compile full entries; in some cases it has been possible to include only selected information. Cross-references within the biographies and histories are indicated as follows: people in italics; factories in capitals.

Abbreviations used for art schools and colleges:

R C A, London: Royal College of Art

Denmark

R D A, Copenhagen: Det Kongelige Danske Kunstakademi (Royal Danish Academy of Fine Arts)
S A A, Copenhagen: Skolen for Brugskunst, formerly Det Tekniske Selskabs Skoler (School of Applied Arts)
S A C, Copenhagen: Kunsthåndvaerkerskolen (School of Arts and Crafts)

Finland

C S I, Helsinki: Taideteollinen Korkeakoulu (Central School of Industrial Design)
H U T, Helsinki: Helsingen Teknillinen Korkeakoulu (Helsinki University of Technology)

Norway

C A D, Bergen: Bergens Kunsthåndversskole (Bergen College of Art and Design)
N C A D, Oslo: Statens Håndverks -og Kunstindustriskole (National College of Art and Design)

Sweden

N C A C D, Stockholm: Konstfackskolen and Tekniska Skolen (National College of Art, Craft and Design)
R A A S, Stockholm: Kungliga Konsthögskolan (Royal Swedish Academy Art School)
R I T, Stockholm: Kungliga Tekniska Högskolen (Royal Institute of Technology)
S A C, Gothenburg: Konstindustrieskolen, Göteborg (School of Industrial Design, formerly School of Arts and Crafts)

NAME	COUNTRY	TRAINING	CAREER	MEDIA	SELECTED AWARDS/HONOURS
AALTO, AINO MARSIO 1894-1949	Finland	1920 HUT, Helsinki (architecture)	1932 Karhula/Iittala, freelance; 1933 founder member of Artek, Helsinki, company selling Aalto and other Finnish designs	architecture; furniture (in collaboration with Alvar Aalto); glass; interior design; lighting; textiles	1932 Karhula/Iittala glass competition, second prize; 1936 Milan Triennale, gold medal
AALTO, HUGO HENRIK ALVAR 1898-1976	Finland	1921 HUT, Helsinki (architecture)	1923-76 practising architect; Paimio Sanatorium, Turku; 1929-33 founder member of Artek, Helsinki, company selling Aalto and other Finnish designs, with Aino Aalto; Nils-Gustaf Hahl and Maire Gullichsen; 1933 Riihimäki, freelance; 1936 Karhula/Iittala, freelance; 1937 Savoy Restaurant, Helsinki, interior designer; 1940-9 Massachusetts Institute of Technology, USA, professor	architecture; furniture (sometimes in collaboration with Aino Aalto and Otto Korhonen); glass; graphics; interior design; lighting; textiles	1933 Riihimäki glass competition, second prize; 1936 Karhula/Iittala glass competition, first prize; 1936 Milan Triennale, grand prix; 1937 World's Fair, Paris, grand prix, gold medal; 1939 New York, Finnish Pavilion Competition, first, second and third prizes; 1957 Great Britain, The Royal Gold Medal of Architecture; France, Chevalier de la Legion d'Honneur
AHO, KAARINA 1925-	Finland	CSI, Helsinki	1946-62 Arabia, designer and associate to Kaj Franck	ceramics	1954, 1957 Milan Triennale, silver medals
AHOLA, JUSSI 1940-	Finland	1965 CSI, Helsinki (metalwork)	1964- Upo Oy; 1969-71 Furey, Sydney, Australia, design office; 1971-5 HUT, Helsinki, teacher; 1975-8 head of department of industrial design; 1978- Form Centre, Helsinki, design office, partner and managing director; 1982-3 University of Oulu, director of industrial design course; 1981 Arabia, freelance; 1987- Helsinki, professor of industrial design	ceramics; cutlery; product design	
ALBERIUS, OLLE 1926-	Sweden	NCACD, Stockholm; 1952-6 SAC, Gothenburg	1957-63 AB SYCO, Strömstad; 1963-71 Rörstrand; 1971- Orrefors	ceramics; glass	1967, 1968, 1969 Faenza, diplomas
ALLERT, HENRIK 1937-	Sweden	1962-6 SAC, Gothenburg (sculpture)	1966-7 Rörstrand; 1967 own studio; 1967 Pentik, Lapland	ceramics	
ANDREASSEN, KRISTIN 1959-	Norway	1980-4 NCAD, Oslo; 1987 School of the Art Institute of Chicago, USA	1984- own studio, Fredrikstad; 1987, 1988 NCAD, Oslo	ceramics	
ASE, ARNE 1940-	Norway	1965 CAD, Bergen	1965- NCAD, Oslo, teacher; 1975-86 head of ceramics department; own workshop, Fagerstrand; 1965- CAD, Bergen, ceramics department, professor; 1986-7 NCAD, Oslo, professor; 1987-	ceramics	1987 Jacob-prize

Name	Country	Education	Dates	Career	Awards
ATTERBERG, INGRID 1920-	Sweden	Konstindustriskolan, Gothenburg	1944-63 / 1963- / 1971	Upsala-Ekeby (ceramics, glass, mosaics, textiles) / Mancioli Natale, Montelupo, Italy, freelance / own studio, Uppsala	1957 Milan Triennale, gold medal
BÄCK, GÖRAN 1923-	Finland	1957-8 Höhr-Grenzhausen, W. Germany	1948-86	Arabia (ceramics)	
BÄCKSTRÖM, MONICA 1939-	Sweden	1959-64 NCACD, Stockholm (advertising and industrial design)	1965-	Kosta Boda (glass)	
BAKKENE, ARVID 1947-	Norway	1964 Hadeland, apprenticeship	1976	Hadeland, 'gaffer', head of glass-blowing team (glass)	
BANG, JACOB E. 1899-1965	Denmark	1916-21 RDA, Copenhagen	1925-42 / 1943-c.57 / 1957-	Holmegaard; 1928 art director / Nymølle Faience, art director / Kastrup, art director (architecture, ceramics, glass, metals)	
BANG, MICHAEL 1944-	Denmark	1960-2, 1964-6 Björn Wiinblad's workshop	1962-4 / 1966-8 / 1968-	Royal Copenhagen / Ekenäs Glasbruk AB, Sweden / Kastrup & Holmegaard (ceramics, glass)	
BENGTSON, HERTHA	Sweden	1946-7 Gerlesborgs art school / 1948 Academie de la Grande Chaumière, Paris / 1948-67 study trips to France, England, Italy, Lebanon, Egypt, USA, Canada	1937-41 / 1941-64 / 1965-8 / 1969-	Hackefors Porslinsfabrik, ceramics / Rörstrand / Andersson & Johansson, Höganäs, ceramics / Rosenthal, W. Germany (ceramics)	1966, 1971 Faenza, gold medal
BERG, SØREN 1897-1978	Denmark	chemistry	1923	Royal Copenhagen (ceramics, glaze chemist)	
BERGH, ELIS (HAGBARD ELIAS) 1881-1954	Sweden	1897-9 RIT, Stockholm / 1899-1902 NCACD / 1905-6 architecture studies in Munich	1906-16 / 1916-21 / 1921-9 / 1929-50 / 1950-4	A/B Arv. Böhlmarks Lampfabric, and Pukeberg / Herman Bergmans Konstgjuteri, Stockholm, metals, director and artistic consultant / C G Hallbergs Guldsmedsaktiebolag, jewellery and tableware / Kosta / Kosta, freelance (glass, graphics, metals)	1925 Paris, gold medal
BERGSLIEN (SOMMERFELDT), GRO 1940-	Norway	1957-60 NCAD, Oslo (textiles) / 1960 three months study at Dannebrog Weavers and Material Printers, Amsterdam / 1964 State School for teachers of drawing and woodwork / 1971 RCA, London	1961 / 1964 / c.1964-	Plus, Fredrikstad, textile and printing section / Hadeland, designer / David-Andersen A/S, Oslo, part-time designer, enamels (enamels, glass, textiles)	

NAME	COUNTRY	TRAINING	MEDIA	CAREER	SELECTED AWARDS/HONOURS
BINDESBØLL, THORVALD 1846-1908	Denmark	1861 AA, Copenhagen (architecture)	architecture bookbinding ceramics furniture glass graphics jewellery leatherwork lighting metals stained glass textiles	1872- numerous architectural, decorative and monumental commissions, designs for furniture, embroidery, books and end-papers; 1882 display in national and international exhibitions; 1883-90 J. Walmann Pottery, Utterslev Mark; c.1890-1 Kaehler Keramik; 1891-1902 Københavns Lervarefabrik, Valby; c.1898- P.Hertz; Holger Kyster; Georg Jensen; A. Michelsen, silver	
BJÖRQUIST, KARIN 1927-	Sweden	1945-50 NCACD, Stockholm (student of Edgar Böckman)	ceramics	1950- Gustavsberg (assistant to Wilhem Kåge); 1961 head of workshop; 1980-8 art director	1954 Milan Triennale, gold medal; 1963 Lunning Prize; Prins Eugen Medal
BÖCKMAN, EDGAR 1890-1960	Sweden	1910-14 NCACD, Stockholm; 1932-3 study trips abroad, ceramic college in Czechoslavakia	ceramics	1915-26 Höganäs-Billesholms AB, art director; 1926-9 Rörstrand; 1935 own workshop, Stockholm; 1947-57 NCACD, Stockholm, head of ceramics department	
BOIJE, LENA 1944-	Sweden	1968 NCACD, Stockholm	ceramics graphics textiles wallpaper	1968-70 AD-agency; 1972- own design company, Boije Design AB; c.1972- DURO, wallpapers; Borås Wäfveri AB, textiles; 1985 Gustavsberg	
BONGARD, HERMAN 1921-	Norway	1938-41 NCAD, student of Per Krogh and Sverre Pettersen	ceramics glass graphics metals textiles wood	1947-55 Hadeland; 1950 Stavangerflint; 1955-60 freelance designer for Polaris (kitchenware); Oslo Sølvvareverksted (silver); 1957-63 Figgjo Fajanse, consultant, ceramics; 1960-4 Plus, artistic manager; 1966-8 J.W. Cappelan, chief designer (book design); 1968- NCAD, senior lecturer	1954 Milan Triennale, gold medal; 1957 Lunning Prize
BRANDSTRUP, FINN 1936-	Denmark	Technical School, Aarhus; Painting and sculpture privately under Hamed Abdalla and Valdemar Foerson Hegndal	stained glass	own workshop, Aulum	
BRANTENBERG, ULLA-MARI 1947-	Norway	1968 NCAD, Oslo; 1975-6 Orrefors, Sweden; 1971-5 SAC, Copenhagen	glass	c.1976- Randsfjord Glassverk, Hadeland, designer and glass-blower; c.1976- Bornholm, Denmark; c.1976- NCAD, Oslo; 1978- own workshop	
BRATT, MONICA 1913-61	Sweden	1932-3 Skolds Målarskola, Stockholm; 1933-9 RAAS, Stockholm	glass painting	1937-58 Reijmyre, art director	

Name	Country	Education	Career	Awards
BREGER, BIBI 1927-	Sweden	NCACD, Stockholm	ceramics (pattern design)	
			1954-7 Gustavsberg	
			1959- Breger Design AB, Stockholm and Malmö with husband Arne Breger	
BRYK, RUT (Sweden) 1916-	Finland	1939 CSI, Helsinki (graphic design)	ceramics, graphics, textiles	1951 Milan Triennale, grand prix
			1942 Arabia, art department	1954 Milan Triennale, diplôme d'honneur
			1959- Rosenthal, W. Germany, freelance, ceramics	1968 Pro Finlandia
			1960s Vassa Cotton Company	
BULL, HENRIK 1864-1953	Norway	1883-4 Technical School, Oslo	architecture, ceramics, furniture	
		1883-4 TU, Copenhagen	1888- own design office, Oslo; numerous public and private architectural commissions	
		1984-7 Königliche Technische Hochschule, Charlottenburg Berlin (architecture)	c.1900-5 Porsgrund, pattern designer	
			1908 RDA, Copenhagen: 1912-34 director	
CASTENSCHIOLD, ELIZABET 1895-1986	Denmark		ceramics	
			1927-63 Royal Copenhagen; later years head of faience painting department	
CHRISTENSEN, KARI 1938-	Norway	1961 NCAD, Oslo	ceramics	
		1963-5 RDA, Copenhagen	1961-5 Royal Copenhagen, designer	
			1966- own studio, Oslo	
			c.1966- NCAD, Oslo, teacher; c.1986- professor	
CYRÉN, GUNNAR 1931-	Sweden	1951 NCACD, Stockholm (apprentice goldsmith's diploma)	glass, metals	1966 Lunning Prize
			1959-70 Orrefors; 1976- freelance	
		1954 Kölner Werkschute, Cologne, W. Germany	1970- Dansk Design Ltd	
		1956 NCACD, Stockholm, (apprentice silversmith's diploma)	1975- own silversmith's studio, Gävle	
			1975-	
DAEHLIN, LISBETH (Denmark) 1922-	Norway (since 1950)	SAC, Copenhagen	ceramics	
		Various studios, Copenhagen, Paris and Lillehammer, Norway	1950- own studios, Norway	
			c.1970- own studio, Frysjä	
DAHLSKOG, EWALD 1894-1950	Sweden	1905-8 Centraltryckeriet, Stockholm	ceramics, glass, painting, wood	
		1908-12 RIT, Stockholm	1924-6 Paris, independent and freelance painting, illustration and journalism	
		1913-7 RAAS, Stockholm	1926-9 Kosta	
		1920- study trips abroad, including France, Italy, Tunisia	1929-50 Bo Fajans	
DUNNE-COOKE H.J. (Britain)	Sweden		glass	
			c.1938 Whitefriars Glasswork (J. Powell and Sons), designer	
			late 1930s Messrs Elfverson and Co., London (agents/retailers of various Scandinavian glassworks), director	
ECKHOFF, TIAS 1926-	Norway	1947-8 Saxbo (student of Nathalie Krebs)	ceramics, cutlery, glass, metals	1951 Hadeland competition, two prizes for decorative and utility glass
		1949 NCAD, Oslo (ceramics)	1949-52 Porsgrund, staff designer; 1952-7 art director; 1957- freelance	1953 Georg Jensen's inter-Scandinavian competition – first prize for silver cutlery
			1960 design advisor; 1974- member of Board of Directors	1953 Lunning Prize
			c.1950- Georg Jensen A/S, silver; Dansk Knivfabrik A/S, cutlery; Halden Aluminiumvarefabrik and Norsk Stålpress, metals	1954 1957,1960 Milan Triennale two gold medals each time
				1962, 65, 66 Norwegian ID Prize

NAME	COUNTRY	TRAINING	MEDIA	CAREER	SELECTED AWARDS/HONOURS
EDENFALK, BENGT 1924-	Sweden	1947-52 NCACD, Stockholm	glass	1953-78 Skruf, art director 1978- Kosta Boda	
EKHOLM, KURT 1907-75	Finland (Swedish citizen from 1952)	RIT, Stockholm	ceramics	1932-48 Arabia, art department, artistic director 1948 set up Arabia Museum using factory collection 1949-50 Rörstrand, Lidköping 1948-66 Konstindustriskolan, Gothenborg, teacher; 1950- director	
ENGELHARDT, VALDEMAR 1860-1915	Denmark	Chemical engineering	ceramics (glazing specialist)	1891-1915 Royal Copenhagen, technical manager	
ENGER, LEIF HELGE 1934-	Norway	1957-61 NCAD, Oslo (ceramics)	ceramics	1961 Porsgrund, freelance; 1964- full-time designer 1961 own studio, Porsgrunn	1963 Faenza, gold medal 1967 Faenza, prize 1967 Faenza, prize
ENGLUND, EVA 1937-	Sweden	1959 NCACD, Stockholm (advertising) 1962 SAC, Gothenburg (ceramics) Kunstakedemie, Munich, W. Germany Schliess Keramik, Austria	ceramics glass	1964-73 Pukeberg 1974- Orrefors	
FINCH, ALFRED WILLIAM (Belgium) 1854-1930	Finland	1878-80 Academy of Art, Brussels (painting)	ceramics painting	1884 lanscape painter; founder member, Les Vingt group of artists, Brussels, Belgium 1890-3 painted ceramics at Boch Frères, Saint-Vaast, Belgium 1896 own studio at Forges-Chimay, France 1897-1902 Iris Workshops, head of ceramics 1902-30 CSI, Helsinki, head of ceramics 1931 Arabia, designer of series of vases	
FISCHER, VILHELM THEODOR 1857-1928	Denmark	1876-82 RDA, Copenhagen (private student)	ceramics painting	1894-1928 Royal Copenhagen, under-glaze painting department	
FJELDSAA, KAARE BERVEN 1918-	Norway	1937-42 NCAD, Oslo (evening classes) 1936-46 Jens von der Lippe workshop	ceramics sculpture	1936-46 Jens von der Lippe workshop own workshop, Blommenholm, Baerum 1947-57 Royal Copenhagen 1956 A/S Stavangerflint, chief designer; 1968-79 A/S 1957-79 Stavangerflint – Figgjo-Fajanse A/S (after the merger of the two factories)	1954 Milan Triennale, gold medal
FLYGENRING, HANS (Denmark) 1881-1958	Norway	1907-11 RDA, Copenhagen (student of Johan Rohde) 1902-18 student of Arnold Krog, Copenhagen 1918 student of Ernst Goldschmidt, Copenhagen	ceramics painting	1920-7 Porsgrund, art director 1927- own studio, Copenhagen	
FORSELL, ULLA 1944-	Sweden	1966-71 NCACD, Stockholm 1971-3 Orrefors glass school 1972 Rie'veld Academie, Amsterdam, Holland	glass	1974- own workshop, Stockholm	

FORSETH, EINAR 1892-1988 — Sweden

Education:
- 1900-11 SAC, Gothenburg
- 1912-15 RAAS, Stockholm (student of Olle Hjortzberg)
- 1915-20 travels in Europe, including England, and Middle East

Disciplines: ceramics, graphics, mosaics, painting, stained glass

- 1917 Frövi church, first stained glass commission
- 1917- stained glass, mosaic and other commissions
- c.1920 Upsala-Ekeby
- c.1920 Lidköpings Porslinsfabrik, Rorstrand
- 1921-3 Gyllene Salen (Golden Hall), Stockholm Town Hall, mosaics
- 1923- Major commissions for church and hospital stained glass and mosaics in Sweden (Stockholm and elsewhere) and Norway
- 1960-5 Chapel of Unity and North-East Lobby, Coventry Cathedral, floor and windows

FRANCK, KAJ 1911- — Finland

Education:
- 1929-32 CSI, Helsinki; (furniture design)

Disciplines: ceramics, furniture, interior design, lighting, plastics, textiles

- 1934 Riihimäki, designer
- 1945-73 Arabia, head of design department for utility ware; Arabia, 1968-73 art director
- 1946-50 Iittala, designer
- 1950-76 Nuutajärvi, designer and art director
- 1968-73 Wärtsilä group, art director
- 1945-60 CSI, Helsinki, teacher; 1960-8 art director; 1973-8 professor of arts
- c.1988 Sarvis Oy, designs for plastics

Awards:
- 1951 Milan Triennale, gold medal
- 1954 Milan Triennale, two diplômas d'honneur
- 1955 Lunning Prize
- 1957 Milan Triennale, grand prix and compasso d'oro
- 1957 Pro Finlandia
- 1965 Prins Eugen Medal
- 1977 State Award for Industrial Arts
- 1983 RCA, London, Doctor Honoris Causa

FREIJ, EDLER 1944- — Norway

Education:
- 1966-71 NCAD, Oslo (student of Jens von der Lippe)
- 1970-3 Hochschule fur angewandte Kunst, Vienna

Disciplines: ceramics, glass, product design

- 1973-c.76 own studio, Vienna
- 1976 Hadeland, designer; 1979- head of product development

FRIBERG, BERNDT 1899-1981 — Sweden

Education:
- 1915-18 Höganäs-Billesholms AB, thrower

Disciplines: ceramics

- 1918-c.34 various workshops in Denmark and Sweden
- 1934-81 Gustavsberg, 1934-44, thrower for Wilhelm Kåge; 1944-81 Gustavsberg studio

Awards:
- 1948, 1951, 1954 Milan Triennale, gold medals
- 1960 The Gregor Paulsson Trophy
- 1965 Faenza, first prize

GALAAEN, KONRAD 1923- — Norway

Education:
- 1943-7 NCAD, Oslo (painting and ceramics)

Disciplines: ceramics

- 1947- Porsgrund, designer, serial production and art department
- 1947- numerous commissions for architectural ceramics and tiles

GARDE, FANNY 1855-1928 — Denmark

Education:
- 1876 Tegneskolen for Kvinder, Copenhagen (student of Pietro Krohn)

Disciplines: ceramics

- 1876-86 Tegneskolen for Kvinder, teacher
- 1885-8 Københavns Lervarefabrik, Valby
- 1886-1928 Bing & Grøndahl

Awards:
- 1925 Paris, gold medal

GATE, SIMON 1883-1945 — Sweden

Education:
- 1902-9 NCACD, Stockholm (painting)
- c.1909- RAAS, Stockholm

Disciplines: glass, illustration, metals, painting, sculpture

- 1916-45 Orrefors, 1916- development of Graal technique with master glassblower Knut Bergkvist

Awards:
- 1925 Paris, grand prix

NAME	COUNTRY	TRAINING	MEDIA	CAREER	SELECTED AWARDS/HONOURS
GEHLIN, HUGO 1889-1953	Sweden	NCACD, Stockholm	glass graphics painting sculpture stained glass	1930-53 Gullaskruf	
GERBER, JOHANNA	Denmark		ceramics	c.1960-5 Royal Copenhagen	
GJERDRUM, REIDUN SISSEL 1954-	Norway	1975-9 Kunstakademie, Trondheim	ceramics	1979 own workshop, Gruppe Ilsrika, Trondheim	
GRIEGST, ARJE 1938-	Denmark	c.1955- father's goldsmith workshop 1960 Just Andersen A/S, silversmith 1962 Rome, sculpture study trip 1963-5 Paris, sculpture study trip	ceramics glass jewellery metals	1968 Bezalel Academy of Art and Design, Jerusalem, professor 1975- Royal Copenhagen 1983- Holmegaard	
GULBRANDSEN, NORA 1894-78	Norway	c.1927 NCAD Oslo	ceramics enamels glass graphics metals	1928-45 Porsgrund, art director 1946- own studio c.1960- David-Andersen A/S, Oslo, enamels and silver	
HALD, DAGNY 1936-	Norway	1951 Academie delle Belle Arti, Faenza, Italy 1952-4 NCAD Oslo 1955 Marianne & Lars Thiirs und workshop 1955 Kaare B Fjeldsaa workshop, Blommenholm	ceramics	1956- own studio with husband Finn Hald, Son	
HALD, EDWARD 1883-1980	Sweden	1903-4 England and Germany, commercial studies 1904-6 Technical Academy, Dresden (architecture and painting) 1907 Artists Studio School, Copenhagen (student of Johan Rohde) 1908-12 studies abroad, including France (Paris with Henry Matisse), Germany, England, Denmark, Italy	ceramics glass painting	1917-44 Orrefors: managing director from 1933 1917-27 Rörstrand, Lidköping, freelance 1924-33 Karlskrona, designer, art director 1944-late 1970s Orrefors, freelance	1925 Paris, grand prix 1945 Prins Eugen Medal
HALIER, CARL 1873-1948 (Germany)	Denmark (Danish citizen from 1915)		ceramics	1898 arrived in Denmark 1898-1913 own pottery, Roskilde 1913-26 Royal Copenhagen (thrower for Patrick Nordström) 1926-30 own kiln with Arne Bang, Bredgade, Copenhagen 1930-48 Royal Copenhagen	
HANSEN, BENTE 1943-	Denmark	1960-4 SAC, Gothenburg	ceramics	1964-70 Bing & Grøndahl 1968- own workshop, Copenhagen 1978-82 Royal Copenhagen, artist-in-residence 1985- SAA, Copenhagen, consultant	
HANSEN, HANS HENRIK 1894-1965	Denmark	1908-13 Royal Copenhagen (apprentice, modellers' department)	ceramics	1918-c.60 Royal Copenhagen (first as an independent artist); from 1926 head of modellers' department	

Name	Country	Medium	Education	Career	Awards
HANSEN, ROLF 1922-	Norway	ceramics	1942 NCAD, Oslo commercial school, Oslo (advertising) / 1943 student of Trygve Mosebekk / 1945-6 Åros Keramikkfabrikk workshop, Royken	1947-c.57 Kongsberg Keramikk Arnold Wiigs Fabrikker, Halden, shape design Plus workshops, / 1958 consultant	
HEGERMANN-LINDENCRONE, EFFIE 1860-1945	Denmark	ceramics	1880-5 Tegneskolen for Kvinder (student of *Pietro Krohn* and others)	1885-6 Københavns Lervarefabrik, Valby / 1886-1945 Bing & Grøndahl	1925 Paris, diplôme d'honneur
HELLMAN, ÅSA 1947-	Finland	ceramics	1967-9 University of Helsinki (art history) / 1969-73 CSI, Helsinki (ceramics) / 1974-5 Akademija Za Primenjene Utmetnosti, Belgrade, Yugoslavia, (ceramics) / 1978-9 RCA, London (ceramics)	1974- own studio, Pot Viapori co-operative, Suomenlinna, Helsinki	
HELLSTEN, LARS 1933-	Sweden	glass	1957-63 NCACD, Stockholm (returned as teacher) / 1954 SAC, Gothenburg (sculpture and ceramics) / c.1955- study trips abroad	1964-72 Skruf / 1972- Orrefors	
HELLUM, CHARLOTTE BLOCK (German) 1911-	Norway (Norwegian citizen from 1937)	ceramics enamels	Arts and crafts colleges, Dresden and Berlin	1946- own workshop, Oslo. ceramics; c.1960- enamels	
HENNIX, MARGARETA 1941-	Sweden	ceramics plastics textiles enamels	1959-63 NCACD, Stockholm	1964 Nyckelviksskolan, teacher / 1965-7 Johansfors / 1967- Gustavsberg own studio / 1977- Works half year in USA	
HERMELIN, CARL 1897-1979	Sweden	glass	State school for industrial glass, Haida, Czechoslovakia	1922- Orrefors, works manager, designer / 1926-30 Sandvik, works manager / 1930-40 Pukeberg, works manager, designer / 1941- Alsterfors Glasbruk	
HILLFON, HERTHA 1921-	Sweden	ceramics	1953-7 NCACD, Stockholm	1959- own studio, Stockholm	1962 Lunning Prize / 1971 Member of the Royal Swedish Academy of Fine Arts
HINZ, DARRYLE (USA) 1949-	Denmark	glass	1969-72 University of California, USA / 1972-3 Uppsala University, Sweden / 1973-4 Glass school, Orrefors	1974-5 Åfors, designer and glassblower / 1975-8 Boda, designer and glassblower / 1978-80 founded Bornholm glassworks with Charlie Meaker / 1983- own workshop with Anja Kjaer, Copenhagen	
HOFF, PAUL 1945-	Sweden	ceramics glass	1963-8 NCACD, Stockholm, postgraduate work / 1968-9 study trips to Africa and America	1969-74, and 1982-7 Gustavsberg AB / 1972-82 Kosta Boda AB / 1988- Rörstrand-Gustavsberg / 1982- own design company artistic adviser to Studioglas AB. / c.1987 Strömbergshyttan	

NAME	COUNTRY	TRAINING	MEDIA	CAREER	SELECTED AWARDS/HONOURS
HÖGLUND, ERIK 1932-	Sweden	NCACD, Stockholm	glass metal painting stone wood wood	1953-73 Kosta Boda 1973- own studio (sculpture) c.1973 visiting professor at Pilchuck Glass Center, Washington, USA 1978-81 Pukeberg and Lindshammer, freelance 1986 Vrigstads Kristallhytta, freelance c.1987 freelance, Studioglas AB Strömbergshyttan	1957 Lunning Prize
HOLMBOE, THOROLF 1866-1935	Norway	1889-90 studied painting in Berlin and at Atelier Fernand Cormon, Paris NCAD, Oslo (sculpture)	ceramics graphics illustration textiles	c.1895- joined group of symbolist Scandinavian artists 1908-11 Porsgrund, designed underglaze porcelain decoration	
HOLZER-KJELLBERG, ELFRIEDE (FRIEDL) AMALIE ADOLFINE (Austria) 1905-	Finland	Kunstgewerbeschule, Graz, Austria	ceramics	1924-70 Arabia	1935 Brussels, gold medal 1937 Paris, silver medal 1954 Milan Triennale, gold medal 1966 Pro Finlandia
HOPEA-UNTRACHT, SAARA 1925-84	Finland	1943-6 CSI, Helsinki (interior design)	ceramics enamels furniture glass graphics himmelis interior design jewellery lighting textiles (patchworks)	1946-52 freelance interior designer 1946-8 Mobilia Oy, furniture 1948-52 Taito Oy, furniture 1951-80 intermittently, construction of himmelis, traditional Finnish hangings made of straws or stalks 1952-9 Nuutajärvi/Arabia, associate to Kaj Franck 1958-60 Ossian Hopea Kultasepänliike Porvoo, the family jewellery and silver business 1960 marriage to enamellist Oppi Untracht 1960-7 USA, freelance enamellist 1963-5 travel in Nepal 1967-80 Ossian Hopea Kultasepänliike 1967-80 freelance enamellist, private patchworks	1954, 1957 Milan Triennale, silver medals
HUNT, MARTIN (England) 1942-	Denmark	1963 Gloucestershire College of Art, Cheltenham 1963-6 RCA, London	ceramics	1966 founded Queensberry Hunt with David Queensberry 1970- Bing & Grøndahl, freelance designer 1976-86 RCA, London, head of glass department 1977-80 Craft Council, London, member 1978-81 Design Council (Industrial Advisory Service), London, member 1986- full-time with Queensberry Hunt	1971, 1975, Design Council Awards for 1977, 1980 ceramic lighting (JRM Designs), tableware (Hornsea Pottery) 1983 Royal Society of Arts, London Royal Designer for Industry

HYDMAN-VALLIEN, ULRICA
1938-
Sweden

Education:
1958-61 NCACD, Stockholm (ceramics and glass)
1961-3 study trips to USA, Mexico

Fields: ceramics, glass, painting, textiles

Career:
1963- own workshop, Åfors
1972- Kosta Boda
1979- Rörstrand
1981-8 Teacher at Pilchuck Glass Center, Washington State USA

JÄDERHOLM-SNELLMAN, GRETA-LISA
1894-1973
Finland

Education:
1912 CSI, Helsinki

Fields: ceramics, glass, lighting

Career:
1921-37 Arabia
1929-37 CSI, Helsinki, lecturer
1937-9 Sèvres, France
1937-49 Riihimäki
1945-62 Iittala

JENSEN, OLUF
1871-1934
Denmark

Education:
Technical School
1885 Royal Copenhagen, under-glaze painting school
1885 Kunstnernes Studieskole
1890-5 RDA, Copenhagen

Fields: ceramic painting

Career:
1885-1934 Royal Copenhagen, head of underglaze painting department

Awards:
1925 Paris, silver medal

JENSEN, POUL
(Denmark) 1950-
Norway

Education:
1968 Kaehler Keramik, Naestved, Denmark
1971-6 external studies at NCAD, Oslo (sculpture and drawing);
1976-9 full-time student (ceramics)

Fields: ceramics

Career:
1983 High School, lecturer
1984 Porsgrund, freelance; 1986- art director

JENSEN, SIDSEL HARTWIG
1916-
Norway

Education:
c. 1935-6 student of Helmuth Drollinger, Berlin
c. 1937-9 NCAD, Oslo
1940-5 Jens von der Lippe workshop, assistant

Fields: ceramics

Career:
1946- own workshop, Oslo, employing Danish thrower Carl Christiansen

JOACHIM, CHRISTIAN
1870-1943
Denmark

Education:
1887 Technical High School
1889-92, 1895 RDA, Copenhagen

Fields: ceramics, painting

Career:
1897-1900 Georg Jensen A/S, ceramics
1901-33 Royal Copenhagen
1904 Royal Copenhagen Alumina Factory, art director
1922-33 Royal Copenhagen Porcelain and Alumina factories, art director

Awards:
1925 Paris, grand prix
1939 Royal Society of Arts, London, Honorary Royal Designer for Industry

JOHANSSON, WILLY
1921-
Norway

Education:
1936 Hadeland, glassmaking workshop
1939-42 NCAD, Oslo

Fields: glass

Career:
1942-5 Hadeland, sandblowing section under sculptor Staale Kyllingstad
1945-7 A/S Christiania Glasmagasin, engraving workshop; also NCAD, Oslo, night school
1947 Hadeland: head of design team, production and art wares

Awards:
1954 Milan Triennale, diplôme d'honneur
1957 Jacob-prize
1957 Milan Triennale, gold medal
1960 Milan Triennale, silver medal

JUTREM, ARNE JON
1929-
Norway

Education:
1946-50 NCAD, Oslo
1952 student of Fernand Léger, Paris
1968-72 Paris, several long periods of study

Fields: ceramics, enamels, glass, graphics, metals, painting, plastics, textiles

Career:
1950- Hadeland, part-time and intermittently
1962-4 Holmegaard, freelance
1963 founder member new Landsforbundet Norske Brukskunst (Norwegian Association of Arts & Crafts); 1965-6 chairman
1964-71 Norsk Designcentrum board member
1965-70 NCAD, chairman and board member
1967 Plus Glasshytte
1967- various public commissions in glass, enamel and metal

Awards:
1954 Milan Triennale, gold medal

NAME	COUNTRY	TRAINING	MEDIA	CAREER	SELECTED AWARDS/HONOURS
JUURIKKALA, ANJA 1923-	Finland	CSI, Helsinki	ceramics	1946-60 Arabia	
KAEHLER, HERMAN AUGUST 1846-1917	Denmark	1866 studies in Berlin 1867 Kaehler Keramik, apprenticeship	ceramics	1872-1917 inherited Kaehler Keramik from his father	1900 Paris, silver medal
KÅGE, WILHELM 1889-1960	Sweden	Valand Art School, Gothenburg (painting) with Carl Wilhelmsson, Stockholm; Artists' Studio School, Copenhagen (student of Johan Rohde); Plakatschule, Munich (posters)	ceramics, graphics, painting	1917-60 Gustavsberg, 1917-1949 art director	1925 Paris, grand prix
KAIPIAINEN, BIRGER 1915-88	Finland	1933-7 CSI, Helsinki	ceramics	1937-54, 1958 Arabia, art department; 1949-50 Richard Ginori, Florence and Milan; 1954-8 Rörstrand, Sweden	1951 Milan Triennale, diplôme d'honneur; 1960 Pro Finlandia; 1982 Prins Eugen Medal, Sweden
KLIM, KAREN 1951-	Norway	1970-5 SAC, Copenhagen; 1975-6 Orrefors, Sweden, glass school; c.1977 assistant and designer at various glass studios in England and Denmark	glass	1978- own studio, Frysja	
KNUTZEN, WILLIAM 1913-83	Norway	1930-1 Eilif Whist workshop, Oslo; 1932-3 student of Andreas Thiele Schneider, Oslo; 1933-5 NCAD, Oslo, (student of Paul Ansteinsson and Thorbjørn Alvsaker); 1936 Berlin, studentship; 1937 Paris, studentship; 1950 Italy, studentship	ceramics	1934 own workshop, Oslo; 1937 collaboration with Andreas Thiele Schneider, Schneider & Knutzen, Slemdal; 1946-9 A/S Graverens Teglverk, Sandes, art director; 1949-52 own workshop, Solliveien, Lysaker and consultant on earthenware production to Arnold Wiik, Halden; 1952-9 own workshop, Fjellmoran, Elverum; 1959 own workshop, Grini, Roa, Oslo; 1963-83 own workshop, Heggenes, Øystre Slidre	
KOEFOED, INGE-LISA 1939-	Denmark	1956-60 SAC, Copenhagen	ceramics, graphics	1959-65 Royal Copenhagen; 1966 own studio, Copenhagen; 1973- Royal Copenhagen, freelance	
KOFOED, HANS PETER 1869-1908	Denmark	Technical High School; 1887-91 RDA, Copenhagen; 1887-91 Kunstnernes Studieskol	painting	1897-1908 Bing & Grøndahl	
KOPPEL, HENNING 1918-81	Denmark	1936-7 RDA, Copenhagen (sculpture); 1938-9 Academie Ranson, Paris	ceramics, glass, metals, plastics	1940-5 Svenskt Tenn, Stockholm; 1940-5 Orrefors; 1945-81 Georg Jensen A/S, silver; 1961-81 Bing & Grøndahl; 1971- Orrefors, freelance	1951, 1954, 1957 Milan Triennale, gold medals; 1953 Lunning Prize
KORTZAU, OLE 1939-	Denmark	Architecture	architecture, ceramics, glass, graphics, jewellery, metals	1978 Royal Copenhagen; c.1978- Holmegaard	

Name / Dates	Country	Field	Education	Career	Awards
KREBS, NATHALIE 1895-1978	Denmark	ceramics	1919 Technical High School, Copenhagen (civil engineering)	1919-29 Bing & Grøndahl; 1929 own studio with Gunnar Nylund, Nylund & Krebs Keramiske Vaerksted, Islev; 1930 moved studio to Herlev; studio re-named Saxbo; 1930-68 collaboration with *Eva Staehr-Nielsen*	1957 Milan Triennale, gold medal; 1971 *Prins Eugen Medal*
KROG, ARNOLD 1856-1931	Denmark	architecture ceramics	1874-80 RDA, Copenhagen (architecture); 1878-81 Frederiksborg Palace, interior repairs and decoration	1883 Henrik Hagemann, architecture design office; 1884-1916 Royal Copenhagen: 1885- art director	1889 Paris, jury member; 1900 Paris, grand prix
KROHN, PIETRO 1840-1905	Denmark	ceramics costume design illustration painting	1860-7 RDA, Copenhagen	1868-c.80 painted landscapes and genre scenes; 1880 Det Kongelige Teater, Copenhagen, artistic director; 1885-95 Bing & Grøndahl, art director; 1888 designed Hejrestellet; 1893-1905 Det Danske Kunstindustrimuseum, Copenhagen, first director	1889, 1900 Paris, jury member
KYHN, KNUD 1880-1969	Denmark	painting ceramics sculpture	1900-2 RDA, Copenhagen; 1902-4 Kunstnernes Studieskol, Copenhagen	1905-23 Royal Copenhagen; 1905-23 Kaehler Keramik, painter and designer-sculptor; 1913-6 Bing & Grøndahl and 1933-5; 1925- own workshop	
LANDBERG, NILS 1907-	Sweden	glass	SAC, Gothenburg; 1925-7 Orrefors engraving school; Study trips abroad	1927-72 Orrefors	1954 Milan Triennale, gold medal
LANDGREN, PER-OLOF 1944-	Sweden	plastics	1962 Nyckelviksskolan, Stockholm; 1967 NCACD, Stockholm	1967- own design company; 1968-88 Gustavsberg, plastics divisions	
LEHTONEN, LINNEA	Finland	ceramics		1950s Kupittaan Savi	1955 Milan Triennale, silver medal
LEIVO, INKERI 1944-	Finland	ceramics enamels glass	1966-70 CSI, Helsinki	1971- Arabia, product planning department; 1971- Nuutajärvi; 1971- Järvenpää Enamel	
LILJEFORS, ANDERS B (USA) 1923-70	Sweden	ceramics	1942-3 Grünewalds målarskola, Stockholm; 1945-7 RDA, Copenhagen; Studies in Paris	1947-53, c.1947- Gustavsberg, and 1955-7 own studio, Karlskrona	
LINDBERG, STIG 1916-82	Sweden	ceramics glass industrial design textiles	1935-7 NCACD, Stockholm; 1937-40 Gustavsberg (student of *Wilhelm Kåge*)	1937-57, and 1970-80 Gustavsberg; 1949-57, 1972-8 art director; 1947- lecturer; 1947- Nordiska Kompaniet, design of hand-printed textiles; 1957-70 NCACD, Stockholm, senior lecturer; 1980- own studio, Italy	1948, 1957 Milan Triennale, gold medal; 1951, 1954 Milan Triennale, grand prix; 1957 Gregor Paulsson Trophy; 1968 Prins Eugen Medal; 1973 Faenza, gold medal
LINDBERG-FREUND, MARIT 1934-	Sweden	ceramics	1956 NCACD, Stockholm	c.1956-70 own studio, Stockholm; 1970- own studio, Västerås	

NAME	COUNTRY	TRAINING	MEDIA	CAREER	SELECTED AWARDS/HONOURS
LINDBLAD, GUN 1954-	Sweden	1977-81 NCACD, Stockholm (glass and ceramics)	ceramics glass	1982-7 Kosta Boda 1987- own workshop, Stockholm c.1987- California College of Arts and Crafts, USA, artist-in-residence 1987- Studioglas AB Strömbergshyttan, consultant	
LINDH, FRANCESCA MASCITTI (Italy) 1931-	Finland	1946-8 Liceo Artistico delle Belle Arti, Rome 1949-52 CSI, Helsinki	ceramics	1953-5 studio shared with husband Richard Lindh, Helsinki 1955- Arabia	1957 Milan Triennale, honourable mention 1973, 1977 Faenza, gold medal
LINDH, RICHARD 1929-	Finland	1952-3 CSI, Helsinki	ceramics	1953-5 studio shared with wife Francesca Lindh, Helsinki 1955 Arabia, art department 1960 Arabia, head of applied art department; 1963 head of design department; 1973-c.1985 art director	
LINDHART, SVEN 1898-c.1985	Denmark		ceramics (porcelain figures) sculpture	c.1920- Bing & Grøndahl, freelance	
LINDKVIST, JONAS 1958-	Sweden	NCACD, Stockholm	product design	c.1980- own design company c.1980- Boras Wäfveri, textiles, DURO, wallpapers; KEVA, computers 1985 Gustavsberg, pattern design	
LINDSTRAND, VICKE (VICTOR EMANUEL) 1904-83	Sweden	1924-7 SAC, Gothenburg, Studies in France and Italy	ceramics glass illustration textiles	1928-40 Orrefors 1935-6 Karlskrona Porslinsfabrik Upsala-Ekeby. 1936-50 Kosta, art director 1942-50 art director 1950-73 own studio, Aahus	
LIUKKO-SUNDSTRÖM, HELJÄ 1938-	Finland	1962 CSI, Helsinki	ceramics	1962- Arabia, applied art department; 1967- art department	
LÜTKEN, PER 1916-	Denmark	1937 SAC, Copenhagen, (painting, technical drawing)	glass	1942- Kastrup and Holmegaard, art director	
MADSEN, STEN LYKKE 1937-	Denmark	1958 SAC, Copenhagen	ceramics	1958 Kaehler Keramik, Nils Kaehler Workshop 1959 own studio, Copenhagen 1962- Bing & Grøndahl	1975 Faenza, gold medal
MADSEN, THEODOR 1880-1965	Denmark	Technical High School 1898-1902 RDA, Copenhagen 1905-6 travel in Germany, employment at various factories	ceramics sculpture	1896-1936 Royal Copenhagen 1900-36 Kaehler Keramik, freelance	1935 Brussels, silver medal
MADSLUND, HANS A	Denmark	Engineering	ceramics	1916-c.35 Bing & Grøndahl c.1935- Royal Copenhagen, chief chemical engineer and technical manager	

Name	Country	Education	Field	Career	Awards
MAGNUSSEN, ERIK 1940-	Denmark	1960 SAC, Copenhagen (ceramics, silver medal)	ceramics, furniture, metals, plastics	1962- Bing & Grøndahl, artistic consultant; c.1976-c.7 Kevi A/S, furniture; 1975 A/S Stelton; 1978- Georg Jensen A/S, silver	1967 Lunning Prize; 1972, 1978 ID-prize, Danish Society of Industrial Design; 1983 'Designer of the Year' Danish Design Council
MALINOWSKI, ARNO 1899-1976	Denmark	Technical High School; 1914-19 apprenticeship under S. Lindahl (engraver to the Royal Court); 1919-22 RDA, Copenhagen	ceramics, metals, sculpture	1921-35 Royal Copenhagen; 1934-9 SAC, Copenhagen, teacher; 1936-44 Georg Jensen A/S, silver	1925 Paris, silver medal
MANICUS-HANSEN, THYRA 1898-1936	Denmark		ceramics	1898-1936 Royal Copenhagen	
MANZ, BODIL 1943-	Denmark	1965 SAC, Copenhagen; 1965-6 Escuela de Diseno y Artesanos, Mexico City; 1966 University of California, USA (student of Peter Voulkos)	ceramics	1967- own studio with husband Richard Manz; 1982-4 Bing & Grøndahl, freelance	
MATHIESEN, OLAF 1878-1953	Denmark		ceramics	1904- Royal Copenhagen, modeller; 1924 works manager	
MEYER, GRETHE 1918-	Denmark	1947 RDA, Copenhagen (architecture)	architecture, ceramics, furniture, glass	1959 Kastrup (with Ibi Trier Mørch); 1960 Royal Copenhagen; 1960- private architectural practice; 1955-60 State Institute for Building Research	1965 Faenza, silver medal; 1973 Scandinavian Industrial Art and Design Award
MO, JORUN KRAFT 1949-	Norway	1967-8 Kunstakademie, Trondheim; 1968-71 CAD, Bergen	ceramics, glass, plastics	1968-75 Haugen Keramikk, Oberhalla; 1974-5. Kunstakademie, Trondheim, teacher, and 1977-8; 1978 own workshop, Gruppe Ilsvika, Trondheim; 1986 Riis Glassindustri A/S	
MØLLER, GRETE 1915-	Denmark	1930-3 SAC, Copenhagen	ceramics	c.1934-c.7 collaboration with *Edith Sonne Brunn* in Denmark; 1943-70 studio with husband *Tom Møller*; 1970- own workshop; c.1980- intermittent collaboration with Kennet Williamsson, Denmark	
MØLLER, TOM 1914-	Sweden		ceramics, glass	1943-70 studio with wife, *Grete Møller*, Stockholm; 1959 Alsterbro glassworks; 1960- NCACD, Stockholm, teacher; 1963-7 Reijmyre; 1967- Lindshammar glassworks, freelance	
MORTENSEN, INGRID 1941-	Norway	1958-62 NCAD, Oslo	ceramics	Various workshops in Denmark and Norway including *Jens van der Lippe* workshop; 1968- own studio, Oslo	

NAME	COUNTRY	TRAINING	MEDIA	CAREER	SELECTED AWARDS/HONOURS
MOTZFELDT, BENNY 1909-	Norway	NCAD, Oslo (graphic art)	glass graphics illustration	1937- exhibited water colours and drawings, State Autumn Exhibition; various employments in commercial art and illustration / 1955- Christiana Glasmagasin / 1955-67 Hadeland, designer / 1967 Randsfjords glassworks, designer / 1970- Plus workshops, designer and manager of glass house	1969 Jacob-prize
MÜLLERTZ, MALENE 1949-	Denmark	1966-70 SAC, Copenhagen / 1973-5 Kunstakademiets Designskole, Copenhagen	ceramics	1970-3 Bing & Grøndahl / 1972 Royal Copenhagen / 1975- own workshop, Copenhagen / 1979- SAC, Copenhagen and Kolding, teacher, part-time	
MUNCH-PETERSEN, LISBETH 1909-	Denmark	1928-30 Kunstindustrimuseets Skole, Copenhagen		1933-5 own workshop, with her sister, Gertrud Vasegaard, Gudhjem, Bornholm / 1935- various own workshops / 1961-6 Bing & Grøndahl, artist-in-residence	1985 Bindesbøll Medal
MUONA, TOINI 1904-87	Finland	1927-33 CSI, Helsinki (student of A. W. Finch)	ceramics glass	1931-70 Arabia / 1963-4 Nuutajärvi	1933, 1951, 1954 Milan Triennale, gold medals / 1935 Brussels, gold medal / 1937 Paris, gold medal (ceramics), silver medal (glass) / 1957 Pro Finlandia
NIELSEN, ERIK 1857-1947	Denmark	Technical High School / Apprentice wood carver / 1885-6 RDA, Copenhagen	ceramics sculpture	c.1886-7 Bing & Grøndahl, modeller / 1887-1947 Royal Copenhagen, model maker and signing artist / Models for Kaehler Keramik	
NIELSEN, JAIS 1895-196?	Denmark	1900-7 Technical High School, Copenhagen / 1907-9 Kunstnernes Studieskole, Copenhagen	ceramics painting (including glass and fresco)	1911-14 painter, Paris / 1915 Københavns, Levrvarefabrik, Valby / 1920 travel in Italy studying Giotto's frescoes / 1920-8 Royal Copenhagen / 1928-61 freelance commissions for ceramics, frescoes and stained glass	1925, 1937 Paris, grand prix
NORDSTRÖM, PATRICK (Sweden) 1870-1929	Denmark	1889-90 Svenska Slöjdföreningens Skola, Gothenburg / 1894-5 Tekniska Yrkesskolan, Lund	ceramics	1902-7 own workshop, Bakkegaardsalle, Copenhagen / 1907-10 own workshop, Vanlose / 1911-22 Royal Copenhagen / 1923-9 own workshop, Herlev	1900 Paris, no details / 1914 Malmö, no details
NURMINEN, KERTTU 1943-	Finland	1966-70 CSI, Helsinki (ceramics)	glass	1972- Nuutajärvi	1977 Coburger Glas Preis

Name	Country	Discipline	Education/Training	Career	Awards
NYLUND, GUNNAR 1904-	Sweden	ceramics, glass	Architectural studies / With his father, Finnish portrait painter Felix Nylund / Bing & Grøndahl, Copenhagen	1929 established Nylund & Krebs Keramiske Vaerksted, Denmark, with Nathalie Krebs / 1931-58 Rörstrand, Lidköping, art director / 1954-67 Strömbergshyttan, designer and art director / 1959- Nymølle Keramiske Fabriker, Denmark, art director / before 1974	
NYMAN, GUNNEL GUSTAFSSON 1909-48	Finland	furniture, glass, lighting, metals, textiles	1928-32 CSI, Helsinki (furniture, student of Arttu Brummer)	1932-47 Riihimäki / 1932-6 Taito Oy, furniture / 1935-7 Karhula / 1946-7 Iittala / 1946-8 Nuutajärvi	1933 Riihimäki glass competition, third prize / 1936 Riihimäki glass competition, second and third prizes / 1936 Karhula glass competition, second and third prizes / 1937 Paris, gold medal (glass) silver medal (furniture) / 1951 Milan Triennale, gold medal (glass)
NYQUIST, KARI 1918-	Norway	ceramics decoration	1934-8 NCAD, Oslo (student of Thorbjørn Lie-Jørgensen and Per Krohg); Eilif Whist and William Knutzen workshop / 1939-40 Åros Kermikkfabrikk / 1941 Scheider and Knutzen A/S, Slemdal	1941- own studio, Oslo working with Jo Vot from 1942, with her husband Jan Hyquist from 1944, with Jens Bindesbøll Schov from 1976 / 1955-68 Stavangerflint A/S free-lance: 1968 Stavangerflint Figgio-Fajanse A/S, freelance	
ÖBERG, THURE (Sweden: 1871-1935)	Finland	ceramics		1896-1935 Arabia, art director until 1932	
ÖHRSTRÖM, EDVIN 1906-	Sweden	glass, sculpture	1925-8 NCACD, Stockholm / 1928-32 RAAS, Stockholm (sculpture and graphic studies) sculpture studies abroad, including at an art school in Paris under Fernand Léger	1936-57 Orrefors (two months per year): developed the Ariel technique together with Vicke Lindstrand and master glass-blower, Gustav Bergkvist / 1936 independently as a glass sculptor in own workshop; technical help and workspace hired from Lindshammar glassworks	
OLIN-GRÖNQVIST, GUNVOR 1928-	Finland	ceramics	1948-51 CSI, Helsinki	1951- Arabia, applied art department; 1968 design department; 1976- art department	
OLSEN, THORKILD 1890-1973	Denmark	ceramics	1908-10 Royal Copenhagen, (student of Arnold Krog) / 1911-14 RDA, Copenhagen	1908-68 Royal Copenhage; 1918- head of the Juliana (revivals) and overglaze department	1925 Paris, silver medal / 1935 Brussels, diplôme d'honneur / 1937 Paris, diplôme d'honneur
ORUP, BENGT 1916-	Sweden	glass, graphics, painting, sculpture	1933-5 Otte Skölds Målarskola / 1937-8 studied painting, Paris	1951-73 Johansfors, staff designer and then art director / 1963 Hyllinge Glasbruk, freelance / 1968 RCA, London, visiting professor / -1988 own workshop outside Hälsingborg as painter, engraver and sculptor	

NAME	COUNTRY	TRAINING	MEDIA	CAREER	SELECTED AWARDS/HONOURS
ORVOLA, HEIKKI 1943-	Finland	1963-8 CSI, Helsinki (ceramics) 1976 Pilchuk Glass workshop, USA	ceramics enamels glass textiles	1968-77 CSI, Helsinki, lecturer 1968- Nuutajärvi 1976- Järvenpää Enamel 1985 Marimekko, textiles 1987 Arabia 1987 Rörstrand	1984 Pro Finlandia
OSOL, OLGA 1905-	Finland	CSI, Helsinki	ceramics	1926-71 Arabia	
PAASIVIRTA, MARJUKKA 1923-	Finland	1948 CSI, Helsinki	ceramics	1949-60 Kupittaan Savi	1954 Milan Triennale, silver medal
PAIKKARI, PEKKA 1960-	Finland	1978-83 Institute of Handicraft and Industrial Design, Kuopio	ceramics	1983- Arabia, thrower, art department; 1988- design department	
PALMQVIST, SVEN 1906-84	Sweden	1928-30 Orrefors engraving school 1931-3 NCACD, Stockholm 1934-6 RAAS, Stockholm (sculpture) 1934 Study trips in Germany and Czechoslovakia 1937-9 Académie Ranson, Paris (student of Paul Cornet and Aristide Maillol)	glass painting sculpture	1930-72 Orrefors 1972-84 Orrefors, freelance	1957 Milan Triennale, grand prix 1976 Venice Biennale, grand prix 1977 Prins Eugen Medal
PERCY, ARTHUR CARLSSON 1886-1976	Sweden	1905-8 Konstnärsförbundets Skola, Stockholm 1906 changed name from Carl Arthur Percy Carlsson 1908 studies with Henri Matisse, Paris	ceramics glass textiles	1923-39 Gefle 1936- Elsa Gullberg Ltd (printed textiles) 1943-51 Karlskrona 1951-70 Gullaskruf	1925 Paris, diplôme d'honneur 1957 Prins Eugen Medal
PERSSON, INGER 1936-	Sweden	NCACD, Stockholm	ceramics	1959-71 Rörstrand Freelance design work own studio	1969 Faenza, gold medal
PERSSON-MELIN, SIGNE 1925-	Sweden	1945-6, 1948-50 NCACD, Stockholm (ceramics and sculpture, student of Robert Nilsson) 1947-8 SAC, Copenhagen (student of Nathalie Krebs) c.1949-50 Andersson & Johansson, Höganäs, apprentice	ceramics glass metals	1951-66 own studio, Malmö 1967-77 Kosta Boda 1970- establishment of Boda Nova (design group), founder member 1980-7 Rörstrand, Lidköping 1985- NCACD, Stockholm, professor	1958 Lunning Prize 1973 The Gregor Paulsson Trophy
PETERSEN, CARL 1874-1923	Denmark	Apprentice carpenter Technical High School 1896-1901 RDA, Copenhagen (architecture)	architecture ceramics	1902-7 own workshop, Hvidore, where he revived and specialised in the traditional decoration method of horn-painting, slip-trailing using a cow's horn with goose quill 1909 founder, Free Association of Architects 1911-2 Bing & Grøndahl, consultant, established the stoneware production 1914-5 Faaborg Museum, Funen, architect 1918 RDA, Copenhagen, professor	

Name / dates	Country	Education	Medium	Career	Awards
PETTERSEN, SVERRE 1884-1958	Norway	NCAD, Oslo	glass, graphics, textiles	1926- Hadeland; 1928-49 art director; c.1930 NCAD, Oslo, senior professor; 1947- Christiana Glasmagasin, head of design office	1926 Foreningen Brukskunst competition, first prize
PONCELET, JACQUI (Belgium) 1947	Denmark	1965-9 Wolverhampton College of Art; 1969-72 RCA, London (MA ceramics)	ceramics, sculpture	1972-7 shared studio with Glenys Barton, Tony Bennett, Alison Britton in succession, London; 1974-7 Portsmouth Polytechnic, teacher; 1978-9 USA, bicentennial scholarship; 1979- own studio, London; 1985-6 Bing & Grøndahl, visiting artist; 1988 announced move from pottery to sculpture	
PROCOPÉ, ULRIKA (ULLA) 1921-68	Finland	CSI, Helsinki	ceramics	1948-67 Arabia	1957 Milan Triennale, diplôme d'honneur
RÅMAN, INGEGERD 1943-	Sweden	NCACD, Stockholm; Istituto Statale d'Arte per la Ceramica, Faenza, Italy	ceramics, glass	1967-71 Johansfors; 1972- own studio, Stockholm; 1981- Skruf	
RASMUSSEN, HANS CHRISTIAN 1949	Denmark	1968-72 SAC, Copenhagen (textiles); 1978-80 RCA, London (MA)	ceramics, textiles	1972-8 own workshop, Copenhagen; 1976- Bing & Grøndahl	
REIFF, ERIK 1923-	Denmark	Self-taught	ceramics	1946-7 Kaehler Keramik; 1948 Alf Magnussen Studio, Drøbal, Norway; 1949-50 Sèvres, Paris; 1949-57 Bing & Grøndahl; 1956 study trip to England, meeting Bernard Leach, Lucie Rie, Hans Coper; 1957- own studio, Regstrup; 1961-74 Teacher training college, Holbaek, teacher; 1977- Royal Copenhagen	
RICHTER, REINHART (Germany)	Finland		ceramics	c.1930-c.1940 Arabia, modelmaker	
RODE, GOTTRED ANDREW ANDERSEN 1862-1937	Denmark	Pharmaceutical chemistry; 1889-92, 1895 RDA, Copenhagen	ceramics, painting	1896-1933 Royal Copenhagen underglaze painter; 1902-37 RDA, Copenhagen, teacher	
RÖNNDAHL, PIA 1953-	Sweden	1975-80 Konstindustriskolan, Gothenburg	ceramics	1980- Gustavsberg; c.1980- own studio	
RØNNING, GRETE 1937-	Norway	1954-8 NCAD, Oslo (ceramics); 1958-9 Hans Chr. Wagner workshop, Copenhagen; 1959 NCAD, Oslo (screen printing); 1963 Leksand, Sweden, (colours course)	ceramics, glass, textiles	1959-60 Plus workshops, manager; 1960- Porsgrund; 1961-4 own workshop, textile printing	1965 Faenza, gold medal; 1967,1970 Faenza, diplômes d'honneur

NAME	COUNTRY	TRAINING	MEDIA	CAREER	SELECTED AWARDS/HONOURS
SADOLIN, EBBE 1900-	Denmark	1918-20 RDA, Copenhagen	ceramics	1925-c.1980 Bing & Grøndahl	1925 Paris, grand prix (wall decorations)
SAETRANG, BENTE 1946-	Norway	1966 Oslo University (art history); 1969-73 NCAD, Oslo; 1974 Art Academy, Poznan, Poland	textiles	1974- own studio, Frysja and collaboration with Lisbeth Daehlin; 1975-9 NCAD, Oslo, guest teacher; 1985-8 member of board; 1976-89 executive member, Norwegian Craftspeople Distribution and Information Centre; 1975, 1976 jury Landsforbundet Norske brukskunst; 1979, 1985 jury, NCAD, Oslo; 1985-6 Norwegian Artist Committee and Norwegian Artists Anti-Apartheid Committee; 1987 CAD Bergen, professor and head of textile department	
SALMENHAARA, KYLLIKKI 1915-81	Finland	1943 CSI Helsinki	ceramics, glass	1943-6 Kauklahti glassworks; 1946-7 Sakari Vapaavuori Ceramic Studio, Helsinki; 1946-7 Saxbo, Denmark; 1947-63 Arabia; 1961-3 Taiwan, teaching; 1963-73 CSI, Helsinki, department of ceramics, teacher; later head of department; 1973-81 HUT, Helsinki, chief instructor of ceramics	1951 Milan Triennale, silver medal; 1954 Milan Triennale, diplôme d'honneur; 1957 Milan Triennale, grand prix; 1960 Milan Triennale, gold medal; 1960 Pro Finlandia
SALO, MARKKU 1954-	Finland	1967 Kankaanpää school of art; 1979 HUT, Helsinki (industrial design)	glass, graphics, product design	1979 Salora design office; 1983- Nuutajärvi	
SALTO, AXEL 1889-1961	Denmark	RDA, Copenhagen (painting)	ceramics, graphics, painting, textiles	1917- co-founder of periodical Klingen; 1923-5 Bing & Grøndahl; c.1925-c.33 working with Nathalie Krebs, Saxbo; 1933- Royal Copenhagen	1925, 1937 Paris, grand prix; 1951 Milan Triennale, grand prix
SANDNES, EYSTEIN 1924-	Norway	1945-9 NCAD, Oslo	ceramics, cutlery, glass	1951-5 Magnor Glassworks, art director; 1955 occasional freelance designs for tableware and art glass; c.1951 S&S Helle, freelance designs, cutlery; 1955-7 Stavangerflint; 1957 Porsgrund, art director	1960 Milan Triennale, silver medal; 1965, 1970 Norsk Designcentrum, prizes

SARPANEVA, TIMO 1926-
Finland
1948 CSI, Helsinki (graphic design)

ceramics
cutlery
exhibition design
glass
graphics
lighting
metals
plastics
textiles
wax
wood

1950- Iittala
1953-7 CSI, Helsinki, teacher in textile printing and design
1955-6 Porin Puuvilla cotton mill, art director
1959-63 W. Rosenlew & Co, cast iron cookware and wrapping papers
1960-2 Villayhtymä Oy, ryijy rugs
1963 Juhava Oy, candles
1964 Primo Oy, metals
1964-72 Ab Kinnasand textile mill, Sweden
1966 Finlayson Forssa, textiles
1970 Tampella Oy, textiles
1970 Opa Oy, metals
1970- Rosenthal AG, W. Germany, freelance
1988 Ensto Oy, plastics; Corning, USA, glass; Venini, Italy, glass

1949 Riihimäki glass competition, second prize
1951 Milan Triennale, silver medal (textiles)
1954 Milan Triennale, grand prix (art glass)
1956 Lunning Prize
1957 Milan Triennale, grand prix (art and household glass)
1958 Pro Finlandia
1960 Milan Triennale, silver medal (cast iron)
1963 Royal Society of Arts, London, Honorary Royal Designer for industry
1967 RCA, London, honorary doctorate
1985 State Award for Industrial Arts

SIESBYE, ALEV (Turkey) 1938-
Denmark
1956-8 Academy of Fine Arts, Istanbul (sculpture)
1956-8 Füreya's Ceramic Workshop, Istanbul

ceramics
glass
metals

1958-60 Dümler & Breiden, Höhr-Grenzhausen, W. Germany, production worker
1960-2 Eczacibasi Ceramic Factories, Art Workshop, Istanbul
1963-8 Royal Copenhagen
1969- own workshop, Copenhagen
1975- Rosenthal, W. Germany, freelance

SIIMES AUNE LINNEA 1909-64
Finland
1932 CSI, Helsinki (ceramics)

ceramics

1932-64 Arabia

1937 Paris, silver medal
1951,1954 Milan Triennale, gold medal

SIMMULSON, MARI (Estonia) 1911
Sweden
1935 Statliga konsthant-verksskolan, Tallinn, Estonia, (State Art School of Tallin)
1938-9 Kunstakademie, Munich

ceramics

1945-9 Gustavsberg
1949-72 Upsala-Ekeby
c.1955 Sten Hultberg Textiltryckeri, Dala-Floda, textiles

SINNEMARK, ROLF 1941-
Sweden
1956-63 NCACD, Stockholm (silver department 1956-9)
c.1963- studies in USA, Mexico and Europe

ceramics
glass
metals
plastics

1967-86 Kosta Boda
1967- GAB Gense AB, Rörstrand

SKAWONIUS, SVEN ERIK 1908-81
Sweden
1927 NCACD, Stockholm
1927-30 RAAS, Stockholm

ceramics
glass
painting
stage design

1933-5 Kosta
1933-9 Karlskrona
1935-9 Upsala-Ekeby
1937-44 Royal Dramatic Theatre and Opera House, Stockholm, set and costume designer
1944-50 Kosta, intermittently
1946-9 Svenska Slöjdföreningen, managing director
1946-9 NCACD, Stockholm, teacher
1953-7 Upsala-Ekeby, art director
1960-68 Karlskrona

1954 Milan Triennale, gold medal

SLANG, GERD 1925-
Norway
NCAD, Oslo

glass

1948-52, and 1963-72 freelance
1952-63 Hadeland

169

NAME	COUNTRY	TRAINING	MEDIA	CAREER	SELECTED AWARDS/HONOURS
SONNE BRUUN, EDITH 1910-	Denmark	1930-1 Emil Rannows Maler-skole; 1931-4 SAC, Copenhagen	ceramics	1934-7 own workshop in Hjortespring; 1938-9 Saxbo and 1946-61 and working with Nathalie Krebs and Eva Staehr-Nielsen; 1951- Saxbo, signing own work; 1962- Bing & Grøndahl, artist-in-residence	1937 Paris, gold medal; 1954, 1957 Milan Triennale, gold medals
STAEHR-NIELSEN, EVA (Wilhelm) 1911-76	Denmark	1930-3 SAC, Copenhagen	ceramics	1932-68 Saxbo, collaborating with Nathalie Krebs; 1968-76 Royal Copenhagen	
STÅLHANE, CARL-HARRY 1920-	Sweden	Painting with Isaac Grünewald, Stockholm; Academie Colarossi, Paris, with Ossip Zadkine (sculpture); Studies in France, Spain, Greece, Turkey, USA, Egypt, Mexico	ceramics	1939-73 Rörstrand; 1963-71 SAC, Gothenburg, senior ceramics tutor; 1973- own workshop 'Designhuset', Lidköping	1951 Milan Triennale, gold medal; 1954 Milan Triennale, diplôme d'honneur
STILL, NANNY 1926-	Finland	1949 CSI, Helsinki	ceramics, cutlery, enamels, glass, graphics, jewellery, lighting, metals, plastics, wood	1949-76 Riihimäki; 1959 moved to Belgium; 1962 Cerabel-Porcelain, Baudour, ceramics; 1965-76 Heinrich Porzellan, W. Germany, ceramics; 1966, 1968 Val Saint-Lambert, Belgium, glass; Rosenthal AG, W. Germany, ceramics and glass; 1977- Sarvis Oy, plastics; 1986- Hackman Oy, cookware; 1987	1954 Milan Triennale, diplôme d'honneur; 1972 Pro Finlandia
STRÖMBERG, GERDA 1879-1960	Sweden	Self taught	glass	1927-33 Eda; 1933-55 Strömbergshyttan	
SVANLAND, KYLLE (ELISABETH) 1921-	Denmark	1940s SAC, Copenhagen; Textile printing, Marie Gudme-Leth Studio, Copenhagen; 1949-54 Paris	glass, jewellery, textiles, wallpaper	c.1955 own studio, Copenhagen; 1961-70 Holmegaard, freelance, engravings and decoration; 1970-7 Holmegaard, glass	
THIRSLUND, JENS 1897-1942	Denmark	Apprenticeshp as a house painter; Technical High School; Studying Persian ceramics, Berlin and Delft, Holland	ceramics, painting	1913 Kaehler Keramik, and 1917-41; 1914 married Stella Kaehler (1886-1948); 1919 introduced and subsequently specialised in lustre painting	1925 Paris, diplôme d'honneur; 1929 Barcelona, grand prix
THORSSON, NILS 1898-1975	Denmark	c.1916 Technical High School, Copenhagen; 1912- Apprentice, Royal Copenhagen; 1917 RDA, Copenhagen	ceramics, painting, silver	1912-75 Royal Copenhagen	1925 Paris, gold medal; Faenza, gold medal
THYLSTRUP, GEORG 1884-1930	Denmark	Apprentice goldsmith, Roskilde	ceramics (stoneware figures), metals	c.1900 Mogs Balin and Georg Jensen A/S, silver; 1911-27 Royal Copenhagen; 1927- P Ipsen s. Enke, Copenhagen, terracottas	1925 Paris, diplôme d'honneur (ceramics), silver
TIDEMAND, NICOLAI (Norway) 1888-1975	Denmark	Apprentice house painter; 1910-14 RDA, Copenhagen (painting); 1920-5 travel in Europe and Paris	ceramics, painting	1918-43 Royal Copenhagen	1925 Paris, silver medal; 1935 Brussels, gold medal; 1937 Paris, gold medal; 1939 New York, medal

Name	Country	Education	Field	Career	Awards
TINGLEFF, MARIT 1954-	Norway	c.1974 CAD, Bergen	ceramics	c.1979 own workshop, Honefoss	
TOIKKA, INKERI 1931-	Finland	Turku Arts Association, Drawing School; 1950-2 Kupittaan Savi; 1952-5 CSI, Helsinki (ceramics)	ceramics, glass	1955-8 Arabia, art department; 1966-9 Urjala Secondary School, teacher; 1970- Nuutajärvi	
TOIKKA, OIVA 1931-	Finland	1953-60 CSI, Helsinki (art, ceramics)	ceramics, glass, stage design, textiles	1956-9 Arabia; 1959 Marimekko, textiles; 1960-3 CSI, Helsinki, teacher; 1959-63 Sodankylä Secondary High School, teacher; 1963- Nuutajärvi, art director; 1985- Rörstrand, Sweden, visiting designer	1970 Lunning Prize; 1975 State Award for Industrial Arts; 1980 Pro Finlandia
TRILLER, ERICH (Germany) 1898-1972	Sweden	Music school; 1929-32 Staatliche Keramische Fachschule, Bunzlau, Germany; 1932-4 Student of the Bauhaus-teacher Otto Lindig, Dornburg an der Saale, Germany	ceramics	1935-72 own workshop with wife Ingrid Triller, 'Tobo Stengodsverkstad', Tegelsmora, Uppland, Sweden; 1936 Nordiska Kompaniet, Stockholm, first exhibition of Trillers joint work; 1937 Paris, exhibited; 1939 New York, exhibited; 1960 Milan Triennale, exhibited	
TRILLER, INGRID 1905-82	Sweden	1929-32 Staatliche Keramische Fachschule, Bunzlau, Germany; 1932-4 Student of the Bauhaus teacher Otto Lindig, Dornburg an der Saale, Germany	ceramics	1935-72 own workshop, with husband Erich Triller, 'Tobo Stengodsverkstad', Tegelsmora, Uppland, Sweden; 1936 Nordiska Kompaniet, Stockholm, first exhibition of Trillers joint work; 1937 Paris, exhibited; 1939 New York, exhibited; 1960 Milan Triennale, exhibited	
TROLLE, ANNE MARIE 1944-	Denmark	1961-5 SAC, Copenhagen	ceramics	1966-72 Royal Copenhagen; freelance from 1972	1971 Faenza, gold medal; 1973 Jablonic, Czechoslovakia, medal
TUOMINEN, KATI 1947-	Finland	1972-6 CSI, Helsinki	ceramics	1977-80 own workshop, Helsinki; 1980- Arabia, art department; 1987- art and design departments	
UOSIKKINEN, RAIJA 1923-	Finland	1944-7 CSI, Helsinki	ceramics (pattern design)	1947-88 Arabia, design department; CSI, Helsinki, teacher	
VALLIEN, BERTIL 1938-	Sweden	1956-61 NCACD, Stockholm; 1961-3 Royal Scholarship; studied and worked in the USA and Mexico	glass, metals	1963- Kosta Boda, Åfors factory; 1963- own workshop, Åfors; 1967-84 NCACD, Stockholm, head of glass department; 1974- lecturer and teacher at art conferences and art schools internationally; Rhode Island School of Design, USA, artist-in-residence; 1980- Pilchuck Glass Centre, Washington state, USA, visiting professor	Svensk Form, first prize

NAME	COUNTRY	TRAINING	MEDIA	CAREER	SELECTED AWARDS/HONOURS
VASEGAARD, GERTRUD 1913-	Denmark	1930-2 SAC, Copenhagen 1932-3 Axel Salto and Bode Willumsen Studio, Saxbo	ceramics	1933-5 own studio with sister *Lisbeth Munch-Petersen*, Gudhjem, Bornholm 1935-48 own studio, Holkadalen, Bornholm 1949-59 Bing & Grøndahl, freelance and full-time 1959-75 Royal Copenhagen, freelance 1959- own studio with daughter *Myre Vasegaard* (and Aksel Rode until 1969), Frederiksberg	1957 Milan Triennale, gold medal
VASEGAARD, MYRE 1936-	Denmark	c.1955 SAC Copenhagen c.1955 Kael'ler Keramik, Naestved c.1955 Inger & Clement Workshop	ceramics	1955-9 Bing & Grøndahl, artist-in-residence 1959- own studio with mother *Gertrud Vasegaard*, Frederiksberg	
VENNOLA, JORMA 1943-	Finland	1970 HUT, Helsinki (industrial design)	glass product design toys	Apprenticeships at Wärtsilä Oy, Riihimäki, Arabia, Upo Oy and Oras Oy. 1973-5 Creative Playthings, USA toys 1973-5 Corning Glassworks, USA, ovenproof products 1975- Iittala, freelance 1986- Erconomia Design	1979 State Award for Industrial Arts
WALLANDER, ALF 1862-1914	Sweden	1879-85 NCACD, Stockholm 1885-9 Academie Morot and Constant, Paris	ceramics furniture glass metals painting textiles	1895-1910 Rörstrand, Lidköping, art director from 1900 1899- Svensk Konstslöjdutställning, Selma Giöbel (interior design), director 1908-9 Kosta 1908-14 Reijmyre 1908- NCACD, Stockholm, senior tutor	1900 Paris, grand prix
WÄRFF (WOLFF), ANN 1937-	Germany	Studied architecture and industrial design in Brunswick and Ulm, W. Germany, and in Stockholm	ceramics glass	1959-64 Pukeberg 1964-74 Kosta Boda; 1974- freelance 1977 New South Wales University, Australia, visiting lecturer 1978 Founded Stenhytta, Transjö 1981-5 Sunderland Polytechnic, England, lecturer in glass and ceramics 1986 changed name to Wolff	1968 Lunning Prize
WÄRFF, GÖRAN 1933-	Sweden	1956-9 studied architecture and industrial design in Brunswick and Ulm, W. Germany, and in Stockholm	glass	1959-64 Pukeberg glassworks 1964- Kosta Boda 1974-8 emigrated to Australia 1978-82 Kosta Boda 1982-5 Sunderland Polytechnic, England, course leader and own workshop 1986 Kosta Boda	1968 Lunning Prize

Name	Country	Education	Career	Media	Awards
WENNERBERG, GUNNAR GUNNARSSON 1863-1914	Sweden	1898-1902 Paris, art school and at the National Porcelain Factory Sèvres	1895-1908 Gustavsberg AG, art director 1898-1909 Kosta 1902-8 NCACD, Stockholm, teacher of painting 1908- Sèvres; Handarbetets Vänner, designs for woven textiles	ceramics glass textiles painting	
WESTMAN, MARIANNE 1925-	Sweden	1946-50 NCACD, Stockholm (student of *Edgar Böckman*) Extensive study trips in USA, Guatemala, Mexico and Europe	1950-71 Rörstrand, Lidköping 1972- Porzellanfabrik Hutschenreuter AG, W. Germany 1972- Skruf	ceramics glass	1954, 1957, 1960 Milan Triennale, awards
WIINBLAD, BJØRN 1918-	Denmark	1936-9 Technical High School, Copenhagen 1940-3 RDA, Copenhagen (illustration) 1943-6 Lars Syberg Studio, Taastrup	1946-56 Nymølle Faience, Fuurstrøm own studio, Kongens Lyngby 1952- Own studio for one year with Gutte Eriksen under *Jacob Bang* 1957- Rosenthal, W. Germany; Numerous commissions for decorations and design throughout USA, Japan and Europe	ceramics furniture glass graphics illustration metals stage design textiles	
WINQUIST, PETER 1941-	Finland	1963-7 Konstindustriskolan, Gothenburg, Sweden	1967-9 Arabia, applied art department; 1969-74 design department 1974 Pentik, Lapland, designer and art director 1984- own workshop, Åland, Eckerö	ceramics product design	1971 Faenza, gold medal (industrial design)
WIRKKALA, TAPIO 1915-85	Finland	1933-6 CSI, Helsinki (sculpture)	1946-85 Iittala 1951-4 CSI, Helsinki, art director 1951-71 design of various international exhibitions 1955-6 working with Raymond Loewy, USA 1955-81 Westerback 1956-85 Rosenthal AG, W. Germany, ceramics and glass 1957-65 A. Ahlström Oy 1959-85 Venini, Italy, glass	ceramics cutlery exhibition design glass graphics lighting sculpture wood	1946 Iittala glass competition, first prize 1951 Lunning Prize 1951 Milan Triennale, three grands prix (exhibition design, glass, wood carving) 1954 Milan Triennale, three grands prix (exhibition design, glass, wood sculpture) 1958 Society of Industrial Arts, London, Medal of the Year 1960 Milan Triennale, grand prix and gold medal 1963 Milan Triennale, silver medal 1963, 1966, 1967, 1969, 1973 Faenza, gold medals 1964 Royal Society of Arts, London, Honorary Royal Design for Industry 1971 RCA, London, Doctor Honoris Causa 1971 Worshipful Company of Goldsmiths, London, honorary member 1980 Prins Eugen Medal

NAME	COUNTRY	MATERIALS	HISTORY
ÅFORS see KOSTA BODA			
ARABIA AB	Finland	Ceramics: sanitary ware, tiles, utilitarian wares	Arabia was founded in 1873 on the outskirts of Helsinki by the Swedish factory RÖRSTRAND, to take advantage of the Russian market. Ceramic production in Finland was in its infancy but increased consumer demand stimulated Arabia's growth and within a few years the output of the factory accounted for half the total production of ceramics in Finland. The process of continuing expansion was directed by Gustav Herlitz, who had joined the factory from Rörstrand in 1881, becoming managing director in 1893. *Thure Öberg*, also from Sweden, and Jac Ahrenberg were employed to improve the range of wares. By 1916 Arabia had passed into Finnish ownership and was largely supplying a home market. The factory was completely modernised and enlarged under the directorship of Carl Gustaf Herlitz. *Kurt Ekholm*, appointed art director in 1932, was responsible for improvements in the standard of utilitarian ware design and for the establishment of the art studio and the factory museum. Increases in production led to further expansion in the late 1930s and by 1939 Arabia, with over 1,000 employees, had a larger production output than any porcelain firm in Europe. It continued to grow throughout the war years, and a post-war initiative was the development of a Product Design Deparment under the guidance of *Kaj Franck*. It also continued with art studio wares by *Kyllikki Salmenhaara, Birger Kaipiainen* and *Rut Bryk*. Production was rationalised and the sanitary ware operation was transferred to a new factory. Brickmaking was discontinued after 1976. Part of Oy Wärtsilä AB from 1940, Arabia established close links with other affiliated companies, including NUUTAJÄRVI and Järvenpää Enamel. Developing uniform utility ranges in different materials became the policy of these firms in the 1970s and 1980s. Järvenpää was sold in 1984 and 70 per cent of Nuutajärvi was sold to Ahlström Oy in 1989; RÖRSTRAND, GUSTAVSBERG and Hackefors Porcelain Factory have joined the group; the individuality of each firm's products has been retained although joint marketing has become an important feature of the group's operation.
BING & GRØNDAHL PORCELAENSFABRIK (Bing & Grøndahl)	Denmark	Ceramics: decorative and art wares, tablewares	Frederik Vilhelm Grøndahl started his career as an apprentice at ROYAL COPENHAGEN in 1833 and in 1839 he became a designer-sculptor. In 1852 he approached Jacob Herman and Meyer Herman Bing, paper and art dealers, and proposed the foundation of a porcelain factory. This was founded in Copenhagen in 1853. Initial production consisted largely of biscuit figures and reliefs based on Bertel Thorvaldsen's sculpture, and these were mainly marketed through Bing's retail outlets. By 1880 J.H. Bing's two sons Ludvig and Harald had joined the company, Ludvig as business manager, Harald responsible for technical developments. In 1885 Harald appointed Pietro Krohn as art director. While many artistically distinctive and technically superb works were produced under Krohn and later J. F. Willumsen, the production of utilitarian tablewares was also established. During the 1920s and 1930s Bing & Grøndahl continued production of sculptural and decorative forms in porcelain and stoneware by, among others, *Knud Kyhn, Axel Salto* and *Kai Nielsen* and also of classically elegant tablewares designed by *Ebbe Sadolin, Hans Tegner* and *Kay Bojesen*. After the Second World War a new factory for dinner ware was built in Vatby, and the original, extended plant became devoted to the production of art wares. One of the two major manufacturers in Denmark, it contributed to all the major international 20th century exhibitions, frequently winning awards. It has maintained a distinguished production of sculptural figures and of well-designed tablewares. It also has a long-established studio where artists are employed full-time and on a visiting or artist-in-residence basis. In 1987 the company merged with Royal Copenhagen and the original factory premises in Vestergade were closed down.
BOBERGS FAJANSFABRIK AB (BO FAJANS)	Sweden	Ceramics: decorative and art wares, tablewares, utilitarian wares	Founded by Erik Boberg in 1874 at Gavel (formerly Gefle) to make utilitarian goods, the factory widened its scope in 1910 when art and decorative wares were introduced. By 1930 production included some distinctive ranges including those by *Ewald Dahlskog*. By the 1940s and 1950s production had dwindled and in 1967 it was bought by Steninge Keramik. It was closed down c. 1978-80.
BODA see KOSTA BODA			
BODA-NOVA see KOSTA BODA			
BORNHOLM GLASS WORKSHOP (BORNHOLM)	Denmark	Glass: decorative and art wares	The Bornholm glass workshop was founded in 1978 in an abandoned herring smoke-house at Snogebaek, by the Americans *Darryle Hinz* and *Charlie Meaker*. It is the most important of a group of four such workshops set up on the island of Bornholm over a period of five years, when the Danish studio glass movement was established under the influence of Finn Lyngaard. Hinz has since moved to his own workshop in Copenhagen. Meaker works in England.
EDA GLASBRUK (EDA)	Sweden	Glass: bottles, decorative and art wares, tablewares	The glassworks was founded in 1835 at Eda by two Norwegians as a window glass factory, but this enterprise had failed by 1838. In 1842 the works were taken over and re-opened by Eda Bruksbolag, under the management of Gustaf S. Santesson. The Santesson family and the master glass-blowers gradually increased their control of the works and began to produce bottles and tableware. Eda was one of the first Swedish firms to produce moulded glass, initially importing moulds from Germany. By about 1900 the firm was employing glass cutters and producing decorative wares. The firm, in conjunction with other leading companies, formed A. B. De Svenska Kristallglasbruken (founded 1903) to encourage good design. Under the management of Edward Strömberg, 1927-33, and with designs by *Gerda Strömberg*, Eda exhibited in 'Stockholmsutställningen', the major exhibition of art and industry, Stockholm, 1930. Eda shut down in 1953.

Factory	Country	Products	History
FRYSJA WORKSHOPS (FRYSJA)	Norway	Ceramics Glass Textiles Various	The Frysja complex of workshops and studios was established in c.1970 in a former industrial area near Oslo owned by the local authorities. The buildings are now rented out as individual workshops and studios to artists and craftspeople working in a variety of materials. Among these are *Lisbeth Daehlin, Ulla-Mari Brantenberg, Karen Klim* and *Bente Saetrang.*
GEFLE PORSLINSFABRIK AB (GEFLE)	Sweden	Ceramics: decorative and art wares tablewares utilitarian wares	In 1910 Gefle Porslinsfabrik AB was established at Gävle on the same site as the earlier tileworks O Forsell Kakel-och Fajansfabrik. In 1913 the factory was reorganised and with designers such as *Arthur Percy* it began to establish a reputation for well-designed and stylish table and decorative wares. In 1936 it was bought by the UPSALA-EKEBY group and during the 1950s continued to build on its established reputation. It was closed down in 1979.
GULLASKRUF GLASBRUK (GULLASKRUF)	Sweden	Glass: decorative and art wares tablewares utilitarian wares	The factory was founded in 1895 at Gullaskruf for the production of window glass. It closed in 1920 but in 1926 it was re-established by the engineer William Stenberg and his daughter. He designed moulds for the range of everyday glassware in which Gullaskruf specialised. This specialisation was later extended to the production of decorative glass with the work of *Hugo Gehlin* and *Arthur Percy.* More recently designers with the firm have favoured coloured glass and experimented with different techniques, often using semi-opaque glass. In 1975 Gullaskruf joined the Royal Krona Group, and from 1977 to 1983, the ORREFORS group.
AB GUSTAVSBERG	Sweden	Ceramics: bricks decorative and art wares ovenwares tablewares utilitarian wares	Gustavsberg was founded in 1640 originally as a brickworks at Värmdö, outside Stockholm. In 1825 the ceramics factory was established. By 1839 new English techniques were being introduced, including the production of bone china with imported English china clays. From 1869 to 1937 the factory enjoyed a period of expansion and success with designers Gunnar Wennerberg and August Malmström contributing Swedish designs to the range of imported patterns. In 1917 *Wilhelm Kåge* was appointed as art director and throughout the 1920s and 1930s he lead the Gustavsberg team at international exhibitions. In 1937 Gustavsberg was sold to Kooperativa Förbundet (the Swedish Consumer Co-operative and Wholesale Society). *Stig Lindberg* and then *Karin Björquist* followed Wilhelm Kåge as art directors and the company continued to concentrate on the production of good design at reasonable prices in utilitarian wares with, at the same time, a vigorous art studio. In 1987 Gustavsberg was bought by the Finnish company, ARABIA and in 1988 it was combined with RÖRSTRAND as Rörstrand-Gustavsberg AB.
HADELANDS GLASSVERK (HADELAND)	Norway	Glass: bottles decorative and art wares lighting tablewares window glass	Work began in 1762 on the Jevnaker site, then owned by the Danish-Norwegian State under Christian VI. The ovens were first lit in 1765 and initial production was of colourful glass bottles, pharmaceutical glass and fishing floats. Various social advantages were part of the employees' rights, including schooling for their children. The works was sold in 1824 and from 1841 joined with two other works to form a private factory. The introduction of clear colourless glass in 1852 led to the production of tablewares. In 1898 the factory became a share-holding company, A/S Christiana Glasmagasin, consisting of a shop on the main square in Christiana (Oslo) and three factories – Hadeland, Hövik Verk (lighting) and Drammens Glassverk (window glass). In 1929 *Sverre Petterson* was appointed, the first full-time designer, followed during the 1930s by *Ståle Kyllinstad* and in the 1940s by *Herman Bongard.* In 1933 Hadeland scored successes at the Milan Triennales with the work of *Willy Johansson.* Today his designs and those of *Arne Jon Jutrem* and *Gro Bergslien* are among Hadeland's best-known lines. The company makes 80 per cent of Norway's total glass production.
HÖGANÄS-BILLESHOLMS AB (HÖGANÄS)	Sweden	Ceramics: decorative and art wares tablewares	The pottery was founded at Höganäs in 1797. It made a variety of wares throughout the 19th century. About 1900 it was continuing with table and decorative wares and had taken on a modest Art Nouveau style. In 1903 it changed its name from Höganäs (bolaget) to Höganäs-Billesholms AB. In 1915 *Berndt Friberg* joined as thrower for three years and in 1916 *Edgar Böckman* was appointed artistic director. The company closed in 1926.
HOLMEGAARDS GLASSVAERK (HOLMEGAARD)	Denmark	Ceramics: Glass: bottles decorative and art wares lighting tablewares utilitarian wares	Count C C S Danneskiold-Samsø, owner of the Holmegaard Marsh, South Zealand, had planned a glassworks utilising the peat as fuel and the works was founded there in 1825 by his widow Countess Henriette Danneskiold-Samsø. The first furnace was built by the Norwegian glassmaker from Hadeland, Christian Wendt. Initial production was of dark green bottles, but from 1835, with the help of glassworkers from Bohemia and Germany, domestic ware was produced in traditional European styles. About 1905, 'Margarethe' was the first designed ware, by the ceramist Svend Hammershøi but fully established designers were not employed until 1923. The first permanent staff designer was *Orla Juul Nielsen*, followed in 1925 by the architect *Jacob Bang.* Bang introduced designs 'Primula' and 'Viola' which were international successes and confirmed his major contribution to the company's production at the exhibition 'Ten Years of Danish Art Glassware'. 1937. He was followed in 1941 by *Per Lütken* who has been the chief designer from then until the present and who has been a similarly crucial figure in the factory's history. During the 1930s, under *Arne Bang*, it produced stoneware figures, decorative wares and lighting. In 1936 Holmegaard, still privately owned, became a limited company. In 1965 it merged with the other big Danish glassworks, Kastrup, which was founded as an extension to Holmegaard in 1845 and became independent in 1873. For a while the company was named Kastrup & Holmegaard A/S, thus comprising the whole Danish glass industry with the exception of sheet window glass. In 1975 the company merged with ROYAL, COPENHAGEN.

NAME	COUNTRY	MATERIALS	HISTORY
IITTALAN LASITEHDAS (IITTALA)	Finland	Glass: bottles decorative and art wares tablewares utilitarian wares	Iittala was founded in 1881 by the Swedish master glass-blower Petter Magnus Abrahamsson. The factory was at first staffed by Swedish workers producing high quality ware. In 1917, Iittala was bought by Ahlström Oy, a company that had already acquired the Karhula glassworks (founded 1899) in 1915. As Karhula-Iittala the merged factories held several competitions in the 1930s to promote good design in both art and household glass. Aino Aalto won a second prize in the 1932 competition and Alvar Aalto secured a first prize in 1936. From 1945 Karhula's production was limited to container glass. The position of chief designer at Iittala was taken by Tapio Wirkkala following the competition in 1946 in which he won first prize. Timo Sarpaneva joined in 1950 and throughout the 1950s and 1960s the two designers attracted international recognition. Sarpaneva continues as their senior designer today, with younger designers such as Jorma Vennola. Iittala became Finland's largest utility and art glass manufacturer and in 1987 formed part of a new company in a merger with NUUTAJÄRVI.
IRIS AB (IRIS WORKSHOPS)	Finland	Ceramics: decorative and art wares tablewares Metalwork Furniture Textiles	Founded in 1899 at Porvoo, the Iris workshops were part of the new movement of national awareness, although, paradoxically established by a Swede. Louis Sparre (1863-1964) with the Finnish painter Aksel Gallen-Kallela (1865-1931). The project included textiles, furniture and ceramic production and was intended to improve and foster Finnish design. The ceramics department was directed by A W Finch. Iris achieved notable success at the international exhibition, Paris, 1900, impressive contacts with progressive Paris retailers and some important exports to St Petersburg. Despite these, economic failure forced an early closure in 1902.
JOHANSFORS GLASBRUK (JOHANSFORS)	Sweden	Glass: tablewares utilitarian wares	Founded in 1891 at Broakulla, Småland, until c.1900 the company specialised in painting bought-in glassware. Then kilns were built and glass production was begun, concentrating on tablewares and utilitarian glass. Bengt Orup was appointed designer and then art director from 1951-73. In 1972 Johansfors was bought by KOSTA BODA.
KAEHLER KERAMIK	Denmark	Ceramics: decorative and art wares	Established by Joachim Christian Herman Kaehler in 1839 at Naestved, South Zealand, the pottery concentrated on the production of earthenware stoves until 1888. In 1872 Herman August Kaehler inherited the works from his father. He introduced red lustre glazes with which he had achieved exhibitable success by the late 1880s. At the same time the company made important architectural ceramics including sculpted friezes by K F C Hansen-Reistrup. Herman J. Kaehler with his brother Nils A. Kaehler continued lustrewares into the 1920s, with Jens Thirslund as chief designer. Thirslund introduced painted lustres in 1919.
KARHULA-IITTALA see IITTALA			
AB KARLSKRONA PORSLINSFABRIK (KARLSKRONA)	Sweden	Ceramics: decorative and art wares tablewares	From its establishment in 1918 at Karlskrona production has been of tableware and art wares. Edward Hald was appointed as designer and then art director from 1924-33, followed by Sven-Erik Skawonius until 1939. The company joined UPSALA-EKEBY AB in 1942. It closed in 1968.
KØBENHAVNS LERVAREFABRIK	Denmark	Ceramics: tablewares utilitarian wares	Københavns Lervarefabrik, established at Valby, was managed by G. Eifrig, former 'head potter', J. Walmann's pottery manufactory at Utterslev Mark, on the outskirts of Copenhagen. Both workshops produced ordinary household wares but for a short period were adopted by a group of painters who were experimenting with ceramics as part of the Danish Skønvirke movement in the arts. The best known of these was Thorvald Bindesbøll who worked at J. Walmann's pottery 1883-90 and at Københavns Lervarefabrik 1891-1901.
KONGSBERG	Norway	Ceramics: decorative and art wares	The Kongsberg workshop was founded by the potter Rolf Hansen in 1947. He was influential in the early years of the Norwegian studio pottery movement and a number of students and potters worked with him. He now works there independently.
KOSTA BODA AB (KOSTA, KOSTA BODA)	Sweden	Glass: decorative and art wares tablewares Forged iron	The earliest Scandinavian glass factory still working was founded in 1742 and named after two county governers: A. Koskull and Bogislaus Stäl von Holstein. Skilled glass-blowers were attracted from Germany and it quickly became the leading Scandinavian manufacturer of household articles and purveyor to the wealthy and the royal courts. The company exhibited in all the international 20th century exhibitions from Paris, 1900, onwards, work by artists such as Gunnar Wennerberg, Alf Wallander, Edvin Ollers, Elis Bergh. In 1864 and 1876 respectively, Boda and Åfors were founded, both by glassblowers from Kosta and in 1946 all three factories merged into one company. Vicke Lindstrand joined as art director in 1950, coming from ORREFORS and from 1953 influential art wares were produced by him and by Erik Höglund, Ulrica Hydma-Vallien and Bertil Vallien, Ann and Goran Wärff and Signe Persson-Merlin. In 1970 the design group, Boda Nova, was established to provide an outlet for the Kosta Boda designers who were working within the company with other materials such as stoneware, textiles, cork, fireproof glass, stainless steel. In the same year Kosta Boda AB was renamed Åforsgruppen AB. There followed 10 years of company changes: 1972 JOHANSFORS was acquired; 1975 the group was taken over by UPSALA-EKEBY and re-named Kosta Boda AB again; 1977 SKRUF and Mälerås Glasbruk were purchased in at the bankruptcy of the Royal Krona Group; 1981 Boda Smide, the forging department, was sold; 1982 Boda Nova was sold (now a private company); 1980 Skruf was closed down (re-opened since) and Mälerås was sold off; 1983 the investment group Proventus acquired the Upsala-Ekeby AB, including Kosta Boda AB.

KUPITTAAN SAVI	Finland	Ceramics: bricks, decorative and art wares, drainage and piping, tablewares	Founded in 1712 at Kupittaa as a brickworks, Kupittaan was the earliest pottery to be established in Finland. Production of domestic ceramics was started in 1915, but marketing problems meant that this was diminishing by the 1930s and the works was used largely for research into industrial acid-resistant ceramic bodies and fire-resistant bricks. However, the development of these new materials and the appointment of a domestic ware designer, Kerttu Suvanto-Vaajakallion, gave the table and kitchen ware production a boost. Before the end of the 1930s, the company had established exports to the USA. Post-war the company continued with an interest in well-designed simple tablewares and achieved a silver medal at the Milan Triennale 1954 with the work of Laine Taitto. *Linnea Lehtonen* and *Marjukka Paasivirta*. Exports were made to Europe, especially Germany. The company closed down in 1969.
AB LIDKÖPINGS PORSLINSFABRIK (LIDKÖPING)	Sweden	Ceramics: tablewares	In 1900 Nymans Porslinsmåleri was founded at Lidköping, painting and decorating imported blank ware. In 1911 it was re-named Lidköpings Porslinsfabrik and began its own porcelain production. By about 1920 it had attracted *Einar Forseth* as a freelance designer. It was bought by the Finnish company ARABIA in 1927 and in 1932 was acquired by RÖRSTRAND which moved its production to the Lidköping works. In 1939 the name was absorbed by Rörstrand.
NUUTAJÄRVI LASI (NUUTAJÄRVI)	Finland	Glass: bottles, decorative and art wares, tablewares	Established in 1793 at Nuutajärvi by Swedish owners under the Swedish name Notsjö. Nuutajärvi was mainly manufacturing window and bottle glass with, from 1851, pressed glass. The company was bought in 1853 by Adolf Törngren who aimed to create a modern factory by improving production methods and using more refined raw materials. Ceramics were manufactured briefly between 1861-78. In 1895 Nuutajärvi founded its own glass shop in Helsinki, named after its acountant G F Stockmann. The shop is now Helsinki's largest and best known department store. It was not, however, until after the Second World War that Nuutajärvi made an important contribution to both art and household glass design. *Gunnel Nyman's* brief but productive association with the factory in the late 1940s established working patterns for the close co-operation of designers and glassworks as well as setting high standards in glass design. In 1950 a fire closed the factory for a short period. The site was bought and the works rebuilt by Oy Wärtsilä AB to complement their other factories producing household ware. *Kaj Franck* was appointed as art director in 1950, a post which he held until 1976 as an extension of his responsibilities at ARABIA. In association with *Saara Hopea*, Franck gained an international reputation for Nuutajärvi. Bottle manufacture ceased and household and art glass production was emphasised, particularly in the use of coloured glass. *Oiva Toikka* became art director in 1963, and the present team includes *Kerttu Nurminen*, *Heikki Orvola* and *Markku Salo*. In 1987 the factory was merged with IITTALA to form a new company.
NYMØLLE FAJANSFABRIK (NYMØLLE)	Denmark	Ceramics: decorative and art wares, tablewares	The pottery factory Fuurstrøm was established at Kongens Lyngby, 1936-8, by A/S Schou Ravnholm, a retail company which specialised in inexpensive goods and imported ceramics. When import contacts were severed by the approaching war the Fuurstrøm factory was set up to manufacture similarly inexpensive earthenwares in Denmark. After the war *Jacob Bang* was commissioned to oversee the production of more artistic wares produced under the factory name 'Nymølle'. Bang invited *Bjørn Wiinblad* to join the company in 1946. Almost Nymølle's entire production was of designs for copper plate engraved transfer prints produced by Wiinblad between 1946 and 1956. In December 1974 the firm of Schou went bankrupt and its group of factories was sold with the exception of Nymølle. In July 1976, faced with the closure of Nymølle, Wiinblad purchased the factory himself.
ORREFORS GLASBRUK AB (ORREFORS)	Sweden	Glass: bottles, decorative and art wares, tablewares, utilitarian wares	In 1726 an ironworks was founded on the Orrefors estate, Halleberg Socken, Småland. In 1898 bottle glass production was started. In 1913 the estate was bought by Johan Ekman who put a forester, Albert Ahlin in control. From 1916 *Simon Gate* and *Edward Hald* were employed as designers, working in collaboration with glass-blowers and Gustav Abels, a former cutter, to revive engraved glass. At the same time, with master glass-blower Knut Bergqvist, the celebrated 'Graal' technique was developed and then launched in 1916. The company exhibited with great success in Paris, 1925, where they were awarded three grand prix and three gold medals. In 1936 *Edvin Öhrström* was brought in to introduce new designs for Paris, 1937. With *Vicke Lindstrand* and master glass-blower Gustav Bergqvist he developed the 'Ariel' technique. In 1889 Sandvik glassworks was leased and then in 1918 bought by Orrefors. The Sandvik works concentrated on production of plain inexpensive table and household ware in soda glass. Between the two factories, Orrefors' output expanded and throughout the 1930s and post-war it has continued with a wide range of high quality table and decorative wares. The factory maintains a glass school for the training of glass-blowers and engravers and has been able to draw on this for its skilled workforce. Its designers, including Nils Landberg and more recently *Gunnar Cyrén*, *Eva Englund*, *Lars Hellsten* and others, contribute both to serial production and to unique works produced as part of the Orrefors Studio range. In 1975 STRÖMBERGSHYTTAN was bought and closed down four years later. In 1984 S E A glassworks and Aighult glassworks joined the company.
PLUS GLASSHYTTE	Norway	Ceramics, Glass: decorative and art wares, Various	The Plus complex was started in Fredrikstad in 1958 by Per Tannum, a Norwegian business executive, as a workshop co-operative. It was originally intended to supply industry with models and designers. Gradually it became the more usual arrangement of adjacent workshops for individual craftspeople. Plus Glasshytte is the glass workshop, managed by Benny Motzfeldt since 1970. There are a minimum of three glass-blowers permanently engaged.

NAME	COUNTRY	MATERIALS	HISTORY
PORSGRUNDS PORSELAENSFABRIK (PORSGRUND)	Norway	Ceramics: decorative and art wares tablewares utilitarian wares	The Porsgrund factory was founded in 1886 at Porsgrunn by Johan Jeremiaessen with the backing of his wife's family, the Knudsens. The German ceramicist Carl Maria Bauer was appointed as technical manager. The first firing took place on 10 February 1887 and after 15 years the factory was fully established and making a profit. Early production was of traditional underglaze painted and transfer-printed patterns including those of ROYAL COPENHAGEN and Meissen. About 1900 Gerhard Munthe, Henrik Bull, Thorolf Holmboe and others produced some patterns in the 'Nordic' style. Jeremiassen died in 1889 and the company's progress, including social benefits for the workers, was due to his brother-in-law Gunnar Knudsen (Liberal Member of Norway's National Assembly and later Liberal Prime Minister). Bauer left in 1890 to join Rosenthal in Germany. Little further progress was made in artistic terms until 1920 with the appointments of Hans Flygenring and, in 1927, of Nora Gulbrandsen, who provided the factory with a continuous run of successful modern designs. Tias Eckhoff was appointed as art director in 1952 and with Anne Marie Ødegaard, Konrad Galaaen and later, Eystein Sandnes, they scored a number of successes at the Milan Triennales. The current team is headed by Poul Jensen and includes Eystein Sandnes, Grete Rønning and Leif Helge Enger. Under its current managing director, Stein Devik, the factory is today extending both factory buildings and technical equipment. It has also recently been experimenting with new uses for porcelain, such as artificial ski-slope surfaces.
PUKEBERGS GLASBRUK (PUKEBERG)	Sweden	Glass: decorative and art wares lighting tablewares	Founded in 1871 at Pukeberg, Småland, in 1894 the works was bought by the lamp manufacturer Arvid Böhlmark and from that date production was put over mainly to lamp manufacture. Under the works manager, Baron CARL HERMELIN, decorative wares were made during the 1930s but not until about 1959 was production of household and decorative glass intensified with designers such as Ann and Göran Wärff. The company was bought by Gashbron AB in 1984.
REIJMYRE GLASBRUK A B (REIJMYRE)	Sweden	Glass: decorative and art wares tablewares	Founded in 1810 at Reijmyra, Östergötland. It became one of the leading Swedish glass manufacturers by 1900, specializing in pressed and engraved decorative and table wares. From 1900 production techniques and design was widened to include Art Nouveau styles by A E Boman and Alf Wallander who both joined in 1908. New machinery for the pressed glass production was installed in 1930 and the company continued to concentrate on table and utility glass. From 1937 Monica Bratt was art director and under her the use of coloured glass was explored. Post-war designers have included Tom Möller. In 1977 the company was acquired by UPSALA-EKEBY.
RIIHIMÄEN LASI OY (RIIHIMÄKI)	Finland	Glass: bottles decorative and art wares glass wool medical wares tablewares window glass Plastics	Founded in 1910, first production was of domestic glassware and a second glassworks producing bottles and jars was in operation the following year. The manufacture of blown window glass began in 1919, ceased in 1924 and was restarted in 1939. Riihimäki purchased various smaller factories to increase and diversify production, including the Kauklahti glassworks and the 'lower works' in which the Finnish glass museum is now housed. In 1928 the factory organised a design competition for glassware won by Henry Ericsson. The factory was modernised in the mid-1930s and further competitions were arranged in 1933 and 1936 to stimulate design. Alvar Aalto, Gunnel Nyman and Arttu Brummer submitted designs, amongst others. By the late 1930s Riihimäki had expanded into medical and technical glass. In 1941 the Kauklahti and Ryttylä glassworks merged with Riihimäki. Modernisation of production methods, technical innovation and the introduction of new ranges of ware by young designers such as Helena Tynell and Nanny Still ensured the international reputation of the company in the post-war period. In 1976 the factory went fully automatic and the production of blown glass was discontinued. Riihimäki now supplies almost half the bottles and jars used for Finnish-made foodstuffs, drinks and technochemical products. The firm was taken over by Ahlström Oy in 1985, with whom Riihimäki had an agreement since 1961.
RÖRSTRAND PORSLINSFABRIK AB (RÖRSTRAND)	Sweden	Ceramics: decorative and art wares ovenwares tablewares	Founded in 1726 at Rörstrand, Stockholm, earliest production was under government supported management and with imported craftsmen, and was of faience ware, initially in cobalt blue only. From 1758 enamel painting and gilding were introduced. In 1783 the rival Marieberg factory was bought, and both factories produced cream coloured earthenware in response to English competition. In 1895 Alf Wallander was appointed as art director and produced his first designs in Art Nouveau style. Edward Hald joined in 1917 and until 1929 produced freelance designs for the earthenware production, which were well received by the critics. In 1926 the company moved to Gothenberg and in 1931 Gunnar Nylund was appointed art director. The company expanded to LIDKÖPING in 1932 moving there fully in 1939. A tradition was established of employing innovative artists producing both porcelain and stoneware, one which is continued today with designers such as Signe Persson-Melin and Rolf Sinnemark and, from Finland, Olva Toikka and Heikki Orvola. In 1983 Rörstrand was bought by ARABIA (Wärtsilä) and in 1988 it became Rörstrand-Gustavsberg AB Rörstrand.
ROYAL COPENHAGEN, DEN KONGELIGE PORCELAINSFABRIK (ROYAL COPENHAGEN)	Denmark	Ceramics: decorative and art wares tablewares	The first Copenhagen pottery with Royal support was established under the patronage of Frederick V in 1755. Its early wares were made in a soft paste porcelain and in Sèvres style under its French manager, Louis Fournier. After Frederick V's death in 1766 and Fournier's return to France, the factory closed. The enterprise was re-started at the behest of Queen Juliane Marie in 1775 and it was this new pottery on a new site in Copenhagen that became, under Frantz Henrich Mueller, the forerunner of the present Royal Copenhagen. Destroyed in 1807 during the bombardment of Copenhagen, by Nelson's ships, it was rebuilt but was in artistic decline until taken over by Philip Schou. It moved from Købmagergade to Smallegarde and Arnold Krog was appointed artistic manager. The company also included the earthenware factory Aluminia, and under Krog both this and the porcelain production was revitalised. Important stylistic influences under Krog were French and Japanese and led to significant success at the late 19th century international exhibitions. The renowned underglaze decoration in soft blues, greys and pinks was developed at this time. In the 20th century Royal Copenhagen developed form and pattern design as well as setting up workshops for stonewares and special glazes. From 1920-40 specialities were figure production by sculptors including Jais Nielsen, Arno Malinowski, Gerhard Henning, Christian Thomsen and Knud Kyhn, and decorative wares and tablewares by Axel Salto and Nils Thorsson. Since the war the company has continued with a successful mix of studio art wares, well-designed tablewares and popular figures as well as continuing designs from their historic production, such as the 'Flora Danica service (designed 1790-1802) for Catherine the Great). Collaboration with HOLMEGAARD started in 1923 when the companies shared retail outlets abroad; the two amalgamated in 1975. In 1969 the factory started production of jewellery in collaboration with the firm of A. Michelsen (Jewellers to the Royal Danish Court) and in 1986 Georg Jensen AS, Silversmiths joined the group. In 1987 BING & GRØNDAHL completed it. Today the four companies are headed by Carlsberg Tuborg.

Company	Country	Products	History
SANDVIK see ORREFORS			
SAXBO	Denmark	Ceramics: decorative and art wares	The Saxbo pottery was established in 1930 at Herlev by *Nathalie Krebs*. She named the new pottery 'Saxbo' and developed it, in collaboration with *Eva Staehr-Nielsen* who joined in 1932, into the most important independent small pottery in Denmark. Under Krebs, who developed the glazes, and Staehr-Nielsen, who created the shapes, several generations of Danish potters worked there and helped to establish what has become known as the 'classic Saxbo' style of simple shapes and oriental-style glazes. The pottery closed in 1968.
SKRUFS GLASBRUK (SKRUF)	Sweden	Glass: decorative and art wares tablewares utilitarian wares	Established in 1897 at Skruv, Småland, as a factory community with workers' houses, school, etc., early production was of simple household wares. In 1908 the company went bankrupt due to unsuccessful experimentation with new kiln types. In 1909 a new company was formed, Skrufs Nya Glasbruk, and throughout the 1920s and 1930s it specialised in catering glass for restaurants. In 1946 the factory burnt down. It was rebuilt to produce both soda glass and crystal from two separate kilns. In 1948 it returned to the original name, Skrufs Glasbruk AB. In 1953 *Bengt Edenfalk* was employed as the first full-time staff artist/designer and production was concentrated more on decorative ware. From 1966 *Lars Hellsten* was employed and techniques were expanded to include cast, moulded and spun glass. In 1973 the company collaborated with GULLASKRUF and Björkshult to promote exports to the USA. From about 1974–7 a series of mergers resulted in the formation of Krona-Bruken AB, marketed under the name Royal Krona. Krona-Bruken AB went bankrupt in 1977 and was bought by KOSTA BODA. Skruf was closed down in 1980. It was re-opened in 1981 as a co-operative to produce hand-blown glass with designers *Ingegerd Råman* and *Anette Krahner*.
STAVANGERFLINT A/S	Norway	Ceramics: decorative and art wares tablewares	Established in 1949 at Stavanger, Stavangerflint was soon running a design department to service both several production and decorative wares. *Kari Nyquist* was employed freelance from about 1955. In 1957 *Kaare Fjeldsaa* was appointed chief designer and art director, a post which he continued to hold after the merger with Figgjo Fajanse in 1968 and until the closure of the combined works in 1979.
A/S STELTON	Denmark	Metal Plastics: tablewares	A/S Stelton was founded in 1960 primarily with the purpose of making and selling stainless steel holloware, concentrating on the Danish market. In 1964 the established but small company engaged Arne Jacobsen, the distinguished architect and furniture designer, to develop design and production. In 1967 Stelton and Jacobsen introduced the 'Cylinda-line' stainless steel holloware. Jacobsen died suddenly in 1971, but Stelton were able to issue the 'Multi-Set' range of serving dishes from drawings left by him. These supplemented the highly successful 'Cylinda-Line'. In 1975 the owner and manager, Peter Holmblad, appointed *Erik Magnussen* who has designed for production in both metal and ABS plastic.
STRÖMBERGSHYTTAN	Sweden	Glass: decorative and art wares tablewares	In 1933 Lindfors Glasbruk (founded 1376), Hovmantorp, Småland was leased by Edward Strömberg, the former head of both ORREFORS and EDA. The works were renamed Strömbergshyttan and production was established of decorative wares designed by Gerda Strömberg with the master glassblower from Orrefors, Knut Bergqvist. Edward Strömberg bought the works in about 1943 and sold it to his son, Erik, in 1944. In 1954 *Gunnar Nylund* was appointed as art director. The works were bought by Orrefors in 1975 and closed down in 1979.
TRANSJÖ HYTTA AB (TRANSJÖ)	Sweden	Glass: decorative and art wares	In 1978 at Transjö, near Kosta, Småland, *Ann Wärff* and *Wilke Adolfsson* established an independent studio, 'Scenhytta', as a glassmaking centre for Swedish and international glass artists. Adolfsson was a master-glassblower, formerly at Orrefors. In 1982 Transjö Hytta AB was founded by a group of glassmasters from the KOSTA factory, as a small commercial glass workshop.
UPSALA-EKEBY AB	Sweden	Ceramics Glass: decorative and art wares tablewares utilitarian wares	In 1886 the Ekebybruk ceramics factory was established in Uppsala. After the first 50 years, from 1936, the company expanded rapidly with a series of mergers and takeovers: in 1936 GEFLE was acquired; in 1942 KARLSKRONA was acquired; 1942 *Vicke Lindstrand* was appointed as art director to oversee the variety of works and production; in 1953–7 and 1962–71 *Sven-Erik Skawonius* was art director; in 1964 RÖRSTRAND was acquired; and in 1978 GAB Gense and REIJMYRE were acquired. In 1984 the Upsala-Ekeby concern itself was bought by the Finnish company Oy Wärtsilä AB.

CONCORDANCE

MUSEUM NUMBER	CAT. NUMBER	MUSEUM NUMBER	CAT. NUMBER	MUSEUM NUMBER	CAT. NUMBER	MUSEUM NUMBER	CAT. NUMBER
251-1894	2	Circ.261-1939	57	Circ.129-1954	363	Circ.54-1961	403
252-1894	2	Circ.262-1939	57	Circ.130-1954	386	Circ.55-1961	403
253-1894	2	Circ.263-1939	54	Circ.131-1954	364	Circ.56-1961	403
254-1894	2	Circ.264-1939	54	Circ.132-1954	373	Circ.57-1961	403
1694-1900	326	Circ.265-1939	49	Circ.133-1954	366	Circ.58-1961	365
1695-1900	323	Circ.266-1939	49	Circ.134-1954	382	Circ.59-1961	365
1696-1900	324	Circ.267-1939	58	Circ.135-1954	396	Circ.60-1961	365
1697-1900	325	Circ.270-1939	58	Circ.136-1954	371	Circ.61-1961	365
456-1901	14	Circ.271-1939	59	Circ.137-1954	390	Circ.62-1961	401
457-1901	15	Circ.272-1939	59	Circ.192-1954	378	Circ.63-1961	405
458-1901	8	Circ.273-1939	59	Circ.193-1954	393	Circ.101-1963	165
459-1901	16	Circ.274-1939	33	Circ.194-1954	367	Circ.194-1963	211
460-1901	12	Circ.275-1939	33	Circ.195-1954	387	Circ.195-1963	301
462-1901	9	Circ.276-1939	47	Circ.196-1954	387	Circ.196-1963	212
1327-1904	10	Circ.277-1939	31	Circ.197-1954	388	Circ.197-1963	109
1328-1904	5	Circ.278-1939	56	Circ.198-1954	379	Circ.248-1963	215
1329-1904	7	Circ.279-1939	50	Circ.199-1954	394	Circ.249-1963	215
C.1264-1917	6	Circ.280-1939	51	Circ.200-1954	394	Circ.257-1963	213
C.220-1918	329	Circ.281-1939	50	Circ.457-1954	196	Circ.258-1963	213
C.501-1921	17	Circ.282-1939	60	Circ.458-1954	202	Circ.259-1963	213
C.502-1921	3	Circ.283-1939	61	Circ.459-1954	207	Circ.260-1963	213
C.60-1930	442	Circ.6-1940	193	Circ.518-1954	494	Circ.261-1963	210
C.111-1931	35	Circ.7-1940	133	Circ.2-1955	496	Circ.262-1963	214
C.112-1931	27	Circ.8-1940	194	Circ.3-1955	497	Circ.263-1963	214
C.113-1931	24	Circ.9-1940	194	Circ.4-1955	498	Circ.264-1963	208
C.114-1931	39	Circ.10-1940	194	Circ.323-1955	134	Circ.267-1963	209
C.115-1931	36	Circ.11-1940	194	Circ.324-1955	146	Circ.268-1963	209
C.116-1931	44	Circ.12-1940	194	Circ.325-1955	145	Circ.281-1963	499
C.117-1931	18	Circ.426-1948	472	Circ.326-1955	201	Circ.313-1963	72
C.118-1931	37	Circ.454-1948	485	Circ.48-1957	138	Circ.26-1964	139
Circ.52-1931	443	Circ.501-1948	488	Circ.49-1957	138	Circ.27-1964	139
Circ.53-1931	452	Circ.502-1948	489	Circ.50-1957	138	Circ.28-1964	140
Circ.54-1931	449	Circ.503-1948	486	Circ.51-1957	139	Circ.29-1964	140
Circ.55-1931	450	Circ.504-1948	487	Circ.52-1957	139	Circ.30-1964	139
Circ.56-1931	455	Circ.505-1948	475	Circ.87-1957	298	Circ.31-1964	139
Circ.58-1931	460	Circ.506-1948	476	Circ.265-1959	411	Circ.32-1964	139
Circ.59-1931	446	Circ.507-1948	477	Circ.134-1960	66	Circ.33-1964	139
Circ.142-1931	447	Circ.127-1949	451	Circ.135-1960	66	Circ.34-1964	139
Circ.143-1931	448	Circ.128-1949	469	Circ.136-1960	263	Circ.35-1964	140
Circ.179-1932	40	Circ.129-1949	471	Circ.137-1960	263	Circ.36-1964	139
Circ.180-1932	38	Circ.130-1949	480	Circ.138-1960	271	Circ.37-1964	142
Circ.181-1932	105	Circ.131-1949	481	Circ.139-1960	271	Circ.38-1964	143
Circ.182-1932	104	Circ.132-1949	483	Circ.140-1960	271	Circ.39-1964	153
Circ.120-1934	463	Circ.133-1949	484	Circ.141-1960	264	Circ.40-1964	153
Circ.121-1934	461	Circ.134-1949	482	Circ.142-1960	263	Circ.41-1964	143
Circ.123-1934	466	Circ.135-1949	462	Circ.143-1960	263	Circ.42-1964	144
Misc.2(65)-1934	465	Circ.136-1949	462	Circ.144-1960	271	Circ.43-1964	158
Misc.2(119)-1934	340	Circ.137-1949	444	Circ.145-1960	271	Circ.44-1964	158
Misc.2(121)-1934	340	Circ.138-1949	444	Circ.167-1960	272	Circ.45-1964	147
Misc.2(122)-1934	341	Circ.31-1950	473	Circ.168-1960	272	Circ.46-1964	148
Misc.2(124)-1934	445	Circ.32-1950	474	Circ.478-1960	457	Circ.47-1964	148
Misc.2(125)-1934	465	Circ.43-1952	64	C.29-1961	406	Circ.48-1964	139
Misc.2(126)-1934	465	Circ.44-1952	65	Circ.23-1961	407	Circ.49-1964	139
Misc.2(138)-1934	453	Circ.45-1952	106	Circ.24-1961	407	Circ.50-1964	142
Misc.2(139)-1934	453	Circ.46-1952	265	Circ.25-1961	410	Circ.51-1964	155
Misc.2(140)-1934	343	Circ.47-1952	266	Circ.26-1961	370	Circ.52-1964	137
Misc.2(141)-1934	343	Circ.48-1952	374	Circ.27-1961	368	Circ.53-1964	142
Misc.2(142)-1934	343	Circ.49-1952	374	Circ.28-1961	368	Circ.54-1964	142
Misc.2(143)-1934	343	Circ.50-1952	375	Circ.29-1961	406	Circ.55-1964	151
Misc.2(144)-1934	343	Circ.51-1952	376	Circ.30-1961	406	Circ.56-1964	152
Misc.2(145)-1934	343	Circ.52-1952	377	Circ.31-1961	406	Circ.57-1964	152
Misc.2(146)-1934	343	Circ.53-1952	269	Circ.32-1961	398	Circ.139-1964	211
Misc.2(147)-1934	343	Circ.54-1952	270	Circ.33-1961	398	Circ.372-1964	506
Misc.2(148)-1934	343	Circ.55-1952	360	Circ.34-1961	369	Circ.373-1964	503
Misc.2(157)-1934	454	Circ.56-1952	360	Circ.35-1961	369	Circ.374-1964	503
Misc.2(158)-1934	454	Circ.57-1952	267	Circ.36-1961	369	Circ.375-1964	504
C.58-1937	131	Circ.58-1952	268	Circ.37-1961	369	Circ.376-1964	505
C.59-1937	192	Circ.59-1952	383	Circ.38-1961	361	Circ.438-1964	198
Circ.105-1937	45	Circ.60-1952	372	Circ.39-1961	361	Circ.439-1964	199
Circ.106-1937	52	Circ.307-1953	332	Circ.40-1961	399	Circ.356-1965	217
Circ.107-1937	48	Circ.308-1953	19	Circ.41-1961	409	Circ.611-1966	444
Circ.108-1937	48	Circ.1-1954	391	Circ.42-1961	350	Circ.612-1966	444
Circ.129-1937	464	Circ.2-1954	392	Circ.43-1961	350	Circ.613-1966	444
Circ.130-1937	458	Circ.13-1954	493	Circ.44-1961	350	Circ.614-1966	444
Circ.131-1937	459	Circ.14-1954	490	Circ.45-1961	402	Circ.615-1966	444
Circ.133-1937	467	Circ.15-1954	495	Circ.46-1961	402	Circ.616-1966	444
Circ.134-1937	468	Circ.16-1954	479	Circ.47-1961	394	Circ.617-1966	444
C.13-1939	13	Circ.17-1954	395	Circ.48-1961	394	Circ.758-1966	121
C.14-1939	32	Circ.124-1954	389	Circ.49-1961	403	Circ.759-1966	121
C.15-1939	53	Circ.125-1954	384	Circ.50-1961	403	Circ.630-1968	507
C.16-1939	41	Circ.126-1954	385	Circ.51-1961	403	Circ.631-1968	501
Circ.259-1939	46	Circ.127-1954	353	Circ.52-1961	403	Circ.632-1968	508
Circ.260-1939	57	Circ.128-1954	381	Circ.53-1961	403	Circ.444-1969	225

Accession	Page	Accession	Page	Accession	Page	Accession	Page	Accession	Page	Accession	Page
Circ.453-1969	161	C.75-1985	528	C.65-1987	180	C.226-1987	189	C.135-1988	294	C.158-1988	318
Circ.454-1969	161	C.76-1985	528	C.66-1987	176	C.227-1987	200	C.136-1988	295	C.159-1988	316
Circ.455-1969	161	C.77-1985	509	C.67-1987	176	C.228-1987	188	C.137-1988	291	C.160-1988	315
Circ.456-1969	161	C.78-1985	478	C.68-1987	177	C.234-1987	243	C.138-1988	280	C.161-1988	314
Circ.457-1969	161	C.79-1985	515	C.69-1987	177	C.261-1987	164	C.139-1988	285	C.162-1988	4
Circ.458-1969	163	C.80-1985	515	C.70-1987	176	C.293-1987	437	C.140-1988	287	C.163-1988	103
Circ.459-1969	163	C.81-1985	515	C.71-1987	182	C.1-1988	339	C.141-1988	283	C.174-1988	157
Circ.460-1969	163	C.82-1985	515	C.72-1987	182	C.2-1988	333	C.146-1988	319	C.175-1988	153
Circ.461-1969	224	C.83-1985	520	C.73-1987	182	C.3-1988	338	C.147-1988	293	C.176-1988	63
Circ.462-1969	216	C.84-1985	520	C.74-1987	183	C.4-1988	492	C.148-1988	292	C.177-1988	80
Circ.662-1969	163	C.85-1985	520	C.75-1987	183	C.5-1988	441	C.149-1988	317	C.178-1988	81
Circ.113-1971	110	C.86-1985	520	C.76-1987	183	C.6-1988	126	C.150-1988	296	C.179-1988	79
Circ.509-1972	78	C.87-1985	520	C.77-1987	183	C.7-1988	312	C.151-1988	299	C.180-1988	284
Circ.618-1972	417	C.213-1985	414	C.78-1987	183	C.8-1988	311	C.152-1988	300	C.181-1988	413
Circ.619-1972	277	C.214-1985	414	C.79-1987	183	C.9-1988	306	C.153-1988	298	C.182-1988	349
Circ.624-1972	173	C.215-1985	349	C.80-1987	183	C.10-1988	313	C.154-1988	297	C.201-1988	529
Circ.508-1973	76	C.233-1985	397	C.81-1987	183	C.11-1988	303	C.155-1988	302	C.1-1989	187
Circ.509-1973	76	C.234-1985	163	C.85-1987	22	C.12-1988	251	C.156-1988	305	C.35-1989	539
Circ.510-1973	76	C.235-1985	355	C.86-1987	20	C.13-1988	252	C.157-1988	310		
Circ.511-1973	76	C.236-1985	400	C.87-1987	34	C.18-1988	327				
Circ.512-1973	76	C.237-1985	137	C.88-1987	62	C.32-1988	245				
Circ.513-1973	76	C.9-1986	29	C.89-1987	68	C.33-1988	248				
Circ.514-1973	76	C.111-1986	55	C.90-1987	25	C.34-1988	218				
Circ.515-1973	76	C.114-1986	85	C.91-1987	21	C.35-1988	221				
Circ.516-1973	76	C.115-1986	85	C.92-1987	11	C.36-1988	223				
Circ.517-1973	76	C.116-1986	85	C.93-1987	30	C.37-1988	227				
Circ.518-1973	76	C.117-1986	85	C.94-1987	28	C.38-1988	250				
Circ.519-1973	76	C.118-1986	85	C.125-1987	94	C.39-1988	205				
Circ.162-1974	172	C.119-1986	90	C.126-1987	95	C.40-1988	228				
Circ.163-1974	172	C.120-1986	90	C.127-1987	97	C.41-1988	236				
Circ.164-1974	172	C.121-1986	91	C.128-1987	92	C.42-1988	204				
Circ.165-1974	172	C.122-1986	91	C.129-1987	98	C.43-1988	234				
Circ.166-1974	172	C.123-1986	91	C.130-1987	102	C.44-1988	249				
Circ.167-1974	172	C.124-1986	91	C.131-1987	100	C.45-1988	159				
Circ.168-1974	172	C.125-1986	69	C.132-1987	67	C.46-1988	127				
Circ.169-1974	172	C.126-1986	74	C.133-1987	67	C.47-1988	186				
Circ.170-1974	172	C.127-1986	77	C.134-1987	67	C.48-1988	174				
Circ.171-1974	172	C.128-1986	77	C.135-1987	67	C.49-1988	161				
Circ.172-1974	172	C.129-1986	77	C.136-1987	96	C.50-1988	162				
Circ.173-1974	172	C.130-1986	86	C.137-1987	71	C.51-1988	122				
Circ.174-1974	172	C.131-1986	81	C.138-1987	73	C.51-1988	123				
Circ.453-1974	511	C.132-1986	70	C.139-1987	73	C.51-1988	124				
Circ.454-1974	513	C.133-1986	70	C.140-1987	73	C.51-1988	125				
Circ.455-1974	510	C.134-1986	320	C.141-1987	73	C.51-1988	128				
Circ.456-1974	512	C.135-1986	330	C.142-1987	89	C.51-1988	129				
C.59-1976	p.139	C.136-1986	321	C.143-1987	279	C.51-1988	130				
C.302-1976	456	C.137-1986	322	C.144-1987	259	C.51-1988	132				
Circ.337-1976	470	C.138-1986	320	C.145-1987	260	C.51-1988	135				
C.144-1977	351	C.139-1986	330	C.146-1987	271	C.51-1988	149				
C.101-1978	368	C.140-1986	337	C.147-1987	288	C.51-1988	150				
C.102-1978	368	C.141-1986	354	C.148-1987	278	C.51-1988	156				
C.75-1979	514	C.142-1986	352	C.149-1987	281	C.51-1988	136				
C.76-1979	516	C.143-1986	414	C.150-1987	282	C.51-1988	141				
C.107-1979	88	C.144-1986	414	C.151-1987	274	C.51-1988	160				
C.148-1979	82	C.145-1986	408	C.152-1987	276	C.51-1988	166				
C.149-1979	82	C.146-1986	359	C.153-1987	286	C.51-1988	167				
C.150-1979	82	C.147-1986	358	C.154-1987	289	C.51-1988	168				
C.151-1979	82	C.148-1986	404	C.156-1987	115	C.51-1988	170				
C.152-1979	82	C.149-1986	422	C.157-1987	107	C.51-1988	171				
C.153-1979	82	C.171-1986	344	C.158-1987	116	C.52-1988	185				
C.154-1979	83	C.172-1986	345	C.159-1987	118	C.53-1988	175				
C.155-1979	83	C.173-1986	346	C.160-1987	112	C.54-1988	178				
C.156-1979	84	C.174-1986	532	C.161-1987	113	C.55-1988	179				
C.15-1980	232	C.178-1986	527	C.162-1987	111	C.56-1988	181				
C.16-1980	233	C.179-1986	533	C.163-1987	491	C.101-1988	502				
C.46-1980	304	C.180-1986	534	C.164-1987	197	C.102-1988	328				
C.47-1980	307	C.181-1986	536	C.165-1987	93	C.103-1988	331				
C.48-1980	308	C.189-1986	335	C.166-1987	429	C.104-1988	440				
C.49-1980	309	C.190-1986	334	C.167-1987	438	C.105-1988	439				
C.105-1981	517	C.191-1986	524	C.168-1987	518	C.106-1988	538				
C.106-1981	119	C.192-1986	525	C.169-1987	530	C.107-1988	531				
C.176-1981	262	C.236-1986	1	C.170-1987	500	C.108-1988	535				
C.93-1982	117	C.17-1987	526	C.189-1987	432	C.109-1988	521				
C.96-1984	23	C.37-1987	101	C.190-1987	433	C.110-1988	537				
C.97-1984	42	C.40-1987	99	C.191-1987	434	C.111-1988	26				
C.98-1984	43	C.45-1987	430	C.192-1987	435	C.112-1988	114				
C.128-1984	347	C.46-1987	426	C.193-1987	120	C.113-1988	108				
C.129-1984	348	C.47-1987	426	C.194-1987	190	C.114-1988	226				
C.130-1984	336	C.48-1987	436	C.195-1987	191	C.118-1988	205				
C.131-1984	427	C.49-1987	431	C.196-1987	195	C.119-1988	206				
C.132-1984	419	C.50-1987	424	C.197-1987	241	C.120-1988	203				
C.133-1984	540	C.51-1987	380	C.198-1987	242	C.121-1988	253				
C.134-1984	421	C.52-1987	380	C.199-1987	230	C.122-1988	254				
C.135-1984	416	C.53-1987	415	C.200-1982	239	C.123-1988	219				
C.136-1984	420	C.54-1987	362	C.201-1987	238	C.124-1988	356				
C.137-1984	412	C.55-1987	154	C.202-1987	231	C.125-1988	357				
C.138-1984	418	C.56-1985	184	C.203-1987	220	C.126-1988	342				
C.139-1984	423	C.57-1987	169	C.204-1987	244	C.127-1988	256				
C.140-1984	425	C.58-1987	180	C.205-1987	222	C.128-1988	257				
C.141-1984	428	C.59-1987	180	C.206-1987	237	C.129-1988	255				
C.162-1984	522	C.60-1987	180	C.207-1987	247	C.130-1988	258				
C.163-1984	523	C.61-1987	180	C.208-1987	229	C.131-1988	273				
C.72-1985	519	C.62-1987	180	C.209-1987	246	C.132-1988	261				
C.73-1985	528	C.63-1987	180	C.210-1987	235	C.133-1988	275				
C.74-1985	528	C.64-1987	180	C.211-1987	240	C.134-1988	290				

INDEX

Designers, artists and factories represented by works in
the museum's collection and listed by page number